Bosch Laurinda Dixon

ART &IDEAS

Φ

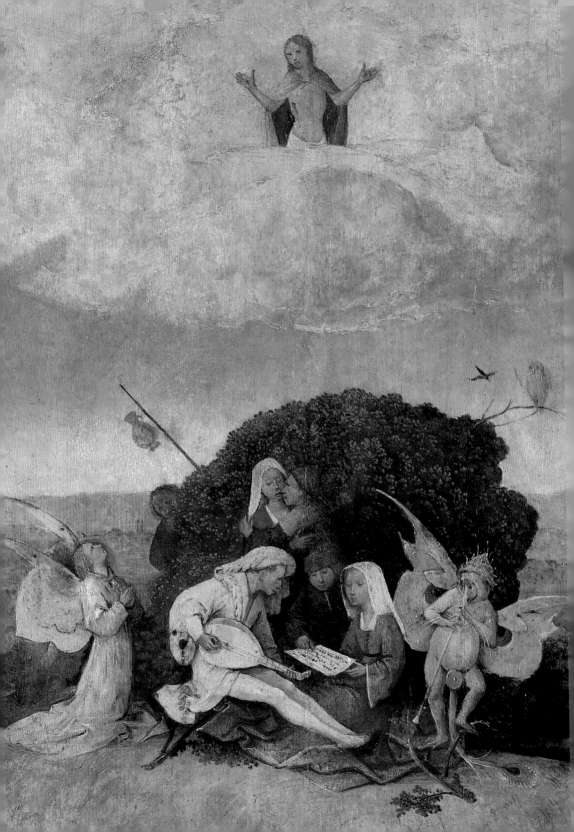

Bosch

Introduction 4

1 **Hieronymus Bosch**
 Facts and Fiction 13

2 **The Spectacle of Human Folly**
 Bosch as Moralist 41

3 **Perilous Paths**
 The Tale of Two Triptychs 67

4 **Redemption Through Emulation**
 The Imitation of Christ 119

5 **Martyrdom and Melancholy**
 The Sufferings of the Saints 147

6 **An Apothecary's Apotheosis**
 The *St Anthony* Triptych 173

7 **The Crucible of God**
 Bosch's Chemical Epiphany 199

8 **Science and Salvation**
 The *Garden of Earthly Delights* Triptych 225

9 **Mirroring the Millennium**
 Bosch's Apocalyptic Visions 279

10 **Lost and Found**
 The Legacy of Hieronymus Bosch 313

& Glossary 332
 Brief Biographies 334
 Key Dates 337
 Map 339
 Further Reading 340
 Index 344
 Acknowledgements 350

Opposite
Haywain
triptych
(detail of 52),
c.1510 or
later.
Oil on panel;
135 × 100 cm,
53$\frac{1}{8}$ × 39$\frac{3}{8}$ in.
Museo del
Prado,
Madrid

Introduction

The art of Hieronymus Bosch (*c*.1450–1516) has fascinated, challenged and enlightened viewers for half a millennium. At first sight, his subject matter seems unprecedented in the art historical canon. We shudder at the sight of fiendish hybrid monsters who torment their helpless victims in the sulfurous depths of spectacular hellscapes. Yet who can suppress a smile when confronted with the antics of the youthful, naked inhabitants of the *Garden of Earthly Delights* (1) as they gleefully seduce one another with giant strawberries and place flowers in bodily orifices best left unexposed in polite society? Viewers from Bosch's time to our own have struggled to interpret this startling imagery.

The first reference to Bosch, written a generation after his death by the Spanish nobleman Felipe de Guevara, who owned several of the artist's works, complained that most people thought of him simply as an 'inventor of monsters and chimeras'. As late as the 1950s, the eminent historian of Netherlandish art Erwin Panofsky refused even to attempt discussion of the problematic painter. Avoiding the risk of speculation, he ended *Early Netherlandish Painting* with a clever rhyme borrowed from Renaissance humanism: 'This too high for my wit, I prefer to omit.'

Since the great Panofsky admitted his ignorance, students of art history have rushed to meet the challenge, devoting more of their talents to Bosch than to any other Netherlandish painter. The more crowded the playing field, however, the more confusing and problematic the game. Frustration with the lack of documentation on Bosch himself (what little we know about his life is discussed in Chapter 1) has led scholars to look to contextual evidence, delving into

1
Garden of Earthly Delights
(detail of 150)

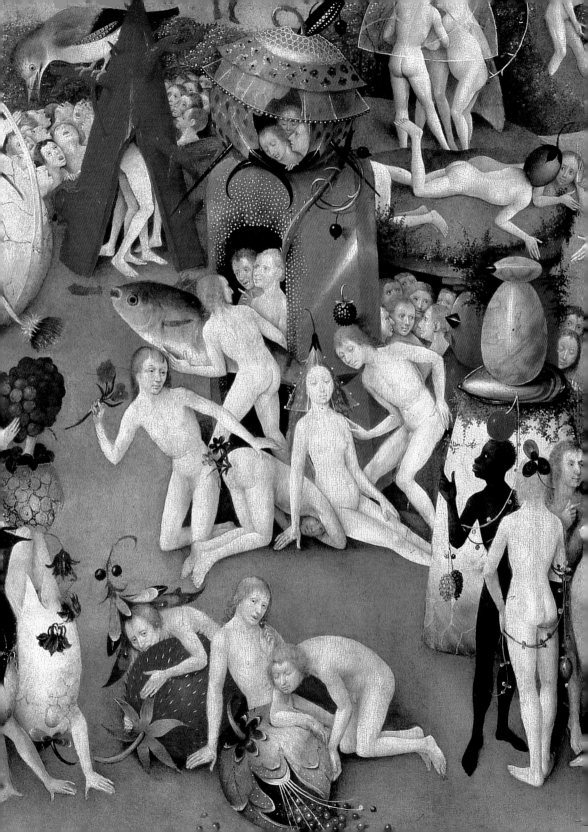

heretical cults, folklore, proverbs, magic, secret societies, Biblical commentary, material culture and even Freudian psychology. Pictorial models have been sought among fifteenth-century prints, illuminated manuscripts, panel painting, sculpture, church furniture and a range of other traditional art media. Drawing on this varied evidence, some present Bosch as a simple moralist, interpreting his unusual forms as figments of the artist's fertile imagination. Others see him as a heretic or a madman, whose wild, often shocking images branded him a social outcast. One group of interpreters believes that the meaning of Bosch's works was accessible only to a highly trained élite, while others claim that Bosch was a typical 'everyman', an ordinary person completely immersed in bourgeois culture and morality. Yet another approach is championed by those who, frustrated with the difficulties of reconstructing lost pictorial contexts, deny the notion of determinate meaning altogether. To them, Bosch's paintings are visual extravaganzas the very attraction of which lies in the impossibility of their being explained. Most scholars, however, now agree that Bosch's art, strange as it is to modern sensibilities, possessed a profound significance for his audience.

Bosch's general style and technique fit within the larger context of Northern Renaissance art. However, no documents exist that pinpoint his artistic training and formative influences. The lack of concrete information makes questions of attribution and stylistic development especially difficult. Scholars and connoisseurs have attempted to distinguish the elements of his style and technique by means of visual analysis and scientific study. They have measured the thickness of paint layers, examined the direction of cross hatchings in underdrawings, and noted the existence of *pentimenti* (images beneath the outer paint layer that differ from the final form). Experts argue about stylistic inconsistencies among the paintings attributed to Bosch, noting that some show a highly finished, careful approach,

with a sinuous linearity of contour and minimal hatching in the underdrawing. Conversely, other paintings show more vigorous modelling and profuse hatching. The paint in some works is thickly applied, whereas in others it consists of a thin, almost translucent layer that allows the underdrawing to show through clearly. Some works, particularly the large triptychs, display different styles and techniques within the same panel. This diversity has led scholars to ask whether the works gathered together under the name 'Hieronymus Bosch' are the creations of a single man or a number of painters working together. If one considers as a group the single panels and triptychs that appear to be by Bosch's hand, the only conclusions possible are that he had no consistent way of working, or that several artists contributed to the finished product. Given Bosch's position within a family dynasty of painters, all working and training in the same place, the traditional view of him as a lone 'original genius' should perhaps be modified to allow for the partici-pation of a large family workshop, with Hieronymus Bosch at its head.

Adding to the difficulty of attribution is the fact that Bosch's name appears on only seven of the paintings accepted as his. The total number of works attributed to Bosch generally ranges from thirty to forty, including several large multi-panelled paintings. None of these shows a date. A stylistic evolution has been proposed from a manner heavily dependent upon the example of manuscript illumination to large-scale works on panel, likely products of a self-confident, 'mature' artistic sensibility. Following this reason-ing, historians seeking to establish a chronology for Bosch's paintings have labelled the triptychs, such as the *Garden of Earthly Delights* (see 133), as mid-career works because, despite their larger size, their numerous pictorial vignettes and scrupulous attention to detail suggest the illuminator's craft. Large, pared-down compositions, such as the Ghent *Carrying of the Cross* (see 63), which contain fewer figures

viewed within a telescoped space, would in this analysis
be late works that demonstrate a supposed evolution away
from the manuscript illuminator's meticulous vision. It is
dangerous, however, to make such assumptions about Bosch.
It is more helpful to consider the many mediating factors
that determine the look of a finished painting, such as the
financial means of the patron and the intended function
of the piece. Unfortunately, this vital information is missing
for most of the extant paintings attributed to Bosch, whereas,
ironically, such documentation exists for several lost works.

As experts have been forced to admit that traditional
assumptions about how Renaissance artists worked are
highly suspect in Bosch's case and ultimately of no use
whatever in charting the evolution of his style, the best
hope for clarification of his chronology and stylistic
development seems to lie with scientific analysis. Modern
museums maintain advanced laboratories for restoration
and examination of works of art, and the technical
investigation of paintings attributed to Bosch yields more
substantive conclusions than visual analysis. Technicians
have examined many of Bosch's paintings by means of
X-rays, infrared photography and pigment analysis. Dendro-
chronology, which reveals the age of wooden panel supports,
is a relatively new and successful analytical process. This
procedure can date the youngest tree ring of a panel to within
one year. On the basis of this information, it is possible to
deduce when the tree in question was felled and to arrive at
a *terminus post quem* (a date after which a work must have
been created).

Despite the ability of dendrochronology to pinpoint the
felling date of a tree, arriving at the actual date of a painting
is more complicated. Painters always stored and seasoned
their wood panels for a number of years before beginning
work. But there is no way of knowing how long a piece of
wood languished in a workshop before being used, and any

attempt to arrive at a standard length of time is purely conjectural. Some historians add an average of eleven to seventeen years or more to allow for ageing and curing, others add only two. Furthermore, wood from several trees can support a single work, a common occurrence in large, multi-panelled compositions. This is the case with Bosch's Vienna *Last Judgement* (see 192), in which the oldest of its six panels dates from *c*.1304. Good, seasoned wood must have been hard to come by, and painters commonly reused old panels by scraping the surfaces and repainting them. Bosch himself may have done this in 1480–1, when, according to the accounts of the Brotherhood of Our Lady, he purchased the damaged 'wings of an old altarpiece', presumably for reuse in his workshop.

Dendrochronology has proven most valuable in assigning late works, once thought to be by Bosch's hand, to followers, for no artist can paint on wood from a tree felled after his death. In this book, I have arrived at tentative dates for Bosch's paintings by adding two years to the date of felling, the minimum time allowed for drying and ageing. I acknowledge the hypothetical result by adding the abbreviation '*c*.', followed by 'or later'. In other words, a date of '*c*.1500 or later' means that the wood for the panel supports was cut in 1498; therefore, painting could not have begun before 1500 at the earliest, though, theoretically, the work could have been finished any time between 1500 and 1516, the year of Bosch's death. It is not possible at this time to date Bosch's works with any more specificity, though future advances in science may provide us with the means to do so. Despite the pitfalls, technical examination of paintings attributed to Bosch continues apace as art historians and the interested public look forward with anticipation to each new discovery.

The problems inherent in dating Bosch's paintings, combined with the paucity of documents relating to the artist, has determined my decision to organize this

book thematically rather than biographically. Instead of following the thread of Bosch's life, noting that a certain work appeared in response to a specific historical moment, the text addresses universal concepts that illumine aspects of his imagery. The main difference between this book and others in the field is my consideration of the alliance of art, piety and science in Bosch's works. Though art historians accept such a synthesis in the case of Italian artists such as Leonardo da Vinci (1452–1519), a near exact contemporary of Bosch, they have been slow to recognize the same phenomenon in their consideration of Northern Renaissance artists. Adding to this reticence is the fact that much of Renaissance 'science' – astrology and alchemy for instance – has proven irrelevant to modern empirical methodology, and we view it today as belonging to the realm of the occult.

The following chapters present Bosch as a man of his time, conversant with current intellectual enquiry. Bosch's world saw the foundations of civilization torn down and pieced back together again as dogmatic scholasticism gradually yielded to the evidence of empirical observation. Geographic and celestial boundaries expanded dramatically during Bosch's lifetime with the discovery of the Americas and the first inklings of the heliocentric universe. Knowledge of the human body followed suit, as medicine advanced in the fields of anatomy and surgery. Nonetheless, the planets and stars were still believed to determine human character, and learned men seriously debated the healing powers of precious stones and unicorn horns. The Renaissance was filled with such contradictions. Latin humanism and vernacular folk culture, science and religion, realism and fantasy, anxiety and optimism all flourished together in a world of mutable boundaries and multiple points of view.

Since my first published study on Bosch in 1981, I have approached his works not from a narrow appreciation of isolated motifs, but from a broad examination of the many

scientific concepts that enriched the Renaissance and which the painter and his audience would have known. The contradictory nature of Bosch's era – the decades on either side of the year 1500 – are explored in the following chapters, each devoted to a phenomenon that influenced the artist, his viewers and his patrons. Bearing this in mind, the reader will find discussions of the application of chemistry (known in Bosch's day as 'alchemy') and the practical craft of pharmacy in the interpretations of the *Stone Operation* in Chapter 2 and the *St Anthony* triptych in Chapter 6. The broader intellectual perception of chemistry as a vehicle for enlightenment and Christian salvation enlarges the multivalent contexts surrounding the Prado *Adoration of the Magi* and *Garden of Earthly Delights* triptychs in chapters 7 and 8. The venerable disciplines of astrology and humoral medicine are introduced in Chapter 3, applied to the *Ship of Fools* and Rotterdam *Wayfarer*. Aristotelian physiognomy makes an appearance in Chapter 4 as a way of enlarging our understanding of Bosch's Passion scenes, and the idea of genius and revelation as manifestations of humoral medicine underlies the interpretation of Bosch's depictions of hermit saints in Chapter 5. In every case, Bosch's use of scientific imagery enhances and magnifies the Renaissance view of Christian morality as underlying every serious intellectual effort.

In Bosch's day there was no division between the spiritual and the material, and scientists practised always with an eye towards Christian salvation. We need not accept Bosch, therefore, as either ignorant or learned, bourgeois or aristocratic, devout or heretical, pragmatic or visionary, as there was no bar to being an interpreter of both popular wisdom and higher knowledge, realms that were not antithetical within the intellectual ambience of his time. The fluid fusion of sacred and secular, urban and court environments, science and religion that characterized the Northern Renaissance produced a unique form of cultural

expression, which Bosch absorbed. This was a world different from but no less complex than our own. A knowledge of its varied contexts and conundrums is key to understanding and appreciating his paintings. This book aims to show that Bosch did not stand alone, but rather reflected and reinforced the predominant world view of his time.

Hieronymus Bosch Facts and Fiction

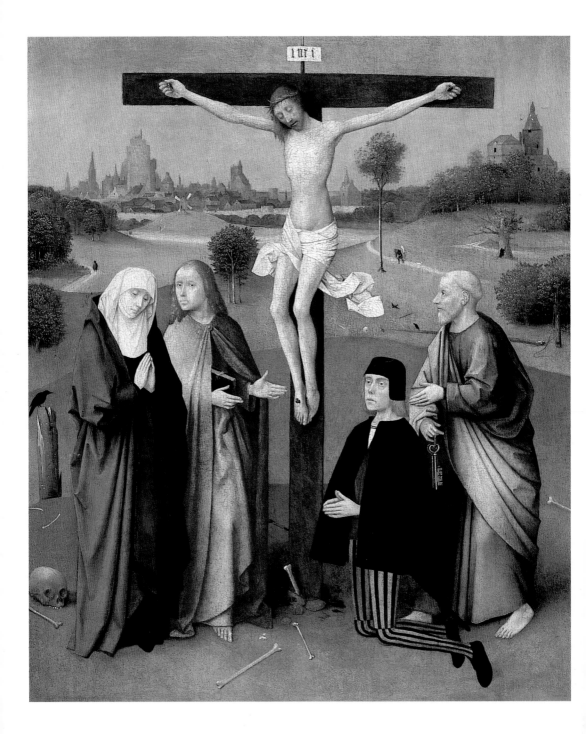

A good place to begin to gain an understanding of Bosch's paintings is with the artist himself. What kind of education did he receive? Who were his friends and patrons? Did he travel and, if so, when and where? Is there an underlying link between the nature of Bosch's art and the circumstances of his life? Unfortunately, the few surviving documents do not provide clear answers to any of these questions.

The meagreness of the Bosch paper trail does not mean that his life was necessarily uneventful or provincial. The volatile history of the Netherlands has left precious little with which to reconstruct events that took place half a millennium ago. Northern Europe has suffered more than its share of violence through the centuries, from religious iconoclastic vandalism and peasant conflicts in the sixteenth century to the mechanized destruction inflicted by two world wars. Entire archives have been obliterated in these conflicts, and crucial evidence of Bosch's life may have perished with them.

2
Crucifixion with Donor, c.1477 or later.
Oil on panel; 73·5 × 61·3 cm, 29 × 24⅛ in.
Musées Royaux des Beaux-Arts de Belgique, Brussels

Further, artists were traditionally assigned a relatively low status in late medieval society, so much so that most fifteenth-century painters did not even sign their works. Attitudes were, however, changing, and art historians view this era as a transitional time when artists were caught between defining themselves as craftsmen on one hand, and as original creators on the other. Bosch's younger German contemporary, Albrecht Dürer (1471–1528), influenced by Italian humanism and its emphasis on individuality, expressed frustration that in northern Europe an artist was still seen as a craftsman at a time when his Italian colleagues were enjoying an elevated status as intellectuals and geniuses. While Dürer documented his

views and his extraordinary accomplishments in numerous personal diaries and letters, there is no reason to believe that Bosch would have done so. Nor is it likely that the anecdotal personal details of a painter's life, even one as great as Bosch, would have been considered worthy of preservation in the historical record or chronicled by biographers. Not until the collected essays of the first 'art historians', the Florentine painter and architect Giorgio Vasari (1511–74; author of *Le Vite* or *Lives of the Artists*, 1550) and the Dutch painter Karel van Mander (1548–1606; author of *Het Schilder-boeck* or *Book of Painters*, 1604), did artists' biographies become appropriate reading for the literate public. However, these earliest accounts suffer from an accretion of anecdote and hearsay that makes them entertaining reading, but sloppy history. We can best begin to understand Bosch's life by looking at the town of 's-Hertogenbosch, where he was born and from which he took his name, and the larger world that encompassed it, then by examining Bosch's status as revealed by the few existing documents that mention him.

During the early years of Bosch's life, 's-Hertogenbosch belonged to the vast territories of the Valois dukes, Philip the Good and Charles the Bold of Burgundy. Following the death of Charles the Bold and the marriage of his daughter Mary of Burgundy to the German Maximilian I in 1477, the Netherlands came under Habsburg rule. The union of the French–Burgundian Valois dynasty with the German–Austrian Habsburg line created a vast empire that extended to the Iberian peninsula and a diverse hereditary aristocracy that remained virtually intact until World War I. More importantly, the merger perpetuated the prestige of a magnificent court, led by Maximilian himself, who not only supported the arts and sciences, but also practised them in the tradition of a Renaissance *uomo universale* (universal man). In so doing, Maximilian proudly bound himself to a great and lavish tradition of long standing, recognizing,

above all, the importance of artists in crafting his imperial image. Following the emperor's example, members of the Habsburg court and their subjects proudly supported the art and scholarship that thrived under their patronage.

Located in the Duchy of Brabant, 's-Hertogenbosch was established in 1185, as the name (translated as 'the duke's woods') suggests, on what were once the private hunting grounds of a noble duke. The town lies close to the present-day Belgian border and was, together with Antwerp and Brussels, one of the three largest cities in Brabant. Its fame increased during Bosch's lifetime, when the city experienced a veritable explosion in population, increasing from 17,280 inhabitants in 1496 to 25,000 in 1500. The town enjoyed a reputation as a thriving commercial and agricultural centre, and was especially noted for its organ builders, metal industry and cloth trade. Items made there were traded throughout Europe, particularly to England and Portugal, and the presence of foreign merchants lent the town a cosmopolitan air. The city also supported many confraternities, lay religious brotherhoods, and several chambers of rhetoric (*rederijker kamers*), amateur literary associations that presented public dramatic performances during festivals and holidays. 'S-Hertogenbosch was a forward-looking place, boasting one of the first printing presses in the Netherlands, established in 1484. The city was also known for its Latin school, though the era of the great Dutch universities was still a century away.

Devotional life flourished in Bosch's home town. Historians estimate that, in the early years of the sixteenth century, about five per cent of the population belonged to a religious order. As can be expected from a town immersed in the cloth industry, 's-Hertogenbosch was home to several monasteries devoted to St Francis, patron of weavers and clothiers. There were also a number of Dominican houses, a *béguinage* (a lay religious house for women), a venerable charity hospital (the

Heilige Geesthuis) and an important Carthusian foundation established by Charles the Bold in 1461. The Observant Franciscans and devout Carthusians were known for the purity and simplicity of their faith, whereas the Dominicans specialized in the interpretation of Church law. By the end of the fifteenth century, there were at least fifty monasteries and churches in and around 's-Hertogenbosch. This devotional abundance inspired the sixteenth-century historian Cuperinus to refer to the town as a 'pious and pleasant city'.

'S-Hertogenbosch was also home to two houses of the Brothers and Sisters of the Common Life, also known as the Modern Devotion (*Devotio moderna*), a lay religious order founded in the fourteenth century by Gerard Groote, a disciple of the mystic Jan van Ruysbroeck. Heralded by some as a precursor to the Protestant Reformation, this organization sought to simplify and reform Catholicism through learning. To this end, they maintained several busy scriptoria for the purpose of copying and distributing ancient and modern scholarly books. Consistent with the Renaissance spirit of the Habsburg rulers, the Modern Devotion professed a form of Catholic humanism that, although it urged reform, nonetheless operated within the existing framework of Church belief. Clearly, faith and learning were important elements in the life of 's-Hertogenbosch and in the art of its most illustrious citizen.

Though historians have provided us with important insights into the cultural and political milieu of 's-Hertogenbosch, only a few documents (painstakingly reconstructed by dedicated archivists) mention Hieronymus Bosch by name. These fall into three categories: the city tax rolls, which inform us of Bosch's financial status; the so-called 'Protocol', which records notarized legal transactions involving Bosch and his family, such as the buying and selling of property, lawsuits, marriages, deaths and so on; and the 'factures', the account books of the Brotherhood of Our Lady, a

confraternity to which Bosch belonged. These sources, though meagre, can shed light on aspects of Bosch's life, and help to correct some of the misperceptions about the artist that have persisted throughout the centuries – including the view that Bosch was of low station until his fortunate marriage to a much wealthier woman, and, more important, that his works harbour intimations of heresy.

The Protocol records that the painter known as Hieronymus Bosch was born Jeroen (sometimes written 'Jerome', 'Joen' or 'Jonen') van Aken, though the date of that event is not noted. In the days when surnames often indicated a family's place of origin, it is safe to assume that Bosch's ancestors came originally from the town of Aachen, also known as Aix-la-Chapelle. We know that his forefathers were painters in Nijmegen, and that his grandfather Jan moved to 's-Hertogenbosch. Bosch's father Anthonis was one of five sons who perpetuated the family profession there. Bosch himself was the fourth of five children in his immediate family, which included two older brothers, and one older and one younger sister. In the days before personal preference decided a young man's future, custom dictated that Bosch be trained in the family craft. We can assume, therefore, that young Jeroen (Hieronymus) and his brother Goessens, who was also an artist, learned their profession as apprentices in the family workshop, located in a large house on the central market square. Goessens's sons Johannes and Anthonis probably also worked there, bringing to four the number of generations in the family atelier.

As a painter Bosch chose to be known by the Latin version of his first name, 'Hieronymus' (also spelled 'Jheronimus' or 'Jeronimus'), and to replace his family name by 'Bosch', a reference to his home town. Other artists, before and after him, did the same, signing their works 'Bos', 'Van den Bossche', 'de Bolduque' and 'Buscodius'. The presence of several works by Bosch in Venice today has led some

scholars to suggest a possible visit to Italy, and to argue that the name change indicates that he was evidently concerned that strangers knew where he came from, and furthermore took steps to make his first name more accessible to a wider, literate audience. However, as there is no documentary evidence that Bosch travelled, as Dürer and others did, the possibility must remain in the realm of speculation, though it would not have been out of the question for such a painter.

Like so much else, the year of Bosch's birth is a point of contention among scholars. Documents suggest 1450 or shortly thereafter. One of these is the 1474 Protocol, which records that he, his father and two brothers took part in a property transaction on behalf of his sister Katherijn. The fact that the young Bosch served as a legal witness at this time strongly suggests that, by 1474, he had reached his majority, though the age of legal adulthood fluctuated throughout the region, ranging from eighteen to twenty-five years in the Duchy of Brabant. Given this information, we can calculate that his birth probably occurred between 1449 and 1456.

Documents dating from 1480–1 refer to Bosch in Flemish and Latin as 'Jerome the painter' (*Jeroen di maelre* and *Jheronimus dictus Jeroen, pictor*). This mention of Bosch's occupation indicates that he had completed his training and was an independent artist, further suggesting a birth date in the early 1450s, which would make him in his late twenties at this time. Normally, in a guild system, an apprentice could attain the rank of master painter any time from his late teens to his late twenties, after several years of service in a workshop and the production of a 'masterpiece' that was judged by the guild before its creator was deemed worthy to practise independently. However, there is no documentary evidence of a painter's guild in 's-Hertogenbosch before 1546, and no evidence that Bosch ever held the guild title of 'master'. Considering the fact that he came from a veritable

dynasty of painters, Bosch probably began formal training at a young age, and may well have been an established painter by his late twenties.

Another biographical fact that supports a birth date in the early 1450s is Bosch's marriage to Aleyt Goyarts van den Meervenne. This event probably took place in 1481, when the Protocol first mentions them as man and wife, or slightly earlier. Aleyt (whose date of birth is unknown) came from a wealthy family and brought a fortune with her to the marriage. From this time, Bosch appears regularly in the Protocol, usually in connection with various financial transactions and legal proceedings conducted on behalf of himself and his wife. Some researchers suppose, then, that he benefited financially from his marriage by obtaining the means to enter a higher social class. The art historian Paul Vandenbroeck goes further, stating that Bosch's fortunate match with Aleyt allowed him the freedom to paint whenever and whatever he wanted. Vandenbroeck echoes earlier art historians in his belief that Aleyt van den Meervenne was much older than her husband (by as much as twenty-five years!). This scenario, however, is unlikely. In the fifteenth century men frequently married younger women, as they do today; however, the social stigma attached to a young man's first marriage to a much older woman was severe. Added to this is the fact that Bosch's marriage lasted thirty-six years, and his wife outlived him by seven, dying in 1522 or 1523. Their marriage, the first for both of them, was more likely normal in every respect.

Bosch probably married in his mid- to late twenties, as was the norm in Brabant, and to a woman the same age or younger than he. It is likely that the two families had known each other for many years and were perhaps connected professionally. The match was contracted between parties of equal stature, for the mutual benefit of all concerned, and Jeroen Bosch must have been considered as fortunate a

mate for Aleyt as she for him. Custom further dictated that Aleyt van den Meervenne's fortune was neither hers nor her husband's to spend at will. Her husband would have been responsible for maintaining and multiplying her dowry so that it could be returned to her intact, along with a percentage of the joint earnings accumulated during the marriage, in the event of his death. Bosch and Aleyt evidently worked together to parlay their already considerable property holdings into liquid cash, as the Protocol records several sales, in both their names, of urban property. This was not unusual, as women often sold their so-called 'movable' assets (furnishings, clothing, jewellery and property) obtained via the marriage exchange for profit and investment. When Aleyt died childless, several years after Bosch, the original amount of her dowry was probably returned to her family, as was the custom. We know that its investment earnings were dispersed according to her will to her husband's sister and nephews. It is possible that the myth of Bosch's unequal marriage may be the result of a simple error, as Bosch's mother, Aleyt van der Mynnen, bore the same first name as his wife.

Bosch's marriage situates him in the highest economic stratum of the population of 's-Hertogenbosch at an early age, for his family would have offered marriage gifts at least equal in value to Aleyt's dowry. The fact that in 1462 Bosch's father Anthonis bought a large stone house located on the city's main square, suggests that the family already enjoyed considerable economic standing at the time of the marriage. Existing tax rolls from 's-Hertogenbosch show that Bosch himself was among the wealthiest of the town's inhabitants, ranking in the upper ten per cent of the population in terms of income. Records also show that he maintained property and had a number of tenants and debtors during his lifetime. Bosch probably lived and worked at his parents' home until his marriage, when he moved into a large house in the busy centre of town. An anonymous painting of the market at

3
Anonymous, *View of the Market at 's-Hertogenbosch* (Bosch's house is the seventh from the right), c.1530. Oil on panel; 126 × 67 cm, 49⅝ × 26⅜ in. Noordbrabants Museum, 's-Hertogenbosch

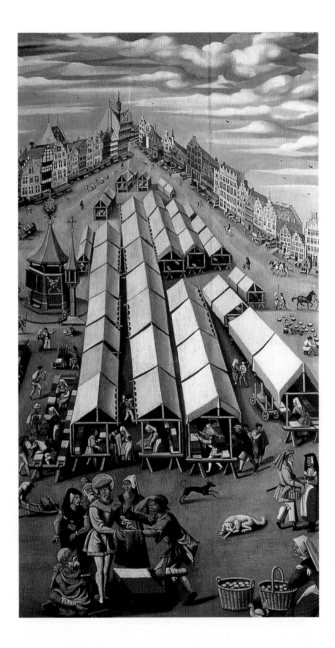

's-Hertogenbosch, from about 1530 (3), shows his home in the upper background of a scene depicting the youthful St Francis distributing clothing to the poor, as busy merchants transact business beneath awnings in the square. Bosch's house, five storeys high and three windows wide, is the seventh from the right, bordering the northern side of the market. Though long-since destroyed and rebuilt in a different style, it remains a landmark in 's-Hertogenbosch.

From the beginning, then, Bosch enjoyed the advantages of wealth and status. The fact that he continued to prosper economically and socially is supported by his documented membership in a confraternity, the Brotherhood of Our Lady (*Confraternitas fratrum beate Marie* or *Onser Vrouwen Broederscap*). Though confraternities have lost much of their relevance in the modern world, remnants exist in such philanthropic organizations as the Catholic Church's Knights of Columbus. They required support in the form of money and service from members, and were dedicated to the performance of the Seven Acts of Mercy, described

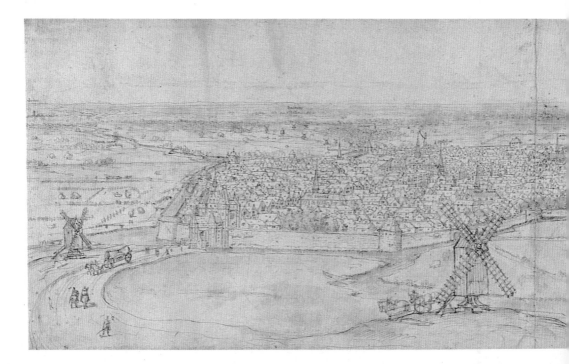

in Matthew 25:35–46 as: feeding the hungry, providing drink for the thirsty, giving shelter to travellers, clothing the poor, visiting the sick, remembering the imprisoned and burying the dead. Members performed these duties as God's servants on earth.

In Bosch's time, membership in a confraternity bridged the gap between the worlds of the Church and town, and was essential for social, professional and spiritual success in this life and beyond. Confraternities offered their members the chance to practise active piety by dispensing acts of mercy and charity through an infrastructure that paralleled that of the Church. They provided 'burial insurance' for members, who were guaranteed not only a dignified funeral and proper interment, but also continued prayers and remembrances after death and assistance to widows and children. Brotherhoods furnished a social context for conducting business and advancing socially. The benefits of membership also enhanced one's time on earth, providing opportunities for fellowship that often took the form of elaborate, expensive

4
Antonius van den Wyngaerde,
View of 's-Hertogenbosch,
c.1545.
Pen and ink
and watercolour;
29 × 94·5 cm,
11½ × 37¼ in.
Ashmolean
Museum,
Oxford

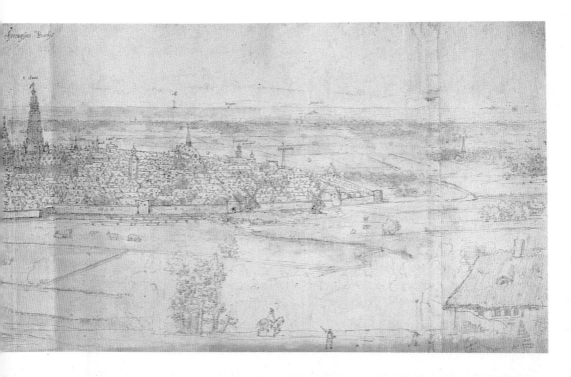

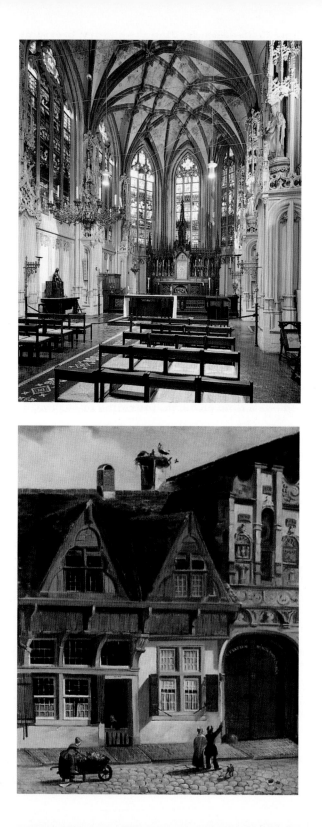

banquets and celebrations. These important lay organizations furnished essential personal, familial, religious, economic and political advantages, all of which directly increased the status and merits of members during their lives and ensured a shortened stay in purgatory after death.

Bosch and his brother Goessens were the third generation of the family Van Aken to be honoured by membership of the Brotherhood of Our Lady. Initially limited to male ecclesiastics, the Brotherhood was established in 's-Hertogenbosch in the early fourteenth century, and eventually became one of the most important confraternities in northern Europe. Much has been written about this worthy group, which maintained both a meeting house in the city and a chapel in the Church of St Jan, which was later designated a cathedral. The church itself was remarkable for its extraordinary tower, which, though destroyed by fire in the late sixteenth century and replaced by a smaller one, appears in old city views (4). The confraternity chapel, a late Gothic marvel, was newly designed and built entirely during Bosch's lifetime. Much grander than a traditional chapel, it had its own nave and apse, as a mirror of its parent church, and included splendid stained glass, impressive stone sculpture and elegant vaulting (5). Modern restoration efforts have uncovered frescoed architectural piers, in addition to delicate floral patterns painted in the upper vaults. The original effect must have been as vibrant and compelling as one of Bosch's paintings, as walls, piers and vaults together formed an intriguing *mélange* of colour and design.

The Brotherhood's chapel is conveniently located in the Church of St Jan, alongside the nave, above the north entrance to the transept. Members needed only to cross the street to go from the confraternity meeting house (6) to the chapel, which they did often, depending upon their office and confraternity responsibilities. The Brotherhood served the church by maintaining an important miracle-working shrine

5
Chapel of the
Brotherhood
of Our Lady,
Cathedral
of St Jan,
's-Hertogenbosch

6
Anonymous,
*Meeting House
of the
Brotherhood
of Our Lady,
's-Hertogenbosch*,
c.1538.
Oil on canvas.
Brotherhood
of Our Lady,
's-Hertogenbosch

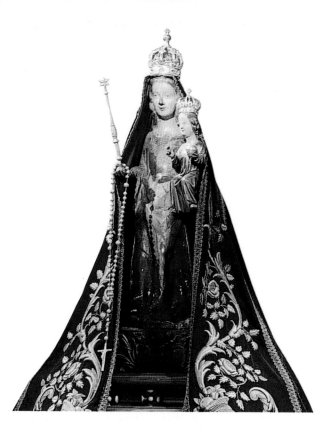

7
Miracle-
working statue
of the Virgin
Mary,
*c.*1380.
Cathedral
of St Jan,
's-Hertogenbosch

of the Virgin, the *Zoete Lieve Vrouw* (7), which dates from the
fourteenth century. The confraternity was also responsible
for providing music and performers for the daily liturgy
and special feast days. By the time Bosch became a sworn
member, probably in 1488, the Brotherhood of Our Lady
was open to both men and women, and included lay and
ecclesiastic constituents. Though membership numbered
in the thousands and spanned all of Europe, Bosch was a
'sworn member', among the power élite of the organization.
Sworn members, who numbered about fifty in the mid-
fifteenth century, received the title of 'cleric'. As such,
Bosch would have worn his hair tonsured and was privileged
to don a colourful cowl, embellished with the organization's
emblem, the lily among thorns. The Brotherhood's insignia
appears in a triptych from 's-Hertogenbosch (8), probably
produced by the Bosch family workshop, emblazoned on

the robe of a donor kneeling in the left panel (9). Bosch's title of 'cleric' was confraternal, not ecclesiastical, and did not preclude him from marrying or practising a profession. Sworn members were required to attend Mass in the chapel each Wednesday and to participate as well in the many religious pageants and requiem masses that the Brotherhood financed and presented during the year.

Food and song were essential components of confraternal celebrations, and the upper echelon of sworn members was obliged to provide both. The hosts of confraternal banquets were chosen from among the wealthiest and most prestigious sworn members, who vied with each other in the expense and elaborateness of their dinners. The banquets offered hosts the opportunity to display preeminence through culinary generosity, and to be honoured in return by wearing a gilded wreath set with pearls during dinner. The first mention of Bosch at a confraternal banquet is in 1488, when, together with six fellow members of the Brotherhood, he marked his 'elevation in rank'. This dinner doubtless celebrated Bosch's promotion to sworn member for, from this date onwards, he appears in confraternity records as a cleric. He also played an important role in the banquet of 1499, during which he was chosen to 'place the tablecoth', meaning he invited the brothers to eat. True to his exalted position, Bosch himself hosted a lavish confraternal banquet on 10 March 1510, for which the confraternity tipped his two maidservants. The Brotherhood held one last feast in honour of Bosch in 1516, when he received the elaborate funeral and memorial banquet reserved for sworn brothers.

During Bosch's time, confraternity members came from all over Europe, and included clergy, academics, merchants and nobles. They were drawn by the promise of indulgences (remissions of punishment in purgatory) and privileges granted exclusively to the confraternity by popes and bishops. Nearly half the membership were priests or

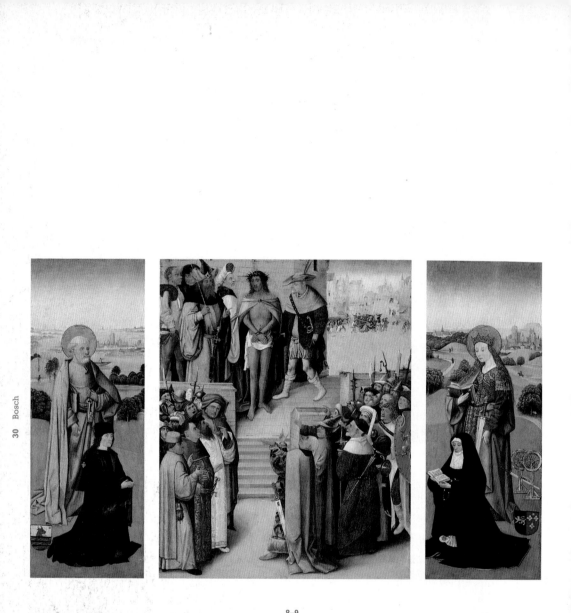

8–9
**School of
Bosch**,
Ecce Homo
altarpiece,
interior,
c.1489 or later.
Oil on panel;
centre panel
73 × 57·2 cm,
28³⁄₄ × 22¹⁄₂ in,
side panels
79·5 × 36 cm,
31¹⁄₄ × 14¹⁄₄ in.
Museum of Fine
Arts, Boston
Right
Detail

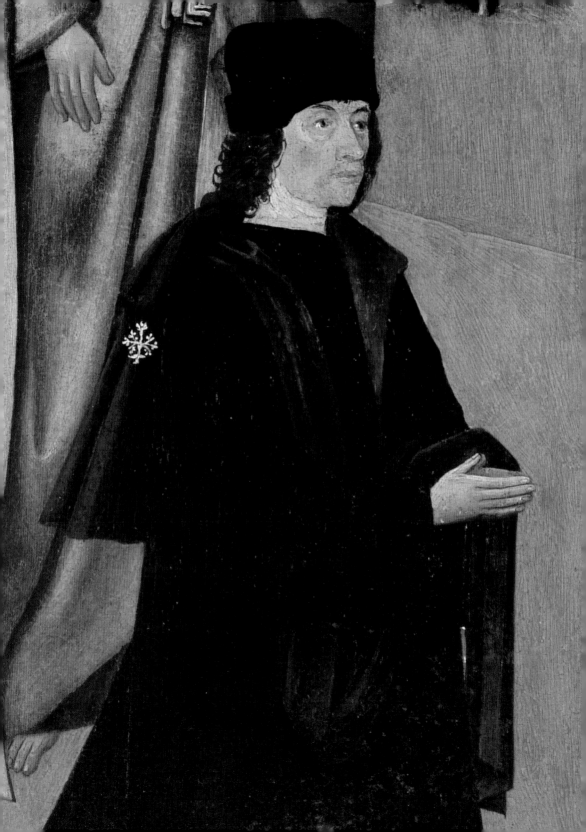

academics – including Franciscans, Dominicans, Carthusians, Carmelites, Benedictines and Augustinians. Knights, counts, countesses and dukes from the houses of Cleves, Egmont and Nassau provided the backbone of confraternal financial support. Spanish, Italian, German and Portuguese members also swelled its ranks, and guild representation included weavers, bakers, apothecaries, embroiderers and artists, as well as aristocrats. Membership required payment of substantial dues and entrance fees, which allowed the Brotherhood to become an important money-lender and landlord in 's-Hertogenbosch by the late fifteenth century. The confraternity further served the community by dispensing bread and clothing to the poor at regular intervals throughout the year, though records show that the costs of their banquets often exceeded the amount spent on charitable gifts. The Brotherhood of Our Lady still maintains a presence in 's-Hertogenbosch, though its former link with the Catholic Church was considerably altered as a result of the Protestant Reformation, and its function today is mainly ceremonial. Its small membership includes the élite of Dutch society, among them Queen Beatrix of the Netherlands.

Bosch's membership of the Brotherhood of Our Lady provided him with opportunities for patronage at all levels – civic, private, ecclesiastical, bourgeois and aristocratic. The documents show that Bosch began working for the Brotherhood in 1489, though, sadly, as is the case with most of his works mentioned in the historical record, none of these exists intact. His first recorded commissions were scenes of *Abigail Bringing Presents to David* and *Solomon and Bathsheba*, intended for the wings of an altar that, ten years before, had been placed in the confraternity's chapel. Other mentions in the factures, dating from between 1491 and 1512, include alterations to a panel listing the names of all the sworn brothers, and designs for windows in the Brotherhood's chapel. Also mentioned are commemorative

escutcheons, intended for the chapel, and designs for a brass chandelier and a crucifix. Other works made by Bosch for the Church of St Jan were still in place when the traveller Jan Baptiste de Gramaye saw them in 1610, including an altarpiece of *The Creation of the World* for the high altar and an *Adoration of the Magi* in the Chapel of Our Lady. We also know of a 'high altarpiece' painted by Bosch for the Dominican order in Brussels. These paintings are all lost, leaving for posterity only the tantalizing mention of their former existence.

Bosch's status within the Brotherhood provided entry into a wide world of wealth and privilege. Among his notable fellow brothers were the Counts of Nassau, who once owned the *Garden of Earthly Delights* triptych (see 133). Another highly placed confraternity member was the Spanish nobleman Diego de Guevara, father of Felipe, who made the first written reference to Bosch. Diego owned six paintings by Bosch, including, it is thought, the *Seven Deadly Sins and Four Last Things* (see 14) and a version of the *Haywain* triptych (see 49). Spanish commissions would not have been unusual for a painter living in 's-Hertogenbosch, whose international cloth trade depended strongly upon Iberian connections. Bosch also worked for several wealthy members of the upper bourgeoisie, such as the Bronckhorst and Bosschuysen families, confraternity members believed to have been the patrons of the Prado *Adoration of the Magi* triptych (see 115, 116). Several of Bosch's paintings are documented as having been ordered or bought by the ruling nobility, including a *Last Judgement* for the emperor's son Philip the Handsome in 1504, and three works owned by Philip's mother-in-law, Queen Isabella of Spain, recorded at her death in 1505. Philip's sister Margaret of Austria was presented with a *Temptation of St Anthony* by one Jhorine Bosch, perhaps a relative of the painter, shortly before Bosch's death in 1516. In addition, the Bishop of Utrecht (Philip of Burgundy, illegitimate son of Duke Philip

the Good) possessed at least one painting by Bosch and perhaps also owned the *Stone Operation* (see 20). Bosch may also have served one or more Italian patrons, including Cardinal Domenico Grimani, a major political figure from an aristocratic house of Venetian doges, whose art collection included several of his works.

The fact that Bosch was wealthy and enjoyed high standing in an important confraternity argues strongly against any involvement with, or sympathy for, heretical sects. The religious stance of the Brotherhood of Our Lady was traditional, as evidenced by the large number of papal indulgences granted to it. Furthermore, Bosch's works appealed to the highest levels of the educated, international aristocracy, both during his lifetime and after his death. Some Dutch scholars, perhaps reflecting a nationalistic bent, prefer to situate Bosch within a bourgeois cultural milieu, defined and limited by Dutch sources. However, divisions between high and low, public and court cultures were fluid, and Bosch's influences more likely came from both directions. In attempting to reconstruct the meaning of the paintings, we must not ignore the interests of his exalted patrons, the people who controlled Europe in the late fifteenth and early sixteenth centuries. Armed with the knowledge that members of the imperial family, dukes, cardinals and bishops supported Bosch during his lifetime, we can begin to reconstruct the painter's imagery as it relates to the concerns of these influential figures and to the populace whom they ruled.

Though we know little about Bosch's training, elements of his style clearly relate to his artistic predecessors and contemporaries. The origins of Bosch's style of painting come from the tradition of Northern Renaissance art introduced in the first half of the fifteenth century by Robert Campin (*c*.1375–1444), Jan van Eyck (*c*.1395–1441) and Rogier van der Weyden (*c*.1399–1464), who worked mainly on

wooden panels with pigments suspended in oil. Unlike this first generation of Northern Renaissance painters, however, Bosch did not apply his colours laboriously in micro-layers of pristine, crystalline glazes. The surfaces of his paintings are not built up meticulously, nor do they present the glossy, gem-like appearance typical of fifteenth-century Northern paintings. Van Mander described Bosch as having 'a sure, rapid, and appealing style, executing many objects directly on the panel ... a manner of sketching and drawing directly on the white ground of the panel and laying over them a transparent, flesh-coloured prime coat, and he often allowed the undercoats to contribute to the total effect'. This method anticipates the *alla prima* technique of later artists, who applied paint directly to a prepared gesso background. Bosch quickly sketched in surface highlights with a brush, giving his forms a fluidity that enhances their appeal. The spontaneous, shimmering result, achieved with bright, fresh colours, has been called an aphrodisiac in paint, and was especially effective in landscape depictions. Though interest in nature had been a concern of northern painters as early as the fourteenth century, Bosch took it a step further, delineating natural forms less distinctly as they recede in spatial registers, culminating in filmy, atmospheric vistas of converging water and sky.

The innovative Northern Renaissance school of painting is credited with introducing worldly realism and human emotion into the predominantly religious subjects inherited from the Gothic tradition. More importantly for the question of meaning in Bosch's works, the Northern Renaissance style, which Erwin Panofsky described as an *Ars nova* (new style), employed hidden meanings and symbolism to a greater extent than ever before. Paintings were intended to be read like texts, and artists often collaborated with scholars and liturgical advisers when planning their compositions. The tradition of hiding deeper meanings beneath surface appearances pervaded the entire culture:

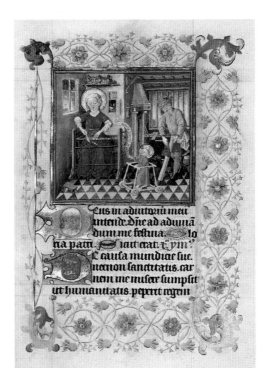

10
Holy Family at Work, from the *Book of Hours of Catherine of Cleves*, *c.*1440. Pierpont Morgan Library, New York

poets wrote in veritable layers of enigma, and composers created sound pictures in a style described by the musicologist Edward Lowinsky as 'the secret Netherlandish art'. The Northern Renaissance tradition gives new meaning to the old adage 'a picture is worth a thousand words', for 'what you get' is always more than 'what you see'.

In general, Netherlandish panel painters, printmakers and manuscript illuminators expanded upon the innovations of the *Ars nova* by interpreting sacred themes in everyday terms, and depicting the natural environment realistically. They enhanced human emotion by exaggerating facial features and gestures, thus making their paintings more immediate and meaningful to the spectator. Such qualities infuse the works of Dieric Bouts (*c.*1415–75), Gerard David (*c.*1460–1523), Quinten Metsys (1466–1530) and others.

The iconographical complexities of Northern Renaissance art were enlivened by the irresistible charm and naturalness

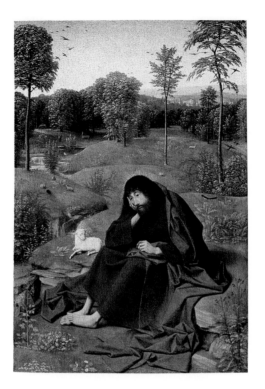

11
**Geertgen tot
Sint Jans**,
*St John the
Baptist in the
Wilderness*,
c.1490–5.
Oil on panel;
41·9 × 27·9 cm,
16½ × 11 in.
Gemälde-
galerie,
Staatliche
Museen,
Berlin

of the early Netherlandish manuscript tradition. The *Holy Family at Work* from the *Book of Hours of Catherine of Cleves* (*c.*1440; 10), which has been linked to Utrecht, is characteristic of the engaging miniatures found in these hand-painted books. The scene shows the Virgin, Joseph and the Christ child working comfortably at home, surrounded by furnishings typical of a fifteenth-century bourgeois abode. Mary weaves at her loom, while, on the wall of the room, hang the utensils that she will need to make dinner. Joseph is busy in his workshop, made warm by a modern fireplace complete with adjustable hooks for holding pots. The Christ child reaches for his mother; but for his small halo, he could be any toddler learning to perambulate with the aid of a walker on wheels. This special family is every family, and its viewers are the silent witnesses to a holy miracle, presented with unstudied charm and spontaneity, that parallels the earthly miracle of daily life.

Bosch's treatment of subject matter also demonstrates affinities with later fifteenth-century painters and printmakers from Haarlem and other territories along the Upper Rhine. The engaging humanity of this style is often accompanied by a deep interest in the natural world, especially landscape, which is rendered with startling tangibility. Geertgen tot Sint Jans's (*c.*1465–95) painting *St John the Baptist in the Wilderness* (11) displays the unpretentious simplicity and interest in nature that would become distinguishing features of later Dutch painting. Geertgen's wilderness is not the arid desert described in the Bible, but

12
Jean Pucelle, *Hours of Jeanne d'Évreux*, folio 174, *c.*1325. Metropolitan Museum of Art, New York

a lush, verdant, northern European forest, rendered with such care and immediacy as to tempt our eyes away from the central subject of the painting. St John himself sits head in hand on a small hillock, so deeply involved in listening to his inner voice that he absent-mindedly scratches the top of one bare foot with the toes of the other. Geertgen's saint is not the fiery prophet of the Bible, but 'Everyman', at one with the natural world that surrounds him.

The bizarre composite creatures for which Bosch is best known also share some common ground with artistic

predecessors and contemporaries. While Bosch's art fits comfortably within a forward-looking context of Netherlandish genre and landscape painting, the medieval world was not that distant. Anthropomorphic forms occur in medieval art in architectural features such as gargoyles and in illuminated manuscripts, which sport playful grotesques ornamenting the margins of even the most sacred texts (12). This interest in the fanciful continues into the fifteenth century, for example in the prints of the so-called Master E S. His design for the letter 'G' from the *Fantastic Alphabet* (13) shows a bare-bottomed monk frolicking with two nuns, a

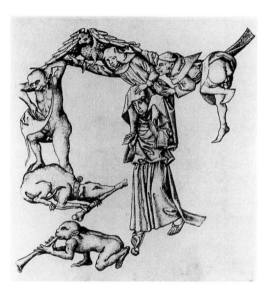

13
Master E S,
Letter G, from
the *Fantastic
Alphabet*,
1465.
Engraving;
14·6 × 9·5 cm,
5¾ × 3¾ in

pair of monkeys, and a dog under the gaze of a watchful owl, all bending into the organic shape of the seventh letter of the alphabet – and communicating a moralistic, anti-clerical message by means of caustic humour. Though Bosch was particularly imaginative in creating his amusing and disturbing hybrid forms and used them as an integral part of the meaning of his art, such figures would not have been new to his viewers.

One of Bosch's more traditional paintings, *Crucifixion with Donor* (see 2), a work of *c*.1477 or later, serves as an example

of this fusion of influences. Here, a typical crucifixion scene, as Van Eyck would have composed it, has been transformed with touches of human interest and naturalistic landscape. The male donor kneels in his 'Sunday best' before St Peter, who gently recommends his worthy charge to the Virgin and St John with an expressive gaze, as if beginning to speak. The patron and saints appear more as friends and relatives than as mortal beings and immortal paragons. Bosch's interest in landscape and his fresh painterly technique are displayed in the distant view of Jerusalem, which he transforms into a simple Dutch town (complete with windmill), embedded within a vista of receding green hillocks and a hazy, violet atmosphere. However, a closer look reveals something slightly awry; note the twisted, dead tree and several menacing black crows that inhabit the same landscape as the devout trio of saints and patron. The unique 'Boschian' brand of imagination is clearly evident, even in such a conventional subject as this.

The Spectacle of Human Folly Bosch as Moralist

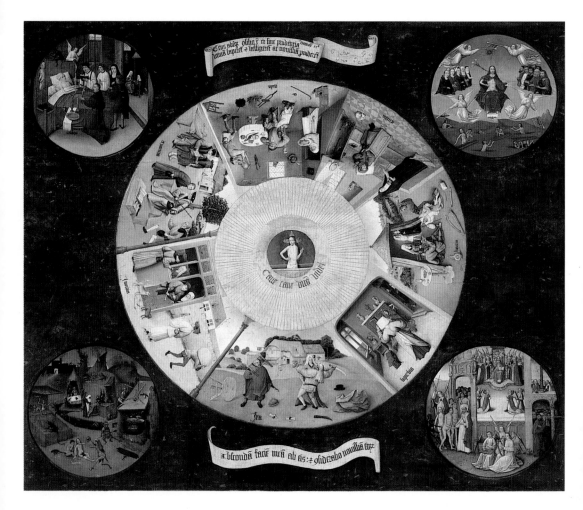

One of Bosch's favourite themes was also a main concern of moralists and thinkers of his era: how human nature, impeded by original sin, struggles weakly against worldly temptations. This chapter looks at Bosch as a moralist, and shows how contemporary ideas about sin and folly provide a key to understanding his work. Though all his paintings in some way draw attention to the consequences of bad behaviour, three single panels, the *Seven Deadly Sins and Four Last Things* (14), *Stone Operation* (see 20) and *Conjurer* (see 25), attributed to Bosch and/or his workshop, do so with especially scathing irony.

The *Seven Deadly Sins and Four Last Things* was first described in 1560 by the Spanish nobleman Felipe de Guevara in his *Commentary on Painting* (*Commentarios de la pintura*). Guevara compared the work, particularly the scene of 'envy', to an ancient Greek form of painting known as *ethike*, or 'pictures which have as their subject the habits and passions of the soul of man'. Mention of the work next appeared in 1574 as part of a shipment of paintings intended for the Escorial, Philip II's palace–monastery complex outside Madrid, described as 'A panel on which are portrayed the Seven Deadly Sins, in a round circle … by the hand of Hieronymus Bosch'. The king, an admirer of Bosch and a ruler noted for the grim conservatism of his faith, kept the painting in his bedroom. Its unique depiction of sin and its consequences doubtless inspired him as he prayed for his soul's salvation, and plotted the cruel course of the Spanish Inquisition.

Bosch communicates his message through a circular arrangement of genre scenes, showing enactments of

14
Hieronymus Bosch and/or Workshop, *Seven Deadly Sins and Four Last Things,* c.1490. Oil on panel; 120 × 150 cm, 47¼ × 59 in. Museo del Prado, Madrid

the seven sins surrounding a central image of Christ displaying his wounds, and the Four Last Things (Death, Final Judgement, Heaven and Hell) in the corners. The organization of scenes suggests to modern sensibilities the need to walk around all four sides in order to see each vignette right-side up. This configuration explains why the painting is often referred to as the '*Tabletop*' of the Seven *Deadly Sins and Four Last Things*. However, its composition was a common medieval didactic device that served several contexts and was not Bosch's own invention. The painting was most certainly not intended to serve as a traditional table, and did not endure the day-to-day distress of a utilitarian piece of furniture.

Though the work is signed, the age of its panel has not yet been determined, and Bosch's authorship has been questioned on the basis of the stocky, awkward figures, flat, bright colours and hard outlines, which are inconsistent with other works ascribed to Bosch. It is likely that five hundred years of damage, over-painting and repeated restorations have blunted the painting's original quality; but it is also possible that the painting is a workshop product. Bosch himself may have been responsible only for the original design, the iconographical programme and certain land-scape and figural elements that display especially sensitive modelling and atmospheric effects, leaving the rest to assistants. Furthermore, some of the costume details point to a date no earlier than the 1490s, well within Bosch's lifetime. All things considered, most scholars include the *Seven Deadly Sins and Four Last Things* among Bosch's 'authentic' works.

The painting portrays the world as a wicked place, and life as a succession of evils punished inevitably by the inescapable judgement of God. We owe our understanding of the work's complex and meaningful iconography to the art historian Walter S Gibson, who noted that the circular ring of genre

scenes surrounding the central figure of Christ is meant to depict the Eye of God, which reflects, like a cosmic mirror, the pathetic condition of the human race. Guillaume Deguilleville's poem *The Pilgrimage of the Life of Man* (*Pèlerinage de la vie humaine*), written *c*.1330 and published in a Dutch edition in 1486, clearly states the simile: 'The supreme eye is Jesus Christ, who is a mirror without blemish in which each man may see his own face.' The reflection of sin in God's cosmic mirror also figures prominently in moralizing treatises of Bosch's day, among them Vincent of Beauvais' *Mirror of Human Salvation* (*Speculum humanae salvationis*), the anonymous *Mirror of Christianity* (*Speculum christiani*) and *Mirror of Man* (*Miroir de l'omme*). Saint Augustine's *Mirror of Sinners* (*Speculum peccatoris*) is a sermon on the very verse from Deuteronomy that appears at the top of Bosch's panel, 'O that they were wise, that they understood this, that they would consider their latter end.'

Close in time to Bosch's painting is Nicholas of Cusa's *Vision of God* (*De visione dei*), written in the mid-fifteenth century, which unites the concepts of God as both witness and mirror:

Lord … thou art an eye … wherefore in thyself thou dost observe all things … thy sight being an eye or living mirror seeth all things in thyself … thine Eye, Lord, reacheth to all things without turning … the angle of thine Eye, O God … is infinite, being the angle of a circle, nay, of a sphere, also, since thy sight is an eye of sphericity and infinite perfection. Wherefore it seeth at one and the same time all things around, above and below.

Nicholas further warned of the consequences, good and bad, of God's universal vision:

O how marvellous is thy glance, how fair and lovely it is to those that love thee. How dread it is to all them that have abandoned thee, O Lord, my God.

Though modern mirrors take many forms, fifteenth-century mirrors were round and convex. Viewers therefore would

have recognized the round shape of Bosch's eye-mirror as related not only to sight, but also to a familiar household object. The circle of sins around it also recalls the predictability of human nature alluded to in Psalm 11:9: 'The wicked walk around in a circle.' The seven scenes of sin and folly that form the cornea of God's eye revolve, wheel-like, around the central half-length figure of Christ. He occupies the pupil and looks outward, engaging the eye of the viewer and pointing meaningfully to his wounds. This is the Christ of the perpetual passion, whose suffering on behalf of the human race did not end with his resurrection, but continues eternally and intensifies as the world degenerates into sin and corruption.

Three Latin inscriptions warn of God's all-seeing vision, and direct the viewer to Bosch's message. Directly beneath the suffering Christ are the Latin words *Cave cave dos [dominus] videt* (Beware, beware, God sees). Two banderoles above and below the circle are inscribed with further Latin admonitions from Deuteronomy. They read, in translation, 'For they are a nation void of council, neither is there any understanding in them. O that they were wise, that they understood this, that they would consider their latter end' (Deuteronomy 32:28–9); and below, 'I will hide my face from them, I will see what their end shall be' (Deuteronomy 32:20). The wages of sin and the ultimate destiny of all people appear in circular medallions in the corners of Bosch's panel. They depict a deathbed scene, the resurrection of the dead, the blessed entering heaven and the tortures of hell.

The concept of the Seven Deadly Sins – anger, vanity, lust, sloth, gluttony, avarice and envy – is a basic tenet of Christianity, and provides a convenient method of recognizing and cataloguing the negative aspects of human behaviour. Though the circular schematic arrangement of the seven sins is not unique to Bosch, his is the only extant

panel painting in which it appears. Medieval treatises of all types – devotional, moral and scientific – featured such diagrammatic explanations in combination with verbal inscriptions. Illustrators also organized many worldly and scientific systems within circular schemes, such as the seasons, labours and signs of the zodiac (15). The visual convention of the seven sins arranged in a wheel-like formation also influenced artists working in other media. A fifteenth-century manuscript illumination of Augustine's *City of God* (*De civitate Dei*; 16) uses the wheel composition

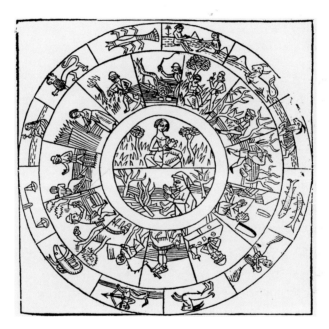

15
Seasons, Labours and Zodiac, facing folio 141v, from Bartholomaeus Anglicus, *His booke De proprietatibus rerum*, translated by Stephen Batman, London, 1582. Huntington Library, San Marino, California

to reinforce the concept of civic responsibility. Each of the sections that comprise the godly city contain genre representations of a virtue and its opposing sin, all rotating around a central hub containing urban architecture. A late fifteenth-century German woodcut (17) employs a compositional and iconographical template similar to Bosch's painting. It depicts the seven sins occupying what look like slices of a cosmic pie, each illustrated by a figure engaged in the vice in question and accompanied by extensive explanatory inscriptions in smaller circles. As in

on tveschier fil; marcel
sin en ceste ēuvre que iay
ordōne afane pour la
mour de toy. et la quelle
re tien queste est due pource que ie tay
promis. iay entrepris adeffondre la tive
glorieuse ate de dieu contre ceulx qui met
tent leurs ydoles au deuant du crateur

dicesse ate sout ou cours de ce temps put
A uant celui qui uit en vraye foy fait
son plermage en ceste vie mortelle entre
lez mescrans ou en la fermete du siege
pardurable que il atant tout par prant
re iusques a ce que iustice sout comitte
en iugement et que icelle fermete sera
aquise par excellēte en la victoire dev

Bosch's painting, Christ occupies the centre of the circle, surrounded by the seven transgressions against him.

Bosch's *Seven Deadly Sins and Four Last Things* has much in common with popular moralizing treatises of the time, especially its concentration on the pitfalls of daily life. The order of sins reflects the traditional sequence established by Pope Gregory the Great in the sixth century. Bosch depicts the venal acts perpetrated in the real world, in earthy and humorous vignettes sometimes set in domestic environments. No viewer can study his painting without

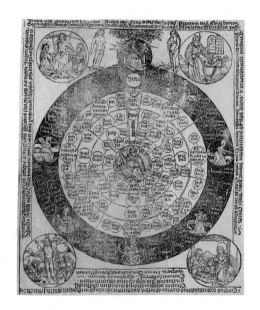

16
Seven Sins and Virtues in the Medieval City, folio 6, from Augustine, *City of God*, fifteenth century. Rijksmuseum Meermanno-Westreenianum, The Hague

17
The Seven Sins, c.1495. Woodcut; 35·4 × 29 cm, 14 × 11⅛ in

shamefacedly admitting a predilection towards one or more of these all-too-human vices. Each sin is labelled in Latin, with *ira* (anger) appropriately occupying the largest pictorial space, directly beneath the suffering Christ. Bosch illustrates this dangerous and universal human emotion as a conflict between two men, weapons drawn and faces contorted with rage, who battle each other within a broad expanse of landscape strewn with items of clothing lost in the conflict. One combatant has already hit his opponent on the head with a footstool, and he prepares to attack again

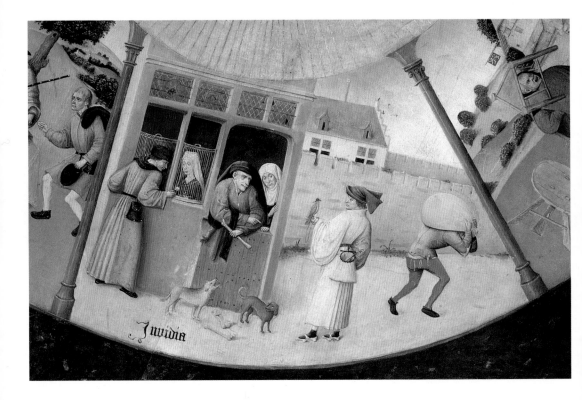

with drawn sword as a woman attempts to restrain him. This is not the seething anger of verbal insult and hurt feelings, but real, immediate physical conflict likely to draw blood or cause death.

The other sins revolve counter-clockwise around God's all-seeing eye. *Superbia* (vanity) appears in the form of a woman seen from behind who admires herself in a mirror held by a grotesque demon familiar. Next, pairs of lovers engage in *luxuria* (lust), as they indolently lounge in an outdoor tent, occupied by the food, drink and musical instruments associated with love. Their folly is emphasized by a mocking fool and his tormentor, who wields a large spoon aimed at the fool's bare backside. Dutch historian Dirk Bax, who identified many proverbs in Bosch's paintings, links this vignette to the expression *door de billen slaan* (to strike through the buttocks), alluding to dissipation and debauchery. *Acedia* (sloth) is next on the circle. Here, a negligent man naps comfortably before a cozy fire. This is not a sin in itself until we notice that a woman – his wife, or perhaps a nun – holds out a string of rosary beads and seems to be entreating him to wake up and come to church. Following sloth is *gula* (gluttony), which takes its toll on a filthy and ragged family, who have eaten themselves not only into obesity, but also into poverty. In his presentation of *avaricia* (avarice), in which a corrupt judge hears the case of one obsequious client while taking a bribe from another behind his back, we see Bosch as social critic as well as moralist. Last on the revolving wheel of transgression is *invidia* (envy), which Bosch illustrates as one man's longing for a woman he cannot have and a poor old man's jealousy of a well-dressed young falconer (18). Their human envy is echoed in the foreground conflict between two dogs snarling over the same bones. Taken together, Bosch's images of human frailty make the same point: small, everyday vices cannot be hidden from God, who sees all.

18
Hieronymus
Bosch and/or
Workshop,
Invidia (envy)
(detail of 14)

It would seem that Bosch's sinners provide ample entertainment for an all-seeing God, were it not for the inevitable payment exacted from them in the end. The ultimate destiny of humankind appears in the four corner roundels of the painting. Like the Seven Deadly Sins, the Four Last Things were a fixture of popular moralizing treatises, among them Denis the Carthusian's *Four Last Things* (*Quattuor novissima*), and *Cordiale quattuor novissimorum*, attributed to Gerard de Vliederhoven. Denis the Carthusian's book was popular in northern Europe, and appeared in a Dutch translation in 1477. The *Cordiale*, whose title begins with a word invented by the author (loosely translated as 'heart and soul', or 'learning by heart'), was a product of the Modern Devotion, the reforming sect that maintained an important presence in 's-Hertogenbosch. The book's popularity was so great that it was published in forty-six editions (thirteen with Dutch presses) before 1500.

Bosch's *Four Last Things* are related in a cause-and-effect way to the central reflective eye of God. The upper left medallion shows the beginning of the end, a deathbed scene in which an angel and a devil vie for possession of a man's soul. The Last Judgement, described in Revelation, appears in the upper right roundel. The medallion beneath it shows the fortunate saved souls entering heaven through a golden Gothic portal to the sounds of angelic music. But the tortures of hell await those who spend their lives in the pursuit of folly, and it is in the lower left medallion that Bosch gives each of the seven sins a suitable punishment.

The little inferno (19) in the roundel is an abbreviated version of Bosch's larger hell scenes (see 172 and 192). Each torturous penalty is labelled with the sin that it fits. For example, the lustful lovers who appeared so carefree in the genre scene above are fated to be harassed for eternity by grotesque demons sharing their bed, while a toad gnaws at vanity's private parts as she gazes forever into a mirror. Anger lies

19
Hieronymus
Bosch and/or
Workshop,
Hell roundel
(detail of 14)

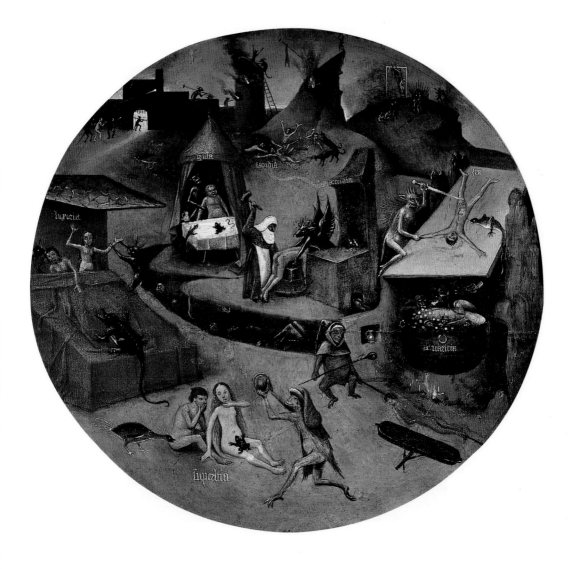

splayed and naked at the mercy of a demon, who menaces him with a sword much like the one he used to threaten his opponent above. Beneath anger, avarice simmers in a giant cauldron, mingling his human flesh with the gold coins he hoarded in life. The substantial figure of gluttony must dine forever on serpents and frogs, while the envious are torn apart by dogs like those that fight over a bone in the genre

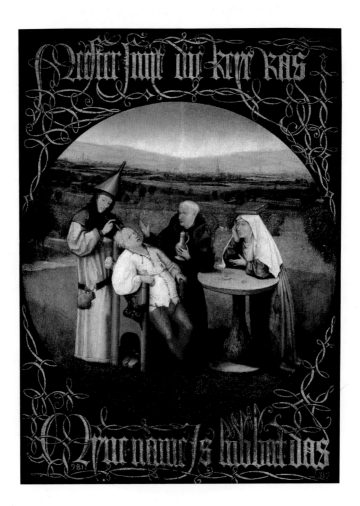

scene. Bosch devised a painful and unique punishment for sloth, who must submit to a perpetual fiendish spanking by a hammer-wielding devil. The world of the damned is a world where things loved too well in life become instruments of eternal torture.

Though treatises and sermons on sin and its consequences were widely dispersed in the vernacular Dutch, Bosch's painting of the *Seven Deadly Sins and Four Last Things* is inscribed in Latin, the universal language of the Church and the university. This suggests that it was intended for an educated, literate audience. Like the moralizing literature of the time, Bosch's painting was certainly intended as an aid to private meditation, and perhaps it was used as such by Felipe de Guevara or his father Diego, who once may have owned it. In its conflation of several popular concepts – the Eye of God, mirror of human nature, the revolving cycle of sin and degeneration and the end that awaits us all – it exhorts viewers to examine their own consciences and arm themselves anew for the many private battles against evil that await them each day of their lives.

20
*Stone
Operation,*
*c.*1488 or
later.
Oil on panel;
48 × 35 cm,
18⅞ × 13¾ in.
Museo del
Prado, Madrid

Bosch's *Stone Operation* (20) is very different from the *Seven Deadly Sins and Four Last Things*, yet it has a similar moralistic meaning derived from contemporary thought. This picture has spent time on and off the 'authentic' list, but dendrochronological examination dates it *c.*1488 or later, squarely within Bosch's time. It is probably the same 'Stone Operation' once owned by Philip of Burgundy, Bishop of Utrecht and illegitimate son of Duke Philip the Good. It is also probably the same work, described as a painting 'in which madness is being cured', purchased by Philip II of Spain from the estate of Felipe de Guevara in 1570.

The *Stone Operation* exposes another species of fool, the charlatan and his gullible victim. It depicts what appears to be a surgeon removing something from the head of a portly, seated man. The process is witnessed by a monk and a nun who rests, head-in-hand, against a table, balancing a book on her head. This strange tableaux is set within one of Bosch's lush landscapes, consisting of layered vistas of green fields that recede artfully into delicate blue atmosphere. Like the *Seven Deadly Sins and Four Last Things* (see 14), the

Stone Operation is contained within a circle, though the dark space of its surrounding rectangular panel is covered with intricate, gilded lettering and interlaced flourishes. Inscribed in elaborate calligraphy is the Dutch inscription *Meester snijt die keye ras/mijne name is Lubbert Das* (Master, cut the stone out quickly/My name is Lubbert Das). The identification of Bosch's stout patient as 'Lubbert' is a clue to the nature of his gullibility, for in Dutch literature this name was ascribed to persons of low intelligence.

Scholars have questioned whether Bosch's painting is based on medical reality or reflects moralizing proverbs or texts. Surgical textbooks of the time clearly describe a cure for insanity and headache: trepanning, or cutting holes into the skull. The procedure is graphically illustrated in printed medical treatises (21), and human skulls have been found bearing the marks of the surgeon's scalpel, belonging to people who survived it. An edition of the *Physica*, a medical text by the medieval abbess Hildegard of Bingen (22), shows four physicians consulting on a case involving some sort of cranial disorder. The object of their concern, a dull, lumpish man, is reminiscent of Bosch's Lubbert. One of the doctors draws attention to a bump or lesion in the patient's forehead, while an assistant prepares for surgery. Like many early medical sources, Hildegard's *Physica*, written in the twelfth century, survived in manuscript form until the printing press brought it to a broader audience. For this edition, the publisher, Johann Schott, wishing to dress up the text, used old blocks from earlier books that he had at hand. It is even possible that this scene originally had no connection to Hildegard's *Physica* but instead was intended to illustrate the removal of the proverbial folly stone.

Medical history aside, in Bosch's day the 'stone operation' was a metaphor for the cure of madness and stupidity, and removal of the so-called 'stone of folly' was an allegory of stupidity at the mercy of dishonesty. Medical historian

William Schupbach believes that the 'operation' itself
never really happened, reminding us that, at this time, the
stone operation was a comedy routine performed by local
rederijkers, amateur theatre companies that entertained
during public celebrations. An actor playing a physician
would pretend to cut the stupid stone from the head of a
cantankerous fool, holding a bladder of blood in one hand
and some pebbles in the other. At the proper moment,
pebbles and blood would reveal themselves and 'Lubbert'
would emerge from the ordeal sane, smart and cured.

21
Trepanation,
from Hans
von Gersdorff,
*Feldbuch der
Wundartznei*,
Strasburg,
1517

22
*Physicians
Consulting*,
from
Hildegard
of Bingen,
Physica,
Strasburg,
1533

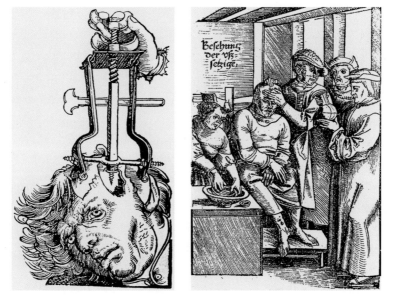

The answer, then, to the question of whether Bosch's *Stone
Operation* is based in reality or fantasy must be 'yes' to both.
The notion of an operation that entailed cutting open the
head mirrors contemporary medical practice, while the
story of the 'stone operation' forms part of a moral allegory.

On one level then, the *Stone Operation* is another clever
allegory of foolishness that castigates trickery and
gullibility. However, a closer look reveals iconographical
anomalies that raise further questions. Why is the surgeon

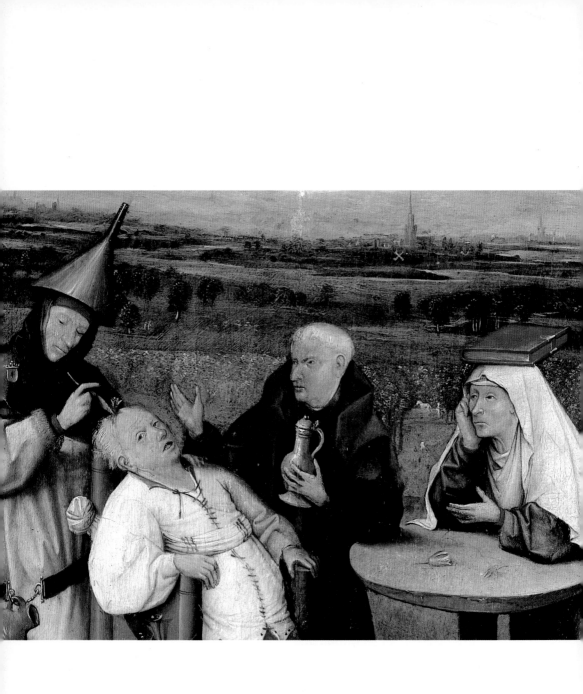

wearing an inverted funnel on his head, and what do the witnessing monk and nun have to do with it all? What does the red book, balanced on the head of the nun, mean? And why is the object being removed from Lubbert's head not a stone at all, but a golden flower, similar to one that appears on the table before him (23)? To answer these questions let us explore another possible level of meaning and read the work as the castigation of a particular kind of quack, the charlatan alchemist, who appears with regularity in scientific and moral treatises of the time.

The perception of alchemy as an occult, heretical science is a modern myth. Alchemy was the chemistry of Bosch's day, and kings and popes alike practised it and supported learned practitioners in the hope of gaining the considerable spiritual and monetary benefits derived from making an elixir of life or turning lead into gold. Bosch's knowledge of alchemy as a serious philosophy, a science that served as an adjunct to medicine, pharmacy and metallurgy, will be discussed later in this book. The negative references to alchemy in the *Stone Operation* would have been recognized by both knowledgeable scholars and sceptical critics as a damnation of those who practised a difficult art without proper training or experience.

Like its sister science, medicine, chemistry in Bosch's day was both a popular and an élite art, based upon laboratory practice and allegorical symbolism inherited from ancient times. Early chemistry and Christianity were closely linked, and it was believed that the proper practice of science could be achieved only through great learning and piety. Serious mastery of the art required time, extensive education and large cash reserves. The Church could provide these, and many early chemical experimenters, such as Thomas Aquinas and Albertus Magnus, were members of the clergy. Dishonest practitioners abounded, however, as did desperate and gullible patrons, and chemical treatises rarely miss the

23
Stone Operation
(detail of 20)

chance to damn charlatans to the hell-fires of their own furnaces. One of many such texts is *A Demonstration of Nature, Made to the Erring Alchemists ...*, attributed to Jean de Meun, author of the medieval *Romance of the Rose*. The voice of 'Nature' warns against charlatan chemists:

Good heavens, how deeply I am often saddened at seeing the human race ... I allude more particularly to you, O stolid philosophaster, who presume to style yourself a practical chemist, a good philosopher, and yet are entirely destitute of all knowledge of me, the true Matter, and of the whole Art which you profess!

Bosch's *Stone Operation* satirizes several basic chemical concepts. The funnel worn by the surgeon, which appears in several of Bosch's 'hell' scenes, was, then as now, essential laboratory apparatus, and was illustrated in practical handbooks of distillation. Worn upside down over the surgeon's academic hood, it marks him as an inept trickster masquerading as a university-trained scholar. The monk and nun who witness the operation belong to the class of scholar-ecclesiastics known to practise chemical experimentation. The inscription on Bosch's painting, referring to the 'stone', which Lubbert implores the 'master' to cut from his head, is perhaps the clearest clue of all. The goal of chemical experimentation at the time was to achieve a transmuted healing substance, called the 'philosopher's stone' (*lapis*). It took many allegorical forms, one of which was the 'flower of wisdom' (*flos sapientum*), illustrated in the *Roll*, written by the fifteenth-century English alchemist George Ripley (24). 'The golden flower of wisdom' appears as a metaphor for the philosopher's stone in the earliest Hellenistic chemical tracts, and regularly thereafter in manuscripts and printed books. Bosch's foolish Lubbert has brought a bulging purse with him, and doubtless will reward the 'master' if he can produce the golden flower, the chemical stone of wisdom, simply by cutting it out of his head.

It has been suggested that the flower sprouting from Lubbert's cranium is a tulip, and that the painting is a satire on the Dutch obsession with these flowers. However, tulips were unknown in western Europe before 1593, when the botanist Carolus Clusius first grew bulbs from seed in his Leiden horticultural garden. The tulip frenzy did cause many instances of foolish behaviour among Dutch botanists and collectors, but not until the seventeenth century. Neither is Bosch's golden flower a water lily, as has been suggested, for there is no body of water nearby, nor is there a reasonable iconographical reason for such a flower. In fact, no flower

on earth claims petals gilded with gold leaf like the ones in Bosch's scene. Such a bloom more likely represents the golden flower of wisdom, the sought-after philosopher's stone with the power to heal the sick and provide instant wealth.

The golden flowers of chemistry were the reward for great learning, endless patience, hard work and suffering in the service of God. However, Bosch's Lubbert would rather submit to surgery than endure the long hours of study and repeated failures required for success, for he implores the

master to cut the stone out 'quickly'. Many a modern scholar has doubtless wished the same thing, that the rigours of study and thought required in the pursuit of wisdom could be eliminated by a mere flick of the scalpel, or that the knowledge contained in a difficult book could pass into the brain by osmosis, simply by placing it on one's head as Bosch's nun does. This reading of the *Stone Operation* sees it

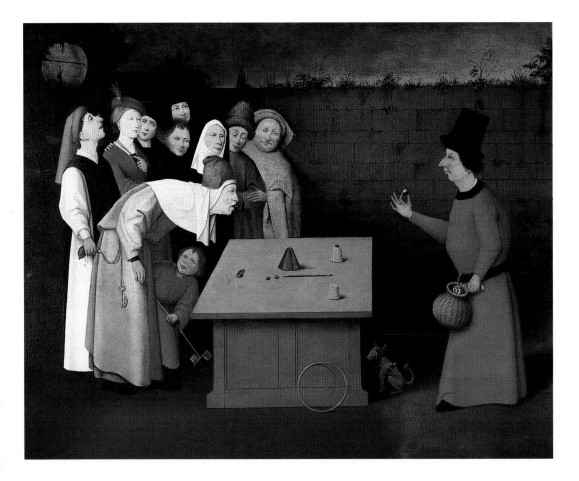

as a morality tale about trickery, gullibility and impatience set within the intellectual and moral traditions of its time, but with a message that is really very modern: only a fool believes in a short cut to success.

The so-called *Conjurer* (25) is another work that castigates foolishness and gullibility by representing a medical

subject. Though historians have expressed reservations about the provenance of this work, dendrochronological examination reveals that it dates from within Bosch's lifetime, *c.*1496 or later. Furthermore, many copies of the scene exist, both as paintings and as prints, indicating that its impact was far-reaching. As in the case of other works by Bosch, scholars argue over the meaning of the scene, which shows a group of gullible people seemingly taken in by a trickster who has set up his table before a crumbling wall.

Bosch's public would have recognized the 'conjurer' as a mountebank, a type of itinerant medical charlatan who hawked his bogus cures in side-show displays, set up in public spaces and urban fairs. Historians of medicine who have specifically studied the phenomenon of the Renaissance mountebank, have identified visual cues, costumes, props and personal routines typical of this class of phoney healer. Such charlatans often worked with trained animals, such as the little dog dressed in fool's cap and bells, 'so that the foolish and curious crowds would gather to see them'. Serious physicians commented disparagingly on the ostentatious costumes of their itinerant rivals, such as the fantastic tall hat worn by Bosch's quack. Contemporary accounts further describe such fakers as deploying a range of theatrical skills in their marketing strategies, which could include music, acrobatic routines and sleight of hand. The gimmick employed by Bosch's swindler, involving the rapid hiding of a number of balls under beakers, is as familiar today as it was in the early sixteenth century.

Mountebanks habitually planted stooges in the crowds pressing around them, and bribed them to come forth at a certain time during their routine. One account describes a charlatan who demonstrated his medical powers by expelling a live worm from one such assistant. Perhaps the frog vomited by the bent figure in Bosch's scene was held in his mouth and spat out on cue to the amazement of

25
**Hieronymus
Bosch and/or
Workshop,**
The Conjurer,
*c.*1496 or
later.
Oil on panel;
53 × 65 cm,
$20^7/_8 × 25^5/_8$ in.
Municipal
Museum,
St-Germain-
en-Laye

onlookers. The crowd, which includes a nun dressed in a black habit and wimple, are so taken in that a bespectacled onlooker is able to grab the purse of the frog spitter without being noticed. The fooler is fooled in his turn. Later images of mountebanks, which continued to be produced into the seventeenth century, usually show the charlatan addressing his entourage, holding up a sample of his wares for their inspection. True to type, Bosch's mountebank grasps a golden ball between thumb and forefinger for examination by the crowd.

Is there, then, a moral lesson to be learned from Bosch's *Conjurer*? Two inscriptions that accompany a sixteenth-century print based upon the painting (26) reinforce the scene as a warning against dishonesty and a call for vigilance. Translated from the Dutch, the longer text reads:

Oh what tricksters are to be found in the world which can hatch wonders from the conjurer's bag and split the people with their false tricks and wonders upon the table from which they make their living? Do not trust them for a moment for if you too lost your purse you would be sorry.

The shorter reads:

One quietly cuts the purse the other runs away with it. Those who turn a blind eye to this are not serious, and even if they do not lose their own money, they will still have to pay.

Though the meanings of certain iconographical details may elude us, what seems certain is that the spellbound folk who throng, open-mouthed, before the trickster's table are easily deceived, and will pay for their foolishness. The mountebank's use of questionable sales techniques and the gullibility of the consumer remain familiar today – seen for example in the thriving market for cosmetic and weight-loss products.

The *Stone Operation* and *Conjurer*, like Bosch's other moralizing paintings, castigate members of the clergy, who, theoretically, should know better. This does not mean, however, that these paintings are heretical or irreligious, for monks and nuns were fair game for satirists throughout the fifteenth century. Bosch was in sympathy with leading northern European theologians in finding fault with the perceived laxness and corruption of the Roman Catholic Church. The abuses of the clergy at the highest levels were notorious; however, more immediate to Bosch was

26
Balthasar van den Bosch after Bosch,
The Conjurer,
c.1550.
Engraving;
23·8 × 31·8 cm,
9⅜ × 12½ in

the situation in 's-Hertogenbosch, which was home to a large number of monasteries and religious houses. In response to this situation, the city government made several attempts to control monastic authority and economic activities, sometimes bringing local religious institutions into conflict with secular authorities.

Tension between Church and State escalated on a broader scale in the late fifteenth and early sixteenth centuries. The sale of indulgences, whereby money was paid to the Church for the purpose of shortening a person's time in purgatory,

increased. In fact, the popes used these funds to rebuild
Rome into the grand Renaissance–Baroque city that it is
today. But most of the Catholics who lived in northern
Europe would never see the Sistine Chapel ceiling by
Michelangelo (1475–1564), paid for by moneys given for the
swift deliverance of their souls. As a result, tension between
northern and southern Catholics, temporal rulers and popes,
reached breaking point. One year after Bosch's death, in
1517, Martin Luther posted ninety-five criticisms on the door
of the church at Wittenberg, thus beginning a chain reaction
of dissent and dissolution that would become known as the
Protestant Reformation.

Bosch witnessed the preliminary events of one of the most
dramatic revolutions in the history of the Western world, as
the ancient bulwark of Roman Catholic dogma and authority
was confronted with demands for change. Had he lived a
few more years, he might have joined the Protestant camp.
The three paintings discussed in this chapter reflect the
reforming trends that led to the Reformation and echo
concerns expressed by writers and moralists. They suggest
that people of Bosch's era perceived foolishness, stupidity
and sin as interchangeable states. No single person can ever
claim complete immunity from these human conditions,
and Bosch's sinners belong to all social classes. Intemperate
paupers share space with greedy rich men, and monks are
just as guilty as beggars when it comes to temptations of the
flesh. The contemporary ideas of good and evil expressed
in the *Seven Deadly Sins and Four Last Things*, the *Stone
Operation* and *The Conjuror* are relevant to Bosch's entire
oeuvre, which assumes even more complex and interesting
dimensions as other avenues of interpretation are explored.

Perilous Paths The Tale of Two Triptychs

3

Bosch painted two triptychs which offer similar moral messages, but in different ways. These paintings have had contrasting histories as works of art. One, the *Haywain* (or *Haywagon*; see 44 and 49), has been maintained intact over the nearly five hundred years since Bosch's death. The other, to which the individual panels known as the *Ship of Fools* (see 28), *Allegory of Intemperance* (see 29), *Death of the Miser* (see 31) and Rotterdam *Wayfarer* (27) once belonged, was cut apart and dispersed. Two of its three original panels have been reunited only recently, through modern scientific methods and art historical detective work, though sadly the central interior panel that once formed the triptych's nucleus is lost. Both triptychs share a common exterior image, that of a stooped and ragged traveller making his way apprehensively along a dangerous path. This image links the two works together as continuances of Bosch's concern with folly, sin and the difficulty of maintaining one's way along the 'straight and narrow' path of life in a world filled with material distractions.

The *Ship of Fools*, *Allegory of Intemperance*, *Death of the Miser* and Rotterdam *Wayfarer* are housed today in the Musée du Louvre, Paris; Yale University Art Gallery, New Haven, Connecticut; National Gallery of Art, Washington, DC; and Boijmans Van Beuningen Museum, Rotterdam, respectively. Prior to reconfiguration in their original disposition (see 32), the four panels were analysed as separate works, though scholars had for many years noted their complementary subjects and similar styles. Close examination showed that the *Ship of Fools* (28) was cut along the bottom edge – presumably by an unscrupulous owner who believed that two works by Bosch would fetch more

27
Wayfarer,
c.1488 or
later.
Oil on panel;
diam. 70·6 cm,
27¾ in.
Boijmans Van
Beuningen
Museum,
Rotterdam

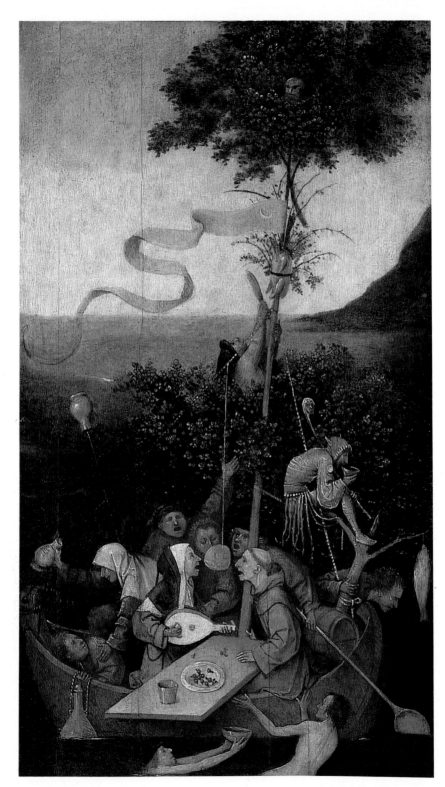

28
Ship of Fools,
*c.*1488 or
later.
Oil on panel;
57·8 × 31·9 cm,
22³⁄₄ × 12¹⁄₂ in.
Musée du
Louvre, Paris

29
*Allegory of
Intemperance*,
*c.*1488 or
later.
Oil on panel;
35·8 × 31·5 cm,
14¹⁄₈ × 12³⁄₈ in.
Yale
University
Art Gallery,
New Haven

30
Montage of
X-ray of *Ship
of Fools* and
detail of
*Allegory of
Intemperance*.
Laboratoire
des Musées
de France
and Yale
University
Art Gallery,
New Haven

than one. Was the missing part lost forever, or, as some authorities suspected, was a small fragment attributed to Bosch, the so-called *Allegory of Intemperance* (29), the severed piece? The subject matter is similar: both panels feature disparate people engaging in gluttonous, lustful behaviour in a watery habitat. The same delicate colour scheme, consisting primarily of rose, ochre and pale green, is common to both, though the cool tones of the *Ship of Fools* have been muddied by layers of old, discoloured varnish. Furthermore, the widths of the two panels are nearly identical: the *Ship of Fools* measures 31·9 cm (12$^1_2$ in), and the *Allegory of Intemperance* 31·5 cm (12$^3_8$ in). After the Yale panel was cleaned in 1972, art historian Anne Morganstern was able to prove that the *Ship of Fools* and the *Allegory of Intemperance* were once part of the same painting, though thousands of miles and an entire ocean now separate the two parts. When the frame was removed from the *Ship of Fools*, and the panel X-rayed to expose what is below the grime, the lower edge revealed elements that fit perfectly with the Yale fragment (29, 30). The tip of the funnel hat worn by the rotund trumpet player in the *Allegory of Intemperance* and the upper part of the flowered branch that he carries appear at the bottom of the Louvre painting. In addition, the partially submerged kneecap that emerges from the water at the lower right of the *Ship of Fools* fits perfectly with the disembodied foot, hand and thigh in the upper right corner of the *Allegory of Intemperance*. Placed end to end, the two panels fit together like long-lost pieces of a puzzle.

The cool palette and oblong dimensions of the *Ship of Fools/Allegory of Intemperance* are shared by the so-called *Death of the Miser* (31). The painted surface of this panel is translucently thin, perhaps the result of harsh cleaning of the surface at some point in its history. Detailed underdrawing is clearly apparent to the naked eye, revealing the interesting fact that the cross-hatched shading lines move from top left to bottom right, which indicates that a left-handed person

31
*Death of
the Miser*,
*c.*1488 or
later.
Oil on panel;
93 × 30·8 cm,
36⅝ × 12⅛ in.
National
Gallery of Art,
Washington,
DC

exterior panel

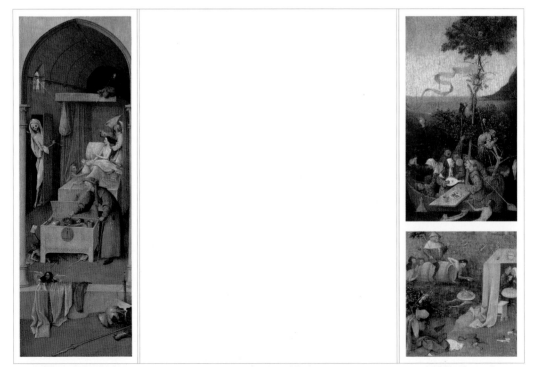

left interior panel

centre interior panel (lost)

right interior panel

made them. These visible hatchings contribute directly to the viewer's perception of form and shadow. Also visible are *pentimenti*, images beneath the final paint layer that the artist decided not to include in the finished work. In the lower right corner of the panel are faint outlines of a wine flask and cup placed originally on the foreground parapet. The similarities of these panels led scholars to ask what the relationship between them might be. Might they be two wings of a triptych? If this were the case, they should be painted on both sides to show different works when the triptych was open or closed. The panels were painted on only one side, but crucial evidence was soon to emerge.

32
Reconstruction of the exterior and interior of the altarpiece showing the *Wayfarer* (above), *Death of the Miser* (below left), *Ship of Fools* and *Allegory of Intemperance* (below right)

The combined width of the *Ship of Fools/Allegory of Intemperance* and *Death of the Miser* panels is close to the width of the Rotterdam *Wayfarer* (see 27), which has been cut down to its current octagonal shape. A join down the middle of the *Wayfarer* is evident to the naked eye, indicating that its two parts, now glued together, were once the hinged exterior panels of a triptych. The link between these works was finally established by recent dendrochronological examination, which reveals that all four panels were cut from the same tree, and date *c*.1488 or later. Evidently, the *Wayfarer* had been painted on its reverse, with the *Death of the Miser* on one side and the unified *Ship of Fools/Allegory of Intemperance* on the other. When parted, the two-part *Wayfarer* scene revealed a central panel of equal width, which remains lost (32). At some point, the two wings were sawn through and made into three separate paintings. Until this evidence came to light, the larger scale, mono-chromatic colour scheme and pared-down composition of the Rotterdam *Wayfarer* were taken as indications that it came late in Bosch's chronology. Now we must reconsider this assumption.

The four parts of Bosch's despoiled triptych complement each other not only stylistically, but also in terms of their

moralizing subject matter. Scholars have devoted much attention to each of the panels separately. However, considered as parts of a whole, their combined message becomes even more powerful, beginning with the *Ship of Fools* (see 28), one of Bosch's most popular and distinctive works. The painting depicts a boat populated not by a captain and crew, but by revellers more intent on having fun than in helping the craft on its dubious way. A tree in full leaf takes the place of the mast, and the only fool in the scene, who brandishes a baton topped with a miniature version of his own smirking features, sits perched on the prow at the head of his motley crew, paying no attention at all to their destination. Seated in the boat's mid-section, a nun plays a lute while vying with her monk companion for a bite of the Lenten pancake that dangles between them. The lute and the dish of red cherries on the tabletop before her are items that also appear in the 'lust' scene of Bosch's *Seven Deadly Sins and Four Last Things* (see 14). According to the astrological theory of the day, they are associated with the planetary realm of Venus and are symbols of venality. One of the boating company absent-mindedly rows with a giant spoon, while another vomits over the side. In the water, two naked swimmers cling to the sides of the unstable craft and request a refill of wine from the jug that cools in the water. An agile passenger clambers up the tree-mast, knife in hand, intent on cutting down the carcass of a roasted goose that is lashed to the trunk, just beneath an unfurled yellow banner bearing the image of the crescent moon. Near the top of the tree-mast, a small owl peers out from amid the leafy foliage. The owl was a symbol of sin and evil, which seems to be its meaning here, as well as great learning, and appears in both guises in Bosch's paintings. The missing lower part of the *Ship of Fools*, the *Allegory of Intemperance* (see 29), continues the saga of watery revelry. Here, swimmers tread water around a large wine barrel straddled by a corpulent man wearing a funnel hat, who

carries a branch over his shoulder and blows a trumpet with puffed cheeks. Below this group, another swimmer balances a large platter, containing a meat pie, on his head. The swimmers' clothing is carelessly tossed on the shore, where two lovers embrace in the privacy of a tent bearing the coat of arms of the patrons, identified as belonging to the Bergh family of 's-Hertogenbosch.

Boating scenes were not uncommon in the visual culture of Bosch's time. Illustrations of May Day festivities show boats rigged with tree-masts as part of traditional celebrations of the arrival of spring (33). However, Bosch's crew are undisciplined rowdies in comparison with the well-behaved young revellers who inhabit May Day boats. A closer parallel appears in a popular printed book, Sebastian Brant's *Ship of*

Fools (*Das Narrenschiff*), a collection of poems first published in 1494. The *Ship of Fools*, written for the amusement and edification of ordinary people, reflects the tension of the pre-Reformation era in its satiric treatment of members of religious orders, along with almost every other human occupation and pastime. Perhaps Brant's audience felt a guilty twinge when confronted with an all-too-familiar portrayal of human folly, and made resolutions to behave better in the future. Perhaps, too, readers put down the book, laughed and thanked God that they were not fools like other men.

Bosch's *Ship of Fools* may have been inspired directly by Brant's poems, which appeared in several vernacular editions, including Dutch. The book is divided into 113 sections, each a rhyming poem devoted to a type of fool or vicious person. Brant was a professor at the University of Basel, and the many references to Classical and Biblical prototypes in his book added greatly to its popularity. Despite its learned references, the book's language is lively and terse, and its pages are adorned with woodcut illustrations of great humour and vigour, the best of which are attributed to the young Albrecht Dürer. All feature a bungling fool, identified as such by a cap adorned with ass's ears tipped with bells. Far from assuming the arrogant stance of an aloof moralist, Brant pictures himself as a doddering scholar at the head of his crew of fools in the first woodcut. Bosch's *Ship of Fools* echoes the composition of the title pages in several editions of Brant's book, which pictures a frail boat, overloaded with fools, sometimes captained by a young monk who takes a swig from a wine flask (34).

Brant's book was a popular example of the ship metaphor, but it need not have been Bosch's only inspiration. Ships representing State or Church abound in medieval literature. Jacob van Oestvoren's *Blue Ship* (*Blauwe Schute*; 1413) is another moralistic allegory. Deguilleville's *Pilgrimage of the Life of Man* features a ship of religion, which bears a

34
Frontispiece, Sebastian Brant, *Ship of Fools*, London, 1497

crucifix for a mast. Brant's book rode the wave, so to speak, when it appeared in 1494.

Bosch's *Ship of Fools* has inspired many overlapping interpretations alluding not only to foolishness and sin, but also to insanity, for truly it is a form of madness to engage in behaviour that would jeopardize one's time in eternity. Art historian Anna Boczkowska interprets the work as a lunar allegory, a reading that requires some understanding of the role of astrology at this time. Bosch and his audience were familiar with astrology as a legitimate science. Knowledge of the planets and zodiac was essential to the study of medicine and theology, and astrologers were well paid for

their expertise by popes and kings alike. The heavens were thought to rule everything on earth, and their configuration at the time of one's birth was generally believed to influence a person's personality, talents and destiny.

In the late fifteenth century, the revolutionary heliocentric universe posited by Copernicus and, later, Galileo, was but a glimmer on the scientific horizon. For two thousand years, the Pythagorean paradigm of the geocentric universe (35), which saw the earth encircled by seven moving planets and a sphere of fixed stars, was unchallenged by mainstream scientists. Bosch and his audience perceived the earth as

safely ensconced in the centre of the cosmos, surrounded by the seven spheres of the known planets, the fixed stars of the zodiac and, finally, the empyrean heaven in which God and the saints resided. According to this ancient scheme, which dominated science until the seventeenth century, human beings were intrinsically linked with the cosmos. Like the stars and planets, the body was thought to comprise four elements and their associated qualities: earth (cold and dry), air (warm and wet), water (cold and wet) and fire (hot and dry). These in turn were associated with four bodily temperaments, humours, and their related physical dispositions: cold, dry earth with black bile and melancholia; warm, wet air with blood and sanguinity; hot, dry fire with yellow bile and choler; and cold, wet water with phlegm and the phlegmatic type. This convenient scheme, which was common knowledge in Bosch's era, appears in a fifteenth-century print that shows the temperaments and qualities as four figures, each positioned on their representative element (36). Clouds billow around the feet of the sanguine figure; the brash choleric type brandishes a sword while flames lick at his heels; the phlegmatic man stands in a soggy puddle of water; and miserly melancholy slumps, head in hand, on dry land, contemplating an open treasure box.

Astrology played an important role in every person's life, for the temperament and qualities of one's natal planet, in combination with the zodiac, were bred in the bone. Saturn dominated melancholics and the element earth, whereas Luna (the moon) was associated with phlegm and the realm of water. Venus, Jupiter and Sol (the sun) were sanguine planets, linked with air and blood, while Mars, the red planet, was considered fiery and choleric. Mercury was changeable, taking its nature from the planet closest to it at any particular time. Every plant, animal, gem, human activity and even colour carried planetary powers. The heavens dominated the human body, and each planet controlled its own

35
Geocentric Universe, from Oronce Finé, *Protomathesis*, Paris, 1532

36
The Four Temperaments, c.1476. Woodcut

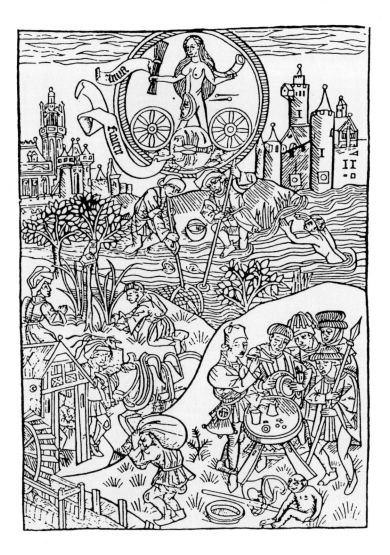

'children', who displayed the physical and personality characteristics of their celestial counterparts. Physicians utilized astrological sympathies to balance the humours and qualities within the body, manipulating the diets and lifestyles of their patients with the intention of bringing the microcosm of the human body into balance with the macrocosm of the universe.

Today we acknowledge that the moon controls the tides; however, early scientists expanded its planetary realm to include all waters on earth. The children of Luna tended to be good sailors, fishermen and swimmers; but they could also be restless and unstable, reflecting the phases of their natal planet, which vacillate from crescent to full and back. The brain, a moist organ, was especially prone to the sway of the moon, and an overabundance of lunar influence was believed to cause insanity. (This belief lies at the root of the modern word 'lunatic'.) In addition to being prone to madness, phlegmatic lunar personalities tended to be stupid, slothful and overly fond of eating and drinking. In fact, of the Seven Deadly Sins, each of which was associated with a planet, gluttony belonged to Luna. Hildegard of Bingen's medical treatise, *Causes and Cures*, which considers traditional humoral theory, further claims that phlegm causes 'careless gaiety ... and inordinate lust'. Early illustrations of Luna's children show these vices, picturing among the moon's various aquatic activities folk who bathe and feast in the open air (37).

The watery world of Bosch's *Ship of Fools* is dominated by the baleful influence of the unstable moon. The yellow crescent on its banner, which unfurls from the tree-mast, may also signify the 'infidel' Turk, adding the imagery of heresy to that of insanity. And the directionless journey of the ship may well reflect Erasmus's criticism, made in the *Praise of Folly*, that 'The foolish change like the moon'. All these interpretations present Bosch's fools negatively; together

37
Children of Luna, c.1470. Blockbook. Staatliche Museen, Berlin

they form an exposé of sin, excess and madness conflated within a single image.

The metaphor of the aimlessly sailing boat, packed with unstable passengers, may also draw on one of the cruel realities of the time. In the days before madness became medicalized and viewed as a treatable illness, few cities made provisions for the housing and feeding of the insane. 'S-Hertogenbosch was unusually forward-looking in this respect, and was, in fact, the first town to designate a small asylum for such people. More commonly, civic authorities arrested the mentally ill and threw them into prison. When no custodial government, family or circle of friends came forward, the insane were sometimes handed over to boatmen who kept them from doing mischief on dry land. Though this practice is sparsely documented in areas of northern Europe in the fifteenth and sixteenth centuries, it did happen, and was one way that city authorities could, for a price, be relieved of the trouble of controlling and segregating the mentally ill.

Historians also link Brant's and Bosch's images with another, more common, event that involved the mentally ill: groups of lunatic pilgrims, gathered together under the custodial eyes of their keepers, making their way by land and sea to a holy site noted for its power to heal their insanity. Bosch, however, does not populate his ship with people who are obviously mentally ill, in the modern definition of the term, nor does he provide them with a responsible custodian. Rather, the passengers in his *Ship of Fools* are ordinary people, who, in their lunatic folly, live aimless, rudderless lives in pursuit of pleasure, never thinking of the consequences of their behaviour.

Wilful folly is also the subject of *Death of the Miser* (see 31). The panel demonstrates two notions common to religious thought of Bosch's era: that human beings persist in sin up to the moment of death, and that redemption is always

possible, even at the last minute. The dying miser confronts the two choices open to him in his last moments as Death enters stealthily, aiming an arrow at the man's heart. An angel kneels at the bedside and tries, with an open-handed gesture, to direct the dying man's attention to a small, luminous figure of the crucified Christ in the window above. Despite the angel's willingness to intercede, the miser is distracted by temptation, and reaches one hand towards a bag of gold held out by a demon peeking from beneath the bed curtains. Other demons, looking vaguely reptilian, peer over the top of the bed frame, frolic inside the large treasure chest at the foot of the bed and crawl beneath it. Clearly, there is more evil than good in this death chamber.

The battle between heaven and hell for the soul of the soon-to-be-departed and the diagonal placement of the bed appear in one of the roundels in the *Seven Deadly Sins and Four Last Things* (see 14), as well as in a number of sources on death

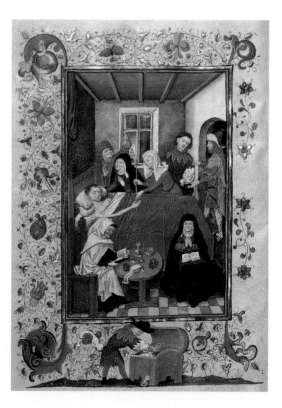

38
Hours of the Dead, from the *Book of Hours of Catherine of Cleves*, c.1440. Pierpont Morgan Library, New York

and dying that Bosch could have known. One of these, the charming mid-fifteenth-century *Book of Hours of Catherine of Cleves*, commissioned by a noble family who were staunch members of the Brotherhood of Our Lady, shows a deathbed scene much like Bosch's, even to the rifled treasure chest in the bottom margin (38). However, this dying man makes his exit comforted by friends, family and clergy who pray for his soul, a far cry from Bosch's lonely miser – or from the isolated, sanitized hospital environments in which many modern souls must depart. Bosch's composition also echoes illustrations from popular books of the time. Brant's *Ship of Fools* illustrates a fool rummaging through the treasure chest at the foot of his bed in the woodcut accompanying the poem 'Of riches unprofitable' (39). Outside the chamber, a starving pilgrim is menaced by dogs, who lick his sores, while the miserly fool within counts the fortune that should be put to better use. Bosch's composition shares both the diagonally placed bed and open-walled architectural framing with Brant's woodcut.

The closest contemporary influence on Bosch was perhaps the popular illustrated treatise *The Art of Dying* (*Ars moriendi*), which first appeared in Latin in 1465–70 and in a Dutch translation in 1488 (40). This important little book was a manual of instruction for those enduring their last days. Its prologue begins: 'Forasmuch as the passage of death ... not only to lewd men but also to religious and devout persons – seemeth wonderfully hard and perilous, and also right fearful and horrible ... in this present matter and treatise ... is drawn and contained a short manner of exhortation, for teaching and comforting of them that be in point of death'. The *Art of Dying* devotes several chapters to specific ways in which the dying can resist temptation, retain their dignity and gain peace, because 'the devil with all his might is busy to avert fully a man from the faith in his last end'. The accompanying woodcuts all feature a dying man lying in a bed placed diagonally within the picture

39
Of Riches Unprofitable, from Sebastian Brant, *Ship of Fools*, London, 1509

40
The Avaricious Man, from *The Art of Dying* (*Ars moriendi*), 1465–70. Blockbook

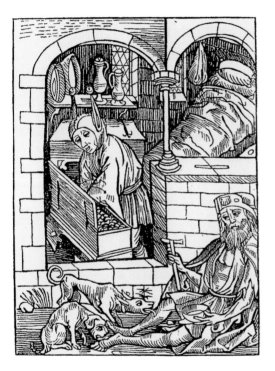
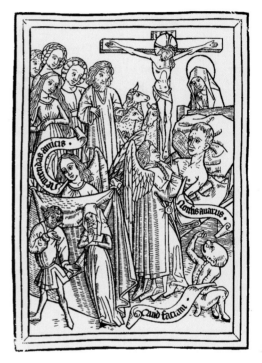

space, accompanied by an angel, a devil and other figures appropriate to the temptation being illustrated.

While the *Art of Dying* describes how 'a Christian man may die well and seemly', the outcome of Bosch's death scene does not look positive. Anne Morganstern believes that the objects strewn in the foreground – a cloak, helmet, tournament shield, sword, lance and gauntlet – are items that were commonly pawned. She suggests that they mark the dying man as guilty of usury, the ultimate manifestation of avarice. The tradition of charging interest on loans is familiar to us today, and most people willingly pay a little more for the privilege of buying over an extended period of time. However, in Bosch's day, the Church defined usury as profiting by another's ill fortune, and forbade Christians from practising it. In fact, Deguilleville's *Pilgrimage of the Life of Man* describes usury as the 'third of Avarice's six hands'. Cold-hearted misers were punished by wretched deaths, surrounded not by friends and family, but by the frigid riches that they loved too well in life.

Art historians Pierre Vinken and Lucy Schlüter offer another convincing interpretation of the collection of armour piled outside the window of the miser's house. They point to a Biblical passage from St Paul's Letter to the Ephesians (6:10–17) in which he calls upon Christians to seek their strength in the Lord: 'Put on the whole armour of God, that ye may be able to stand against the wiles of the devil.' Paul further associates specific pieces of armour with tenets of Christianity: the shield with faith, the helmet with salvation and the sword with the Holy Spirit. Bosch's countryman Erasmus elaborated upon this concept of spiritual armour in his *Handbook for the Christian Knight* (*Enchiridion militis Christiani*), published in 1501. A Biblical reading of Bosch's painting therefore presents the collection of armour as the spiritual protection that the miser has discarded in favour of material wealth.

In his encyclopedic representations of the manifold aspects of human folly, to which the *Death of the Miser* belongs, Bosch reserves his most cutting commentary for the sin of avarice. He did so in response to the beginnings of capitalism that emerged in northern Europe during his lifetime. As banking gradually gained respectability, and vast fortunes were acquired by members of the merchant élite, class distinctions became blurred. No longer was the ancient feudal division between noble and peasant an undisputed indicator of status and wealth. The dying miser is guilty of avarice, for he has not distributed his fortune to the needy, but hoarded it.

The themes of greed and debauchery pictured in the *Ship of Fools/Allegory of Intemperance* and *Death of the Miser* contribute to an understanding of the figure of the *Wayfarer* that once adorned their reverses. The Rotterdam *Wayfarer* (see 27) shows the figure of a shabby, haggard man, who makes his way with trepidation along a perilous path, carrying his belongings in a basket on his back. Stooped and ashen, the traveller walks with difficulty on his bandaged leg, wearing a slipper on one foot. In addition to his backpack, from which a cat's skin hangs, he carries a purse and a dagger. Behind him is a dilapidated building, perhaps a brothel, judging from the lascivious pair in the open doorway. Here, a man relieves himself against a side wall while pigs feast from a trough in the front yard. A snarling little dog guards the shoddy pathway, which is blocked by a closed gate.

The meaning of Bosch's *Wayfarer*, who also appears on the exterior of the *Haywain* triptych (see 44), has engendered much lively art historical controversy. Scholars have interpreted the two as depictions of the Prodigal Son, the sin of sloth, a cheating peddler, the astrological image of Saturn, a Christian pilgrim, a repentant sinner and a pauper. Bosch's sources have been seen as the treatises of the ancients,

proverbs and moralizing axioms, medieval Middle Dutch plays, the Bible or the grim realities of life blighted by poverty. Are we to see the *Wayfarers* as negative depictions of sin or as paragons of Christian virtue? Do the two pictures, in fact, represent different things, despite their similarities?

As in the case of Bosch's other depictions of human folly, clues to the meaning of the *Wayfarers* emerge from within the contemporary wisdom of the time. It was not at all

common for a person living in the late fifteenth century to travel alone voluntarily. Brigands and highwaymen haunted the roadways, and responsible travellers, like the pilgrims described in Chaucer's *Canterbury Tales*, hired armed guards to accompany them for protection. The pedestrian caught on the open road was most likely an outcast of some sort – a madman or peddler – or a poor student away from home. Nonetheless, the image of the solitary traveller could also take on elements of picturesque

glamour in late medieval lyric poetry and art. The lone
voyager, subsumed within nature (41), became a metaphor
for the solitary soul embarking on a spiritual voyage.
Bosch's *Wayfarers*, however, move through treacherous
landscapes, which encourage them not to linger. Their
journey is a symbol for the Christian voyage through life,
seen as a pilgrimage fraught with temptation and danger.

Bosch's *Wayfarers* are vulnerable and, judging from their
shabby clothes, obviously poor. Our understanding of
Bosch's intentions must therefore also take into account
the meaning and significance of poverty in early modern
northern Europe, when urban living brought paupers into
direct contact with affluent city dwellers. Though the
reasonably well-off never travelled without companions, the
sight of a lone, hungry man, carrying his earthly belongings

41
Nuremburg
Master,
*Cliff
Landscape
with
Wanderer*,
c.1490.
Pen on paper;
21·1 × 31·2 cm,
8⅜ × 12¼ in.
University
Library,
Erlangen

on his back, was common in Bosch's era. During the acute
crises of existence that plagued the pre-industrial era,
desperate people were forced to leave their homes and
empty their houses of goods. They turned over everything
of any value at all – kitchen pots, clothes and linen – to
peddlers and pawn brokers, who, like Bosch's dying miser,
made enormous profits by reselling them. Sometimes the
poor became itinerant peddlers themselves. The situation
was not limited to the Netherlands, but spanned all of
Europe. An especially pathetic Italian poem, entitled
Lament of a Poor Man Over his Cares (*Lamento de uno
poveretto huomo sopra la carestia*), could describe the plight
of Bosch's wanderer: 'I sold the bed sheets/ I pawned the
shirts/ such that now my uniform/ is that of a rag-peddler.'
Working people complained about this practice, grumbling
that 'peasants are all given to selling second-hand goods,
one can no longer buy without them already having been
resold two or three times'. The cat's skin hanging from the
Rotterdam *Wayfarer*'s basket was one of the things that was
frequently sold by the itinerant poor, for feral cats could be
caught and skinned at no expense, and their fur sold to make

clothing. Thus, the identification of Bosch's figure as a peddler is not without foundation, for the poor routinely acted in that capacity out of desperate need.

Tracts on poverty and descriptions of the poor abound in every medium of historical writing in the late fifteenth and early sixteenth centuries. Examples include the anonymous *Mirror of Vagrants* (*Speculum cerretanorum*) and Johannes von Amberg's *The Vagrant's Life* (*De vita vagorum*), which describe the poverty and trials of the homeless and the tricks they employ to maintain themselves. Vagrants are described as 'lovers of idle liberty', who dressed in rags and acted the part, with 'apparent bruises and studied paralysis' perpetrating a 'fiction of broken limbs'. Such beggars would often sport bandages and limp, mimicking debility so as to appear worthy of alms. These criticisms suggest that, by the fifteenth century in northern Europe, pauperism was viewed increasingly as a social and economic problem, and a harsh, judgemental attitude took the place of sympathy where the poor were concerned. Poverty was often seen as resulting from, or leading to, illness, licentiousness and sloth.

42
Allegory of Poverty and Wealth, late fifteenth century. Engraving

Changes in the perception of poverty in the early modern era resulted from a combination of factors, documented by modern social historians. Most dramatic was the migration of impoverished country folk into prosperous cities in search of work or assistance. They were perceived as swooping down like locusts on the hard-working urban affluent, depleting reserves of money and food. The situation became worse during times of economic depression, famine and plague, which recurred with numbing frequency throughout Bosch's lifetime. Driven by the illusion of better and easier living, or even simply by the promise of some bread in their stomachs, homeless vagrants often ended up doing the lowest type of work as porters or latrine emptiers. Work of this kind, always hard, did not guarantee even minimum sustenance, and such folk often slid even further

into vagrancy and beggary. The increasing mass of the homeless poor expanded the population of rogues, beggars and criminals that threatened the safety and security of cities and the affluent middle class. The resulting bleak view of the poor is pictured in a late fifteenth-century engraving, which shows the allegorical struggle between wealth, poverty and fate (42). The print depicts 'wealth' as

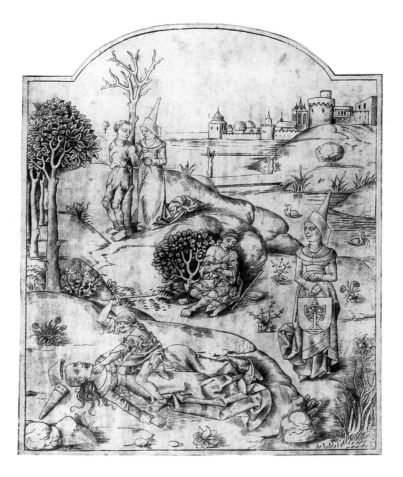

an aristocratic woman and 'poverty' as a ragged, barefoot man. The figure of 'fate' stands with her wheel near the right margin, indicating that poverty and wealth are not a matter of choice. Central to the scene, a suffering beggar cowers in the shelter of a bush. Above him, wealth ties poverty to a tree, fixing him in his unfortunate station, while below,

a violent beggar throttles wealth and beats her with a stick –
a disturbing image of poverty overcoming prosperity.

There are a number of indications that the Rotterdam
Wayfarer may illustrate the negative view of poverty shared
by many social and religious authorities of Bosch's time.
Among these is the dilapidated building in the left back-
ground of the scene. The vagrant looks over his shoulder at
this ramshackle structure, as if hesitating in his journey,
perhaps lured by its dubious charms. Obviously, the place
is disreputable; holes gape in its roof, several glass panes
are broken, and a shutter dangles from a window. It is likely
to be an especially unsavoury tavern and brothel. That it
provides sex and drink is evidenced by the embracing
couple in the doorway and the man urinating against a wall.
The tavern represents the vagabond *demi-monde*, and it is
unlikely that Bosch intended to disassociate the decrepit
figure of the wanderer from the equally shoddy shack and
the lustful, gluttonous activities that it harbours. Because the
poor could rarely sate their thirst and hunger, it was believed
that they over-indulged whenever they could, resulting in
gluttony, drunkenness and violent, rowdy behaviour. In fact,
the Rotterdam *Wayfarer* carries a purse and is armed with a
knife; he does not suffer his condition submissively, but is
prepared for violence.

The wayfarer's bandaged leg and slippered foot suggest that
he suffers from the physical consequences of excess. Gout,
a painful arthritic condition that primarily affects the feet,
has been associated since ancient times with gluttony and
lechery. Though the image of the gouty sensualist, resting
his bandaged foot on a stool, is more familiar to us in art of
the eighteenth century, medical authorities in Bosch's time
were well aware of the condition, which they called *podagra*.
The wayfarer's bad foot suggests that he has paid an excru-
ciating price for overindulgence in the vices harboured by
the ramshackle tavern. The closed gate towards which he

heads suggests that perhaps the door to salvation will not open easily for him. A small owl perched in the branches above him is a symbol of evil and reinforces other negative elements of the scene.

Art historians Lotte Brand Philip and Andrew Pigler believe that the Rotterdam *Wayfarer* reflects aspects of astrological theory that further explain the wanderer's lame foot and reinforce a negative interpretation of the figure. As in the *Ship of Fools* (see 28), which alludes to the wayward children of Luna, the Rotterdam panel is filled with humoral and astrological elements, this time associated with Saturn. This planet, the furthest (it was thought) from the earth and slowest of all in its journey around it, was linked with the element of earth, the unfortunate, melancholic temperament, and the bodily humour of black bile (excrement). The 'Saturn' page from the popular *Children of the Planets* series (43) shows its offspring as

43
Children of Saturn, c.1460. Florentine engraving

farmers, grave diggers, criminals and hermits. They work
the earth and display the negative, anti-social personalities
associated with melancholia, decay and death. Pigs, because
they wallow in mud, are also at home among the planet's
human progeny. Saturn is personified at the top of the page
as an old, lame man, supporting himself with a crutch.

The relationship of the astrological imagery of Saturn to
Bosch's panel is clear. The wayfarer is lame and carries a
stick, as do Saturn and his children. The background tavern
displays the decay also governed by Saturn's influence,
and the swine belonging to the planet cluster about it.
Furthermore, the pervading colour scheme is decidedly
earthen, composed of delicate tones of brown, ochre and
grey. Even the sky is a predominantly neutral shade of
buff. The association of the wandering poor with Saturn's
humour, excrement, was often crudely made. Vagrants
were described as stinking of the dung heaps on which they
sometimes slept for warmth. One especially callous source
portrays them as looking like 'wandering dung heaps' with
ashen skin, seemingly 'born from decay'.

Saturnine iconography is thus apt for depiction of the sad
reality of poverty, for the planet dominated the wretched
of the earth, who lived on the margins of the world in social
isolation. The lure of material things, reinforced by the
scenes of greed and excess that once appeared on the
reverse of the Rotterdam panel, is perhaps the very reason
for the wayfarer's condition, for they have the power to entice
him from his pathway. The combined image of gluttony,
greed and poverty presented by Bosch's now-unified panels –
the *Wayfarer*, the *Ship of Fools/Allegory of Intemperance* and
the *Death of the Miser* (see 27–29) – recalls the passage that
begins 'On Gluttony and Feasting' in Brant's *Ship of Fools*:
'He merits future poverty/ Who always lives in luxury/ and
joins the spendthrift's revelry.' Functioning as the exterior
panels of a triptych that included at least two scenes devoted

to sins of overindulgence, the *Wayfarer* both introduces and sums up Bosch's message in the very act of opening and closing its doors: poverty is both the cause and the result of greed and excess.

The Rotterdam *Wayfarer* (see 27) shares its subject and its original function with the exterior of the *Haywain* triptych (44), which exists in two nearly identical versions, one in the Prado museum in Madrid and the other in the Escorial, just outside that city. Though the panel of the Escorial triptych is earlier than the Prado version – *c*.1498 or later, versus *c*.1510 or later – the Prado *Haywain* contains many *pentimenti*, which strongly suggest that it is an original composition, though it may have been completed after Bosch's death. One of these triptychs was included among the works of art shipped by Philip II to the Escorial in 1574, and was described in the inventory as, 'A painted panel with two wings, on which is depicted a haywain being plucked at by everyone, symbolizing the pursuit of vanity ...'. Whether one or both are original, copies or workshop products, the Prado version is the one featured here, owing to its better state of preservation, slightly higher level of execution and obvious *pentimenti*.

Though the *Wayfarer* on the exterior of the Prado triptych shares common elements with the Rotterdam *Wayfarer*, the two are not identical. The Rotterdam figure moves through a landscape populated by references to the sins of lust and gluttony, but the environment in the Prado panel is much more threatening; a gang of hoodlums strip and rob a rich merchant, gibbets and wheels are silhouetted against the sky, and bones, picked clean by scavenger birds, lie scattered near the traveller's feet. In the background to the right, a shepherd plays the bagpipe as a rustic couple dance to his tune. The piper sits beneath an outdoor tree-shrine, his staff propped against the prayer rail, seemingly oblivious to the crucifix hanging above him. As in the Rotterdam panel,

a mean little dog snarls at the wayfarer's heels; but, unlike the Rotterdam wanderer, the Prado figure does not suffer a sore foot. Furthermore, his posture and expression seem to express fear and trepidation rather than reluctance and uncertainty. Whereas the path in the Rotterdam *Wayfarer* is blocked by a closed gate, that in the Prado panel leads without impediment across a small footbridge. In general, the Prado *Wayfarer*, though threatened, seems untouched by the elements of folly, danger and death that surround him on all sides.

Clearly, the *Wayfarer* of the Prado *Haywain* is poor, but he does not display the negative characteristics that stigmatize the Rotterdam traveller. In fact, Christian thought of the pre-industrial era recognized two types of pauper. Those who were poor because of bad luck and low social position were, of course, numerous and ubiquitous. However, a devout person could elect to live in 'voluntary poverty' as one of the few saintly individuals, the 'faithful good' (*fideles boni*), who purposefully practised the discipline of self-denial in emulation of Christ. Despite their difficult lives, those who renounced worldly goods strove to remain humble, docile, meek, servile and acquiescent. Contemporary texts on poverty describe 'Christ's poor' as physically resembling the wandering wastrels who populated the streets, marked by 'maimed limbs, bleeding sores, torn coats, putrid bandages, vile rags'. However, the walking sticks of the voluntary poor were 'glorious trophies of their Christian patience'. Rare is the individual in the mechanized, computerized Eden of the twenty-first century who chooses to live as a destitute pauper. In Bosch's day, however, such a choice was deemed honourable and admirable, and was upheld by religious and civic authorities.

Historian René Graziani demonstrates that the concept of voluntary poverty originated in the writings of the ancient Romans, and was absorbed very early by Christianity. In

44
Haywain
triptych,
exterior,
c.1510 or
later.
Oil on panel;
135 × 90 cm,
53⅛ × 35½ in.
Museo del
Prado, Madrid

fact, a passage from Seneca's *Moral Epistle XIV* considers a poor traveller in threatening surroundings similar to those that Bosch's wayfarer navigates undeterred: 'If you are empty-handed, the highwayman passes you by; even along an infested road, the poor may travel in peace.' The image of the besieged wanderer on the pathway of life eventually became a medieval commonplace, akin to the proverbs that also inspired Bosch.

Art historian Virginia Tuttle notes another possible influence upon Bosch, traditional Franciscan iconography, which came from Italy to northern Europe with the spread of the order. Among the examples she cites is a fourteenth-century roundel illustrating an *Allegory of Poverty* in the Baroncelli Chapel, Santa Croce, Florence (45), which demonstrates striking affinities with Bosch's *Wayfarers*. Common to both is the image of a man carrying a walking stick, looking over his shoulder in fear and apprehension at a snarling dog. Closer to Bosch's home is a fifteenth-century misericord carving from Breda (46), which illustrates a similar scene and may also have Franciscan associations.

Franciscans were foremost among the mendicant religious orders, and encouraged a simple life of poverty and detachment from the material world. Purposefully poor, they took literally their founder's belief that the things of the world belong to no one and are simply on loan from the Almighty. In fact, at his death, St Francis begged forgiveness of his body for the pain and discomfort he had inflicted upon it during life. Franciscan houses and those of their sister order, the Poor Clares, were prominent in 's-Hertogenbosch. Both groups were conspicuous in the civic life of the city, and were also key members of the Brotherhood of Our Lady. Members of the Modern Devotion were also urged to devote themselves to poverty, and to look towards St Francis as an example. Thomas à Kempis, author of the *Imitation of Christ* (*Imitatio Christi*) and a major figure of this movement,

45
Workshop of Taddeo Gaddi, *Allegory of Poverty*, c.1328–30. Fresco. Baroncelli Chapel, Santa Croce, Florence

46
Misericord carving of Poverty, c.1460. Wood. Grote Kerk, Breda

admonishes readers to 'keep yourself a stranger and pilgrim upon the earth, to whom the affairs of this world are of no concern'. Preachers extolled the virtues of voluntary poverty from pulpits all over Europe. The 'Palm Sunday sermon' of Gerard Groote, founder of the Modern Devotion in the late fourteenth century, explains that those who devote themselves to voluntary poverty must, like Christ himself, expect to be reviled and abandoned by the rest of the world.

To choose the path of voluntary poverty was to follow Christ in the strictest sense, as he urged in the 'Beatitudes' ('Blessed are the poor'; Luke 6:20). The duality of poverty – its positive and negative aspects – appears in many popular treatises, among them Deguilleville's *Pilgrimage of the Life of Man*, where poverty takes the form of Impatient Poverty, who is miserable with his lot, and Willing Poverty, who declares, 'I despise all riches, sleep in joy and secureness, Nor thieves may not rob me.' The devout yet impoverished wanderer on the earth appears as a pilgrim in a German woodcut entitled *Mirror of Understanding* (47). Like Bosch's *Wayfarers*, he carries a staff and makes his way along a difficult path shared with death and the devil. In common with the Prado *Wayfarer*, the Christian pilgrim in this image advances across a footbridge that leads from this life to the next.

Though the Prado figure does not wear the hat and cockle shell that would identify him as a man on a holy pilgrimage, his situation reflects the concept of voluntary poverty. The sermons of St Bernard (published in the Netherlands in 1495) describe how best to negotiate one's way through life in words that could just as easily describe the Prado *Wayfarer*:

Blessed are those who can live as pilgrims in this wicked world, and remain untainted by it ... For the pilgrim travels the king's highway neither on the right nor the left. If he should come upon a place where there is fighting and quarrelling, he will not become involved. And if he should come to a place where there

47
Mirror of Understanding (Der Spiegel der Vernunft), c.1488.
Woodcut;
40·4 × 29·1 cm,
15⅞ × 11½ in.
Staatliche Graphische Sammlung, Munich

is dancing and leaping, or where there is a celebration ... these will not entice him, for he knows that he is a stranger, and as such has not interest in such things.

The Church of St Jan possessed a very visible reminder of the poor and the importance of poor relief. Its splendid baptismal font, cast in brass by Aert van Tricht (fl.1492–1502) in 1492, consists of a wide basin mounted on six figures of ragged and stooped men, each stepping forth, like Bosch's *Wayfarers*, with the assistance of a walking stick (48). These figures literally underscore the importance of charity to the poor as the very basis of Christian faith and, furthermore, as an important civic priority. 'S-Hertogenbosch was well known for its generous policies on poor relief. In fact, aid to the poor in 's-Hertogenbosch amounted to twice as much as in Brussels, the next largest distribution centre. Even during the economic woes that gripped the Netherlands between 1475 and 1520, the town continued to outspend other cities in charitable giving. It is estimated that solvent citizens donated at least ten per cent of their patrimony to poor relief, most of it for the purchase of bread and footwear. Predictably, migrants from outlying areas streamed into 's-Hertogenbosch in such large numbers that city authorities were eventually forced to curtail aid to 'undeserving' newcomers in favour of those who lived within the walls. These measures entailed turning away beggars and vagabonds so as to preserve the social order.

As a sworn member of the Brotherhood of Our Lady, Bosch was not only aware of the distinction between voluntary and involuntary poverty, but also part of a group whose mission recognized voluntary poverty as a virtue and rewarded its practice with material support. The confraternity distributed alms regularly to the poor, though they were discriminating in their charity. Gifts of food and clothing went primarily to their own membership, specifically to ecclesiastics who practised *voluntary* poverty. The Brotherhood also sponsored

48
Aert van Tricht, Baptismal font, 1492. Cathedral of St Jan, 's-Hertogenbosch

hospices in which the poor were fed and housed, and members volunteered their time, anonymously serving and bathing the vagrants who stayed there. Such menial service, though laudable, was not conducted entirely out of the goodness of their hearts. Charitable acts allowed Christians the opportunity to secure salvation and earn a place in heaven. Though the Brotherhood was generous in

its donations to the poor, the membership gave twenty to forty times as much money for Church masses in honour of deceased members, intended to shorten their time in purgatory. Clearly, salvation could be had for a price: by giving generously, but not too generously, of personal resources to the deserving poor.

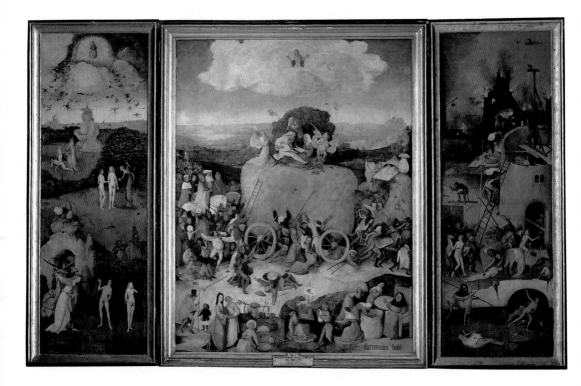

Bosch's poor traveller suffers through his acceptance of Christ-like poverty, sustained by knowledge of the troubles that accompany wealth, and which appear in horrifying detail on the triptych's interior (49). The left panel tells the story of the origin of sin, beginning with the expulsion of the rebel angels, when Lucifer was cast out of heaven, and evil born. Here, Lucifer's minions, resembling a vast swarm of demonic mosquitoes, descend in a great cloud, ready to bring stings of sin and death to the earth (50). Beneath, represented from top to bottom in continuous narrative, God creates Eve from Adam's rib, and Lucifer, now Satan, tempts Eve with fruit from the Tree of Knowledge. Bosch's tempter takes the form of a serpent with the head and upper body of a woman. This strange composite creature was described by Biblical commentators, who maintained that only by assuming the guise of Eve's own kind was Satan able to coax her into tasting the forbidden fruit. The devil appears thus in representations dating from early medieval times. Bosch's older contemporary, Hugo van der Goes (*c.*1440–82), depicted the tempter as a golden-haired, snake-tailed girl in his *Fall of Man* (51). The evil deed being accomplished, the lower sector of Bosch's panel shows the expulsion of Adam and Eve from Paradise. Though aspects of the figural representation in this panel seem awkward, perhaps as a result of workshop participation, the upper regions display the delicate atmospheric effects that distinguish Bosch's landscapes. The way in which rock shapes yield to curling vines and bursting vegetal forms gives this Garden of Eden an exotic, otherworldly look in keeping with Bosch's vision.

The central panel (52) is the main focus of the triptych; here, greedy folk of every age, occupation and class cluster around a large hay wagon, grasping handfuls of straw and fighting each other for the privilege. Bosch's hay wagon resembles a parade 'float', much like the ones that wend their way through modern city streets in celebration of athletic victories or public holidays. Indeed, Bosch

49
Haywain
triptych,
interior,
*c.*1510 or
later.
Oil on panel;
centre panel
135 × 100 cm,
53⅛ × 39⅜ in,
side panels
135 × 45·1 cm,
53⅛ × 17¾ in.
Museo del
Prado, Madrid

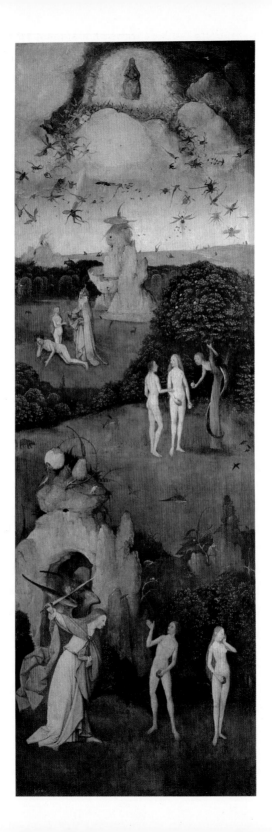

participated in many such processions, sponsored regularly by the Brotherhood of Our Lady in 's-Hertogenbosch.

For once, the general meaning of Bosch's scene is fairly clear, though the significance of some of the details within the composition still eludes us. Most interpreters agree that the hay wagon recalls several proverbs that employ 'hay' (*hooi*) as a symbol for the transient nature of the flesh,

50
Haywain
triptych,
left panel,
*c.*1510 or
later.
Oil on panel;
135 × 45·1 cm,
53⅛ × 17¾ in.
Museo del
Prado, Madrid

51
**Hugo van
der Goes**,
Fall of Man,
left panel of
diptych,
*c.*1468–70.
Oil on panel;
33·8 × 23 cm,
13⅛ × 9 in.
Kunst-
historiches
Museum,
Vienna

as well as the ultimate worthlessness of material things. A popular fifteenth-century Flemish song describes the riches of the earth as a stack of hay that God has provided for everybody's use; even so, each individual wants it all for himself. Many proverbs use the word 'hay' to represent the ephemeral things of the world, as opposed to the eternal life of the immortal spirit. To 'grab at the long hay', 'crown

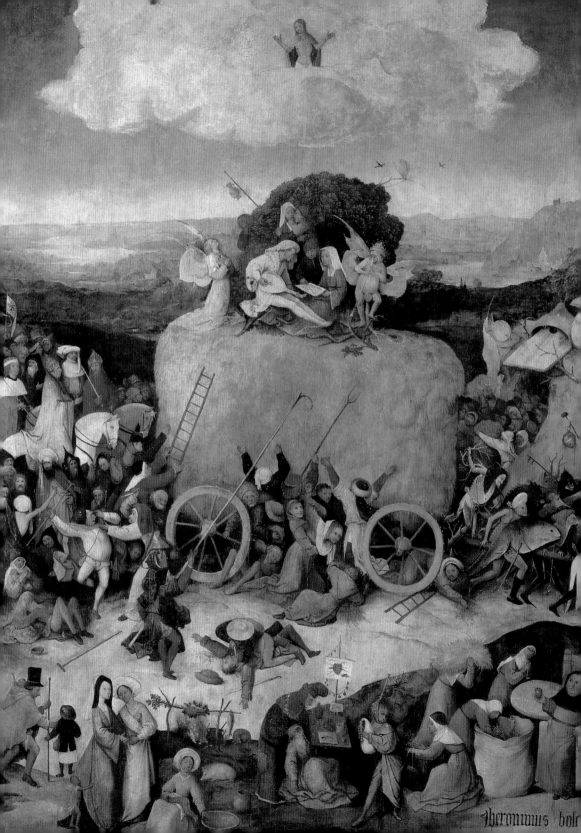

with hay', 'stuff someone's cap with hay' and 'drive the hay wagon' all refer to the human tendency to be concerned with material things that are ultimately meaningless. The English sayings 'it's all hooey' and 'to grasp at straws' have similar associations.

The cataloguing of folly and sin occupied the greatest thinkers of Bosch's time, especially the erudite reformer Desiderius Erasmus, who studied briefly at one of the houses of the Modern Devotion in 's-Hertogenbosch. His moralizing treatise *In Praise of Folly* (1509) claims, with humanist irony and in erudite Latin, that stupidity is the natural state of all human beings. Erasmus was a master of acerbic wit and sarcasm, qualities that are evident in the scathing panorama of human avarice in Bosch's *Haywain* triptych. Christ watches the shameful display, much as he does in the *Seven Deadly Sins and Four Last Things* (see 14), this time from the sky above. With arms outstretched, Christ displays his wounds, although his gesture could just as well be interpreted as one of abject dismay. The view from on high is not pretty; men, women and children alike commit murder and mayhem, sacrificing dignity and humanity to get near the wagon or grasp just one more handful of worthless hay. Some of those who have succeeded are crushed beneath the wagon's weight or caught in the great spokes of its wheels, reminding viewers that to sacrifice all in the pursuit of material things can be a risky business.

Bosch's greedy mob is guilty not only of avarice, but also of vanity. The two sins were linked by Bosch's contemporary Thomas à Kempis in his *Imitation of Christ* (*Imitatio Christi*). This text, which was written for the Modern Devotion, stresses the concept that 'all is vanity', and enumerates the various behaviours that distinguish Bosch's crowd:

Vanity, therefore it is, to seek after perishing riches, and to trust in them. Vanity also it is to hunt after honours, and to climb to

52
Haywain
triptych,
centre panel,
c.1510 or
later.
Oil on panel;
135 × 100 cm,
$53\frac{1}{8} \times 39\frac{3}{8}$ in.
Museo del
Prado, Madrid

high degree. Vanity it is to follow the desires of the flesh, and to long after that for which thou must afterwards suffer grievous punishment. Vanity it is, to wish to live long, and to be careless to live well. Vanity it is to mind only this present life, and not to foresee those things which are to come. Vanity it is to set thy love on that which speedily passeth away, and not to hasten thither where everlasting joy abideth.

Bosch reserves the lower register of the central scene for some of the same thieves and charlatans that populate his other works. Here are the clergy, represented by a portly monk who oversees four nuns as they collect and store hay for his benefit. A quack dentist appears in the lower centre, advertising his trade by a sign hung with the teeth he claims to have pulled from the mouths of other gullible victims. Further to the left, a mother washes the bare bottom of her baby, a witty scatological comment on the load of 'hay' on the road above her. Representatives of the ruling temporal powers of the earth, designated by banners bearing the Habsburg double eagle and the French *fleur de lis*, follow closely behind the hay wagon. These three wear the crowns of a king, an emperor and a pope, and sit on horseback, aloof from the pandemonium that surrounds them. They can afford to retain their dignity, for the 'hay' is already theirs. Even so, the ruling élite, as surely as the rest, are destined to follow the wagon as it lumbers inexorably towards its final destination.

Atop the hay wagon, a trio of well-dressed young people perform music, flanked on either side by a prancing blue devil and an imploring angel (see frontispiece). A couple embrace lustily in the bushes behind them, while another figure peers voyeuristically through the foliage. The significance of these pairs of lovers has inspired much scholarly debate. Perhaps the love-making couple in the bushes suggests a link between the sins of avarice and lust. St Gregory emphasized the connection, describing 'a

tabernacle of devils who labour in this world for riches and fame, and after he has got them gives himself to lechery, so that lechery may waste all that covetousness has gathered together'. Do the youthful merrymakers atop the haystack point to the blindness of sinners, who dally in the pleasures of the flesh, oblivious to their fate? Or do they have a more positive role? It has been suggested that Bosch intended the decorously singing couple to be compared with the lustful pair as embodiments of physical and spiritual love. Or perhaps the music-making group represents the virtue of harmony, or concord, in direct contrast to the chaos that surrounds them. These positive images seem less likely, however, as the young revellers are headed just as surely into the jaws of hell as the people who follow the hay wagon.

For Bosch, hay is the bait that lures sinful souls into the abyss, as anthropomorphic demons lead the wagon and its followers directly into a diabolical hell scene. The bucolic range of green hills and atmospheric sky in the central scene turn red in the right panel, as the procession of the damned files into the blazing inferno that awaits them. Many of the ingenious demonic vignettes seen here appear in Bosch's other hell scenes, particularly the image of the hunter being hunted. This inversion, part of the 'world-turned-upside-down' concept that dominated carnival celebrations, is reflected in the figure of the stag leading his human prey into hell at the left. There is also a trumpet-blowing demon with a black hood at the bottom left of the panel whose human quarry hangs from a staff thrown over its shoulder (54) and another doomed soul being torn apart by hunting dogs at the lower right. A fourteenth-century manuscript of the *Romance of Alexander* similarly illustrates this concept, showing among its drolleries a rabbit with a hunting horn hoisting its human prey over its shoulder (53). Further demonic atrocities fill Bosch's scene: a winged devil drags yet another sinner, perhaps guilty of lust judging from the frog that gnaws his genitals, towards his end, preceded by

a doomed knight who rides naked on the back of an ox. Fiendish masons are constructing the tower into which all enter. In a bizarre irony, the flesh of the sinners will bake, along with the 'hay' of the material things they loved too well, into the bricks that form the diabolical structure.

The fact that Bosch based his *Haywain* triptych upon popular proverbs does not indicate that his audience was limited to those who knew these sayings in the vernacular Dutch. This is to assume that Bosch and his patrons would not have had access to books written in other languages or, if they had, would not have been likely to buy them or capable of understanding them. Limiting Bosch's literary influences to vernacular Dutch sources underestimates the literacy of his

audience and is based on an incomplete understanding of the linguistic history of northern Europe.

Today, one of the realities of European travel is that different languages are spoken in different countries; however, in Bosch's day, language was a much more powerful indicator of social status and education than it is today. Most of the nobility, including many of Bosch's patrons, had little or no knowledge of vernacular Dutch, which, in the fifteenth century, was considered a dialect of low German. The upper bourgeoisie and aristocracy of the Netherlands spoke French, the language of the court, and the public pageants mounted by town chambers of rhetoric (*rederijker*

53
Hunter Rabbit and Prey, folio 46v, from *Romance of Alexander*, c.1338–44. Bodleian Library, Oxford

54
Haywain triptych (detail of 49, right panel)

kamers) were performed in both Dutch and French. Latin was the language of the Church and the universities, and to be 'literate' meant being trained to read, write and communicate in that language. Most important books appeared first in Latin, or, if the first edition were in another language, a Latin version soon followed. This practice assured authors of the wide dissemination of their work and an international reading audience. Not until after the Reformation, when northern European nationalistic feeling strengthened in response to an oppressive Spanish, Catholic overlord, did the Dutch language become pervasive across class lines. It is no accident that Sebastian Brant's compendium of fools appeared first in a low German Alsatian dialect, though its author was a member of the intellectual élite, for the language of low-lifes and 'fools' was always the vernacular. Likewise, Bosch's *Stone Operation* (see 20), which castigates a broad range of foolish behaviour, is ornamented with a Flemish vernacular saying written in the pompous, calligraphic style of a Latin inscription penned by a professional scribe. Bosch's choice of a 'low' language, dressed up in 'high'-class calligraphy, suggests a veiled criticism of arrogant scholars who think they know more than they really do.

Knowledge of Latin was not limited to the educated élite, however, and was more common among the middle class than we generally assume today. Schoolboys played Latin games, and the ancient tongue was considered a necessary tool for the proper cultivation of vernacular languages. In her important studies of proverb imagery, art historian Margaret Sullivan reminds us that the quaint proverbs and pithy maxims that inspired Dutch painters did not originate in the provinces, but are based on clever sayings of the ancient Romans. Collections of proverbs in several languages appeared in the late fifteenth and sixteenth centuries, such as the *Common Proverbs (Proverbia communia)*, which saw twelve editions between 1480 and 1500. This comprehensive

encyclopedia of proverbs is often cited as an example of the 'Dutchness' of northern European artists who illustrated and interpreted its sayings. However, the *Proverbia* was a bilingual text, published in Dutch/Latin and German/Latin editions, juxtapositions that clearly demonstrate the link between Classical and vernacular traditions. Despite modern trends in scholarship that see Bosch as a provincial artist, the fact is that he was probably much like Erasmus, whose sarcastic treatises on folly and proverbs were written in Latin. Both appear in their works as thinkers whose intellectual imagery masqueraded as conventional wisdom. Proverbs were undoubtedly important to Bosch, as they were to Erasmus. However, Bosch's interest in proverbs, which is most clearly manifested in the *Haywain* triptych, was closely connected to the Classical foundations of Renaissance humanist learning.

Bosch's *Haywain* triptych illustrates a universal belief, understood by the ancient Romans and maintained by Christian humanists and moralists: the path of life is hard, and the virtuous road made even harder by the temptation of material riches. The relationship between the triptych's exterior and interior scenes appears to chronicle the difference between a guiltless life of self-denial and a frenzied existence devoted to meaningless strife. The lighter the burden of the material world, the easier the journey through life. The message applies as much to the lonely pilgrim on the exterior of the triptych as to the chaotic multitude on the interior.

Today it is difficult to conceive of a world in which Church and State were inextricably linked, and in which most people viewed good citizenship as synonymous with Christian morality. However, Bosch lived in such a world, and, for this reason, we cannot divide his paintings into two groups, the 'sacred', which illustrate Biblical subject matter, and the 'secular', which do not. All of Bosch's works deal in some

way with the subjects of sin, folly, punishment and/or redemption, which gives all of them a religious dimension. Bosch's view of the human race as hopelessly corrupt and blithely yielding to the seductive pleasures of the material world had always been integral to Christian philosophy. However, the dawn of the modern era brought social and moral criticism to the forefront even more urgently than before, and popular writers of the day echoed Bosch in their attitude towards moral irresponsibility.

The desire to obtain salvation through the intimate and
immediate experience of Christ's life and death was one
of the most significant aspects of Christian piety during
Bosch's time. As a result, new subjects appeared in art and
literature, which were intensely emotional and dramatic in
their representations of the sufferings of Christ. Art historian
James Marrow has shown how this intense popular interest
in the descriptive details of Christ's suffering resulted in
illustrated commentaries on Biblical tellings of the Passion.
These 'Passion tracts', which began to emerge as early as
the thirteenth century, took as their point of departure
descriptions of Christ's Passion in the Gospels, but also
contained extensive interpolations of extra-Gospel narration,
characterized by nearly hysterical peaks of pain and pathos.
Brimming with vivid detail and clothed not in ancient guise,
but in contemporary attitudes and customs, these accounts
spare nothing in their portrayal of Christ's misery and
humiliation under torture.

55
*Mocking
of Christ*,
c.1470 or
later.
Panel;
75 × 61 cm,
29½ × 24 in.
Städelsches
Kunstinstitut,
Frankfurt

Passion tracts were produced in all vernacular languages,
and Netherlandish examples of the fifteenth and sixteenth
centuries would have been familiar to Bosch and his audience.
Their emphasis on the Saviour as the ultimate martyr, and
imitation of his life in all of its aspects as one means of gaining
eternal salvation, was in keeping with the fundamental tenets
of the Modern Devotion, especially its stress on the personal
relationship between Christ and each individual. However,
cultivation of the virtues of patience and resignation in the
face of human brutality was especially painful and difficult.
Bosch reflects the fevered pitch of the Passion tracts in several
single panels illustrating Christ's suffering and humility.

Significantly, the Brotherhood of Our Lady, to which Bosch belonged, chose the lily among thorns as its emblem, an image taken from the Song of Solomon 2:2. It was commonly understood as a typological reference – that is, an Old Testament image that foreshadows or corresponds with a counterpart in the New Testament – in this case the lily among thorns referring to Christ among his persecutors. The Brotherhood's 'lily among thorns' insignia appears on the sleeve of the donor, Peter van Os, in an altarpiece depicting Christ's Passion, which dates *c*.1489 or later, and is believed to belong to Bosch's workshop (see 8, 9). The badge not only marks Van Os as a member of the Brotherhood, but also demonstrates his and his confraternity's devotion to the imitation of Christ. A painting of the *Mocking of Christ* (55), which dates *c*.1470 or later, and which most authorities accept as being by Bosch's hand, emphasizes with brutal clarity the contrast between the wounded Saviour and the mob calling for his death. Modern over-painting was removed in 1983 to reveal the ghostly shapes of the male and female members of the donor family, faintly visible in the lower left and right corners of the panel. The words that they uttered, *Salva nos xpe [Christi] Redemptor* (Save us, Christ the Redeemer), still unfurl in archaic gold letters above the place where the male donors originally knelt. In contrast, the vile mob of persecutors, gathered beneath the parapet upon which the bleeding Christ stands, utter the damning words, *Crucifige eum* (Crucify him). Bosch's vision of the 'lily among thorns' – the pure, serene Christ among tormentors who wield prickly spikes and swords – reflects both his and his confraternity's devotion to the Passion.

Bosch's Passion pictures appear traditional on the surface, and are easily understood as Biblical exhortations, urging people to follow Christ's teachings. Compositionally, they show links with the late medieval German panel-painting tradition (56) and with the works of printmakers such as Martin Schongauer (*c*.1435/50–1491; 57). However, Bosch's scenes invariably magnify the reprehensiveness of the heathens and tormentors.

56
Master of the Karlsruhe Passion, *Arrest of Christ*, *c*.1440. Oil on panel; 68 × 46 cm, 26³⁄₄ × 18¹⁄₈ in. Wallraf-Richartz Museum, Cologne

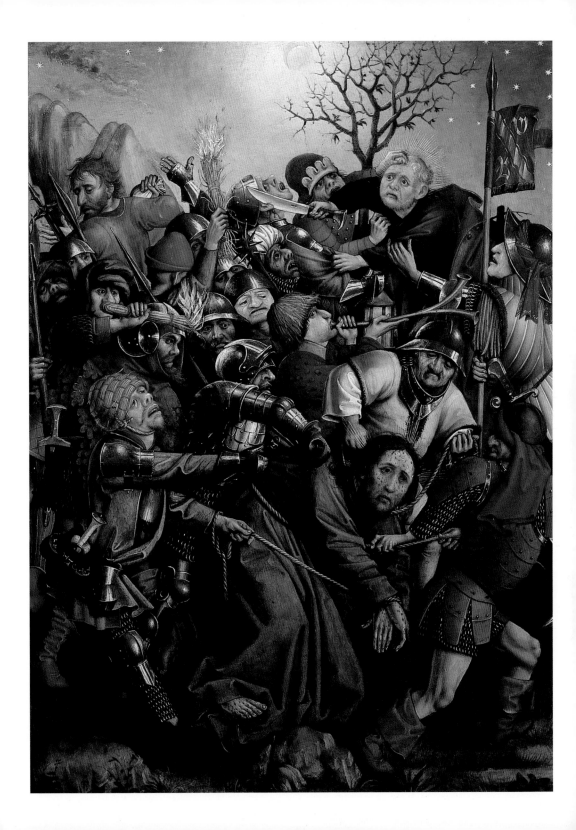

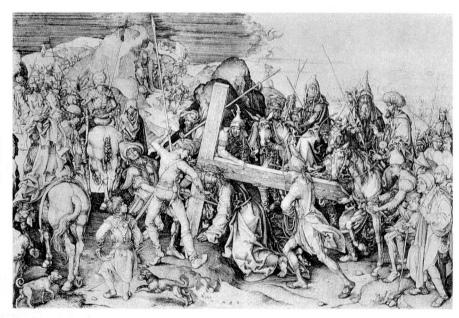

57
Martin
Schongauer,
Christ
Carrying
the Cross,
*c.*1475–80.
Engraving;
28·6 × 41·9 cm,
11¼ × 16⅞ in

58
Christ
Carrying
the Cross,
*c.*1492 or
later.
Oil on panel;
150 × 94 cm,
59 × 37 in.
Patrimonio
Nacional,
Palacio Real,
Madrid

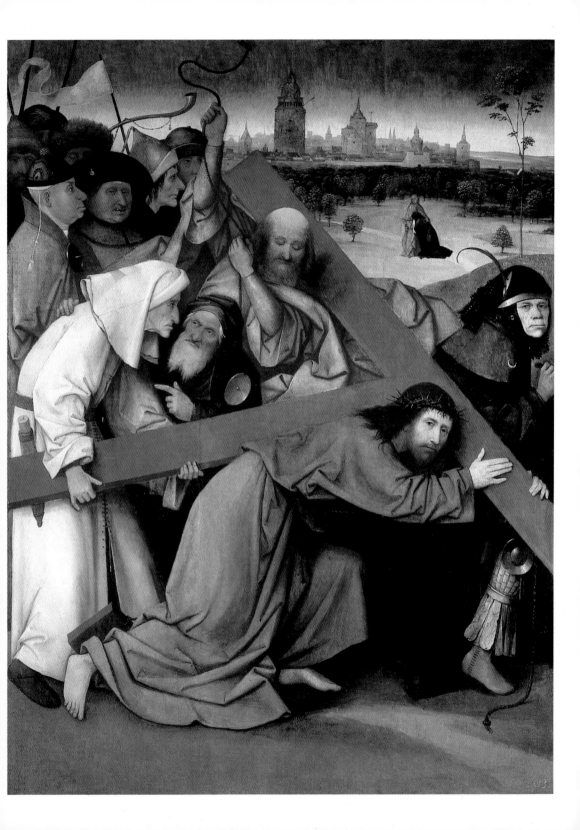

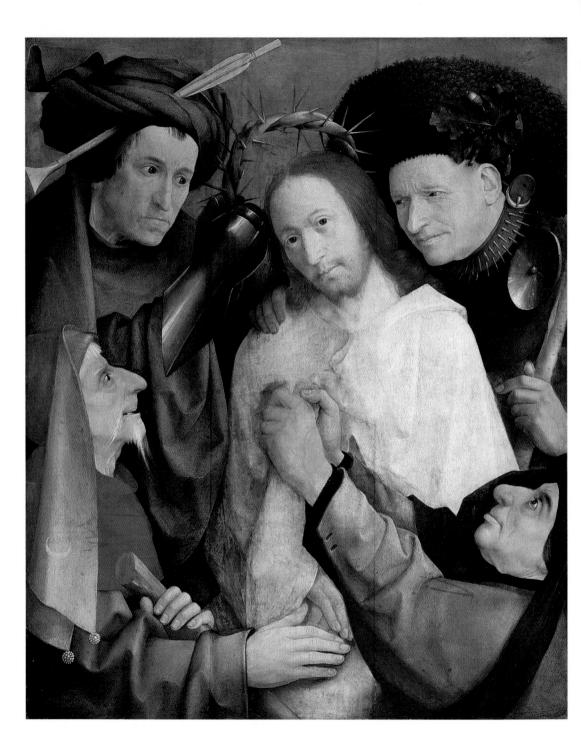

In several, Christ looks outward from the ugly masses, directly engaging the viewer's sympathy. This is most notable in *Christ Carrying the Cross* (58), which dates *c*.1492 or later, and is signed with Bosch's name. Once owned by Philip II, it depicts Jesus trudging along the road to Calvary, surrounded by a crowd of unsavoury characters. One wears the crescent mark of the infidel Turk on his collar, while another sports curious pointed headgear associated with non-Christians. Christ himself has fallen to his knees, and his exposed heel bears the bloody imprint of a spike block, a torture device used in

59
Christ Crowned with Thorns, *c*.1479 or later.
Oil on panel; 73·7 × 58·7 cm, 29 × 23⅛ in.
National Gallery, London

60
Hans Memling, *Deposition of Christ*, *c*.1490.
Oil on panel; 51·4 × 36·2 cm, 20¼ × 14¼ in.
Capella Real, Granada

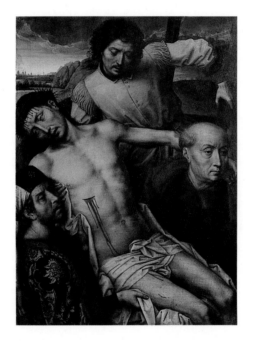

Bosch's day to increase the pain of criminals on their way to execution. A fifteenth-century Passion tract describes the mob as Bosch shows them, 'striking, spitting, mocking and blaspheming'. One tormentor prepares to strike Jesus with a lash or rope, as Simon of Cyrene makes ready to lift the burden of the cross from Christ's shoulders. Simon's action is an immediate call to the charity taught by Jesus. Despite the mob's abuse, Christ looks calmly and meaningfully outward, seemingly exhorting Christians to follow the Way of the Cross:

'If any man will come after me, let him deny himself, and take up his cross, and follow me' (Matthew 16:24).

Bosch intensifies the impact of Christ's suffering in two single-panel Passion scenes (59 and see 63) that depict Jesus and his persecutors close-up in half-length. In these works Bosch exaggerates the vicious, ugly faces that press towards the serene, handsome Christ, while the peaceful expression on Jesus's face suggests that he has withdrawn to a higher sphere, where his enemies cannot reach him. Victorious in the midst of suffering, he is a model for all who choose to follow him. Variety is sacrificed to economy, as the substantial figures of Christ and his tormentors crowd against the picture plane, eliminating any indication of space before or behind. Christ engages the viewer eye-to-eye, as in *Christ Carrying the Cross* (see 58), but his proximity to the picture plane magnifies the psychological bond between Saviour and viewer. The effect is most striking in the London *Christ Crowned with Thorns* (59), where the calm, passive figure of Jesus is surrounded by a quartet of threatening, disagreeable characters, one of whom reaches up with an armoured gauntlet to crown Christ with thorns, while another rends the Saviour's robe with both hands. The work dates from *c.*1479 or later, and its dramatic composition exists in numerous versions and copies made in the sixteenth century (see 209).

The half-length format and close-up view in this painting reflect a type of devotional image that became popular in Italy and northern Europe towards the end of the fifteenth century. Related to the German *andachtsbild* (devotional image) tradition, which emphasized Christ's physical suffering, it was popularized by other northern painters, such as Hugo van der Goes and Hans Memling (*c.*1430/35–94; 60). Bosch involves the viewer even more directly by magnifying the emotional impact of the scene, depicting the sacred moment as a perpetually enduring event, experienced in both past and present time.

The timeless aspect of the London *Christ Crowned with Thorns* recalls the concept of the 'perpetual Passion', the belief that, as the 'Man of Sorrows', Christ's suffering did not end with his death on the cross, but continues and is amplified with every new sin perpetrated by humankind. Bosch's message is much like that of Dürer's image of the suffering Christ in the frontispiece of his *Small Passion* (61). The accompanying text applies to Bosch's Christ as well: 'Oh cause of such sorrows to me; Oh bloody cause of the cross and death; Oh man, is it not enough that I suffered these things once for you? Oh stop crucifying me with your new sins.'

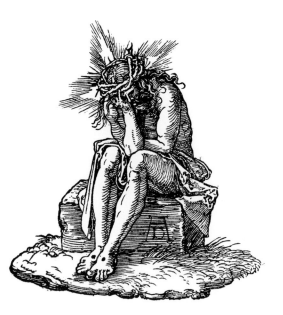

61
**Albrecht
Dürer**,
frontispiece
from the *Small
Passion*,
1509–11.
Woodcut

Like the Christ in the centre of God's cosmic eye in the *Seven Deadly Sins and Four Last Things* (see 14), the Saviour in Bosch's *Christ Crowned with Thorns* gazes knowingly from the centre of iniquity gently to reprimand the human race for its continued sinfulness. Several interpreters have noticed that the four surrounding figures are dressed in contemporary clothing, suggesting that they represent the human race, past and present, which persists in tormenting Jesus. Those familiar with Renaissance scientific traditions see these figures as representing the four temperaments and their

corresponding elements. (See Chapter 3 for a discussion of humoral theory.) The visual grouping of the four temperaments around a central Christ figure was a common scientific conceit. A typical example appears in the fifteenth-century *Guildbook of the Barber Surgeons of York* (62), in which the temperaments are labelled and, as in Bosch's painting, appear in the corners of the page, surrounding the central face of Christ. The image teaches that mortal beings must suffer

62
*Head of Christ
Surrounded
by Figures
Representing
the Four
Temperaments*,
folio 51v,
from the
*Guildbook of
the Barber
Surgeons
of York*,
late fifteenth
century.
British Library,
London

physical and mental imbalances of humours and elements as a result of original sin. But Christ, whose mission on earth was to 'repair the Fall', embodies a perfect balance of all four elements – earth, air, water and fire. He is, in fact, a fifth element, a transforming 'quintessence', embodying the promise of eternal life beyond this flawed, earthly existence.

The distinct attributes of each temperament are not difficult to discern in Bosch's unsavoury quartet. The figure in the

upper left, wearing an armoured gauntlet and an arrow stuck through his turban, is a natural choice for the choleric representative. Ruled by fire and the planet Mars, such people were ruddy of face, as is Bosch's figure, and drawn to violence and soldiering. The old, pale man in the lower left, whose cowl displays the image of a crescent moon, embodies the phlegmatic type. This figure fits physical descriptions of people dominated by the moon's watery realm, who tended to be pale with fine, light hair; the crescent moon on his headdress may associate him simultaneously with the infidel Turk and the lunar realm. The melancholic temperament, controlled by Saturn and earth, appears as the figure in the lower right, whose skin betrays an earthy, ashen tone. Above him, the smiling man who places an offending hand on Christ's shoulder embodies the sanguine temper, associated with the planet Jupiter. Known as the jovial planet, Jupiter ruled mirth and merrymaking, and this tormentor's simpering expression is appropriate for a sanguine face. Some see the oak leaf and acorn stuck in his hat as anti-papal symbols related to the family crest of Pope Julius II della Rovere, and interpret their presence as a subversive attack on the Church. However, humoral theory places the oak tree among the plants and animals belonging to Jupiter, which reinforces a reading of this figure as sanguine. Bosch and his audience were certainly cognizant of humoral theory, for the physical attributes of the four temperaments, first described in the Hippocratic treatise *The Nature of Man* in the fourth century BC, formed the basis of all medical theory until the eighteenth century. By the fifteenth century, knowledge of one's temperament was as important as knowing what one's blood type is today. If Bosch wished to include all the peoples of the earth among the tormentors of Christ, there could be no better way than to illustrate the four physical and personality types that encompass all of humanity.

The vivid faces in Bosch's half-length *Christ Carrying the Cross* in Ghent (63) are much more strongly delineated than in the

London *Christ Crowned with Thorns* (see 59). Almost cartoonish in their expressiveness, they crowd claustrophobically together, pushed to the front of the empty, black space. In fact, the exaggerated treatment of Christ's tormentors in this work is so different from the subtle portrayal in *Christ Crowned with Thorns* that it is difficult to believe that they are by the same hand. Until scientific evidence proves otherwise, however, their profound stylistic differences must be explained as the result of an evolution in style, workshop participation or perhaps especially insensitive over-painting. The condition of the Ghent *Christ Carrying the Cross* is unfortunate; an entire strip of wood at the left side has been lost and the other three edges were sawn off at some point in its history, with the result that the painting has been diminished on all four sides.

Christ, in this panel, is not alone in his serenity, but shares his tranquil space with St Veronica, whose placid face echoes Christ's peaceful expression. Veronica, an apocryphal figure who does not appear in the Bible, was said to have wiped the face of the Saviour with her veil as he struggled beneath the cross, receiving a permanent imprint of the holy face on the cloth. Veronica holds the veil in the painting, displaying the image to the viewer. The calm, beautiful faces of Jesus and Veronica contrast starkly with the horrible visages that press around them. The implication is that serenity and beauty are indicative of holiness, and ugliness synonymous with sinfulness.

The science of reading the face and body for signs of a person's character or personality, known as physiognomy, began with Aristotle. His treatise *Physiognomia* (attributed today to 'Pseudo Aristotle') was printed several times in the early sixteenth century, and provided the template for over two thousand years of physiognomic studies. Vernacular translations of early treatises, such as the fourteenth-century *Knowledge of Mankind by Many Signs* (*Den mensche te bekennen bi vele tekenen*), emphasize the practical application

63
Christ Carrying the Cross, c.1515. Oil on panel; 76·7 × 83·5 cm, 30¼ × 32⅞ in. Museum voor Shone Kunsten, Ghent

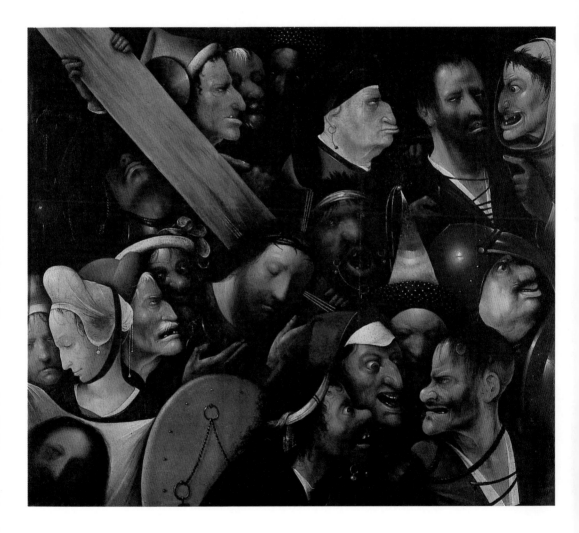

of physiognomic principles, while medical texts, beginning with the Hippocratic treatises, present physiognomy as the basis of diagnosis. Printed editions were available during Bosch's time, including those written by Bartolommeo Cocles and Johannes Indagine, the latter of which was illustrated.

The grotesque enemies of Christ who inhabit Bosch's Passion scenes display facial deformities that physiognomic theorists associated with specific character flaws. Many show missing or gapped teeth, reflecting the belief that teeth 'out of order' were signs of a 'man of no worth who babbles and is arrogant, proud, pompous, inconstant'. Deep-set eyes 'hidden in the

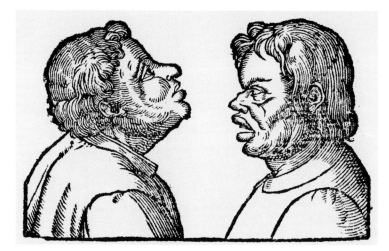

64
Physiognomy of the Mouthe, from Johannes Indagine, *Chiromantia*, London, 1558

head' signified a person full of suspicion, a malicious, cruel liar. Fat cheeks denoted a foolish and rude character, whereas large, bulging eyes and thick lips revealed a lecherous nature (64). A short neck showed one to be foolish and stupid, whereas a long, scrawny neck indicated a predisposition to violence. Noses receive much attention in physiognomic studies, and many of Bosch's tormentors appear in profile so as to highlight this facial feature. They reveal snubbed noses, associated with stupidity, lust, anger and pride, as well as prominent, hooked noses indicative of avarice and malice. In fact, Bosch treats the faces of Christ's tormentors as a veritable encyclopedia of sin.

Correspondence between animal and human characteristics was another important aspect of physiognomic studies. Erasmus echoed Aristotle in associating human traits with animals. For example, he linked brutality and greed with the eagle: 'Anyone who is practised in reading faces, let him have a good look at the very features of the eagle, the greedy, evil eyes, the cruel *rictus* [fixed smile], the grim cheeks, the fierce brows and lastly … the hook nose.' The description of the cruel, predatory bird fits many of the faces surrounding Christ in Bosch's Passion scenes. The Christian recognition of animal correspondences, as Marrow shows, appears in Psalm 21:13–17, in which the psalmist describes his foes surrounding him 'like many dogs'. Psalm 21 was a popular topic of Good Friday sermons, and Biblical commentators commonly interpreted the image of the psalmist menaced by fierce dogs as a typological reference to the Saviour surrounded by enemies during the Passion. The allusion to Christ's tormentors encircling him like a pack of snarling dogs could explain the prominent spiked dog collar that one of Christ's adversaries wears in the London *Christ Crowned with Thorns* (see 59).

If Bosch shows Christ's enemies bearing the marks of inner evil on their outer bodies, then the Saviour himself must appear as a paragon of goodness, his virtue evident in the very fabric of his flesh. If physical deformities betrayed sin and evil, then Christ's body, which was comprised of a perfect balance of all four elements, must reflect an ideal of goodness and beauty. A surprising number of authors, including Erasmus, discuss Christ's appearance, and artistic depictions of the Saviour are remarkably consistent with ancient physiognomic precepts. All agree that Christ looked as Bosch shows him, a man of medium height, with symmetrical, regular features, a fair complexion, thin beard and brownish-auburn hair. These physical characteristics contrast dramatically with the exaggerated imperfections of Bosch's mob, and serve to isolate the rare quality of goodness from the mass of evil that predominates in the world.

The vividness of Bosch's portrayals of Christ's enemies transcends reality. However, his exaggerated contrasting of beauty with ugliness is not unique among Renaissance artists. Dürer employed a similar device in his *Christ Among the Doctors* (65) and the sketches of Leonardo da Vinci (66) show a fascination with grotesque human features. The German late medieval tradition also emphasizes the physical repulsiveness of Christ's enemies (see 56), much as Bosch does in his Passion scenes. Scholars have suggested mutual influence and even personal meetings between Bosch, Dürer and Leonardo. However, the Renaissance practice of contrasting the beauty of Christ with the hideousness of his persecutors need not have resulted from direct contact with any single artist. Bosch was inspired as much by contemporary wisdom as by visual example.

Today, we accept the fact that a misshapen body does not necessarily house an unattractive spirit, but this was not the case in Bosch's time. The early modern era inherited the ancient Platonic belief in the absolute affinity of virtue with beauty and ugliness with sin. In the course of everyday life, knowledge of the tenets of physiognomy was considered essential in choosing virtuous friends and determining the honesty of tradesmen. Humanist scholars were especially fascinated with the science of physiognomy because it combined Christian moralistic concerns with ancient scientific precepts. Erasmus is an appropriate source from which to extrapolate physiognomic references in Bosch, for he was not only a scholar and moral critic, but also the painter's younger contemporary and countryman. Throughout his writings, Erasmus repeatedly refers to the face as the image of the soul. The *Adages* (1500), for example, includes among its proverbs *Ex fronte perspicere* (To read from the face), and the 1525 treatise *On Language* (*De lingua*) relies heavily on physical appearance and body language as vehicles of non-verbal communication. Erasmus could have been speaking of Bosch when he praised the ancient Greek artists who 'made it

65
Albrecht Dürer,
Christ Among the Doctors,
1506.
Oil on panel;
65 × 80 cm,
25⅝ × 31½ in.
Thyssen-Bornemisza Collection, Lugano

66
Leonardo da Vinci,
Drawing of Grotesque Heads,
c.1494.
Pen and ink on paper;
26 × 20·5 cm,
10¼ × 8 in.
Royal Collection

possible for the physiognomist to read off the character, habits and life-span from a painted image'.

The association of ugliness or deformity with sin and beauty with goodness is still present in the collective consciousness. Not until the mid-twentieth century did the American Federal Bureau of Investigation end its search for a 'criminal type', distinguished by a specific shape of cranium, nose, mouth, etc. The conceit is perpetuated by modern film-makers, who cast strong, handsome actors as romantic leads, and assign villainous roles to unattractive actors with physical flaws. Oscar Wilde's fictional Dorian Gray escaped the physical

consequences of moral evil only because his portrait reflected, in all its hideous ugliness, the imprint of his debauched existence. Though physiognomic imagery has outlived the scientific precepts upon which it was based, the power of Bosch's depictions continues to communicate, in a visceral way, to modern audiences.

While Bosch's Passion scenes emphasize the persecution and suffering of Christ the man, another group of paintings connects the humanity and martyrdom of Christ to his infancy and early childhood. Hugo van der Goes, for example, chose to show the infant Jesus at his birth, naked on the cold ground

before his sorrowing mother, accompanied by allusions to the Eucharistic bread and wine in the sheaf of wheat and wine container set out before him (67). In the case of a panel depicting *Christ Carrying the Cross* in Vienna (68), it appears that Bosch devised yet another way to link the vulnerability of childhood with the Biblical concepts of the Incarnation and the Passion. On one side of the panel (which has not yet been subjected to dendrochronological dating) Christ is shown carrying the cross, surrounded by the usual throng of mockers and tormentors and accompanied by the good and bad thieves

67
Hugo van der Goes,
The Nativity,
central panel
of the *Portinari
Altarpiece*,
before 1483.
Oil on panel;
253 × 304 cm,
99⅝ × 119¾ in.
Galleria
degli Uffizi,
Florence

68
*Christ Carrying
the Cross*,
c.1500.
Oil on panel;
57 × 32 cm,
22½ × 12⅝ in.
Kunst-
historisches
Museum,
Vienna

who were crucified with him. On the reverse is a scene that has puzzled scholars since 1923, when the brown paint that covered it was removed and the image revealed (69). Within a black circle on a red background is the figure of a naked male child who pushes a three-legged walker before him with one hand, while holding a paper whirligig in the other. Who is this child, and why was he depicted here?

Most writers recognize a connection between the child on one side of the panel and the Passion scene on the other. Some

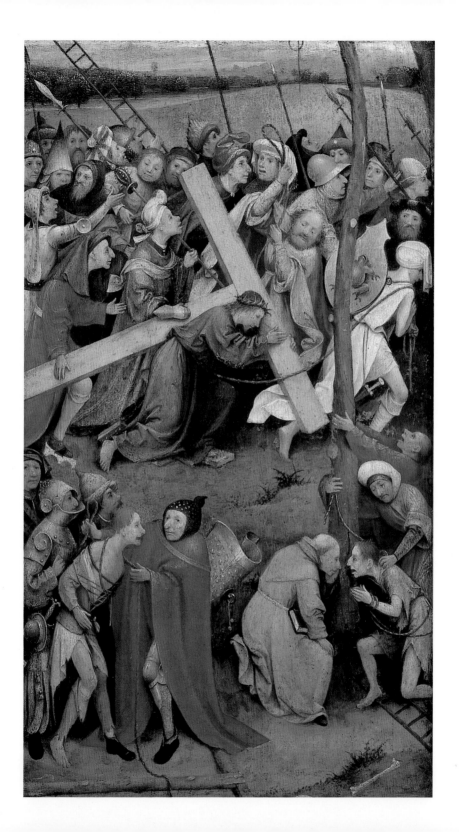

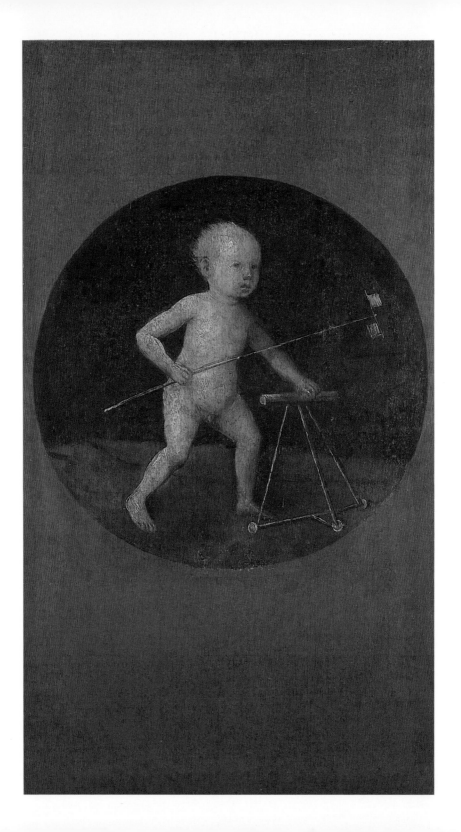

interpret the figure as a symbol of the folly of those who fail to recognize the meaning of Christ's suffering and live accordingly. The whirligig would then signify foolishness, as it does in Bosch's *Conjurer* (see 25) and in other pictures of the same time that satirize loose living. For others, Bosch's little boy is the infant Christ himself, taking his first halting steps on the path through life – whose prophesied end is depicted on the reverse. Following this line of thinking, Walter S Gibson offers the most convincing interpretations of the child's walker and the whirligig, which he sees as related symbolically to the Passion of Christ.

The walking frame that Bosch's boy child pushes must have been a common fixture in every household with toddlers, as similar contraptions are today. By Bosch's time, its look had remained virtually unchanged for over a thousand years, for it appears in Roman funerary art commemorating deceased children. The Latin term for the implement is *sustentacula*, and its three-legged construction on wheels is a practical and ingenious means of steadying the perilous wobble of a child's first steps. Christian tradition is full of images of the Christ child steadying himself with the help of such a walking frame. A charming miniature of the Holy Family in the *Book of Hours of Catherine of Cleves* (see 10) shows the infant Christ ensconced in a *sustentacula*, kept safely out of mischief so that his parents can work around the house. Likewise, in an anonymous mid-fifteenth-century German woodcut (70), St Dorothy receives flowers and fruit from the Christ child, who reaches one hand bravely up from his 'three-wheeler'. Artistic tradition, then, supports an identification of the child in Bosch's panel as the young Christ, forced to endure the indignity of a toddler's first halting steps in his new role as the Son of Man.

In the dual contexts of the Incarnation and Passion, the child's whirligig serves not as a pejorative sign of folly, but as another symbol of the Passion. A clue to the iconographic meaning of the toy can be found in the connotations that windmills had for

Bosch and his audience. Like the paper whirligig, the arms of the real mills that punctuate the northern European landscape are turned by wind, or water. Their main function was to grind grain into flour by means of the action of heavy stones moving against one another. The parallels to the Passion of Christ are undeniable. The grain that forms the Eucharistic bread, the 'body of Christ', must be ground and pulverized just as Christ's body was tortured and beaten during his sufferings. The simile continues in modern times, for the saying 'to go through the mill' describes an especially punishing experience.

70
St Dorothy with the Christ Child, c.1440–60. Woodcut; 26·9 × 19 cm, 10⅝ × 7½ in. National Gallery of Art, Washington, DC

Mills were widely employed as Eucharistic symbols in the art and sermons of Bosch's time, and it is difficult to find a Netherlandish Passion scene that does not include a windmill silhouetted against the horizon. This apt simile was inspired by the words of Christ, who described himself as 'the living bread, which came down from heaven ... and the bread that I will give, is my flesh, for the life of the world' (John 6:51–2). Deguilleville's *Pilgrimage of the Life of Man* expands the link between mill and Passion, inspired perhaps by the resemblance of the windmill's sails to the arms of the cross.

Christ is described as the heavenly grain, tortured by being reaped, threshed and ground in the mill. Bosch's image, then, aptly pictures the young Christ, who, sustained by his walking frame and diverted by his whirligig, steps forth in full recognition of his fate. The image is a powerful reminder of Christ's sacrifice, and the Holy Child, sustained by a *sustentacula*, is a potent Incarnation motif that prepares viewers for the scene on the other side of the panel, devoted to the all-too-human suffering of Christ. Bosch reminds his viewers of the power of redemption, while also exhorting them to imitate the Saviour in every aspect of their daily lives.

Whereas Bosch's paintings of the sufferings of Christ the man are conspicuous in their evocations of pain and pathos, his infancy scenes cloak the same message in the sweet rosy glow of childhood. These paintings were also intended as reminders of the Incarnation, for the medieval Church believed that the sufferings of the Saviour began long before his Passion. Several commentaries and apocryphal texts treat the hardships and afflictions endured by Jesus during his childhood and youth as precursors of his eventual martyrdom. One such treatise, a work on the origin of the rosary attributed to Alanus de Rupus, quotes the Christ child as saying, 'From the first hour of my conception unto my death, I bore continually this pain in my heart, which for thy sake was so great … all other children have never suffered that which I suffer for thee.'

Two single panels devoted to Christ's infancy, formerly attributed to followers of Bosch, can now be accepted into his *oeuvre* and/or that of his workshop. They are the charming *Adoration of the Magi* in the Metropolitan Museum, New York (71), and another painting of the same subject in the Philadelphia Museum of Art (72). Scholars have been divided in their opinions of these works, some citing the charming *naïveté* of the scenes as evidence of Bosch's early style, and others pointing to the artless composition, awkward

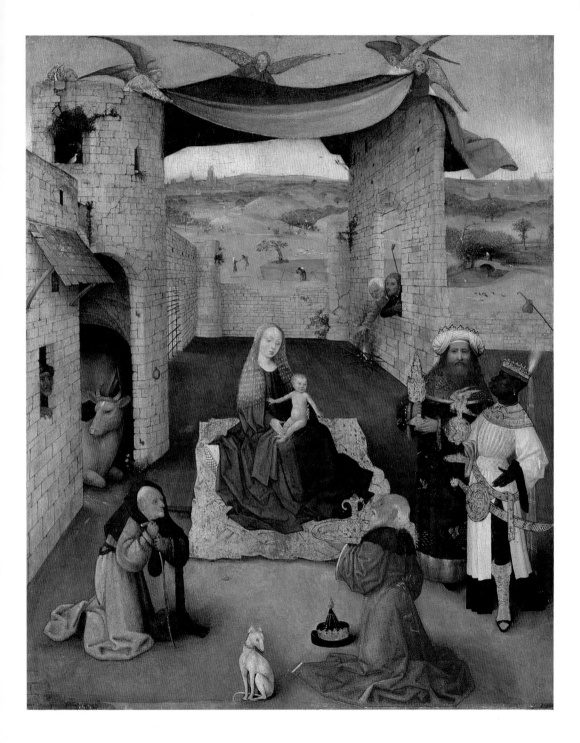

perspective and pastiche-like qualities as evidence of a less accomplished hand or a later, archaistic trend in Dutch art. In fact, the New York *Adoration* dates *c.*1468 or later, and the Philadelphia painting *c.*1493 or later, both within Bosch's lifetime.

The Philadelphia *Adoration of the Magi* displays especially interesting iconography, juxtaposing the infant Christ with a table signifying the sacrificial altar. The resulting association

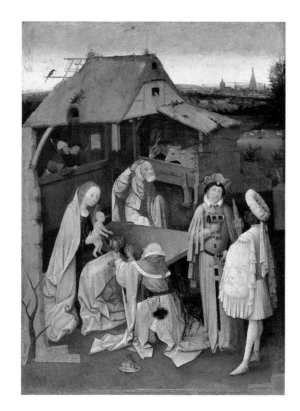

71
Adoration of the Magi,
*c.*1468 or later.
Oil and gold on panel;
71·1 × 56·5 cm,
28 × 22¼ in.
Metropolitan
Museum of
Art, New York

72
Adoration of the Magi,
*c.*1493 or later.
Oil on panel;
77·5 × 55·9 cm,
30½ × 22 in.
Philadelphia
Museum of Art

of Christ's infancy with his Passion parallels the juxtaposition of the Christ child and walker with the carrying of the cross in the Vienna panel (see 68, 69), and suggests an artist of intellect and originality, if not Bosch himself. The New York *Adoration* has suffered by comparison with a twin *Adoration* in Rotterdam. Because of its location in the Netherlands, the Rotterdam panel has usually been considered the model after which the New York panel was copied. However,

dendrochronological evidence turns this assumption on its head, for it now appears that the Rotterdam *Adoration* could not have been painted before 1536, whereas the New York version may have been finished as early as 1468. The latter work is enlivened by uncharacteristic, archaic touches of gold leaf, which only add to its winsome delicacy. It may be a youthful painting by Bosch or a product of the family workshop, but historians who accept it back into the fold must reconcile its anomalies with what is known of Bosch's painterly style.

Though Bosch's Passion and infancy scenes are very different in tone, they communicate similar messages. Both point to the humanity of Christ; at his birth, becoming human and taking on all the inconveniences that come with the role; and at his death, enduring the unspeakable pain and humiliation of martyrdom. When considered together, these paintings reflect a belief in the value of the imitation of Christ, from the first inklings of sorrow at his birth to the suffering and grief engendered by his death. Christ is human in these paintings, both child and man, and every viewer is urged to emulate the patience and forbearance of his exemplary life. This theme is repeated and expanded in Bosch's paintings of the saints, who serve as intercessors between the viewer and God.

5

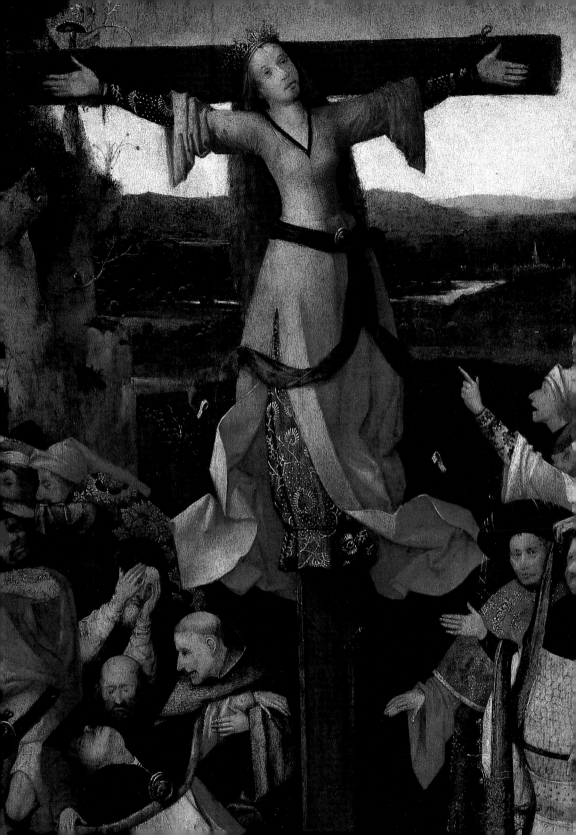

For Bosch, the suffering of Christ was echoed in the
martyrdom of the saints. For the most part, Bosch painted
holy figures who lived in isolation and deprivation; he was
not concerned with the miraculous phenomena and victorious
triumphs over evil that permeate devotional literature of the
time. Even the morbid martyrdoms of suffering virgins that
so fascinated medieval audiences are nearly absent from
his repertoire. An exception is the so-called *Crucified Martyr*
triptych (74), which illustrates a most curious event, the
crucifixion of a fully-clothed female saint. This triptych
bears Bosch's signature, and dates *c.*1491 or later, well within
his lifetime. Most art historians accept it as having once
belonged to the collection of Cardinal Domenico Grimani,
an intellectual and important collector of art and antiquities
who belonged to an eminent family of Venetian doges. The
triptych is one of a group of works by Bosch commissioned or
purchased by Grimani, which also included the *Hermit Saints*
triptych (see 84) and four panels devoted to visions of the
Afterlife (see 204–207). These works eventually became the
property of the Venetian Republic, and can still be seen in
the Doge's Palace.

73
*Crucified
Martyr*
(detail of 74,
centre panel)

The *Crucified Martyr* triptych is in poor condition and has been
over-painted. The interior wings retain the ghostly traces of
two male donors, one on each side, that were painted over,
perhaps by Bosch himself or by an art dealer wishing to make
an easier sale by removing references to specific owners.
The current configuration consists of St Anthony on the left
wing and two unidentified figures on the right. No convincing
explanation has yet been offered for Anthony's relationship to
the central crucifixion scene in this triptych. The exteriors of
the wings are not painted, though they once may have been.

Considering the problematic history of the triptych, the exterior scenes may have been removed or destroyed in a fire that damaged the rest of the altarpiece. It is also possible, though not probable, that they may never have been painted, and that the triptych was only intended to be displayed open, with its back against a wall.

The central crucified female figure (73) has traditionally been identified as St Julia, but this has been challenged by some scholars. In 1960 Dirk Bax suggested a change in identification to St Wilgeforte, also known by the names Uncumber and Liberata. In a vigorous attempt to confine Bosch's circle of influences to Dutch vernacular culture, Bax noted that Wilgeforte was a popular Netherlandish saint, and therefore the most logical choice. Furthermore, an altar to her existed in the Church of St Jan in 's-Hertogenbosch. The legend of Wilgeforte describes her as the noble daughter of the King of Portugal, betrothed against her will to the King of Sicily. Wilgeforte, however, had vowed perpetual virginity as a bride of Christ, and prayed to God for deliverance from a fate worse than death. At this point, the legend departs from Bosch's depiction, for God honoured the chaste virgin's request by causing a beard to grow on her girlish face. She became so unattractive, and therefore unfit for marriage, that her furious father ordered that she be crucified. Bosch's saint, however, lacks the single attribute that would identify her as St Wilgeforte, for close inspection of the panel fails to turn up a single ugly hair on her lovely face.

Art historian Leonard Slatkes suggests a return to the traditional identification of Bosch's figure as Julia. The legend of this saint describes her as the Christian slave of the Syrian merchant Eusebius. When she refused to join in the worship of idols, she was crucified and her body returned to Brescia, where her relics remain today. The problem with this identification is that Julia's cult was virtually unknown in northern Europe, though it was strong in Corsica and, of

74
Crucified Martyr,
c.1491 or later.
Oil on panel; centre panel 104 × 63 cm, 41 × 24¾ in, side panels 104 × 28 cm, 41 × 11 in. Palazzo Ducale, Venice

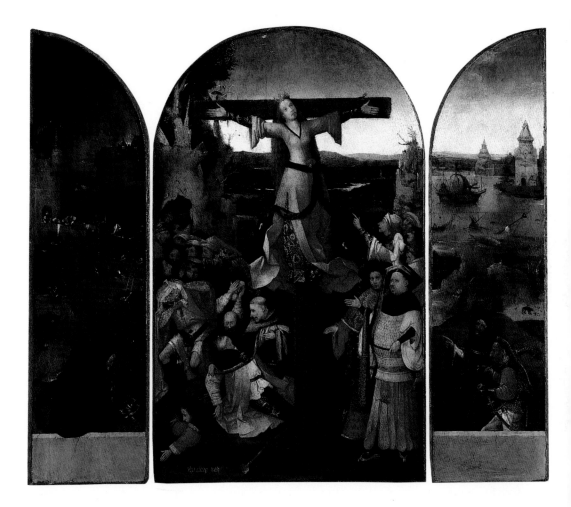

course, Brescia. Slatkes posits a visit to Italy by Bosch in the late 1490s and notes elements of Italian dress among the people who surround the martyr's cross. However, the strong Italian presence in 's-Hertogenbosch in the fifteenth century would have made such a journey unnecessary. It is equally possible that Grimani or one of the many foreign merchants who lived and worked in Bosch's home town, a noted commercial trading centre, could have commissioned a work in honour of a favourite Italian saint. Other possibilities also exist as several crucified females populate the legends of the saints, among them Febonia, Blandina, Eulalia, Benedicta and Tarbula. The only sure thing about Bosch's suffering saint is that, whoever she is, she imitates Christ in her martyrdom, serving as a model of faith and forbearance.

75
St Christopher,
c.1490 or
later.
Oil on panel;
113 × 71·5 cm,
44½ × 28⅛ in.
Boijmans Van
Beuningen
Museum,
Rotterdam

Unlike Bosch's enigmatic crucified female saint, the subject of his *St Christopher* panel (75), signed by the painter, is easily identified. Laboratory examination of this painting reveals that its arched top is original, and dendrochronological analysis dates it to *c.*1490 or later. Jacobus de Voragine's *Golden Legend*, the standard handbook of saints' stories from the fourteenth century on, recounts the legend of the confused giant Reprobus (later Christopher), who spent his days seeking the most powerful man in the world. He first served a king who feared the devil, then encountered the devil himself, who feared Christ. On the advice of a hermit whom he met by the banks of a hazardous river, Reprobus began to carry travellers across on his back in an effort to prove his worth. One evening a small child came to him, asking to be helped across. As the giant began his journey, his burden became more and more heavy, until the boy explained to Reprobus that he was, in fact, carrying the weight of the world on his shoulders. Revealing himself to be the Saviour, the child caused the saint's staff to burst into bloom as proof of his claim. The helpful giant was converted straightaway and changed his name to Christopher, which means 'he who carries Christ'. The saint's conversion is suggested by the fish, one of the earliest Christian symbols,

that hangs from his staff. Next to the fish on the picture plane, but meant to be perceived as behind it, is the lone hermit who directed Christopher in his quest. The saint's staff already begins its transformation into a blooming tree, as the giant struggles under his sacred burden.

St Christopher was popular throughout Europe in the fifteenth century; the Church of St Jan in 's-Hertogenbosch held a shrine to him, though there is no evidence linking Bosch's panel to it. In general, Bosch's *St Christopher* follows traditional

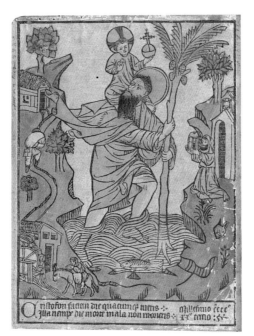

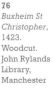

76
Buxheim St Christopher, 1423. Woodcut. John Rylands Library, Manchester

depictions of the saint, as reflected in popular prints of the day (76). However, true to form, Bosch also includes several enigmatic elements that have no place in traditional accounts of Christopher's life. What is the meaning of the burning city in the upper left background? Does it represent the realm of the devil or that of the king who feared him? Why did Bosch include, in the mid-left background, the bizarre vignette of a hunter using a rope to hoist a bear, already dead of an arrow wound, on to a tree? Does this allude to an element

of Christopher's story found in a German account, in which the
saint assisted a group of hunters, or does it suggest a guild of
archers as the patron of the work? And why does the hermit's
tree-house abode take the form of a giant wine jug surmounted
by a bird house and a bee hive? Does the huge jug suggest
material pleasures abandoned in pursuit of an ascetic life,
or does it represent the pleasures of the flesh that tempt all
travellers who ford the treacherous waters of life? Perhaps we
must, for now, be content with the reasonable assumption that
Bosch's *St Christopher*, like the many tellings of his story,
generally reinforces the value of serving Christ, though the
way may be hard and fraught with peril.

Chief among Bosch's saintly subjects distinguished by lives of
ascetic self-denial and isolation are St John the Baptist, St John
the Evangelist, St Jerome and St Anthony. Works accepted as
being by Bosch's hand are a single panel of *St John the Baptist*
in Madrid (77), a *St John the Evangelist* in Berlin (78), a triptych
depicting the hermit saints Anthony, Jerome and Giles in
Venice (see 84), a single panel of *St Jerome at Prayer* in Ghent
(see 88) and a spectacular *St Anthony* triptych in Lisbon (see
90–92), all of which are discussed here with the exception of the
St Anthony triptych, which is analysed in Chapter 6. Paragons
of self-discipline, tested by God and granted the gift of
prophecy, these saints, whom Bosch and his patrons favoured
above all others, reflect the Modern Devotion's concern with
the relinquishing of material things and renunciation of the
world. Bosch's holy hermits are also in keeping with a revival
of interest in the rich life of the inner spirit, demonstrated in
popular theology and humanist thought.

Bosch's two single panels devoted to St John the Baptist (77)
and St John the Evangelist (78) date *c.*1474 or later and *c.*1489
or later respectively. Nonetheless, scholars have suggested
over the years that they may have formed a pair, which is not
beyond the realm of possibility, considering the workshop
practice of using panels of different ages in the same work.

Dutch art historian Jos Koldeweij believes that the panels once served as painted wings for an altarpiece documented as having been commissioned by the Brotherhood of Our Lady in 1477. The polyptych also included two sculpted depictions of the same saints (79) by Adriaen van Wesel (*c.*1417–*c.*1489), which are still held by the confraternity in 's-Hertogenbosch.

The Evangelist panel is painted on both sides, indicating that it most certainly belonged to an altarpiece; the Baptist panel may once have been painted on its reverse and the image removed by sawing through, as happened to the Rotterdam

77
St John the Baptist,
*c.*1474
or later.
Oil on panel;
48·5 × 40 cm,
19⅛ × 15¾ in.
Museo Lázaro
Galdiano,
Madrid

78
St John the Evangelist on Patmos,
*c.*1489 or later.
Oil on panel;
63 × 43·3 cm,
24¾ × 17 in.
Gemäldegalerie,
Staatliche
Museen,
Berlin

79
Adriaen van Wesel,
Sculpted wings of the
Altarpiece of the Brotherhood of Our Lady,
1476–7.
Wood;
48·3 × 34·5
× 17 cm,
19 × 13⅝ × 6¾ in.
Illustre Lieve-Vrouwe
Broederschap,
's-Hertogenbosch

Wayfarer (see 27). Both panels are close in width and style, though the Evangelist is longer by some 12.7 cm (5 inches) – the Baptist panel having been severely cut down. Infrared reflectography shows that the panel depicting John the Baptist has been over-painted – beneath the fantastic thistle-like plant with globular fruit that coils sinuously upward to the left of the Baptist, the original donor once kneeled, facing right. His pose would have countered the leftward direction of the Evangelist's pose in the panel that probably faced it. As in the *Crucified Martyr* triptych (see 74), in which the images of the original donors were also obliterated, the over-painting may have been

intended to make the work more saleable by removing specific references to an individual owner.

Bosch's images of the two St Johns make a logical coupling, for their pairing was a common late Gothic conceit, and the two were important in the devotional practices of Bosch's confraternity and the Church of St Jan. A well-known example from Bosch's time is Hans Memling's *Mystic Marriage of St Catherine* (1479) in Bruges (80). The interior wings of this triptych depict scenes from the lives of the two saints, flanking a central panel in which they join Saint Catherine and Saint Barbara in adoring the Virgin and Child. Memling chose the

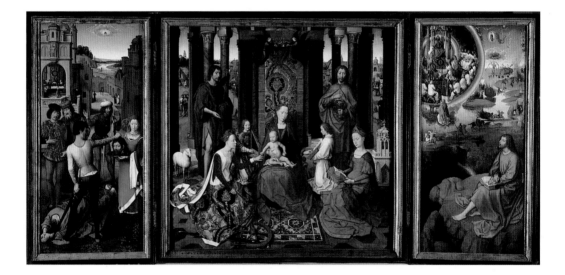

most well-known events from each saint's legend for the interior wings: the Baptist's gruesome beheading, and the Evangelist's exile on Patmos. Viewers would have understood the juxtaposition as examples of two sanctioned ways of serving God, the active life (*vita activa*) and contemplative life (*vita contemplativa*). The Baptist's fearless confrontation of secular authority made him a model for Christians seeking to serve the Church while actively living in the public sphere, whereas the Evangelist's devout retirement from the world offered an example for those seeking to serve the Church from within. Bosch's St Johns, however, belong to another

tradition, for both are depicted alone and withdrawn from the turmoil of the secular world.

Bosch's *St John the Baptist* may have been influenced by Geertgen tot Sint Jans's painting of the same subject, dated *c.*1490 (see 11). Both artists eschew the Baptist's dramatic execution, depicted with macabre exuberance by Memling and others. Instead, the Baptist appears as a hermit, meditating not in the arid deserts of the Holy Land, where he retired to find peace, but in a lush, verdant northern European forest, far from urban woes. Bosch's holy man points to a small white lamb in the lower right corner of the panel. His gesture is crucial in the context of the Baptist's role as the last prophet to preach the coming of Christ. The lamb is Christ, the 'lamb of God', whose imminent coming John the Baptist foretold.

Bosch's Baptist takes the attitude of a melancholic, resting head on hand against the grassy knoll before him. This pose was part of the stock repertoire of physiognomic body language long before Dürer's popular engraving *Melencolia I* of 1514 (81). We have seen that Bosch employed the iconography of Saturn and melancholy in the Rotterdam *Wayfarer* (see 27) to underscore the subject's poverty and misanthropy. However, humanist culture brought another view into play. By immersing the holy hermits in a Saturnine environment, Bosch represents melancholia as the privileged domain of prophecy and genius, an attitude that was at the cutting edge of humanist culture. With the Renaissance came a revival of the concept of the scholarly melancholic genius, which came under renewed investigation by philosophers and medical theorists. Their primary source was Aristotle, who linked the personality quirks and physical complaints of melancholics to creative geniuses and visionary prophets. Aristotle reasoned that great intellectual effort produced a combustion of humours within the body, a 'fire of inspiration', which was followed by an inevitably dark and smoky aftermath. The resulting fetid vapours ascended from the

80
Hans Memling,
The Mystic Marriage of St Catherine triptych,
1479.
Oil on panel; centre panel 173·7 × 173·8 cm, 68⅜ × 68½ in, side panels 176·2 × 79 cm, 69⅜ × 31⅛ in.
Hospital of St Jan, Bruges

81
**Albrecht
Dürer,**
Melencolia I,
1514.
Engraving;
24 × 19 cm,
9½ × 7½ in

spleen to the head, and finally to the brain, interfering with normal function. The Florentine physician-priest Marsilio Ficino, in his influential *Three Books on Life* (*De vita triplici*; 1489), which was published in the Netherlands during Bosch's lifetime, revived Aristotle's link of melancholia with genius, and added a veneer of social and intellectual privilege to Saturn's children.

There existed a humanist cult of the intellectual, revolving around the hermit saints, long before Ficino and Dürer adopted the condition as a badge of privilege. The type of melancholia suffered by saintly hermits, called *enthousiasme*, predisposed them to anti-social behaviour and frenzied prophetic vision. This state of mind and body was believed to be instigated by the same sort of inner fire that drove scholars to great heights of intellect. Holy men, whose natural humour was highly flammable, suffered a kind of divine ravishment

while in the throes of humoral conflagrations. Their fantastic visions, born of starvation, desperation and intense religious fervour, seemed to come from God himself. Consequently, by the fifteenth century, hermits and monks shared space with miscreants and earth-workers as progeny of Saturn in the popular 'children of the planets' calendar series (see 43).

The life and legend of St John the Evangelist embodies the distinctive characteristics of hermetic *enthousiasme*. The youngest of the twelve Apostles, John endured much suffering at the hands of the Emperor Domitian. On one occasion, the emperor ordered him to drink wine mixed with poison, which became neutralized and departed in the form of a snake when John took the cup. On another occasion, John was thrown into a cauldron of boiling oil, but emerged miraculously unscathed. The Evangelist certainly suffered enough to serve as an exemplar and imitator of Christ. This aspect of his legend is clarified on the reverse of Bosch's panel (82), where grisaille scenes of Christ's Passion encircle a central roundel of a pelican reviving her young by piercing her breast and allowing her blood to flow over them. Bosch's image of the self-sacrificing pelican is echoed in many manuscript and printed sources, such as Hieronymus Brunswyck's *Book of Distillation*, first published in 1490 (83). The blood of the pelican, like the blood of Christ, brings healing and renewal, and reinforces the metaphorical union of St John the Evangelist with the Saviour.

Bosch depicts the Evangelist in exile on the island of Patmos, where he composed Revelation, the last book of the Bible. The Evangelist's account is a harrowing description of the end of the temporal world, after which Christ returns to receive the blessed into his kingdom. Today it reads like science fiction, describing stars falling from the sky (6:13), hail and fire mingled with blood covering the earth (8:7), 'beasts full of eyes before and behind' (4:6), angels blowing trumpets of doom and the 'four horsemen of the Apocalypse' bringing warfare, plague, famine and death in their wake (6:2–8). Memling's

painting of the Evangelist's vision is a literal illustration of the major events of Revelation, which appear in miniature continuous narrative in the upper part of the panel (see 80). Bosch does not depict the full vision, though the bizarre, bespectacled creature in the lower right may represent the human-faced, winged beasts described in Revelation as wearing 'breastplates of iron' and having 'tails like unto scorpions' (9:8–10). The Evangelist gazes past a blue angel, graced with delicate, moth-like wings, who serves as the saint's intermediary between heaven and earth. Beyond, in the heavens, is a vision of the Virgin Mary, who appears

82
Scenes of the Passion, reverse of *St John the Evangelist on Patmos,* *c.*1489 or later. Oil on panel; 63 × 43·3 cm, 24¾ × 17 in. Gemäldegalerie, Staatliche Museen, Berlin

83
Pelican Reviving her Young, from Hieronymus Brunswyck, *Book of Distillation,* London, 1527

in Revelation as the 'apocalyptic woman clothed with the sun'. The future devastation of the world foretold by the saint is suggested in the background landscape, where several boats burn and sink in an otherwise bucolic rendition of green earth and hazy atmosphere.

Continuing the saga of saintly *enthousiasme* is Bosch's *Hermit Saints* triptych (84), which gives St Jerome the place of honour in the central panel. This work was part of Cardinal Grimani's bequest, and hangs today in the Doge's Palace in Venice. The triptych, which dates *c.*1487 or later, is in poor condition and retains the marks of past damage by fire. In addition, the

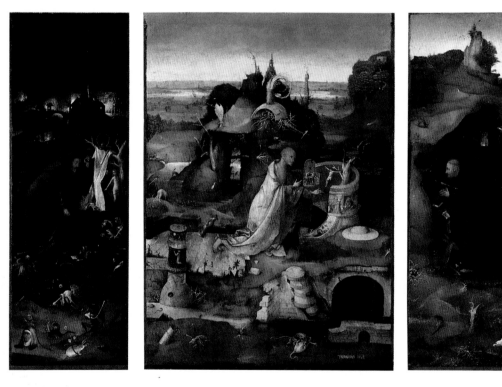

84–85
Hermit Saints
triptych,
*c.*1487 or later.
Oil on panel;
centre panel
86·5 × 60 cm,
34 × 23⅜ in,
side panels
86·5 × 29 cm,
34 × 11⅜ in.
Palazzo Ducale,
Venice
Right
Detail

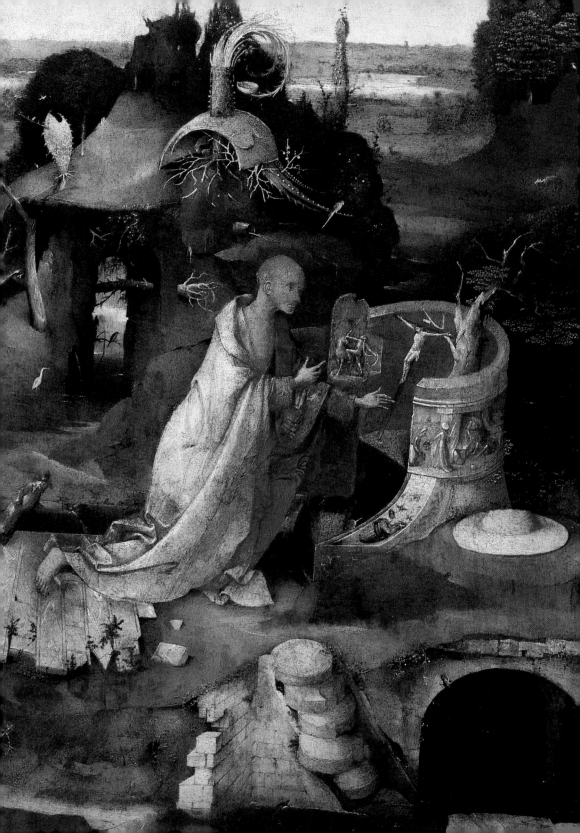

panels are extensively over-painted and further marred by having been cut down. Originally, they were taller, and perhaps rounded at the top like the *St Christopher* (see 75). The three hermits clearly embody the virtues of self-denial, visionary *enthousiasme* and suffering in imitation of Christ. St Anthony, about whom more will be said later, inhabits the left wing, where he endures daily torments by demons. St Giles (Aegidius), a healer and miracle worker, occupies the right wing. His chest is pierced by an arrow, a wound obtained as he attempted to protect a deer, who shares his shelter, from hunters. The sinister environment shared by all three panels emphasizes the hermits' struggles against evil and worldly corruption. As pristine imitators of Christ, they fulfil Thomas à Kempis's ecstatic evocation of the monastic ideal: 'How strict and self-denying was the life of the holy fathers in the desert! How long and grievous the temptations they endured! How valiant the battles fought to overcome their vices!'

Accounts of the life of St Jerome, the central figure, relate that, in his youth, he had been a devoted scholar, but a serious illness caused him to retire to the desert, where he did penance in solitude for several years. Returning to the active world of ancient Rome, Jerome devoted himself to the service of the Church in the form of study, teaching and writing, eventually becoming more famous for his scholarship than for his sanctity. Jerome's greatest contribution to the world is the Latin Vulgate Bible, which he translated from Greek and Hebrew sources. Artists depicted the saint as both scholar and hermit, either alone in the desert surrounded by wild animals, sometimes battering himself with a rock (which, he explained in a letter, he did whenever he was tormented by visions of Roman dancing girls; 86), or as a pensive savant in his study, accompanied by his devoted companion the lion, whose injured paw Jerome nursed in the desert (87). Depictions of Jerome apart from the other Church Fathers (Ambrose, Gregory and Augustine), with whom he formerly customarily appeared, were instigated by the efforts of the Bolognese

86
Albrecht Dürer,
St Jerome in the Wilderness, 1496.
Engraving;
32·4 × 22·8 cm,
12⁵⁄₈ × 8⁷⁄₈ in

87
Albrecht Dürer,
St Jerome in his Cell, 1514.
Engraving;
24·7 × 18·8 cm,
9³⁄₄ × 7³⁄₈ in

humanist Giovanni di Andrea. Giovanni's biography of the saint, *Hieronymianus*, written in 1342, was a formative source for the image of Jerome as a lone intellectual that predominated in the fifteenth century. The vast number of images of the saint produced in the sixteenth century were doubtless inspired by the printing of Giovanni's text in 1511 and, following closely, Erasmus's publication in 1516 of a complete edition of Jerome's writings. This revival was part of an increased interest in Saturnine melancholia, to which, as both hermit and scholar, Jerome was more than usually prone. Dürer portrayed Jerome in paintings and prints at least ten times, and the studious hermit and patron of scholars enjoyed great popularity as a subject for artists in Italy as well. Bosch rode the crest of a veritable tidal wave of interest in Jerome in the waning years of the fifteenth century and early years of the sixteenth.

In the centre panel of Bosch's *Hermit Saints* triptych, Jerome kneels and prays to a crucifix that seems to hover weightlessly within a ruined enclosure (85). Visible on the pagan ruin that serves as Jerome's makeshift altar are images that recall the saint's constant battle to purge himself of lustful thoughts, as described in his own words: 'My face was pale and my frame chilled with fasting; yet my mind was burning with desire and the fires of lust kept bubbling up before me when my flesh was as good as dead.' These images have been identified as: a battle with a unicorn, symbol of chastity; Judith with the head of Holofernes, whose lust for the virtuous widow caused his death; and a man hiding in a basket (perhaps a reference to Virgil), his naked hindquarters exposed, an image linked with lust. Yet, at the same time, Bosch reminds us of Jerome's status in Christian history as one of the four Church Fathers by placing a red, broad-brimmed cardinal's hat on the ground before him, an anachronistic but honorary symbol of esteem. Among the fantastic and natural forms that comprise Jerome's lonely retreat are the 'scorpions and wild beasts' that shared his solitude. Not even the trusty lion consoles him in this place, an omission that emphasizes the

total abrogation of companionship imposed by Jerome's hermit state.

Bosch's *St Jerome at Prayer* in Ghent (88), which dates *c.*1476 or later, explores another aspect of suffering in imitation of Christ. Here, the holy hermit has cast off his splendid red cardinal's hat and robe and thrown himself upon the ground. Eyes closed and clasping a crucifix, Jerome enacts the intense agony of penitence as he himself described it: 'Tears and groans were my everyday portion and if drowsiness chanced to overcome my struggles against it, my bare bones, which hardly held together, clashed against the ground ... Helpless, I cast myself at the feet of Jesus.' The same sinister rock and root forms that lurk in the *Hermit Saints* triptych (see 84) occupy the foreground of this picture. As if to underscore the menace of the hermit's silent world, a broken orb, scored by lines of longitude, floats half submerged in a murky puddle. Topped with thorns reminiscent of the cross that surmounts traditional depictions of the world orb, this bruised and damaged sphere suggests a planet marred by evil. In contrast the background presents a green and peaceful vista.

Jerome's lion is present in the Ghent panel, though he is no bigger than a house cat. The beast's lowered head and timid glance seem to offer an apology to his master that he cannot protect him from guilt and inner torment. Two other animals share the lion's abode – a small owl perched on a dead branch and a sleeping fox, barely visible curled up in the extreme lower left corner of the panel. This owl most likely does not symbolize evil, as it does in Bosch's *Ship of Fools* (see 28), but learning. Like the owl of Minerva/Athena, goddess of wisdom, Jerome's bird is the 'wise old owl', companion of his lonely scholarly pursuits and symbol of his great erudition. The little fox suggests a Biblical passage relevant to Jerome's solitary existence: 'The foxes have holes, and the birds of the air nests; but the son of God hath nowhere to lay his head' (Matthew 8:20–22). This passage, often cited in Passion tracts devoted to

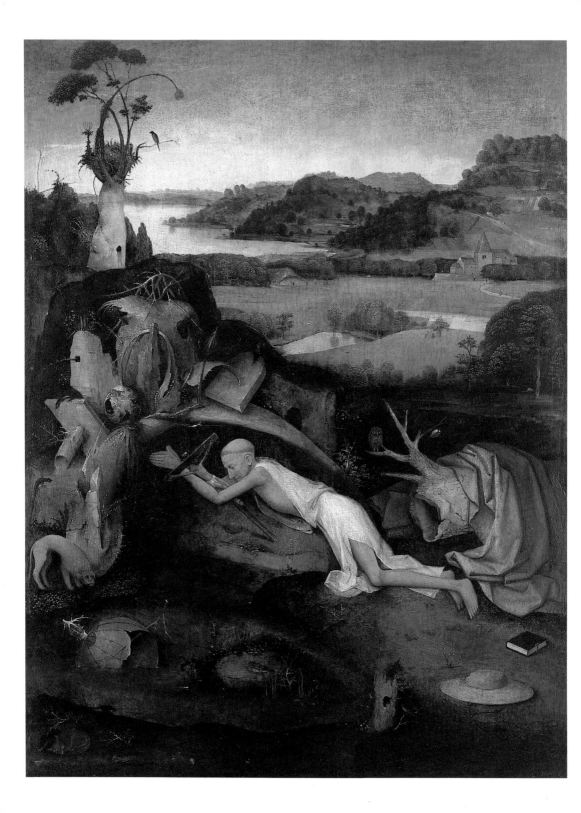

Christ's agonies, was quoted by Jerome himself in describing his desert exile. The fox's presence reminds onlookers of Jerome's Christ-like forbearance and facilitates the viewer's access to God through a saintly intermediary.

Bosch's depiction of Jerome lying prone within a cave is unique in the representation of the saint. Art historian Wendy Ruppel draws a parallel between this unusual feature and a passage from Canticles 2:14: 'In the clefts of the rock ... show me thy face.' Biblical commentators embroidered upon this famous line from the Song of Solomon, interpreting the clefts in the rock as the wounds of Christ in which the faithful find salvation. In fact, Christ is the rock upon which the Church is built, and his wounds the rocky clefts in which redemption lives. Jerome himself wrote that, to follow Christ, one must emulate his Passion and suffer as he did. Bosch therefore shows Jerome literally dwelling within the body of Christ, lying prone in the 'cleft in the rock'. The cave's oval shape and smooth edges resemble the very wounds upon which Jerome meditates, the cuts and slices, administered by whip and lance, suffered by Christ.

Bosch's namesake Jerome (Hieronymus) held special significance for the painter and for the Brethren of the Common Life (Modern Devotion), who called themselves 'Hieronymites'. It is tempting to speculate about the possibility that one or more of Bosch's paintings of Jerome may have been intended originally for one of their chapter houses in 's-Hertogenbosch, as a tribute to the virtues of learning and holiness upheld by this devout and scholarly lay religious order. However, until more information comes to light, this idea must remain in the realm of speculation.

Bosch's paintings of saints reinforce the same religious concepts and moral messages as do his representations of sin and folly and the Passion/infancy of Christ scenes. On the one hand viewers are exhorted to behave in a Christian manner by admonitions such as in the *Seven Deadly Sins and Four*

88
St Jerome at Prayer, c.1476 or later.
Oil on panel; 77 × 59 cm, 30¼ × 23¼ in.
Museum voor Shone Kunsten, Ghent

Last Things (see 14) and *Haywain* triptych (see 49). In these paintings the folly of humankind is paired with scenes of the ultimate punishment that awaits evil-doers. On the other hand, Bosch's saints, like the suffering Christ in his Passion scenes, are paragons of virtue to be emulated and revered. They serve as powerful intermediaries, linking the viewer with the self-effacing virtues they represent. Bosch himself must have been personally devoted to St Jerome, his namesake, and it is this figure's scholarly aspects, reflective of Renaissance humanist concerns, that underlie the discussion of Bosch's paintings in the following chapters.

St Anthony occupies a special place in Bosch's *oeuvre*. In addition to his appearance in the *Hermit Saints* (see 84) and *Crucified Martyr* (see 74) triptychs, Anthony is the subject of a spectacular triptych all his own, signed by Bosch and currently housed in Lisbon's National Museum (90–92). The work dates *c*.1495 or later, and its brilliant technique and unique imagery bespeak extraordinary skill and maturity. Bosch's original patron is unknown; however, the triptych's earliest recorded owner was the Portuguese courtier Damiaan de Goes, who lived in the Netherlands between 1523 and 1544. The work must have been well known, for approximately twenty early copies exist. The three interior scenes feature events from the life of St Anthony, and the two grisaille exterior panels chronicle Christ's journey to Golgotha, encountering human violence and cruelty along the way. Bosch here continues the tradition of counterpoising Christ's humiliation and pain against the travails of the hermit saints. Anthony is a perfect subject for this treatment, for no saint suffered more than he. According to the *Golden Legend*, his very name means 'he who holds higher things and despises the world'.

St Anthony, also known as St Anthony of Egypt, lived probably between 251 and 356 AD, and is the acknowledged father of monasticism. Bosch's triptych depicts the events of his life in abbreviated form. The left panel shows the hermit, senseless after a row with the devil, being carried by friends back to his abode in an abandoned tomb. Monstrous creatures from Bosch's fertile imagination look on, including a red-caped, anthropomorphic demon standing on the cracked ice in the lower right corner. This armless, floppy-eared monster, who wears an inverted funnel on its head and ice-skates on its feet, is one of the most beloved and problematic of Bosch's

89
St Anthony triptych (detail of 90, centre panel)

creations. Impaled on its long beak is a folded piece of paper marked with illegible letters. Some scholars think the letters read 'Bosco', the Spanish spelling of 'Bosch', and serve as the artist's signature; however, the letters themselves and the ultimate significance of the creature remain uncertain.

Satan continues his torments in the centre panel, sending demons and fantastic monsters to beset Anthony, who, by now, is wondering why God has not come to his rescue. When the Lord (barely visible in the dark recesses of the tomb) finally does intervene, Anthony asks him, 'Why didst thou not come to me then, to succour me and heal my wounds?' Christ responds, 'Anthony, I was here, but I waited to see thee fight and now that thou hast fought the good fight, I shall spread thy glory throughout the whole world!' Satan's persecutions do not stop, however, but persist in the right panel, where demons of gluttony and lust continue their torments. With the knowledge that his sufferings were not in vain, St Anthony returned to his demonic battles with renewed strength. His combat with the forces of evil continued throughout his life, which was unmercifully long. He purportedly died in his sleep at the age of one hundred and five.

Anthony is represented in art with the things usually associated with him – the t-shaped 'tau' cross, bell, book, flames and pet pig, which, like Jerome's lion, befriended the saint during his exile. He appears with all these attributes in Hans von Gersdorff's *Feldbuch der Wundartznei*, a medical book geared towards treating battle wounds, first printed in 1517 (93). Anthony's association with fire is linked to his confrontations with the demons of hell, and flames appear in the background of Bosch's centre panel. The triptych, however, focuses typically upon Anthony's torments, familiar to his audience through accounts in the *Golden Legend* and *Lives of the Church Fathers* (*Vitae patrum*), both of which in turn drew on the biography of Anthony by the fourth-century bishop Athanasius. In the fifteenth century these grisly accounts were

90
St Anthony triptych, c.1495 or later. Oil on panel; centre panel 131·5 × 119 cm, $51\frac{3}{4} \times 46\frac{7}{8}$ in, side panels 131·5 × 53 cm, $51\frac{3}{4} \times 20\frac{7}{8}$ in. Museu Nacional de Arte Antiga, Lisbon

greatly expanded and embroidered upon in the manner of Passion tracts of the time. Anthony's stoic endurance of conflict and pain, like Christ's Passion, offers viewers an example of forbearance in the face of life's suffering.

The cult of St Anthony greatly increased in popularity during the fifteenth and sixteenth centuries in Europe, due in part to the resurgence of a dreaded illness, called holy fire (*ignis sacer*), also known as St Anthony's fire. Holy fire was documented only sporadically until the fifteenth century, when a series of famines, combined with peasant poverty, caused the

91–92
Arrest of Christ and *Christ Carrying the Cross*, exterior panels of the *St Anthony* triptych, *c*.1495 or later.
Oil on canvas; each panel 131·5 × 53 cm, 51³⁄₄ × 20⁷⁄₈ in.
Museu Nacional de Arte Antiga, Lisbon

93
St Anthony, from Hans von Gersdorff, *Feldbuch der Wundartznei*, Strasburg, 1540

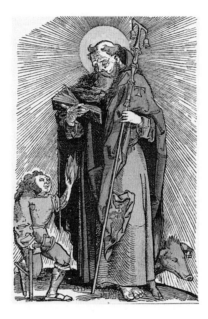

disease to break out with renewed force. Accounts describe epidemics of tragic proportions, such as one that decimated Paris in 1418, purportedly killing fifty thousand people in one month. France and the Netherlands were the most severely affected, but outbreaks occurred as far afield as Russia. The symptoms – gangrene of the extremities resulting in the withering and eventual detachment of affected limbs, hallucinations, muscle contortions, convulsions and agonizing, burning pain – were horrific. Once established, the progress of the disease was rapid and relentless. Because of St Anthony's

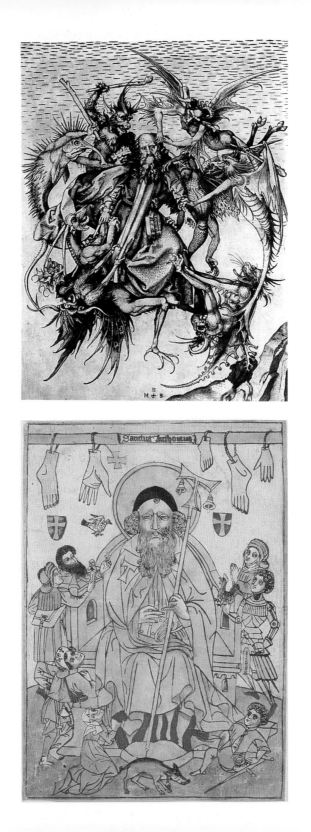

intense suffering and his fiery attribute, he became the intermediary for victims of holy fire. He could inflict it as a punishment or heal it through divine intercession.

We now know that St Anthony's fire was the disease of ergotism, caused by the contamination of grain, most often rye, by ergot mould. This explains the ubiquitous and random nature of the malady, which struck young and old, rich and poor alike. It also offers an explanation for the hallucinations suffered by victims. Ergot mould, when heated in an oven with dough in the bread-baking process, transforms into a form of lysergic acid diethylamide, known today as LSD. In Bosch's time, however, no one had yet reasoned that the seeds of madness and death were sown in the staff of life. The only hope for sufferers was St Anthony's intercession, employed in combination with the primitive expertise of doctors and surgeons.

Many images of St Anthony date from Bosch's time, when the plague of *ignis sacer* reached its height. Among the best known are Martin Schongauer's lively engraving (94) and the panel by Matthias Grünewald (1475–1528) from his *Isenheim Altarpiece*. More modest woodcut images, however, were abundantly available to the general populace (95). These prints frequently replace the pestering demons described in the legends with victims of holy fire who petition St Anthony for relief. Often, flames are shown shooting from the arm or leg of a supplicant, as detached limbs dangle above the saint and his entourage (see 93). Such images reflect the practice of hanging the shrivelled, amputated limbs of plague victims above the entrance portals of Antonite monasteries, thereby designating them as hospitals sanctioned to heal in the name of the saint.

The history and traditions of the Antonite order supply the strongest clues to the lost context of Bosch's triptych. In the early modern era, hospitals in northern Europe were almost exclusively run by the Church as part of its charitable mission. However, unlike modern hospitals, which aim to discharge

94
Martin Schongauer,
Temptation of St Anthony,
c.1470–5.
Engraving;
31·2 × 23 cm,
12¼ × 9 in

95
St Anthony,
c.1445.
Woodcut;
37·6 × 25·6 cm,
14¾ × 10 in.
Staatliche Graphische Sammlung, Munich

patients as soon as possible, early hospitals cared for hopeless cases until the end. Cures were sometimes achieved, however, in which case former patients often remained to nurse fellow sufferers. By the fifteenth century, Antonite monasteries served primarily as charity hospices that housed and cared for the victims of holy fire until their deaths and kept amputated limbs for collection and restoration to the original owners at the bodily resurrection preceding the Last Judgement. Antonite infirmaries employed renowned physicians and surgeons, many of whom received their training at major universities. Surviving records show that the medical staff were well paid, and that persons of means, as well as the poor and destitute, availed themselves of their services. Monastic retreat in such a place offered the quiet and comfort favourable to the successful treatment of the disease, and the salubrious environment was enhanced by a good diet that included pork from the pigs the Antonite monks kept. These animals, sacred to St Anthony, wore identifying bells around their necks and were allowed to roam freely through the streets of the towns, begging scraps of food from private homes. The well-fed animals were sometimes sold to augment the income of the hospitals.

Good hygiene, quietude and healthy diet were supplemented by medicines made by the apothecaries employed by Antonite infirmaries. Large distilleries for the making of cooling elixirs and surgical anaesthetics were indispensable to their purpose. Among the many healing potions produced by these monastic pharmacies, none was as fantastic as the legendary 'holy vintage' offered once a year on the Feast of the Ascension (forty days after Easter). On that Thursday, suffering pilgrims thronged before the monastery entrance, where the medicine was given to a select few whose illness was considered too advanced for ordinary measures. On this day, the holy vintage was strained over the bones of St Anthony, which the hospitals kept in precious reliquaries. The victims who received the elixir took only a few precious drops in a pseudo-communion

96
Anonymous, *Miracle of St Chandelle*, sixteenth century. Oil on panel; 77 × 57 cm, 30⅜ × 22½ in. Musée des Beaux-Arts, Arras

ritual, while gazing at an image of St Anthony and saying a prayer, one version of which reads: 'Anthony, venerable shepherd who renders holy those who undergo horrible torments, who suffer the greatest maladies, who burn with hellfire: Oh merciful Father, pray to God for us.' As the plague of holy fire relentlessly spread, Antonite monasteries

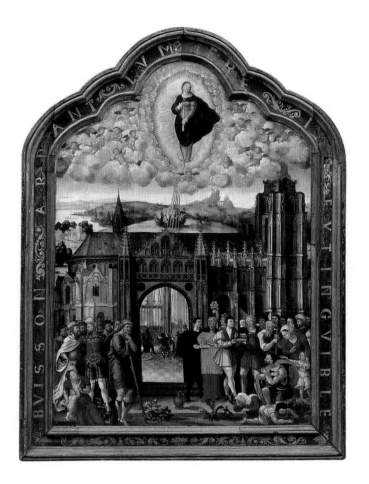

appeared throughout Europe, each claiming to have the authentic relics needed to make the holy vintage. To discourage abuse, regulation of cures for holy fire was the subject of at least three papal bulls during Bosch's life. These proclamations made it illegal to distill an elixir with counterfeit bones, and granted Antonite monasteries sole right to administer the holy vintage.

If we consider Bosch's triptych in a healing context, it emerges as a devotional image, intended to be viewed by victims of holy fire during their mystical identification with St Anthony. As Walter S Gibson suggests, the scene presents the saint as a model whom disease victims were instructed to emulate. A sixteenth-century painting of the rite of the holy vintage (96) shows a celebrant offering a shallow dish to a group of ergotants; such a dish also appears in Bosch's centre panel,

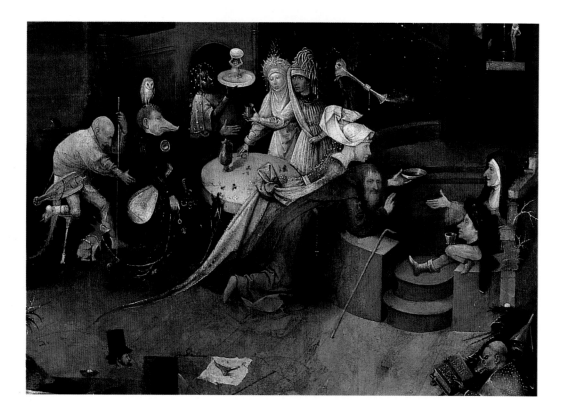

being offered to a nun and a deformed man (97). In light of the ceremony of the holy vintage, the abnormal persons clustering around the saint are probably not meant to be celebrating a black mass or mocking the Lord, as some have suggested. Rather, the scene recalls the healing ritual of the holy vintage, as perceived by the fevered, hallucinating brains of ergotants.

In addition to the holy vintage, Antonite monks made many other cures for holy fire in their monastery distilleries. Some

ingredients occur more often than others in medicinal recipes, particularly those that induce sleep, cause numbness and have cooling properties. Bosch's hallucinatory central panel is full of such substances; fish, for example, was rated cold 'in the highest degree' by physicians. It counteracted the extreme heat of holy fire, as did the cooling, sometimes frozen, water that permeates Bosch's hellish firescape. In fact, the thirteenth-century physician Johannes Anglicus, whose treatises were printed in the fifteenth century, suggested that 'cold fish' be applied to illness 'if the cause be hot'.

Another effective cold ingredient used in curing holy fire was mandrake (also called mandragora), which grows indigenously in southern Europe and North Africa. The fruit of this plant belongs to the tomato–nightshade family and grows atop a strong, forked root. Among the many legends that surround the mandrake plant, the most bizarre involve accounts of the uprooting process, which is pictured in many manuscripts and printed herbals (98). These represent the mandrake plant, sometimes shown bearing a human head topped by leaf-like plumage, tethered to a dog. While the dog's owner wields a sword and blows a trumpet, the animal pulls the mandrake from the ground. The procedure was necessary because the mandrake supposedly uttered a horrible shriek, when yanked from the ground, that drove the hearer mad or, worse, killed him. The trumpet blast masked the sound, while the dog, rather than its owner, risked madness.

Mandrake was used along with other ingredients in elixirs against ergotism. But it is the root, depicted in the earliest medical herbals (99), that received the strangest treatment. Its forked shape, resembling two human legs, was given even more human form by drying and twisting into the shape of small doll-like figures (100), which were carried as talismans against holy fire. These root charms appear in images of St Anthony, held in the hands of pilgrims who lift them to the saint, or hanging from windows among withered limbs (see 95).

97
St Anthony triptych (detail of 90, centre panel)

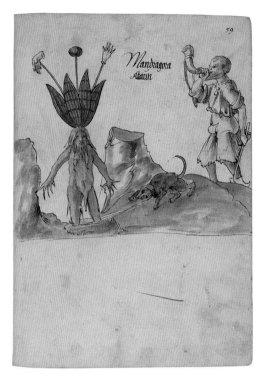

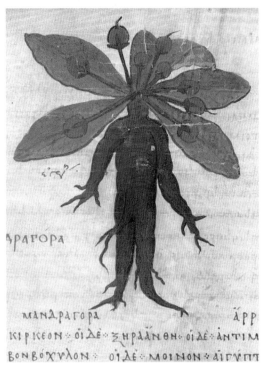

Mandragora
Alätin

ΔΡΑΓΟΡΑ

ΜΑΝΔΡΑΓΟΡΑ ΑΡΡ
ΚΙΡΚΕΟΝ · ΟΙΔΕ · ΞΗΡΔΛΝΘΗ · ΟΙΔΕ · ΑΝΤΙΜ
ΒΟΝΒΟΧΥΛΟΝ · ΟΙΔΕ · ΜΟΙΝΟΝ · ΑΙΓΥΠΤ

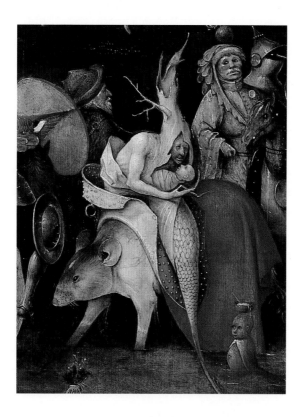

98
Mandrake,
folio 59r, from
Icon 26,
early
sixteenth
century.
Bayerischen
Staatsbibliothek,
Munich

99
Mandrake,
folio 103v, from
Dioscorides,
*De materia
medica*,
c.950.
Pierpont
Morgan
Library,
New York

100
Mandrake
talismans.
Wellcome
Institute
Library,
London

101
St Anthony
triptych
(detail of 90,
centre panel)

102
Mandrake,
from
Pier Andrea
Mattioli,
Commentarii,
Venice, 1565

The composite creature in Bosch's centre panel, which seems to be part bark and part fish (101), bears the tendrils and woody texture of actual mandrake dolls, which were also often formed into the shape of nursing mothers. Victims of holy fire prized the power of mandrake root talismans to restore fertility and sexual potency, for female victims experienced spontaneous abortion and premature delivery as side effects of ergot poisoning, and male sufferers lost their sexual organs to the gangrenous effects of the disease. Bosch's curious hybrid bark–fish mother and child, seated upon a giant rat, suggests an amalgam of two effective remedies against St Anthony's fire: fertility-restoring mandrake and cooling fish.

In the context of Antonite healing, the giant red fruit in the left foreground of the centre panel appears to be a mandrake 'apple', cousin of the tomato (see 89). Mandrake fruit is realistically illustrated in Pier Andrea Mattioli's *Commentarii* of 1554 (102) and described as 'about the same size and colour as a small apple, ruddy and of a most agreeable odour ... quite round and full of soft pulp'. Like the mandrake's roots, its apples had a practical application in curing St Anthony's fire. Their juice, which contains a sleep-inducing substance, was effective as an anaesthetic and valued by Antonite physicians as an aid to amputation, the most common 'cure' for afflicted limbs.

Mandrake's soporific powers were recognized by the earliest authorities, whose writings formed the basis of medical knowledge in Bosch's time. The Roman physician Apuleus Platonicus wrote, 'If one would cut, let the patient drink one-half ounce of mandrake in wine, and he will sleep while the member is cut without feeling any pain.' Bosch's contemporary Hieronymus Brunswyck recommended mandrake as a local anaesthetic, advising victims of St Anthony's fire to soak their clothes with the juice 'to take away the feeling in the members'. In the late sixteenth century Giambattista della Porta described a manner of inhaling the

fumes of a strong distillation of mandrake (sometimes mixed with opium) by means of a dried sponge that was re-wet and inhaled each time it was needed. This method is illustrated in Hans von Gersdorff's 1517 medical book (103), which also shows a recent amputee wearing the tau cross associated with the Antonite order. Likewise, Bosch alludes to the process of amputation by placing a severed foot, carefully laid on a square of white cloth, close to the kneeling figure of St Anthony in the centre panel of the triptych (see 97).

While mandrake effectively relieved the physical symptoms of ergotism, it actually aggravated the mental suffering of

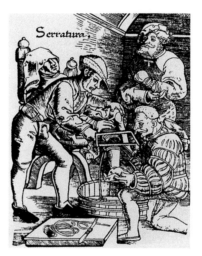

103
Amputation, from Hans von Gersdorff, *Feldbuch der Wundartznei*, Strasburg, 1517

victims, for its chemical content produces hallucinations of its own. Della Porta, aware of these effects, claimed that mandrake gives a sensation of flying, and numerous vignettes of airborne creatures appear in the skies of all three interior panels of Bosch's triptych. St Anthony himself straddles the bodies of several grotesque flying reptilian creatures in the skies of the upper left panel. Ergot poisoning also produces the illusion of flight. In fact, the chemist Albert Hofmann, who first synthesized LSD from ergot mould, described a feeling of 'floating outside my own body', in his first report of an LSD 'trip' in 1943.

The unfortunate victims of St Anthony's fire were thus twice afflicted by hallucinations: initially from the ergot in their systems, transformed into a form of LSD in the very bread that they ate, and secondly from the narcotic poisoning of the mandrake itself. The fantastic quality of Bosch's imagery therefore reflects not only the tortures of the saint, but also the hallucinations of his followers, caused by their illness and magnified by the medicines they took for relief. Bosch assembled society's outcasts, suffering from the repulsive holy fire and surrounded by the cures on which they depended: mandrake fruit and root, fish and freezing water, and, of course, the stoic St Anthony himself. All appear as feverish hallucinations, seen through the eyes of suffering ergotants.

Bosch goes a step further, including in his panels the chemical laboratory apparatus used by Antonite apothecaries to refine and concentrate substances into cures for holy fire. He had more reason than most to be familiar with medicine-making machinery, for at least one member of his wife's family is documented as being involved in the apothecary trade. Pharmacists employed practical distillation to manufacture the medicines, herbal cooking preparations, artists' paints and cosmetic products they sold in their shops. However, family connections were not the only way that Bosch could have gained knowledge of chemical distillation. The practical aspects of early chemistry were abundantly explained and illustrated in many printed books. An excellent example is Brunswyck's *Book of Distillation*, a practical manual that was translated and published several times during Bosch's life. Brunswyck geared the text of this popular illustrated book towards the new reading public, claiming to show how to make medicines without cost 'in the oven while bread bakes'. The fact that Brunswyck's book is pharmaceutical in nature, yet intended for use by common people, illustrates the wide acceptance that distillation had gained among folk of all levels of wealth and education. The *Book of Distillation*, and others like it, show without a doubt that the processes of chemistry

104
St Anthony triptych (detail of 90, centre panel)

105
Furnace, folio 106v, from MS Harley 2407, fifteenth century. British Library, London

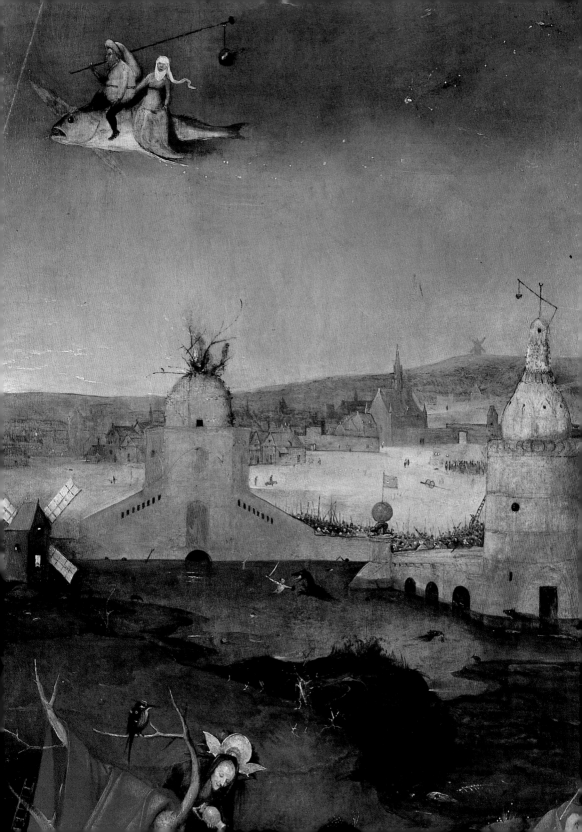

and pharmacy were inseparable in Bosch's time, and that the people who used this book to make healing elixirs in their kitchens were not practising a forbidden, esoteric art.

We have seen that Bosch's *Stone Operation* (see 20) appears to castigate false alchemists; however, the proper practice of early chemistry was greatly respected as a useful pursuit. The types of flasks and furnaces scattered throughout the *St Anthony* triptych would have been recognized by anyone familiar with popular printed manuals or involved in the medical or apothecary professions. An example is the metallic egg-shaped object (104) in the right mid-ground of the centre panel, which resembles a type of furnace illustrated in distillation books (105). In the logic of the time, its oval, egg-like shape would have affected the transformation going on

106
St Anthony
triptych
(detail of 90,
right panel)

107
Flask and
heat source,
folio 108v,
from MS
Harley 2407,
fifteenth
century.
British Library,
London

108
Furnace,
folio 1r, from
MS O.8.1,
fifteenth
century.
Trinity
College
Library,
Cambridge

109
Hook-up of
two distillation
furnaces,
folio 256,
from MS 719,
sixteenth
century.
Wellcome
Institute
Library,
London

inside, just as a hen's egg changes through warmth into a living chick. Typical of most furnaces, Bosch's structure has an opening in its bottom for the introduction of fuel, and belches flames and vapour from a chimney on top. A bather prepares to dive from the roof of the rectangular building in front of the oval furnace-house, while another descends a stairway towards the icy, dark pool at its base. Here we are reminded that cold baths were essential therapy for people suffering from hot illnesses, and would have been prescribed by Antonite physicians as part of the course of treatment for holy fire.

More familiar distillation apparatus appears in the upper background of Bosch's right panel (106). The tower on a tubular pedestal resembles a type of long-necked beaker that held

the ingredients, while the columnar pedestal takes the form of a heat source with an entry in the bottom for the introduction of fuel. In fact, this form, consisting of a bulbous flask and columnar base, was perhaps the most familiar distillation device, found in every chemical laboratory (107), as it was the simplest way of warming substances above a heat source. A bridge plunging into water links this structure with the pyramid-shaped form behind it. This, too, is similar to a type of furnace (108), fitted with an alembic to trap escaping steam. Flames burst from its domed roof, much as they would in an actual laboratory. Chemists connected stills similarly by means of a delivery tube run through a cooling water jacket, designed to aid condensation in the receiver at the other end of the tube. Likewise, cooling seems to be the purpose of Bosch's dual distillation hook-up, the connecting bridge of which disappears in water as it slants towards the pyramidal edifice in the distance. Seen as a pair, these structures resemble typical furnace combinations (109), used to heat vapours by steam as well as to cool them through water.

Bosch disguises his furnaces and flask as architectural constructions, which is why authors have seen in them exotic Eastern buildings, lighthouses and beacons. This artifice, however, was used by distillers themselves, who referred to their furnace as a 'house' (*domus*) – a place where materials 'lived' during their transformation into healing substances. Half submerged in the murky water of the upper right panel, before the two furnace-like towers, a tiny figure brandishes a sword against a fire-breathing green dragon (see 106). This vignette reminds viewers of one of the best-known, most often illustrated chemical metaphors. In the symbolic visual language of alchemy, the green dragon could represent several things, but was always associated with struggle and danger. An illustration of the alchemical dragon fight from *Rising Dawn* (*Aurora consurgens*; 110), an early fifteenth-century manuscript, shows symbolic figures of the sun and moon (representing opposite elements) pitting their

110
Battle with the Green Dragon, folio 36, from *Rising Dawn* (*Aurora consurgens*), *c.*1400. Zentral-bibliothek, Zurich

strength against their foe. Here the dragon represents danger and difficulty, which they must overcome, much as Bosch's diminutive warrior does. One ancient allegory that fits Bosch's image describes the 'Chemical Citadel', where the secret of life lies guarded by a dragon. To enter the city, the successful chemist must not only know all practical procedures and materials, but also be pure of heart, faithful, wise and devout. Bosch's city, guarded by a fierce green dragon, represents the spiritual obstacles that the alchemist must overcome to reach his goal, much as St Anthony himself triumphed over adversity. In the context of Antonite healing, Bosch's small battle with a dragon represents the struggle of distillers to conquer their

materials, just as Anthony prevailed over his demons, and victims of holy fire must triumph over their disease.

The image of St Anthony among distillation apparatus has its counterpart in depictions of the chemist as a saturnine hermit accompanied by his trusty flask and furnace (111). Similarly, a small *St Anthony* in the Prado, Madrid (112), shows the troubled saint huddled in the hollow trunk of a tree on the bank of a pond, as impish devils wreak havoc around him. This panel is sometimes given to Bosch, and the attribution is not without substance. Though its forms are harsher than in some of Bosch's other paintings, the work dates *c.*1462 or later, placing

111
Chemist as
hermit,
folio 34v,
from MS
Harley 2407,
fifteenth
century.
British
Library,
London

112
Hieronymus
Bosch and/or
Workshop,
St Anthony,
*c.*1462 or
later.
Oil on wood;
70 x 51 cm,
27½ x 20 in.
Museo del
Prado, Madrid

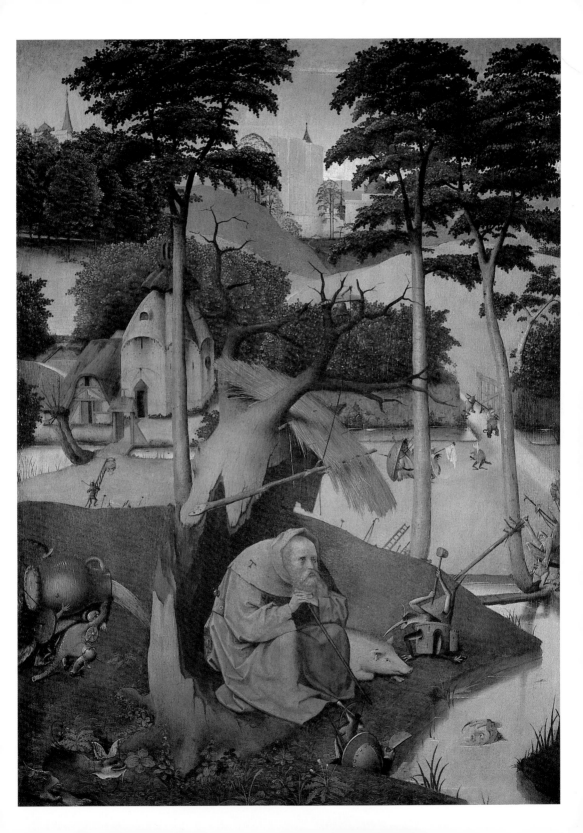

it early in Bosch's career or perhaps in the family workshop. The association of St Anthony with the craft of pharmacy is evident in the small portable furnace, like the ones employed in domestic distillation (113), inhabited by a troublesome devil who threatens the saint's pet pig with a hammer. Here, as in Bosch's large triptych, distillation apparatus is as much an attribute of the saint as are his bell, fire, book and staff, suggesting that by the late fifteenth century the image of St Anthony and the trappings of the pharmacy trade were inseparable. The passive role that Anthony played in the healing of holy fire as intercessor and empathic figure expanded to include the active role of apothecary and healer.

Finally, we can see that, while Bosch depicts the well-known legend of St Anthony tormented by demons, his message is directed to a singular audience: those seeking deliverance from their own demon – the demon of holy fire – through the intercession of the saint and the healing powers of surgery and medicines. Thus, to the Christian context of Antonite monasteries and the mystical–medical rite of the holy vintage, we must add the practical trade of the apothecary, who, in distilling cures for St Anthony's fire, surely found the apotheosis of his art.

ieronimus bosch

We have seen in the discussion of the *St Anthony* triptych that apothecaries and physicians, like those employed by Antonite hospitals, used distillation to concentrate the healing essences of organic and animal substances into medicines, and that their use of this science is reflected in Bosch's art. Bosch's use of chemical imagery and metaphor also throws light on our understanding of the *Adoration of the Magi* triptych (115, 116) now in the Prado, a work at the centre of much art historical debate. Various approaches have been used to analyse this problematic work. When applied to the triptych, the processes and allegories of alchemy not only expand its meaning but also point to the interface between science and religion in Bosch's time.

Today, the word 'alchemy' conjures up images of sorcerers and deviant friars murmuring spells over steaming cauldrons in vain attempts to make gold out of lead. However, devout scholars of Bosch's time envisioned alchemy/chemistry as a spiritual quest, and were led by God's example, combining precepts of Christian morality with intellectual discipline and practical experimentation. At the highest level, alchemists were pious, dedicated churchmen and scholars who practised their art as a means of obtaining salvation for themselves and for the world. They appear, tonsured and cowled, sweating over hot furnaces, in illustrated chemical texts (117). Not until the late seventeenth century did the Aristotelian concept of the four elements, upon which alchemy was based, become discredited. When the practical and theoretical aspects of alchemy split, the visionary metaphors that underlay the ancient philosophy became occult curiosities, irrelevant to modern, empirical scientific thought.

114
Adoration of the Magi
(detail of 115, centre panel)

115–116
Overleaf
Adoration of the Magi
triptych,
*c.*1500.
Oil on panel;
centre panel
138 × 72 cm,
54⅜ × 28⅜ in,
side panels
138 × 33 cm,
54⅜ × 13 in.
Museo del
Prado, Madrid
Right
Adoration of the Magi
triptych,
exterior

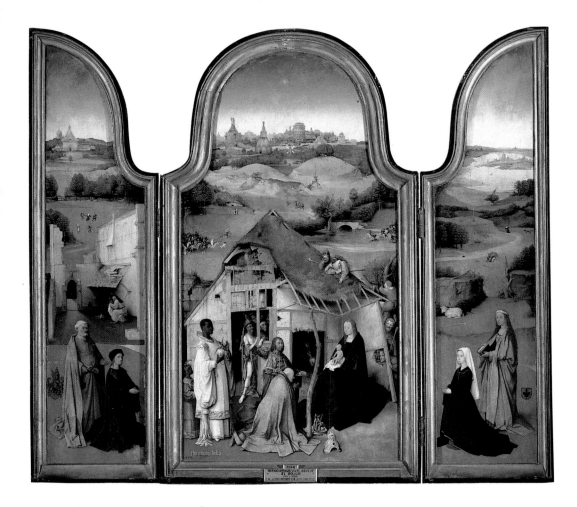

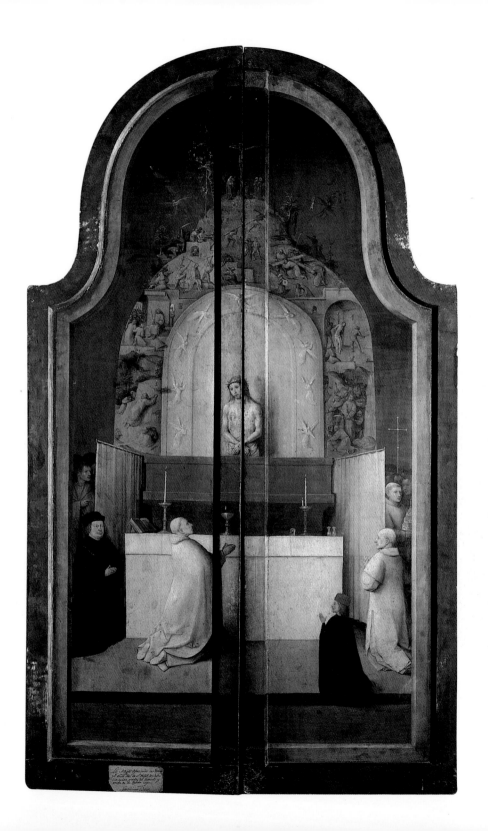

In Bosch's time, alchemy was both a practical pastime and a
learned philosophy, and both spheres are represented in his
paintings. Basic chemical processes were familiar, even to
illiterate folk, through medieval legends; however, historians
of science note a conspicuous increase in active lay interest
and participation in alchemy beginning in the fourteenth
century. At the same time, there appear numerous castigations
of alchemy's abuses aimed at those who neglected its lofty
principles (see Chapter 2). The invention of printing in the
fifteenth century sped the process of popularization, making
chemical principles and procedures widely available in both
Latin and vernacular languages.

As well as medicine, chemical principles were essential
to other scientific and technical disciplines in the fifteenth
and sixteenth centuries. Metallurgists employed chemical
precepts to refine and plate metals, and the by-products of
early chemical experimentation produced the first fertilizers,
pesticides and preservatives. All these things had the effect
of improving agriculture, increasing trade and generally
enhancing the quality of life.

The devout practice of chemistry was sanctioned, legitimized
and patronized by the Church. Bishops, cardinals and popes
subsidized chemical experimentation, including Pope John XXII,

to whom an alchemical treatise, *The Art of Transmutation* (*Ars transmutatoria*), is attributed. Kings and highly placed nobles also embraced alchemy, among them Alfonso IV of Castile, Robert the Bruce of Scotland, Edward III and Henry VI of England, and the French kings John II, Philip VI, Charles VI and Charles VII. The scholar-king Charles VI, like Pope John XXII, is alleged to have written an alchemical treatise himself, the *Royal Work of Charles VI, King of France* (*Oeuvre royale de Charles VI, roi de France*). Admittedly the support of alchemy by kings was due in part to their desire to find a means of creating gold, in order to finance wars and increase their power. Closer to Bosch's time and place, Duke Philip the Good of Burgundy, patron of Jan van Eyck, supported alchemists, and his enemies accused him of counterfeiting money with their assistance. More importantly, the Habsburg dynasty of rulers, documented patrons and collectors of Bosch's works, were noted for their support of alchemy. Clearly, economic motives determined the policies of rulers and governments towards chemical experimentation. Secular authorities attempted to limit and control its practice by requiring licences and punishing those who worked without authorization.

Whatever the practical goal, alchemy was based upon the concept of transmutation – the changing of substances at the elemental level. The conversion from base to precious, sick to healed, was achieved by bringing into balance the four elements and perfecting them into a fifth element, the quintessence, capable of healing bodies or perfecting metals on contact. Chemists mimicked the Christian life cycle in their operations, allegorically marrying their ingredients, multiplying them, then destroying them so that they could be cleansed and 'resurrected'. The alchemical process was accompanied by constant prayer, appropriate religious music and self-sacrifice, often likened to Christ's Passion. Success, granted by God's favour, meant the return of the human race to its original perfectly balanced state before the Fall, and the ultimate creation of paradise on earth.

The bulk of alchemical texts date from before the fifteenth century – some as far back as the Hellenistic era – and they display a rich visual tradition that has not been widely studied by art historians. Chemical authors include such famous names as Albertus Magnus, Thomas Aquinas, Roger Bacon and, later, Isaac Newton, all of whose works were widely copied and printed in succeeding centuries. The hundreds of alchemical books and manuscripts that exist today attest to the fact that knowledge of alchemy was widespread in Bosch's time, when chemical literature was compiled and edited for printing. By the fifteenth century, pictorial symbolism had been a part of alchemy for over a thousand years. Chemical books often contain scenes and figures that represent recipes and procedures cloaked in a secret visual language. Their pictorial quality is uneven, ranging from naïve line sketches to masterpieces of printmaking and manuscript illumination. Certain stock images, such as the 'green dragon' (see 110), appear frequently, regardless of the name attached to the treatise, and were repeated so often that they became generic, their origins buried in obscurity. On the other hand, alchemical texts could inspire visual interpretations of startling originality. These display a blend of fantasy and reality, a merging of bizarre allegorical images with lucid diagrams of apparatus, which suggests that artists were given free rein to combine traditional symbolism with individual imagination.

Scholars have noted some of the obvious alchemical elements in Bosch's paintings, such as eggs and composite creatures. (These are discussed in greater detail in Chapter 8.) Several art historians, among them Madeleine Bergman, Jacques Chailley and Jacques Combe, have employed alchemical interpretations as evidence of Bosch's supposed heresy or to note the presence of 'evil' in his works. The historian of science Jacques van Lennep, however, sees alchemy correctly as a legitimate science, proposing that Bosch was, in fact, a chemical practitioner. The alchemical parallels put forth in

this chapter go a step further, noting the practical nature of early chemistry by recognizing not only the symbols and religious metaphors that underlie the science, but also the many examples of common laboratory apparatus apparent in Bosch's paintings. When speaking of an alchemical influence upon Bosch, I do not refer to specific texts or authors as influences upon his imagery, but to overriding concepts and universal metaphors shared by both religion and science, which are basic to all chemical texts and processes. Bosch was no mere copier of chemical motifs; his selective use of alchemical imagery must have come from a deep understanding of the spiritual aims and practical procedures of this important philosophy.

The Prado *Adoration of the Magi* triptych (also known as the *Prado Epiphany*; see 115, 116), which is signed by Bosch but has not yet been dated dendrochronologically, is believed to be the work described as the 'painting of three Kings, made by Jeronimus bossche, closing by means of two panels' that was confiscated in 1567 by the Duke of Alva, who took it to Spain. It eventually formed part of the collection of Philip II, and was among the paintings most admired by Fra José de Siguenza, one of the first to study Bosch's work.

Unlike many of Bosch's paintings, the origins and iconography of which clearly reflect visual traditions and moral concerns of his era, this work is unique and puzzling. When the triptych is open, the male and female donors appear, occupying customary positions in the side wings. The identification of the couple as Peter Bronckhorst and Agnes Bosschuysen, who are represented with their name saints, is generally accepted. But the coats of arms placed near them do not seem to correspond to either family, and have not, in fact, been identified. None of Bosch's other paintings displays heraldry so prominently, and the family crests may have been added at a later date to personalize the triptych for another owner. The identification of the donors as members of the Bronckhorst and Bosschuysen

families makes sense, for both were stalwart members
of the Brotherhood of Our Lady for several generations.
Like Bosch himself, they belonged to the upper stratum of
's-Hertogenbosch society, and their lengthy association with
the confraternity not only supports their absolute devotion
to the fundamental tenets of the Church, but also reinforces
an orthodox interpretation of the Prado triptych.

The central interior panel shows the elaborately dressed Magi
or kings offering gifts to the Christ child, who sits on the
lap of the Virgin outside a dilapidated stable (see 114). The

painting offers parallels to the Mass and links the infancy
and Passion of Christ, as seen in other works by Bosch. The
first king, old Melchior, has placed his gift of a small metal
sculpture on the ground at Mary's feet (118). Its Old Testament
subject, the Sacrifice of Isaac, was seen as prefiguring Christ's
Passion; printed editions of the *Mirror of Human Salvation*
(119), for example, illustrate the two scenes side-by-side to
make the connection between Abraham's sacrifice of his best-
beloved son and God's. The small sculpture is appropriately

placed beneath the Christ child, who sits squarely on his mother's lap, much as the sacred host, the body of Christ, sits on a church altar during the Mass. Confirming this interpretation, Balthasar, the middle king, reverently extends his gift on a golden plate covered partially by a neatly folded napkin, in the manner of a priest offering the sacrament.

In Christian doctrine the theme of the Adoration of the Magi is itself closely associated with the Mass, during which bread and wine are mystically transformed into the true body and blood of Christ in the sacrament of the Eucharist. Just as Christ made himself known to the three kings, so does he continue to appear to the faithful each time they partake of the Eucharist.

118
Adoration of the Magi triptych (detail of 115, centre panel)

119
Christ Carrying the Cross and *Sacrifice of Isaac*, from *The Mirror of Human Salvation* (*Speculum Humanae Salvationis*), c.1470

The connection is made explicit on the triptych's exterior, which depicts the Mass of St Gregory in earthen tones of grey and brown (see 116). According to tradition, during Gregory's celebration of the Mass in the basilica of Santa Croce in Rome one of his assistants expressed doubts as to the truth of the Eucharistic rite. Immediately, Christ appeared before the group as the Man of Sorrows, bleeding into the chalice placed directly before him on the altar. The miracle of transubstantiation was thereby enacted before the eyes of the faithful.

In the fifteenth century, the papacy awarded indulgences to those who prayed before an image of Gregory's Mass. The

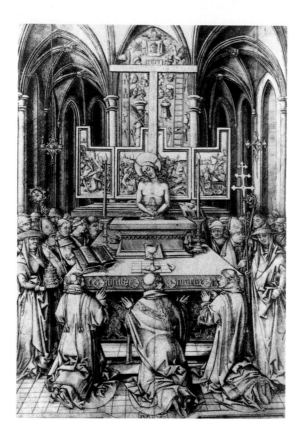

120
**Israhel van
Meckenem,**
*Mass of St
Gregory,*
*c.*1490–5.
Engraving;
46·3 × 29·5 cm,
18¼ × 11⅝ in

subject therefore became popular in northern European art,
and was usually depicted in a manner similar to the engraving
by Israhel van Meckenem (*c.*1440/45–1503) dated *c.*1490–5
(120). Here, ecclesiastics crowd around the altar, upon which
Christ appears in half length before an altarpiece painted with
scenes of the Passion. Behind him, on the back wall, a number
of the instruments of the Passion appear; among them are
the column of flagellation, whip, sponge, lance and crown of
thorns. By comparison, Bosch's interpretation is typically
unconventional. His scene, filling the two exterior panels,
manages to merge, yet at the same time demarcate, several
levels of experience, portraying the realms of spirit and body,
past and present, that share the same sacred space. The area
behind the altar enlarges the miraculous account by including
all the events of Christ's Passion, not just the bleeding Man of
Sorrows and implements of his torture. Painted with wonderful

vitality and movement, the dreamlike forms materialize around the altar in continuous narrative, like a ghostly *film noir*, culminating in the Crucifixion at the top. The only figures rendered in flesh tones and colour are two kneeling male donors on either side of the altar, which were added at a later date either by Bosch's hand or another's.

The central panel of the Prado *Adoration of the Magi* offers a serious challenge to interpreters. Most iconographical readings centre on the extraordinary presence of six menacing figures who witness the Magi's visit from within the shelter of the dilapidated stable (see 126). Prominent among them is one who is distinguished by a running sore on his leg. The wound is not wrapped with cloth in the usual way, but encased in a crystal bandage, bordered in gold. Art historian Lotte Brand Philip believed that this figure is the Jewish Messiah, who, according to Hebrew legend, was supposed to appear as a leper in golden manacles. He and his minions would therefore represent the evil of the world into which the infant Christ has been born. Philip linked this figure with a number of Hebrew sources supposedly made available to Bosch through his association with a Jewish convert and fellow confraternity member. However, an obvious reliance upon Jewish sources, which were not dispersed through printed editions, would have limited the ability of viewers to comprehend Bosch's message. Furthermore, by the fifteenth century the hunt for heretics reached a fever pitch in northern Europe and the Inquisition had begun in Spain. An obvious reliance on esoteric non-Christian literature would have veered dangerously close to heresy, especially in the context of the conservative membership of Bosch's confraternity. It is true that confraternities throughout Europe courted the membership of converted Jews, seeking to enlist them before Christ's Second Coming in keeping with St John the Evangelist's call to unify all peoples in the Church. In fact, the Brotherhood of Our Lady included several converted Jews on its membership rolls. They were not, however, valued for their expertise in non-Christian

lore, but rather as tangible proof of the superiority of Christianity in the battle against heresy.

Art historian Ernst Gombrich rejected Philip's hypothesis, but put forth another uncertain scenario, identifying the exotic figure in the hut as King Herod, whose character appeared in mystery plays as a witness to the birth of the Messiah that he so feared. This reading interprets the decayed hut as a symbol of the Old Law, or Synagogue, and the figures huddled in the shadows as Herod's spies. Both Gombrich's and Philip's theories call upon texts and traditions current in Bosch's time, but neither reinforces the Eucharistic parallel clearly established on the triptych's exterior. There is yet another reading that considers the presence of the figures in the hut in combination with the miracle of transubstantiation. The basis of this explanation lies in the philosophy of alchemy, which provided Bosch with texts and images the main focus of which was the attainment of salvation by means of transmutation of matter in imitation of the Eucharist.

An alchemical reading explains many of the anomalies in the Prado *Adoration*. The six corrupt onlookers in the hut behind the Christ child, the shapes and forms of the Magi's bizarre gifts, and the strange cityscape in the background can all be seen to take their forms and meanings from the rich tradition of alchemical allegory and illustration. We can begin with the landscape in the upper background, which suggests alchemy's practical sphere. The objects here (121) would have been recognized by anyone familiar with a chemical laboratory. An example is the half-buried rounded tower topped by a bulbous beacon, exposing its long upper neck and rounded form. It resembles a common flask seated atop a furnace (see 107), imagery that also appears in the *St Anthony* triptych (see 106), as does the similar connection of two furnace-like constructions via a bridge over water. The two connected towers allude to a common way of linking stills by means of a delivery tube run through a cooling water jacket, designed

121
Adoration of the Magi triptych
(detail of 115, centre panel)

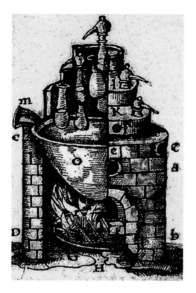

to aid condensation (see 109). The multi-levelled tower at the other end is similar to a stepped furnace of Eastern origin, built with several levels, that appeared in laboratory manuals as late as the seventeenth century (122). By camouflaging distillation apparatus as architecture, as in the *St Anthony* triptych, Bosch illustrates the common chemical metaphor that referred to furnaces and flasks as the 'houses' in which the ingredients lived during their transmutation (see Chapter 6). The result is a uniquely exotic representation of Bethlehem.

The *Adoration* scene, as a whole, reflects a common chemical analogy that compares the birth of Christ to the birth of the transmuting agent, the 'philosopher's stone', 'lapis' or 'elixir'. The earliest author to make the connection was probably Petrus Bonus, whose fourteenth-century treatise *New Pearl of Great Price* (*Pretiosa margarita novella*), first printed in 1503, refers to the incarnation as the ultimate transmutation: 'God must needs become one with man. And this came to pass in Christ Jesus and his virgin mother.' The fifteenth-century *Book of the Holy Trinity* (*Buch der heiligen Dreifaltigkeit*), dedicated to Frederick I, Count of Nuremberg and Margrave of Brandenburg, contains numerous analogies between the

alchemical process and Christian concepts, including the Trinity, Immaculate Conception and Passion of Christ. An example also appears in the popular *Philosophical Rose* (*Rosarium philosophorum*), which shows the lapis as the risen Christ stepping from the tomb (123).

Chemical tradition further equates the Magi's discovery of Christ with the birth of the philosopher's stone. The *Hermetic Museum* (*Museum hermeticum*), a compendium published in 1678 that includes several early alchemical texts, devotes a chapter to the lapis, describing it as 'the ore of gold, the purest of all spirits ... the wonder of the world, the result of heavenly virtues'. The lapis/Christ analogy continues:

The Almighty has made him [the lapis] known by a most notable sign, whose birth is declared throughout the East on the horizon of this hemisphere. The wise Magi saw it at the beginning of the era, and were astonished, and straightaway they knew that the most serene King was born in the world. Do you when you see his star, follow it to the cradle, and there you shall behold the fair infant. Cast aside your defilements, honour the royal child, open your treasure, offer a gift of gold: and after death he will give you flesh and blood, the supreme Medicine in the three monarchies of the earth.

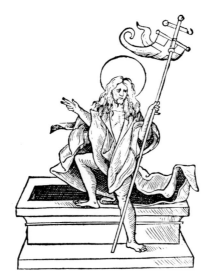

123
Christ as Lapis,
from *Rosarium philosophorum,*
Frankfurt am
Main, 1550

Christ was commonly equated with the power of the elixir of life to redeem and perfect. The chemical subtext of Bosch's work reinforces the well-documented parallel between Christianity and alchemy: the link between transubstantiation and transmutation. In both processes, common substances change miraculously to higher ones by God's intervention. In fact, there are examples of alchemical masses that mimic the Christian Eucharist. An illustrated version of one such Mass by Melchior Cibinensis, a contemporary of Bosch, shows the practitioner attired as a priest in liturgical raiment (124). Behind him, a vision of the Virgin and Child appears,

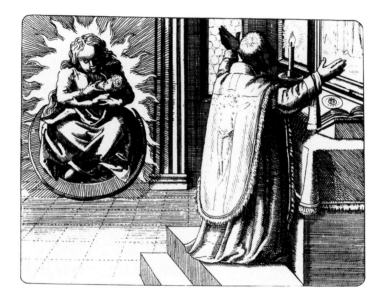

124
Alchemist as Priest, from Melchior Cibinensis, *Symbolum*, reproduced in Michael Maier, *Symbola aureae mensae*, Frankfurt, 1617

demonstrating the allegorical link between the incarnation of Christ and the appearance of the philosopher's stone. By pronouncing the consecrating words that bring about the change, the priest, like the alchemist, redeems his base substances – the bread and wine of the Eucharist – from their elemental imperfection. Evidently, this parallel was part of common wisdom, as history records that, in 1436, during the Hundred Years War, Henry VI of England called on alchemists to help finance his campaign against France. The king issued several decrees addressed to clerics, professors and

medical doctors, asking them to contribute their talents to the replenishment of the treasury, and promising special royal privileges to those who responded. He made a special plea to priests, for whom, he said, it should be easy to change (he used the word '*transubstantiare*') base metal into precious gold, for did they not daily change bread and wine into the body and blood of Christ?

The link of the birth of Christ with the birth of the elixir of life is not the only alchemical allusion in Bosch's triptych. Alchemical allegory also suggests the identities of the six unsavoury-looking men crowded within the hut (see 126). Renaissance scientific tradition recognized a hierarchy

125
Alchemical King and Six Lesser Metals, from Petrus Bonus, *New Pearl of Great Price (Pretiosa margarita novella),* Venice, 1546

of planets and metals, viewing all but the sun and its corresponding metal, gold, as imperfect. The six contaminated metals – lead (Saturn), iron (Mars), tin (Jupiter), copper (Venus), quicksilver (Mercury) and silver (Luna) – each had the capacity to be transmuted, cleansed and healed into gold, the perfect metal. In an alchemical context, the six corrupt characters lurking within the dilapidated hut would represent the six unclean metals awaiting transmutation through the grace of incarnate God. The process paralleled the cleansing of souls on the Day of Judgement and the Christian belief in a debased world redeemed by Christ's sacrifice.

Chemical books illustrate gold both as Christ himself and as a secular 'king' of metals. An image from Petrus Bonus's *New Pearl of Great Price* (125) shows six human figures, representing the six base metals, paying homage to their 'king', gold, to whose perfection they aspire. Bosch's decrepit hut, traditional in Adoration scenes, here reinforces the corrupt nature of the six figures within, whose physiognomies bear the marks of villainy and sin. In their physical degeneracy, they correspond to the base metals that honour their king in the *New Pearl of Great Price*. Because the foremost figure in the hut is clearly the most bizarrely reprehensible (126), he would embody lead, the lowest of all metals, linked in astrological and humoral theory with Saturn, earth and melancholia. The planet Saturn and its metal, lead, were furthermore associated both with lameness, Saturn's malady in the *Children of the Planets* illustrations (see 43), and the disease of leprosy. In affirmation, Bosch's figure displays a festering leprous sore on his lower leg, encased, reliquary-like, in its curious gold and crystal bandage. Bosch's odd image reflects the fact that alchemists praised lead's filthy leprosy as containing the seeds of gold and the power to become pure. In fact, practitioners anticipated and heralded signs of the leprous *nigredo*, the blackening of their ingredients dominated by Saturn, as an indication that transmutation was progressing. Behind the group of six, a glowing fire, barely visible within the depths of the tumble-down manger, identifies it as a place of chemical and spiritual transformation and cleansing.

126
Adoration of the Magi triptych (detail of 115, centre panel)

Bosch's elegant African Magus exhibits the importance of the *nigredo* stage, described in alchemical literature as being brought by a Moor or black man. He carries a most unusual object – an orb surmounted by a golden bird grasping a small red ball in its beak (127). Though unique among traditional depictions of the Magi's gifts, this strange object does appear in alchemical texts and also in the *Adoration of the Magi* now in the Metropolitan Museum in New York (see 71), newly attributed to Bosch or his workshop. In addition, two more

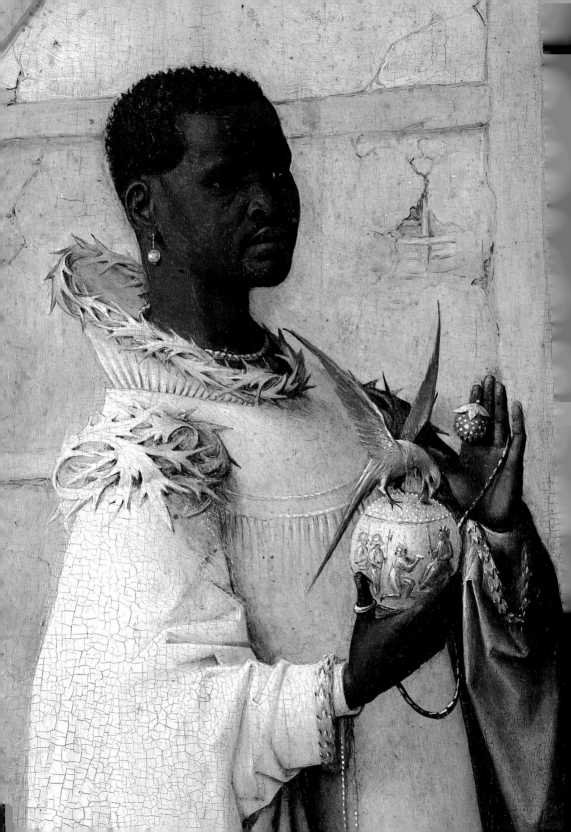

birds, holding red orbs in their long beaks, ornament a golden helmet (128) placed on the ground before the Virgin in the Prado *Adoration*. Chemical symbolism suggests an explanation of the Magus's curious gift, which knows no parallel in traditional Christian iconography. *Rising Dawn (Aurora consurgens)*, a manuscript from the fifteenth century, personifies alchemy as a female figure holding a scale in one hand and, in the other, a bird perched on an orb, grasping in its beak the round, red lapis (129). Salomon Trismosin's early sixteenth-century treatise *Splendour of the Sun* (*Splendor solis*) includes a similar image (130). The alchemical king, rather than a female personification, holds the orb, described in the

127
Adoration of the Magi
triptych
(detail of 115,
centre panel)

128
Adoration of the Magi
triptych
(detail of 115,
centre panel)

text as 'a golden apple whereon perched a white dove of a fiery nature ... with wings of golden hue'. Above him, the sun blazes, and a bright star, the 'morning star aris(ing) over the king', links this royal figure to the star that led the Magi to the Holy Child. Bosch's composite image of golden bird and rosy orb combines elements of the chemical 'golden apple' upon which the 'fiery dove' perches.

The third strange gift of the Magi, a gilded sculpture depicting the Sacrifice of Isaac (see 118), is balanced on the squashed bodies of three black toads. Chemical theory relegated toads to the lowest sphere of creation, for they were believed to arise spontaneously from the action of heat on rotted substances.

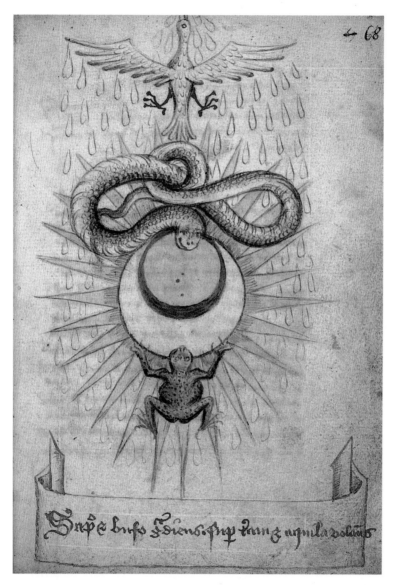

129
Alchemical
bird,
folio 12v,
from *Rising
Dawn (Aurora
consurgens),*
c.1400.
Zentral-
bibliothek,
Zurich

130
Alchemical
king, from
Salomon
Trismosin,
Splendor solis,
c.1582.
British
Library,
London

131
Alchemical
toad,
folio 68,
from MS
Harley 2407,
fifteenth
century.
British
Library,
London

Their low nature is also reflected in Christian iconography, which associated toads with sin and heresy. Chemical texts picture them as symbols of *nigredo* (131), upon which the entire process rests. Like Christ, they must be killed before their resurrection into perfected substances. Bosch's sacrifice of Isaac, balanced upon the backs of common toads, refers, as well, to the potential salvation of the human race, made possible materially by the chemists' own sacrifice, and spiritually by Christ's Passion.

The presence of chemical symbols in the Prado *Adoration* and Bosch's other paintings does not brand him as a heretic or a purveyor of élite, hermetic knowledge. Rather, the common chemical symbols and metaphors in his works were consciously borrowed from Christian iconography, and support the view of Bosch as a man of learning and faith. As such, he chose the Mass of St Gregory for the exterior of his triptych. The parallel between the interior transmutation and exterior transubstantiation is clear. The bread and wine of the Eucharist transform into the material body of Christ during the Mass, just as the chemists' common materials transmute into healing medicines and precious metals. Alchemists, like all early scientists, equated success in their endeavours with purity of soul and altruistic motives, and strove to imitate Christ in their lives and work. What better example for early chemists, seeking human salvation through transformation from base to precious, than the miracle of the Eucharist?

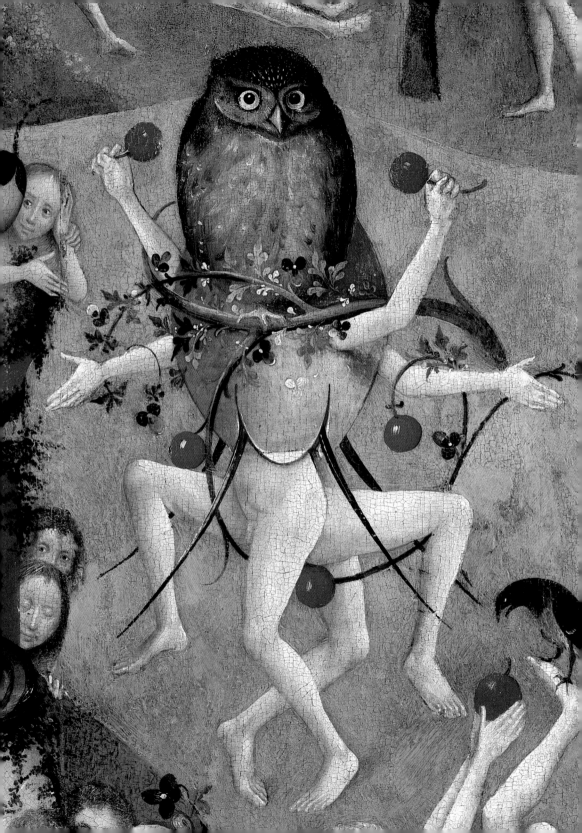

There is no other Renaissance panel painting like the so-called *Garden of Earthly Delights* (133 and see 181), Bosch's best-known work. When opened, the triptych reveals three scenes that, at first glimpse, present a straightforward Biblical account. Adam and Eve appear in the left panel, their many children in the centre, and a monstrous scene of hellfire and damnation in the right. However, upon closer inspection, things are not as they should be. To begin with, no descendants of the first parents ever lived so well! Instead of the thorns and thistles the Bible says were food for Eve's children, who were consigned to lives filled with pain and work, Bosch's handsome young people feast with abandon on huge berries and frolic naked among giant birds. They seem more like children at play, innocently taking exuberant advantage of a world devoid of any hint of danger or evil.

132
Garden of Earthly Delights (detail of 150)

The *Garden of Earthly Delights* is probably the same work seen hanging in the Brussels palace of Hendrick III of Nassau in 1517, a few months after Bosch's death, by Antonio de Beatis, secretary to Cardinal Louis of Aragon. Like the Prado *Adoration of the Magi* (see 115, 116), this painting was confiscated by the Duke of Alva during the Spanish conquest of the Netherlands and taken to Spain, where it is today. Dendrochronological examination of the oak panel supports of the triptych indicates that the trees from which they were cut were felled as early as 1460. As wood was sometimes aged for ten to fifteen years, and several more might have been spent on the actual painting, the triptych could date from the early to mid-1470s. It is thus very probably an early work of Bosch, and not likely to have been painted as a wedding gift for Hendrick III of Nassau in the second decade of the sixteenth century, as has been proposed. In fact, given the early date

suggested by the age of the panels, Hendrick's uncle Engelbert II is a more likely candidate for the original patron. As a courtier serving the ruling Habsburg dynasty, Engelbert had the same broad intellectual training and elevated tastes as the ruling nobility. From 1473, he was a knight of the exclusive, chivalric Order of the Golden Fleece and a *stadholder* (military governor) in Brabant. Under Philip the Handsome, Engelbert was promoted to *stadholder*-general of the Netherlands, a post equivalent to prime minister. Furthermore, the House of Nassau had strong connections to 's-Hertogenbosch through its active membership in the Brotherhood of Our Lady.

Questions surround this masterpiece. Was the *Garden of Earthly Delights* a private commission or a liturgical 'altarpiece'? How long had the triptych been in the Brussels palace by the time Antonio de Beatis saw it? Was the painting purchased by or given to this influential family, which must have known Bosch as a fellow confraternity member during his years of active service? We may never know the answers, but one thing seems certain: the religious devotion and strong community involvement of the Brotherhood of Our Lady, to which both Bosch and the counts of Nassau belonged, argue definitively against any heretical content in the *Garden of Earthly Delights*, no matter how obscure its imagery. We must search for answers once again in the contemporary wisdom of the time, setting aside the biases and prejudices of our own era.

Most modern scholars view the nudity in Bosch's triptych through the prism of post-Victorian morality and post-Freudian psychology. Some see the triptych as a moralistic sermon on the wages of sin and the transience of human pleasures. Others detect rampant sexual immorality in the work, and use this to support the theory that Bosch was a heretic or a pervert. Art historian Paul Vandenbroeck views the triptych as 'a warning against the consequences of sexual

133
Garden of Earthly Delights, c.1470 or later.
Oil on panel; centre panel 220 × 195 cm, 86⅝ × 76¾ in, side panels 220 × 97 cm, 86⅝ × 38⅛ in.
Museo del Prado, Madrid

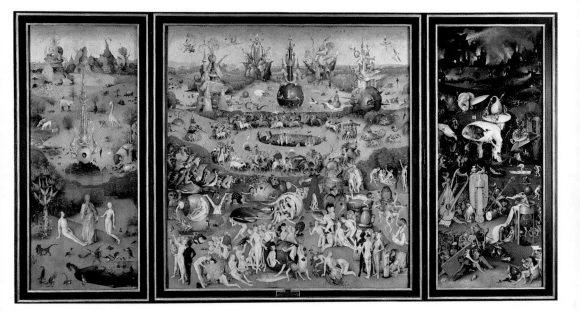

perversion', an interpretation that points to the stubborn
persistence of modern cultural conventions regarding nudity
and sexuality. In fact, in Bosch's time, allusions to sex
and the appearance of genitalia were not expunged from
contemporary life as they are today, when films with explicit
sexual content are restricted to an adult audience. Proof of this
more relaxed attitude emerges from archeological findings in
the modern town of 's-Hertogenbosch. Municipal archeologist
Hans Janssen has discovered things in his excavations of the
medieval city that would make modern viewers blush. Among
the objects of material culture retrieved from ancient cesspits
and rubbish dumps are hundreds of tin badges, which were
sold as mementos to pilgrims during festivals and at religious
and secular performances. Some of these are extremely
explicit, such as one in the form of a mussel shell enclosing
a vulva, and another shaped like a large winged and crowned
phallus with legs (134). These items of inexpensive ornament,
worn pinned to hats and cloaks for all to see, suggest that
Bosch's audience was less puritanical than we are today
when confronted with candid visual representations of sexual
subjects. The antics in the *Garden of Earthly Delights* are
tame by comparison.

The interpretation of Bosch's triptych that finds its way into most introductory art history textbooks is the most obvious and the most superficial – the central panel is the Garden of Eden where the children of Adam and Eve commit the sins for which they will be punished by eternal damnation in hell. However, this explanation, while based upon the triptych's self-evident Biblical programme, does not account for the absence of any conspicuous wrongdoing by Bosch's contented folk, which we would expect to find in a decadent world doomed to eternal hellfire. Custom offered Bosch many models for real evil punishable by the tortures of hell, as used by the painter himself in the *Seven Deadly Sins and Four Last Things* (see 14). In all Bosch's other works, particularly his scenes of the Passion of Christ, evil doers appear as sinister, ugly or old, their sins often indicated by elements of physiognomy, dress or attitude. By contrast, the populace of Bosch's garden remain admirably free of the accoutrements of sin, lacking even the clothing required to compete for material gain. They feast upon giant fruit, not the rich food that decorated the sumptuous banquet tables of the time. It is easy to imagine recipients more deserving of the vengeance of hell than these innocent youths. Fifty years ago, art historian Wilhelm Fraenger rightly noted that Bosch's people are 'peacefully frolicking about the tranquil garden in vegetative innocence, at one with animals and plants'. If there is sex in the *Garden of Earthly Delights*, it is not the sinful kind, for the traditional iconography of lust is nowhere to be seen.

Historians posit various interpretative strategies to explain Bosch's visual anomalies. Some see astrological imagery, while others read allusions to the coming apocalypse in Bosch's vision of a naïve world headed for hellish destruction. Fraenger saw the triptych as a manifesto of the heretical Adamite group, a millennial sect who prepared for the world's end by practising amoral sexual bonding without guilt so as to experience life as Adam and Eve knew it. Art historians Roger Marijnissen and Paul Vandenbroeck, following the

example of Dirk Bax, recognize allusions to bawdy Dutch proverbs having to do with sexual indulgence, while Walter S Gibson sees a relationship between the amorous horseplay of Bosch's youthful folk and the late medieval traditions of the love garden and fountain of youth (135). In fact, the bathing couples, flowers and birds in the *Garden of Earthly Delights* all belong to the realm of Venus, familiar to viewers through astrological and humoral traditions.

A proper review of all the literature on the *Garden of Earthly Delights*, in disciplines ranging from art history to psychology,

135
Master of the Banderoles, *Fountain of Youth*, *c.*1460. Engraving; 23·5 × 31·4 cm, 9¼ × 12⅜ in

would be a book in itself. Suffice it to say that much has been written about Bosch's famous triptych, some of it convincing and ingenious. However, too often erudite scholarship is applied to individual motifs, neglecting the relationship of these motifs to the whole, or sweeping surface readings are offered that either neglect the painting's many puzzling vignettes or dismiss them as artistic licence. It is clear that we in the twenty-first century lack the symbolic vocabulary that once supplied the key to Bosch's patrons and public, whoever they were.

As in several of Bosch's other works, the science of alchemy provides a sub-theme that complements the triptych's Biblical programme while also explaining its strange forms. Scientific imagery provides a way of accepting the co-existence of Biblical, astrological, erotic, millennial and proverb imagery in the *Garden of Earthly Delights*, for alchemical tracts themselves display an aggregate symbolism culled from centuries' work. By the fifteenth century, the philosophical side of the art had reached an apex of complexity, especially in its visual metaphors. The search for a cure-all elixir of life, having occupied scholars since ancient times, had reached the status of a religious quest. The ultimate goal of early chemistry was serious and high-minded – to find a way to return the world and its inhabitants to a new Garden of Eden, where sickness and death were but dim memories of a troubled past.

Chemists communicated their theories symbolically in order to hide their discoveries from ignorant, unworthy, hostile or competitive eyes. In fact, texts often caution about speaking too clearly 'so that the stupid can know the science as well as the wise'. Nonetheless, alchemical motifs in Bosch's triptych, like those in his other paintings, are not difficult to spot, given a familiarity with the basic furnishings of a distillation laboratory and common chemical metaphors. In fact, the subject matter and organization of the *Garden of Earthly Delights* is identical to the oldest chemical allegory of all, which sees distillation as an imitation of the creation, destruction and rebirth of the world and its inhabitants. In Christian thought, the ultimate example of the philosopher's stone was the earth itself, God's creation, which will achieve perfection after its final destruction as foretold in the Bible. The four separate scenes that comprise the *Garden of Earthly Delights* triptych delineate four basic steps in the alchemical work, which have both allegorical and practical significance: 'conjunction', in which ingredients are brought together for mixing, is represented by the left interior scene of the joining

of Adam and Eve; the slow cooking and bringing together of the ingredients into an undifferentiated mulchy mass, the alchemical 'child's play' step, appears in the riotous centre interior panel; next, the substances are burned and 'killed', in putrefaction, symbolized by Bosch's diabolical hell scene; finally, the chemical ingredients are cleansed, resurrected and transmuted in their vessel, a stage that appears on the triptych's exterior. The entire process was intended to imitate God's making of the earth, and the first creator was looked upon as the ultimate example by all serious chemists. This allegory, which dates from Hellenistic times, was expanded in

136
Alchemical Copulation, folio 34, from *Rosarium philosophorum*, sixteenth century. Stadtbibliothek Vadiana, St Gallen

137
Garden of Earthly Delights, left panel, c.1470 or later. Oil on panel; 220 × 97 cm, 86⅝ × 38⅛ in. Museo del Prado, Madrid

the fifteenth century in the writings of Bosch's contemporaries, and continued as part of alchemical imagery through the seventeenth century.

It is the very incongruity between the traditional appearance of sin and the lack of it in Bosch's triptych that makes an alchemical subtext especially cogent. Chemical theory saw the whole world and all of its elements as engaged in continuous sexual reproduction. This scientific view, in which plants, animals, humans and even stones riotously copulated throughout creation, is a convincing parallel to

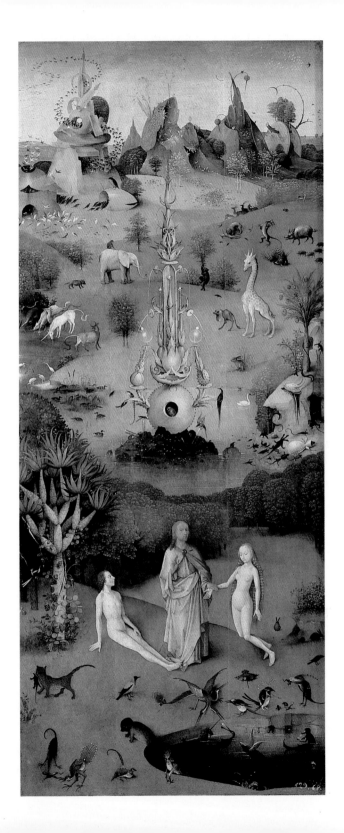

Bosch's sybaritic garden of delights. It also justifies the curious innocence of its naked inhabitants, for lust has no place in the Christian scientific plan for the perpetuation of life. Chemical theory maintained that all substances reproduce in a mystical marriage or conjunction of opposites – black and white, sun and moon, man and woman, etc. – often depicted in chemical texts as human copulation (136). Practically speaking, the union was achieved in the laboratory by mixing, or 'marrying', materials of opposing qualities in a gentle water bath. The ingredients were then allowed to

138
Alchemical Opposites as Adam and Eve, from George Ripley, *Ripley Roll*, scribal copy, seventeenth century. Bodleian Library, Oxford

139
Garden of Earthly Delights (detail of 137)

140
The Fall of Man, folio 7r, from Hartmann Schedel, *Nuremberg Chronicle*, 1493. Herzogin Anna Amalia Bibliothek, Weimar

'multiply', or ferment into a mulchy mass. Theoretically, this mating conceived the 'elixir of life', 'lapis' or 'philosopher's stone', the transmuting agent capable of restoring health to the sick and paradise to the world.

The story of the chemical marriage can be seen in Biblical guise in the left panel of Bosch's triptych as the joining of Adam and Eve (137). It is described and pictured similarly in George Ripley's *Roll*, where the opposites appear as Adam and Eve in an alchemical Garden of Eden (138), standing knee-deep

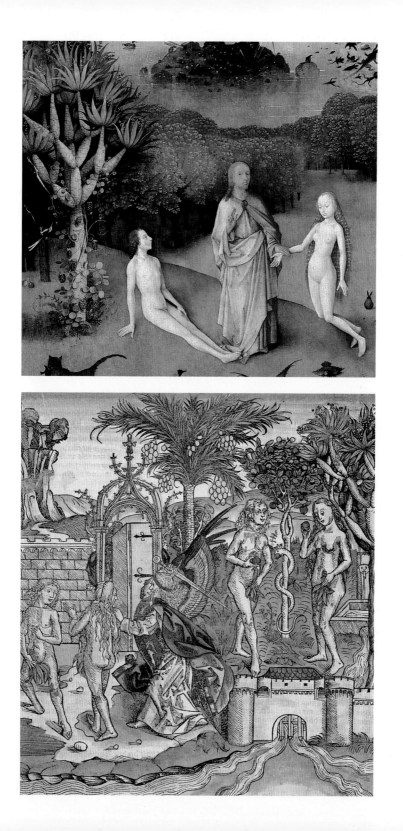

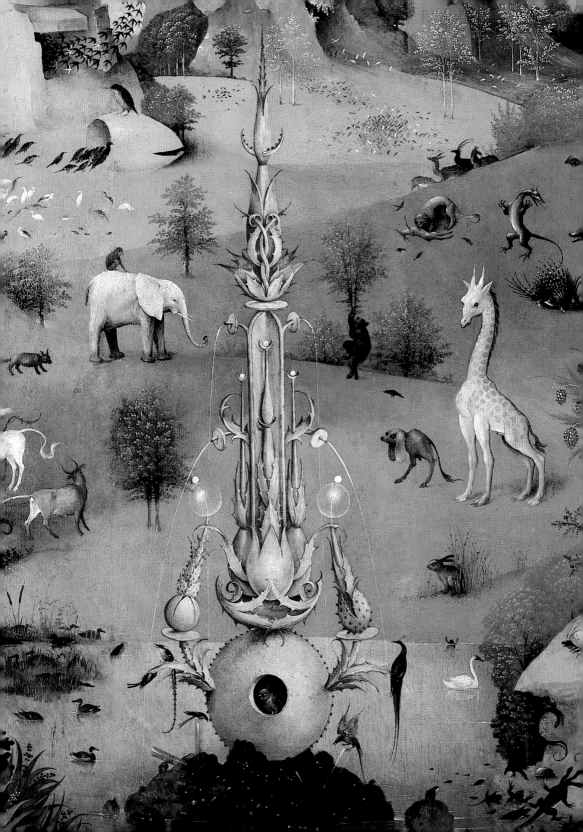

in water and feasting on the forbidden fruit of chemical knowledge. Likewise, Bosch's Adam and Eve, joined by God as Christ, stand in a fantastic environment, surrounded by a host of weird creatures. Adam sits before an exotic tree (139), which art historian Robert Koch identified as a dragon palm (*dracaena draco*). According to herbal texts, this tree, native to the Iberian peninsula, exuded a medicinal red sap known as 'dragon's blood', which was made into a rare and costly drug, much prized for its power to improve strength and stanch the flow of blood. Bosch need not have seen an actual dragon palm to know what it looked like. The exotic tree was pictured in prints by Martin Schongauer and Albrecht Dürer, and appears in Hartmann Schedel's famous *Nuremberg Chronicle* (1493) on the page devoted to the Fall of Man (140).

Bosch's inclusion of the dragon palm, known for its curative blood-sap, reminds viewers of the healing power of Christ's blood. Confirming this interpretation, grape vines entwine its trunk, a reminder of the common source of Eucharistic wine, transubstantiated by the power of God. Instead of the usual pointed grape leaves, however, its leaves take the familiar, round shape of host wafers, known to every partaker of the Eucharist. By including disguised references to the body and blood of Christ, Bosch suggests the healing power of the Mass, and supports the notion of a medical subtext that is repeated throughout the triptych.

A graceful pink fountain dominates the upper middle space of the Adam and Eve panel (141). Anna Boczkowska, noting the fountain's pink hue, round base, crescent-shaped attachments and spiky, claw-like appendages, sees it as a reference to Cancer (the crab), the astrological sign of the moon. Her identification, which forms the basis of a complex astrological interpretation, also supports an alchemical subtext. The power of Luna was important in chemical operations, which followed the astrological calendar, for the changeable moon dominated transformation. Bosch's pink fountain of life also resembles

a 'pelican' vase in shape (142). This common vessel, still used today, is comprised of a round base and narrow neck, connected by two arms, and is used for the circulation and condensation of vapours. The name 'pelican' refers to its practical function in the laboratory, which was to revivify desiccated materials in its base via the connecting arms. The shape mimics the bending of the allegorical pelican's neck as she pierces her breast, allowing her healing blood to flow over her young. Bosch here indicates another parallel to Christ's sacrifice, as he did by placing a pelican in the middle of the circular grisaille Passion narrative on the reverse of the *St John the Evangelist* panel (see 82).

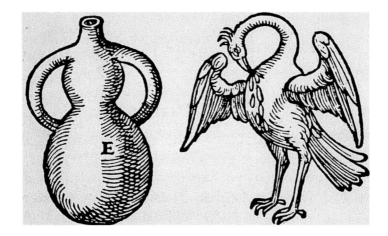

142
Pelican flask, from Giambattista della Porta, *De distillationibus*, Leiden, 1604

A small owl (see 141) perches in the round base of the pink fountain, peering wide-eyed at the mass of black rubble beneath it. The owl, symbol of learning and, according to legend, hated by other birds for its nocturnal habits, was the alchemists' mascot; like the wise owl, chemists worked into the night, often drawing criticism for delving too deeply into the secrets of nature. On closer inspection, the dark mound reveals surprising riches, in the form of crystals, pearls and other sparkling gems embedded within it. This is a clear reference to one of alchemy's common metaphors, the *prima materia* (prime matter), the original base matter from which all substances are formed. This substance, the raw material

of chemical transmutation, was perceived as both base and noble, precious and worthless. The thirteenth-century churchman and alchemist Roger Bacon described the valuable *prima materia* as 'cast out upon a dung hill as a vile thing', and the ancient philosopher Hermes Trismegistus called it 'most dear and valuable, yet vile and the most vile'. The murky black mass upon which Bosch's fountain rests contains the precious elements inherent in all things, capable of being perfected by science with God's guidance.

Bosch suggests yet another, more mundane, type of creation, that of 'spontaneous generation', in the lower right sector

143
Sea Creatures,
from *Hortus sanitatis,*
Strasburg,
1491

144
Sea Unicorn and Sea Monk,
from *Hortus sanitatis,*
Strasburg,
1491

145
Overleaf
Garden of Earthly Delights
(detail of 137)

of the Adam and Eve panel (145). Here, fantastic creatures inhabit a muddy puddle of primeval ooze and slither onto its banks, recalling the belief that base creatures were spontaneously generated from water, mud and dung. The ancient philosopher Aristotle theorized that the heat secreted by rotting, being in itself a source of life, created new organisms out of the particles dissolved during the process of putrefaction. Albertus Magnus later explained that such organisms were deformed and imperfect because they were not generated sexually, as normal creatures are, but from the accidental interaction of heat and moisture alone. Following nature's example, alchemists believed that, with divine aid

and wisdom culled from the ancients, they too could create life out of putrefaction.

The wonderfully varied, flippered, feathered and clawed beasts that crawl, creep and swim in and around the murky pool are more than figments of Bosch's fertile imagination. Such creatures abound in the popular *Garden of Health* (*Hortus sanitatis*, or *Gart der Gesuntheit*; 143), a pharmaceutical bestiary printed and translated several times in the fifteenth century. Among Bosch's beasts are frogs, the creatures most commonly featured as products of spontaneous generation, as well as others never seen on earth, but described and pictured in the *Garden of Health*. Among them is an aqueous unicorn (144), like the one swimming in Bosch's pool. Next to it is a flying fish, described in the book as having 'wings on its back wherewith he flyeth marvellously well'. Next to the winged fish in Bosch's muddy pool is a cowled, fish-tailed beast reading a book, which bears comparison with the *monach marin*, the sea monk, which the *Garden of Health* describes as having 'a head like a monk … but the face is nosed like another fish and also his body'. The curious sea monk is as bookish as its human equivalent, thus pointing to the state of universal wisdom that

146
Cyriacus d'Ancona, *Egyptian Voyage*, late fifteenth century. Paper; 22 × 14·5 cm, 8⅝ × 5¾ in. Biblioteca Medicea-Laurenziana, Florence

147
Frontispiece for Book 18, from Bartholomaeus Anglicus, *On the Properties of Things (De proprietatibus rerum)*, Haarlem, 1485

existed before the Fall of Man. Bosch's teeming pool would have been understood by literate viewers as reinforcing creation as the overall theme of the panel and the primary goal of early chemistry.

As our eyes move further towards the summit of the Adam and Eve panel, more exotic animals greet us. Of particular interest are the elephant and giraffe who flank the fountain's tall pinnacle (see 141). Though these animals were unknown to northern Europeans in the late fifteenth century, Bosch represents them accurately and realistically. Art historian Phyllis Williams Lehman suggests a relationship with the Venetian painter Gentile Bellini (*c.*1429–1507), who also painted a realistic giraffe. She believes that both Bosch's and Bellini's giraffes were inspired by a late fifteenth-century manuscript copy of Cyriacus d'Ancona's account of his journey to the Holy Land that is housed in the private library of the Medici in Florence (146). However, manuscript texts of books and their illustrations circulated in intellectual circles for decades before their eventual publication. Bosch need not have seen this particular picture, which has always been in Florence, to have known it. Popular books printed in the Netherlands would have been closer to home, and do contain images of exotic animals that correspond to Bosch's. A giraffe appears on the bestiary page of Bernhard von Breydenbach's *Holy Pilgrimages* (*Sanctae peregrinationes*), printed in 1486, and Bosch's elephant is virtually identical to one pictured on the bestiary page of the thirteenth-century traveller Bartholomaeus Anglicus's encyclopedic *On the Properties of Things (De proprietatibus rerum)*, published in 1485 (147). Regardless of the source of Bosch's inspiration, the very real elephant and giraffe in the *Garden of Earthly Delights* comfortably coexist with fantastic creatures, such as the legendary unicorn and sea monk. The fact that real and mythic animals share the same space in the triptych provides an insight into the intellectual fabric of the early modern era, which, like Bosch's painterly vision, drew upon both medieval superstition and empirical observation.

The upper landscape in the Adam and Eve panel (148) gives visual form to a common metaphor that described circulating gases in the process of distillation. Black birds gather at the base of an egg-shaped rock, while others fly circuitously upwards through peculiar natural forms, and return downwards, having changed colour on their journey. In alchemical iconography, birds symbolized vapours, and mountains and houses were the vessels and furnaces that contained them. Chemists spoke of black birds (unclean vapours) flying to the tops of mountains (furnaces and flasks), becoming white (cleansed) and finally returning to earth in the cyclic process of vaporization and condensation. Bosch's black birds spiral upwards

148
Garden of Earthly Delights (detail of 137)

149
Furnace, from Andrae Libavius, *Alchymie*, Frankfurt, 1606

150
Garden of Earthly Delights, centre panel, *c.*1470 or later.
Oil on panel; 220 × 195 cm, 86⅝ × 76¾ in.
Museo del Prado, Madrid

through a post-and-lintel-shaped rock pile, becoming lighter the higher they fly. They circle and descend to a neighbouring rounded hillock, entering as mostly white birds through a hole in its top. In this way, Bosch illustrates the cleansing of impure gases and the circular rise and fall of condensed vapours into liquid, as described in many alchemical tracts. Furthermore, the hut-shaped hillock through which the white birds enter at the bottom left corresponds in shape to a type of rounded furnace (149), including openings for the entrance of fuel and the escape of smoke, that appeared in manuals throughout the seventeenth century. The rounded hillock visually embodies the chemical symbol for furnace, 'mountain'.

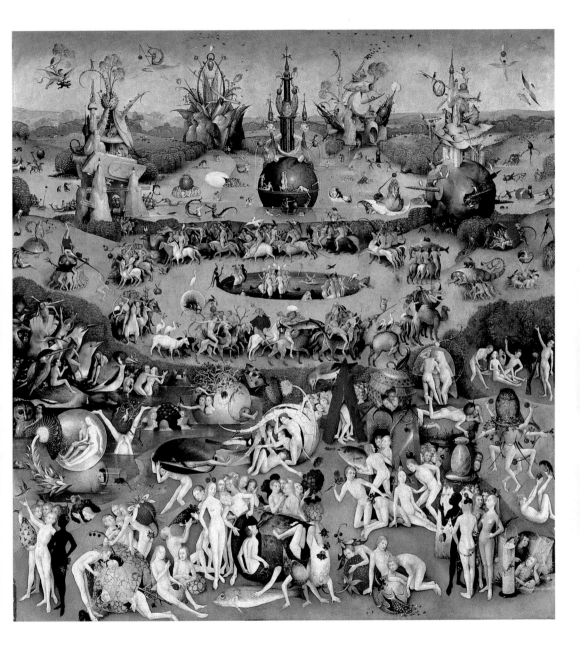

The central panel of the *Garden of Earthly Delights* (150) continues the alchemical thread, picturing full-scale conjunction and the ensuing multiplication of the *prima materia*. Chemists referred to this stage as 'child's play', because they perceived their ingredients as joyfully coupling in imitation of their parents. Bosch's younger contemporary, Salomon Trismosin, compared this step to 'the pleasure and high spirits of children doing frivolous things', and chemical books illustrated it with images of naked putti frolicking in vapours (151) or nude children playing (152). The erotic element inherent in this stage of the alchemical work is congruent with God's command to Adam and Eve to 'Be fruitful and multiply'. Confirming this the inhabitants of Bosch's garden exhibit a certain adolescent sexual curiosity,

allowing glimpses of casual embraces here and there among the pairs of men, women, plants and animals. Among them, black and white people mingle nonchalantly, personifying the marriage of opposites (153).

The light-hearted couplings in the triptych, which sometimes occur between different species altogether, demonstrate alchemists' intention to 'engender by the forces of exuberant love', 'marrying the elements indiscriminately one form with another'. Then, 'the elements being diligently cooked, rejoice and are changed into different natures'. The flower/animal/human forms that cavort throughout Bosch's central panel ingeniously illustrate this alchemical cross-breeding (see 132 and 170). One of the earliest and most venerable alchemical

151
Alchemical Child's Play, folio 60v, from Cod. Voss. Chym. F. 29, c.1522. Bibliotheek der Rijksuniversiteit, Leiden

152
Alchemical Child's Play, folio 76, from Salomon Trismosin, *Splendor solis*, c.1582. British Library, London

treatises, the *Turba philosophorum* (loosely translated as *Convention of Philosophers*), which was translated from the Arabic in the mid-twelfth century, describes this merging of forms: 'things contrary are commingled ... God hath united them peacefully, so that they love one another'. The very uncertainty with which we label the veined buds and amorphous sproutings of Bosch's forms as plant, stone or flesh attests to the process of transmutation of plants into minerals and of animals into plants. Bosch suggests the nature of the philosopher's stone, which, in the words of Roger Bacon,

153
Garden of Earthly Delights (detail of 150)

'springs or grows like a vegetable and abounds with life like an animal'.

A favourite game of Bosch's folk, and of children the world over, involves performing handstands and somersaults. The chemical metaphor of 'turning upside-down' refers to the cyclical rising of vapours and their eventual condensation, and first appeared in the Hellenistic philosopher Hermes Trismegistus's famous saying that 'what is below is like that which is above'. Albertus Magnus linked the topsy-turvy aspect of distillation with the 'play of children, who, when

they play, turn undermost that which before was uppermost'. Many of Bosch's exuberant youths turn themselves upside-down in this, the boisterous 'child's play' stage of the work. Not only do they stand on their heads, but several of them also spread their legs, forming human 'Y' shapes (155). This accords with the doctrine of the thirteenth-century chemist Raymond Lull, whose treatises were collected, copied and printed in the fifteenth century. Lull ascribed letters of the alphabet to various stages of the work, and reserved the letter 'Y' for the 'hermaphrodite', a symbol for the coming together of diverse substances that occurred during alchemical conjunction (154). The imaginative 'Y's that appear throughout Bosch's centre panel therefore suggest the union of opposites necessary for transmutation.

The most curious playthings that occupy the carefree inhabitants of the *Garden of Earthly Delights* are several shiny red spheres scattered throughout the centre panel, distinguished from cherries by their lack of stems (156). The rosy globes also appear in the Prado *Adoration of the Magi*, held in the beaks of golden birds (see 127). Ripley describes the alchemical lapis as 'round, clear, hard, red in colour like a ruby ... the medicine and the perfect red stone, transmuting all bodies', which fits these red spheres perfectly. The lapis was also supposed to taste 'delicious', a characteristic demonstrated by the delight with which Bosch's figures feast on the red balls, which resemble sweets, and offer them to one another as gifts. The lapis as ruby sphere appears in the *Turba philosophorum* as a thing that 'is raised aloft to the clouds, dwells in the air, is nourished in the river, and sleeps on the summits of mountains'. Likewise, Bosch's red orbs are carried aloft by winged humans, float and bob in the water like giant beach balls and rest on the tops of the conglomerate towers that mark the four rivers of paradise, which the Bible describes as existing in the Garden of Eden. They identify Bosch's garden as the very place where Adam, Eve and all the creatures of the earth existed in perfect harmony before

154
*Alchemical
Hermaphrodite*,
from Michael
Maier, *Symbola
aureae mensae*,
Frankfurt, 1617

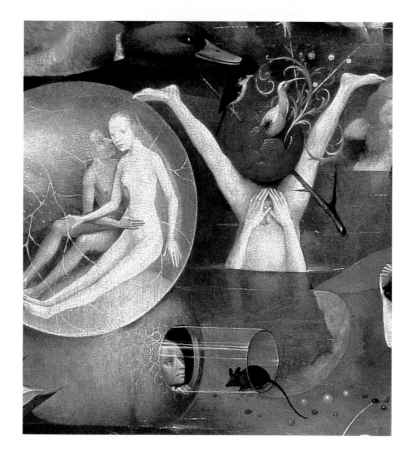

155–156
*Garden of
Earthly
Delights*
(details of
150)

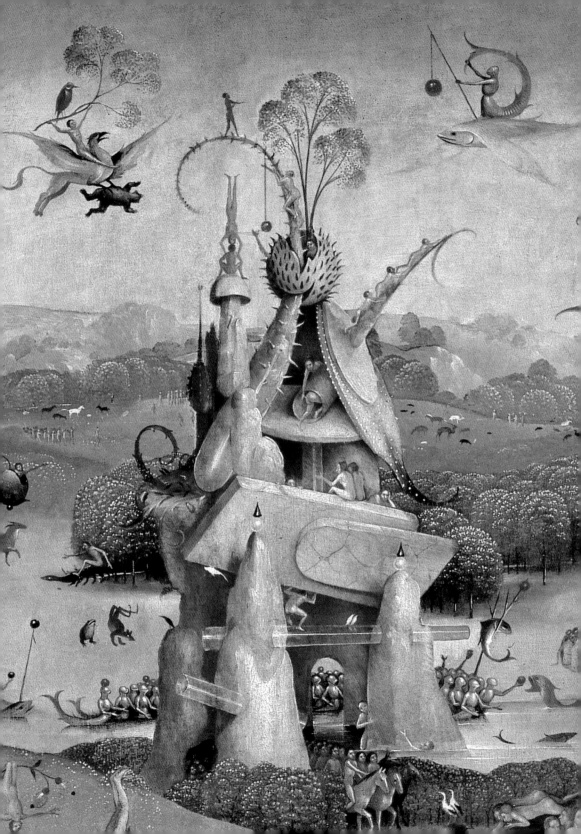

the Fall; yet, the Bible does not describe Eden the way Bosch does – populated with such a human multitude. Perhaps Bosch wished to remind viewers of the possibility of paradise regained by the transmuting elixir of life and achieved through selfless devotion to God. Bosch's wondrous garden, placed between the 'Adam and Eve' and fiery 'hell' panels, further reminds viewers of the salvation that awaits the elect after the final judgement foretold in the Biblical Book of Revelation.

Scattered among the realistic birds, animals and fruit that fill Bosch's scene are several fantastic creatures familiar to the contemporary popular imagination. To the left of the dark fountain of life, several mermaids (157 and see 171), called 'sirens' in the *Garden of Health* (158), frolic in the water. They flirt with male humans and consort with dark, fish-tailed 'merknights' (159), which the *Garden of Health* describes as 'like an armoured man with a helmet on his head'. Several of Bosch's mer-creatures grasp their tails and bend their bodies into circles. In so doing, they mimic one of the most familiar visual images of alchemy, the *ouroboros*, the serpent that symbolizes the circular nature of distillation by simultaneously devouring and giving birth to itself (160). This action embodies the rhythm of nature as a perpetual repeated circuit of birth, life, death and rebirth.

Bosch's delightful garden is punctuated by forms and shapes that at first seem to be flights of fancy, until compared with diagrams in practical distillation manuals. The arrangement of the centre panel, in particular, resembles the frontispiece of an edition of Brunswyck's *Book of Distillation* (1500; 161). Both show a spring garden, populated by merry youths who tend their apparatus amid flowers, baths and various medicinal plants and animals. Bosch's dark-blue fountain of life (164), its neck culminating in a blooming pinnacle of buds and veined tissue, has particularly strong alchemical implications. At first glimpse, this hybrid flower/fountain seems unique – a fantastic growing flask. However, its shape echoes the pelican

157
Garden of Earthly Delights (detail of 150)

158
Siren, from *Hortus sanitatis*, Strasburg, 1490

159
Merknight, from *Hortus sanitatis*, Strasburg, 1490

160
Ouroboros, folio 297, from *Copy of Synosius by Theodoros Pelecanos*, 1478. Bibliothèque Nationale, Paris

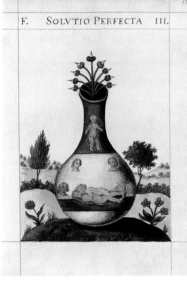

F. SOLVTIO PERFECTA III.

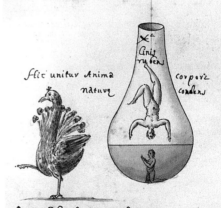

Hic unitur Anima naturæ

Gñs rubeus

corpore condens

Atq̃ nebulæ ad corpus unde exierunt reuersæ sunt facta est unio et coniunctio inter terram et aquam effectus est unio mirtini caloris siue ignis mirtini maturi espertus sum hicit Arnoldus Natura nullum habere metum nisi calore mediante nam vi ut sapiens et calorem et aquam et ignem atq̃ mensus fueris omnia hæc tibi sufficiunt nam corpus albuerit mundant et nutriunt et eius obscu ritatem aufarunt ipsa à aqua habitans in deve

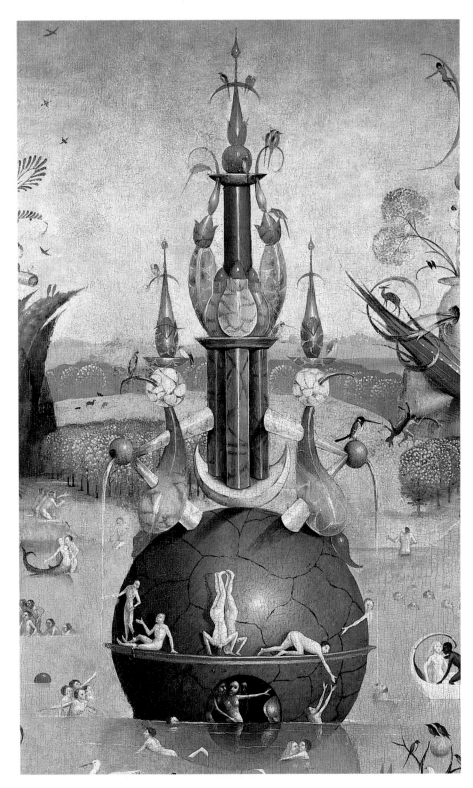

161
**Opposite
top right**
*Pleasant
Garden of
Distillation*,
frontispiece
from
Hieronymus
Brunswyck,
*Liber de arte
distillandi*,
Strasburg,
1500

162
**Opposite
far left**
*Alchemical
Conjunction*,
folio 13, from
*Pretiosissimum
Donum Dei
Georgium
Anrach.*
Bibliothèque
de l'Arsenal,
Paris

163
**Opposite
bottom right**
Distillation
as turning
upside-down,
folio 40, from
MS 29.
Wellcome
Institute
Library,
London

164
*Garden of
Earthly
Delights*
(detail
of 150)

retort (see 142), nicknamed the 'marriage chamber', in which opposites were mixed in the mating of the elements. In affirmation, Bosch allows us to glimpse, through a round peephole in the fountain's base, a small man and woman engaged in erotic activity. The image of a budding flask containing little men and women, some of them engaged quite openly in sexual congress, originated in the *Turba philosophorum*. The image is standard in early alchemical manuscripts, particularly those inspired by Bonus's *New Pearl of Great Price*, written *c.*1330 (162). The two acrobats poised in a double handstand on the rim of Bosch's blue fountain embody the 'turning upside-down' of cyclic distillation, illustrated similarly in chemical tracts as a somersaulting figure (163). Bosch's vision of an organic

165
Hollow glass tubes, folio 78, from Cod. Voss. Chym. F. 29, *c.*1522. Bibliotheek der Rijksuniversiteit, Leiden

166
Bain-marie, from Andrae Libavius, *Alchymia*, Frankfurt, 1606

167
Garden of Earthly Delights (detail of 150)

fountain of life housing a sexually engaged couple corresponds to the image of conjunction described by the twelfth-century alchemist Artephius in his *Secret Book* as taking place in a 'fountain of living water, which circumvolveth and contains the place in which the King and Queen [opposites] bathe themselves'.

Bosch camouflages his fountain/flask with a profusion of organic ornament. It and the other suggestive laboratory machinery serve as toys for Bosch's playful folk, attesting to the frivolous nature of alchemical 'child's play'. However, one type of chemical apparatus is unadorned and unmistakable, even to modern eyes. The glass tubes jutting from the black

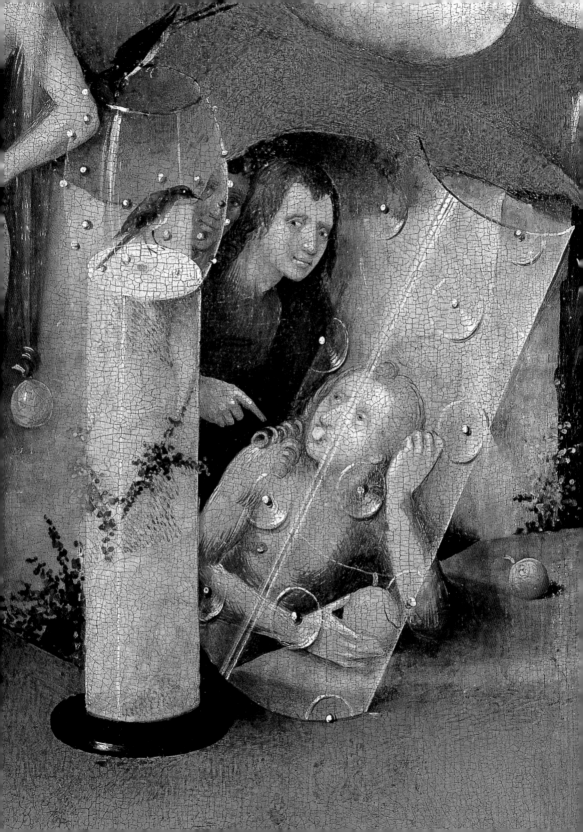

mass on which the fountain rests in the left panel (see 141),
and strewn about the garden-scape in the central scene (see
150), are essential chemical tools still used by modern
chemists. Brunswyck's manual illustrates them, and describes
them as 'pipes of glass ... hollow and open at both ends' (165).
Bosch includes other references to the practical furnishings of
a distillation laboratory in the centre panel. One such object,
in the lower right corner (167), resembles a *bain-marie*, a
type of water still in which materials were placed for gentle
heating (166). Bosch depicts the base, columnar cooking
vessel and rounded glass head, in and on top of which are
two birds, symbolizing vapours. Brunswyck recommended
this particular type of still for the gentle cooking of herbs,

168
Egg vessel,
Germanisches
Nationalmuseum,
Nuremberg

169
Egg coupé, from
Conrad Gesner,
*Quatre livres des
secrets*, Paris,
1573

fruits and vegetables, best accomplished in the month of May,
'near the smell of flowers'.

The symbolic language of alchemy referred to the ovoid vessel
in which transmutation took place as the 'egg' (168). Eggs
of the mundane sort appear in every panel of the *Garden of
Earthly Delights* triptych, and it is one alchemical symbol that
scholars frequently note. Eggs were considered microcosms of
the world, containing all the qualities of life, the four elements
perfectly conjoined. A vessel shaped like an egg might, by
its resemblance to the common object, aid transmutation of
the substances within it. Bosch scatters egg retorts about the
centre panel, the largest of which lies on its side in the lower
central sector (170). It contains a man who leans out with open

170–171
*Garden of
Earthly
Delights*
(details of 150)

172–173
*Garden of
Earthly
Delights*,
right panel,
*c.*1470 or later.
Oil on panel;
220 × 97 cm,
86⅝ × 38⅛ in.
Museo del
Prado, Madrid
Top right
Detail

174
Bagpipe
retort, folio
10r, from
MS 0.3.27,
fifteenth
century.
Trinity
College
Library,
Cambridge

175
House
furnaces,
folio 65,
from
MS 446,
late
fifteenth
century.
Wellcome
Institute
Library,
London

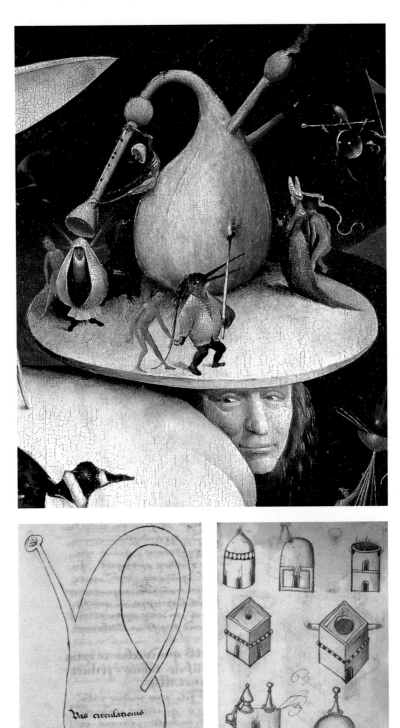

mouth to accept fruit being offered him. This is an *egg coupé*
(169), the top of which was cut off to allow the stirring of
mixtures. Another, more realistic, egg lies near the shore of
Bosch's lake in the upper sector of the panel (171). A group of
people climbs into it, imitating the orderly procession of birds
in the Adam and Eve panel (see 148). This unexpected reverse
hatching signifies the initial entrance of materials into the egg
vessel, where they were heated gently in imitation of the
natural internal heat thought to exist within a hen's egg.

The alchemical egg is most unmistakable in Bosch's 'hell'
panel (172), where it forms the body of a grotesque human-
headed monster. Jacques Combe, one of the first art historians
to discern alchemical motifs in Bosch's triptych, recognized
this egg's chemical significance, calling the creature the
'alchemical man', and noting its hollow tree legs, which blaze
from within like furnaces. The bagpipe atop the head of the
egg man has both musical and alchemical connotations (173).
Its shape is identical to that of a common vessel that was
also called the 'bagpipe' (174) because it was 'shaped like a
musical instrument which the Germans play vulgarly'.
Bosch's pulsating, rosy bagpipe serves as both musical
instrument and alchemical flask, in the same way that the
creature's white egg body is both everyday object and
laboratory apparatus.

The spectacular scene of hellfire and destruction in which
the forlorn egg man stands contrasts starkly with the pastoral
calm of the Adam and Eve panel and the riotous high spirits of
the centre scene. While buildings burn, icy rivers flow through
a lurid cityscape, its buildings belching steam and flames
like so many furnaces (175). The shivering inhabitants in this
panel, nude here as in the central scene, undergo grotesque
tortures visited upon them by hordes of fiendish demons. In
the lower right foreground, a giant bird creature (see 177),
seated on a potty-chair throne, eats and excretes sinners
through his oversized anus into a murky cesspool, mimicking

176
*Satan Eating
and Excreting
the Souls of the
Damned in
Hell*,
Florentine
engraving.
22·3 × 28·4 cm,
8³⁄₄ × 11¹⁄₈ in

traditional depictions of Satan in Last Judgement scenes (176).
Clustered around the hellish latrine are vignettes that relate
to proverbs, moral prohibitions and Biblical warnings against
sin. Here, a glutton is forced to vomit for eternity the rich food
that occupied him during life, while a miser must defecate his
carefully horded gold coins into the satanic cesspool. A woman
guilty of vanity and lust endures perpetual demonic fondling,
while simultaneously confronting her pained visage in a
mirror stuck to a demon's backside. As in the reconstructed

triptych containing the *Death of the Miser* (see 31) and *Ship of
Fools* (see 28), Bosch singles out the sins of avarice, gluttony
and lust for special condemnation.

The oversized musical instruments in the hell panel assist
in tormenting the damned (177). The giant lute crushes a
figure beneath it, while another poor sinner is bound to its
neck by a demon's serpentine tail. Bosch's harp, so often

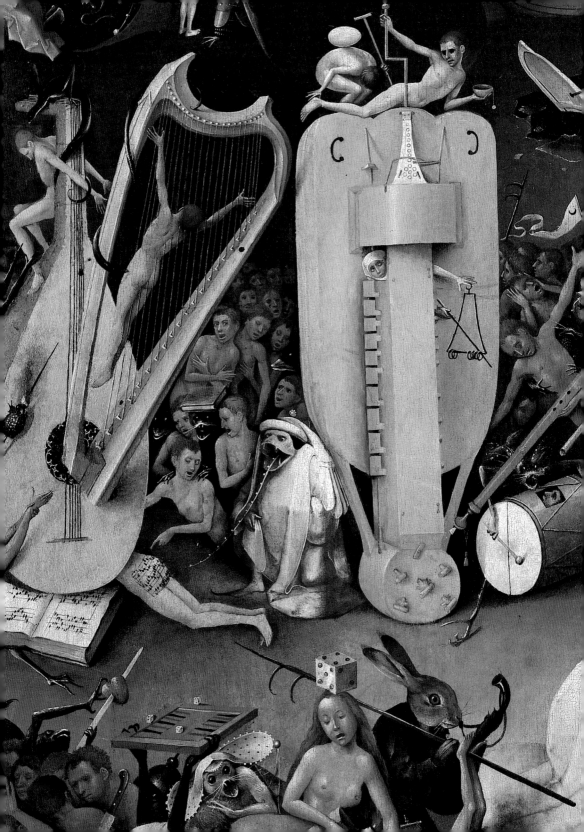

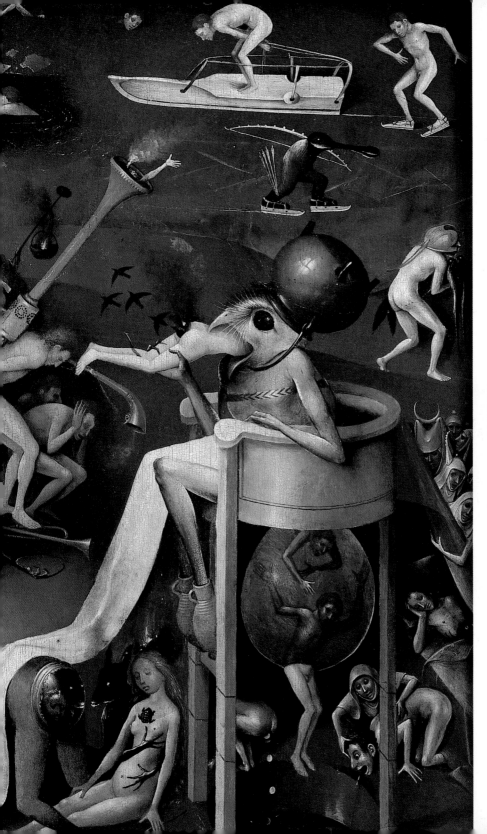

*Garden of
Earthly
Delights*
(detail of 172)

shown played by angels, crucifies a sinner between the
span of its strings. The hurdy-gurdy was the instrument
of peasants and beggars, as indicated by the blind figure
balanced on its top. He holds the bowl and disc required
by order of Duke Philip the Good to be carried by beggars.
The hurdy-gurdy houses a small woman who, trapped
between its turning wheel and strings, is in danger of
being torn apart by friction. We should not assume, in
looking at these horrifying vignettes, that Bosch meant
to castigate either music or alchemy by placing them
in hell. Rather, the unfortunate inhabitants of the nether-
world are being punished for eternity by the very things
they abused in life.

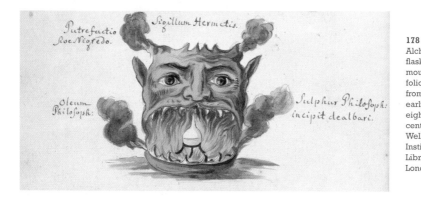

178
Alchemical
flask in hell
mouth,
folio 74,
from MS 4775,
early
eighteenth
century.
Wellcome
Institute
Library,
London

While commenting upon the nature of sin and the fear of
damnation, Bosch's inferno continues the evolving thread of
chemical symbolism begun in the Adam and Eve panel. It
reflects alchemical putrefaction, the stage characterized by
fire, violence and death. Standard chemical synonyms for this
stage include Saturn, melancholia, chaos, hell and the end of
the world. Indeed, one imaginative chemical book illustrates
putrefaction by placing the long-necked marriage flask
literally within the mouth of hell (178), while another depicts
scenes of execution and torture (179). In putrefaction, as
in all aspects of alchemical practice, Christian ideology
supplied an allegorical framework for the routine of the

laboratory. Metaphorically, chemists 'killed' and 'punished' their ingredients by fire before 'resurrecting' them into pure, transmuted matter. In so doing, they knowingly imitated the Christian cycle of birth, life, death and resurrection.

The ingredients of putrefaction were called 'leprous', leprosy being the disease associated most strongly with Saturn, the planet that ruled laboratory procedure during this time.

179
Alchemical
putrefaction,
folio 5v, from
*Buch der heiligen
Dreifaltigkeit*,
early fifteenth
century.
Kantons-
bibliothek
Vadiana,
St Gallen

Bosch's alchemical man, like the Rotterdam *Wayfarer* (see 27) and the enigmatic crowned figure in the Prado *Adoration of the Magi* (see 126), wears a bandage around one of his tree legs, which covers a running, leprous sore. The appearance of Bosch's egg man, mired in a dark pool, recalls the *Turba philosophorum*'s description of the ingredients in putrefaction as 'an unfortunate man … who waits to finish his days in a

stinking infected spot'. The image, culled from ancient sources, is reinforced in Bosch's panel by a small figure leaning against the lower edge of the egg man's white shell body, resting head on hand in the universal pose of melancholia.

Bosch's hell panel is crowded with scenes of torture and punishment, many of which allude to alchemical putrefaction. Among the most prominent recurring images are knives, swords and other sharp objects. The most striking cutting implements in Bosch's panel are two giant knives (180), each bearing a curious letter on their blades. Scholars have read this cipher as a Gothic 'M' or 'B', and an actual knife bearing such a marking has been found in archeological excavations in 's-Hertogenbosch. However, close inspection reveals that this character is, in fact, not a Latin letter at all, but the Greek vowel omega (Ω). Chemists assigned the omega, the last letter of the Greek alphabet, to Saturn and that planet's dominance over death, violence and putrefaction. The giant knife would therefore symbolize the destruction of elements necessary to prepare the way for transmutation, while the omega on its blade would be a synonym for both the violence of putrefaction and the horrific end of the world in the final Apocalypse. In a humorous aside typical of Bosch's fertile imagination, the large blade, painfully slicing through a pair of ears, seems to make a sly commentary on the nature of the sounds emanating from the demonic musical instruments beneath it.

An alchemical reading of the *Garden of Earthly Delights* is not complete without a discussion of its exterior panels (181). Bosch's monochromatic image of a transparent globe containing clouds of vapour, water and earth represents God's creation of the earth, which alchemists imitated, and recalls the egg in its common laboratory form, a spherical or ovoid glass vessel. The image of a drowned and soggy earth, encased in a glass container, corresponds to the alchemical vision of the stage of 'ablution', also called the 'flood of Noah',

180
Garden of Earthly Delights
(detail of 172)

when the ingredients were washed, cleansed and resurrected (182). In the laboratory, alchemists noted that the heavy parts of earth remained in the bottom of the flask and the subtle vapours rose upwards. Bosch expertly reproduces the reflective properties of glass and the steamy vapour clouds as they appeared at this time. Among the amorphous sproutings and embryonic landscape forms encased within the glass orb, there is one that is clearly recognizable (183) as the same furnace-and-flask combination (184) that appears in the *St Anthony* and Prado *Adoration of the Magi* triptychs (see 106 and 121). This structure points to the subtext of Bosch's Biblical story, for those prepared to appreciate its scientific iconography.

181
Garden of Earthly Delights, exterior, c.1470 or later.
Oil on panel; 220 × 195 cm, 86⅝ × 76¾ in.
Museo del Prado, Madrid

182
Inundated world, folio 10, from MS Sloane 12, seventeenth century. British Library, London

Bosch places God at the top of the triptych's exterior, along with two Latin Biblical inscriptions describing the creation of the earth: *Ipse dixit et facta su[n]t* (For He spoke, and it was) and *Ipse ma[n]davit et creata su[n]t* (By his command, they were created). Chemists revered God as the ultimate creator and healer, and strove to imitate him in every aspect of their work. 'It is why some doctors have written that the Philosopher's work will be perfected in seven days,' wrote Salomon Trismosin, who believed that a closer tie to the Creator could be experienced in this time span. Most authorities directly referred to God's example, justifying

their efforts by summoning the ancient authority of Hermes Trismegistus, who asserted, 'Thus was the world created.'

Bosch's inclusion of a benevolent God raising his hand in blessing confirms salvation through faith as the ultimate goal of medieval science. The promise of an earthly paradise, like the one hidden beneath the exterior of the triptych, was strong enough to keep the myth of chemical transmutation alive throughout the seventeenth century, despite repeated failure. Bosch's vision, masterfully spread across five extraordinary panels, perfectly illustrates Ripley's vivid description of the

183
Garden of Earthly Delights, exterior (detail of 181)

alchemical work: 'The floods shall dry up, thou shalt see a mist upon the face of the water and the dry land or earth shall appear as in the first creation. Thou shalt see appear before thy face ... all things that God did create in six days ... You will now see what body Adam and Eve had before their fall ... What fruit they did eat, where and what Paradise is and what it was.' Ripley, who was court alchemist for King Edward IV of England, spoke of paradise lost and paradise regained after the 'flood', reflecting the belief that success would result in a return to Eden for the human race. Likewise, beholders of

Bosch's triptych would have connected the luscious garden of delights with the rewards of a life devoted to earnest study and Christian devotion.

Art historians disagree about the order in which the separate scenes of Bosch's triptych were meant to be viewed. Do the exterior panels represent the Biblical Flood of Noah, as suggested by Ernst Gombrich, and, if so, does the image show the world before or after its destruction? Should we accept the exterior panels as a depiction of the earth on the third day of creation, and the interior scenes as a straightforward Biblical

184
Flask and
heat source,
folio 108v,
from
MS Harley
2407,
fifteenth
century.
British Library,
London

narrative with moralistic overtones? Alchemical allegory does not contradict any of these interpretations. Chemists believed that the first step in every distillation cycle was built upon the ashes of a previous cycle; thus the first step in the process was also the last. Within this regimen, every ending was a beginning and every beginning contained an end, in imitation of the rhythm of nature and the Biblical rise, fall and renewal of the world itself, described in the legend of Noah and predicted in Revelation. The very act of opening and closing Bosch's triptych imitates the process

of distillation, the end of which exists in its beginning, like the self-perpetuating *ouroboros*. The odyssey of creation, multiplication and destruction in the interior panels is superseded and obliterated by the final cleansing, or 'redemption', of the chemist's materials. By proper imitation of God's creation of the world and its inhabitants, devout chemists intended to save the human race from obliteration and guide it to an age of grace and renewal.

The *Garden of Earthly Delights* remained in the Brussels palace of Hendrick III of Nassau until 1568, when it entered the collection of the Duke of Alva during the Spanish occupation of the Netherlands. By 1593, seventy-seven years after Bosch's death, the triptych had found a new home in the monastery of the Escorial, built by Philip II as a place of meditation and healing. Philip not only collected Bosch's works, but was also a patron and student of alchemy, and paid for the translation of several chemical texts. In fact, José de Siguenza, the same authority cited earlier as one of the first connoisseurs of Bosch's art (see Chapter 7), describes a tower and wing at the east end of the Escorial, designed by architect Juan de Herrera to house a hospital dedicated to St Anthony and elaborate chemical laboratories in the service of the king. Siguenza laments, 'It would take a long time to render a proper account of the apparatus of distillation, alembics and other extraordinary things which one encounters in the quintessences and other abstractions and sublimations of the Grand Art.' Another contemporary account of the Escorial's laboratory describes 'a cloister or patio, which is devoted to pharmacy ... Here one sees all sorts of distillation apparatus, each more extraordinary than the other, new models of alembics, some of metal, others of glass.' Philip II deplored the use of alchemy for magical or materialistic purposes; but he clearly supported its use in medicine and recognized its philosophical importance and power in obtaining moral insight and spiritual salvation. It is therefore of great significance that this same monarch acquired the *Garden of Earthly*

Delights and Prado *Adoration of the Magi* (see 115), works replete with chemical imagery, for placement within the Escorial, a space dedicated to study and healing. Clearly the king, a devout Catholic, was neither shocked nor offended by the content of these paintings and, in fact, probably recognized and valued their deft synthesis of science and piety. It is also significant that succeeding generations of Habsburg nobility continued to collect paintings by Bosch, including the Emperor Rudolf II, who, in the late sixteenth century, designated an entire sector of the city of Prague for state-supported chemical laboratories. As a matter of fact, historians of science recognize a 'golden age of alchemy' achieved under Habsburg patronage, which flourished until the close of the seventeenth century.

The all-inclusive nature of the philosophy of alchemy was summarized by Petrus Bonus, who compared the elixir of life to

things heavenly, earthly, and infernal ... to things corruptible and incorruptible ... to the creation of the world, its elements and their qualities, to all animals, vegetables and minerals, to generation and corruption, to life and death, to virtues and vices, to unity and multitude, to male and female, to the vigorous and weak, to peace and war, white and red and all colours, to the beauty of Paradise, to the terrors of the infernal abyss.

Early chemists further defined their work as a means of bringing them nearer to God and viewed their research as a Christian duty. Bosch's day witnessed a revival of alchemical philosophy, which emphasized the redemptive power of the work. Thus, the central panel of the *Garden of Earthly Delights* suggests a future Eden, where there is no illness, sin or other imperfection – the result of the alchemist's success, made possible with God's help. It can be read sequentially as representing alchemical 'child's play', but also as the focal point of the triptych – a reminder of Paradise regained, the reward that awaits all devout Christian men and women after

Christ's second coming. Martin Luther, a reformer not well disposed to the purposes of painting, recognized alchemy's moral value, describing it as 'rightly and truly the philosophy of the sages of old with which I am well pleased, not only by reason of its virtue and manifold usefulness ... but also by reason of the noble and beautiful likeness which it hath with the resurrection of the Dead on the Day of Judgement'. Indeed, alchemy's eschatological relevance – its promise of an earthly paradise achieved by science – was important to Bosch and his educated patrons, who feared the coming Apocalypse.

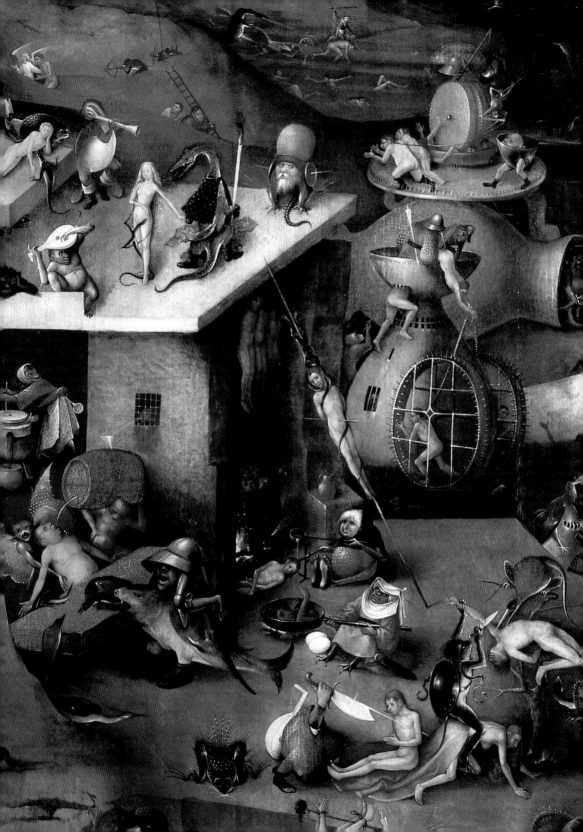

Fearful anticipation of the approaching Apocalypse was an integral part of medieval thought, and preparation for the final days of the world was a chief concern not only for the Church of Bosch's day, but for all people. Bosch's paintings of apocalyptic subjects – two *Last Judgement* triptychs in Bruges (see 190) and Vienna (see 192), the *Devastation by Fire* (see 199) and the *Flood* (see 196) in Rotterdam, and four *Afterlife Panels* in Venice (see 204–207) – are typically rich in their encyclopedic depictions of the horrific and corporeal wages of sin. They both reflect and reinforce the ubiquitous apocalyptic panic that gripped all levels of society in Bosch's time.

The Biblical Book of Revelation, written, according to tradition, in the first century by St John the Evangelist on the island of Patmos, tells of a future war between good and evil (Armageddon), followed by a thousand years (a millennium) of peaceful existence. After the millennium, Christ will reappear to preside over the final destruction and judgement of the human race, the Apocalypse. Only then will the privileged elect experience the bliss of eternal paradise as the ultimate reward for lives spent in Christian devotion and self-denial. Infidels and sinners, who are much more numerous in the world, will receive their due by being sentenced to eternal damnation.

185
*Last
Judgement*
(detail of 192)

The terrors of the End Time had loomed large since the early days of the Church, when Christianity was persecuted and followers hoped for a day of deliverance and the divine transformation of the world. As the end of the first millennium approached, believers quaked in expectation; the harrowing images of the Last Judgement carved on

Romanesque church portals (186) still have the power
to inspire fear and awe. However, the year 1000 passed
unremarkably, and, in fact, was followed by a time of
increased optimism and social progress. Had the Evangelist
been mistaken about the time of the final judgement, or did
God have another plan for humanity? Certainly the world
will end, like all things, but when, and how?

The twelfth-century Biblical commentator and Cistercian
monk Joachim of Fiore believed that there was a pattern and
meaning in Revelation that enabled him to prophesy the

186
Gislebertus,
*Last
Judgement*,
west
tympanum,
Cathedral of
Autun, *c.*1130

events of the divine plan and date the Apocalypse from his
own time. He posited three ages of the world, ending with a
'golden age' of peace and plenty, in which he was living, just
before the last days. The failure of the world to end in 1260,
as Joachim predicted, was explained by succeeding genera-
tions as the result of human error. Joachim's prophecy was
based on the belief that the age of the earth at its end would
be about six thousand years, but no one was sure how old the
earth actually was. Had the millennium been delayed, would
it begin tomorrow, or had it already been set in motion?

Prophets of doom throughout history used Joachim's formula to place the end of the world in their own time, so that each era perceived it as a constant threat. As the centuries passed, foretellings of the final days proliferated, reaching fever pitch during difficult and unstable times. Apocalyptic terror was not confined to any time, place or class of people, and the horrors of the world's end were no less immediate and tangible than the brutality of daily life in the Renaissance. Though End Time calculators disagreed as to the time and means of the Apocalypse, and debated whether they were living before or during the millennium of peace, nobody denied the inevitability of the End.

The boundary between the medieval and Renaissance eras is mutable and permeable. Cultural historian Eugen Weber sees the two times as linked by many bridges, and observes that 'One of the processions that marched freely from one side to the other was made up of enthusiastic believers in the imminent end of the world.' The Renaissance claimed a return to truth through examination of ancient wisdom; however, the new appreciation of the Classics was inevitably tainted by medieval superstition. Renaissance Christianity retained the expectation, both fearful and hopeful, that the Apocalypse was at hand. New to this belief, however, was Joachim of Fiore's idea of a 'golden age', an earthly paradise achieved in the final phase of the world. The medieval idea of heaven became united with the Renaissance vision of a terrestrial paradise such as the one envisioned by Bosch in the *Garden of Earthly Delights* (see 133). Intellectually, this change in focus allowed the Renaissance to justify and valorize its cultural and scientific achievements as heralding the prophesied golden age, essential preparation for the coming Apocalypse.

Astrologers and self-proclaimed prophets set the date of the Last Days variously, some at 1499, others at 1505, 1524 or 1533. The year 1500 was marked by apocalyptic terror on a

grand scale, for it represented the auspicious 'half-time after the time', the millennium plus five hundred years. Scholars and simple folk alike scanned the horizon intently for signs of the End Time. What they saw convinced them that the world was indeed foundering under a pall of sin and evil. Half-starved peasants wandered the land, whipping themselves into a desperate frenzy to atone for their sins. Deadly plagues of ergotism and syphilis ravaged a world already weakened by famine, poverty and warfare. In 1490, the charismatic Dominican priest Savonarola convinced the people of Florence to burn their material possessions, which he saw as evidence of their worldliness and vice, in readiness for the coming end. He would experience his own, personal conflagration at his public execution eight years later. The Church itself seemed to be assailed by the forces of evil and dissolution. The Great Schism, during which rival popes established separate courts, had transpired between 1378 and 1414, simultaneously with the Hundred Years War, which decimated northern Europe in 1337–1453. An even more heinous outrage occurred in 1453, when 'infidel' Turks sacked Constantinople, killing Christians and desecrating the city. The world much needed cleansing and rebirth. Devout Christians, who saw themselves as the future martyrs and saints of the Last Days, were certain of their moral superiority. They awaited the Apocalypse eagerly for their chance to reign with Christ in eternal bliss, while the rest of the world quaked in fear.

To the ordinary person living in Bosch's time, signs of corruption appeared to be increasing daily. Earthquakes, plagues and floods seemed more numerous than before as prophets of doom assiduously distributed the bad news to all levels of society via printed books and broadsheets. The portentous conjunction of the planets Jupiter, Saturn and Mars in the zodiac sign of Scorpio in 1484, vividly illustrated in a single woodcut sheet attributed to Dürer (187), was regarded with great fear. This astrological event was blamed

in hindsight for the plague of syphilis that had, in all likelihood, been introduced into Europe by the first travellers to the New World. Dürer's print shows a syphilitic, covered with sores, standing beneath an astrological configuration of the disastrous planetary conjunction. Riding the crest of millennial paranoia in 1498, Dürer's *Four Horsemen* (188), which was part of a larger series of woodcuts illustrating apocalyptic events, pictures the fierce and relentless progress of plague, warfare, famine and death as riders who trample the people of the world in the Last Days. This image

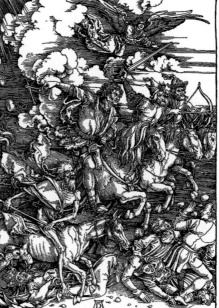

187
Albrecht Dürer,
Syphilitic with Conjunction of Saturn, Jupiter and Mars in Scorpio,
1496.
Woodcut

188
Albrecht Dürer,
Four Horsemen of the Apocalypse,
1498.
Woodcut;
39 × 27·9 cm,
15½ × 11 in

was calculated to appeal to those who feared for their eternal souls; it ended up making its creator wealthy and famous beyond his dreams.

Apart from generating societal angst, awareness of the coming Apocalypse also inspired important cultural advances. Christopher Columbus, for example, undertook his voyages in the late fifteenth century with the firm conviction that the world would end in 1650. His study of the Bible had convinced him that, by sailing west, he could

189
'Last Judgement Machine', reconstruction by Jan Mosmans

reach the Indies, where he would find the legendary mines of Solomon and the Garden of Eden. Columbus assured his patrons, King Ferdinand and Queen Isabella of Spain (the latter collected Bosch's works), that his excursion would finance the great Spanish crusade to retake the Holy Land from the Turks, and the subsequent leading of the world to glorious renewal through 'the restitution of the House of God to the Holy Church'. Though Columbus failed to find the Garden of Eden, he succeeded in discovering the other half of the terrestrial world.

The years around 1500 were populated with heretical millennial sects claiming to be the saints of the Last Days. One such group was the Brethren of the Free Spirit, or Adamites, whose philosophy of amorality and practice of celebrating rituals in the nude were believed by art historian Wilhelm Fraenger to have influenced Bosch. Though the

Adamites were numerous in northern Europe, their presence
was considerably lessened when their stronghold in Bohemia
was destroyed in 1421. Millennialist historian Norman Cohn
makes a case for the continuance of the Adamite heresy in
the Netherlands well after that date. He notes, however,
that members of the sect were hunted, persecuted and
often executed by civic and Church authorities alike.
Bosch's public prominence and membership in the pious
Brotherhood of Our Lady makes his participation in the
Adamite heresy inconceivable.

Bosch's fascination with apocalyptic imagery reflects
the larger Christian artistic tradition. However, he was
confronted with more immediate reminders of the imminent
Apocalypse very close to home. The Brotherhood of Our
Lady did their part to fulfil the Evangelist's call for the
unification of all peoples in the Christian Church by
including several converted Jews among their membership.
However, one need not have been a member of an exalted
confraternity to be reminded of the millennium count-down
in 's-Hertogenbosch. The Church of St Jan, dedicated to the
author of Revelation, housed a 'Last Judgement Machine'
made by the clockmaker and goldsmith Peter Wouterszoon.
The device, an ingenious combination of clock, celestial
calendar and wind-up music box, was installed in 1513.
Though the marvellous contraption is unfortunately lost,
the Dutch historian Jan Mosmans reconstructed its possible
appearance by consulting early accounts of its workings
(189). According to seventeenth-century descriptions,
angels blowing trumpets of doom ornamented its top. When
their trumpets sounded, two doors opened to reveal the three
Magi, followed by an enactment of the Last Judgement that
featured devils with hooks in their hands bursting forth to
drag the damned into hell, as the blessed rose to heaven. The
Last Judgement Machine sat atop a working clock that not
only kept track of the movements of the planets and zodiac,
but also ticked away the hours until the final reckoning.

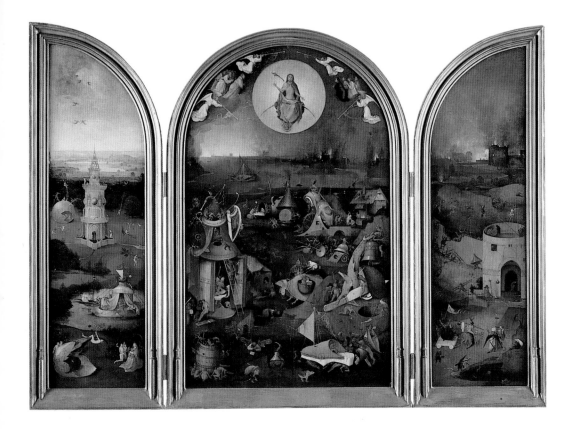

190
*Last
Judgement*,
*c.*1480 or later.
Oil on panel;
centre panel
99 × 60·5 cm,
39 × 23¾ in,
side panels
99 × 28·5 cm,
39 × 11¼ in.
Groeninge-
museum,
Bruges

There exist two complete *Last Judgement* triptychs attributed to Bosch in Bruges (190) and Vienna (see 192, 193), and fragmentary remains of a *Last Judgement* in Munich (191). Dendrochronological evidence dates the Munich fragment *c*.1442 or later, perhaps too early for Bosch, but not for his family workshop. The Bruges and Vienna triptychs date *c*.1480 and *c*.1476 or later respectively, making them strong candidates for firm attribution to Bosch. Both *Last Judgements* contain figures and vignettes also seen in the hell panels of the *Garden of Earthly Delights* (see 172) and *Haywain* triptychs (see 49), such as the large knives marked

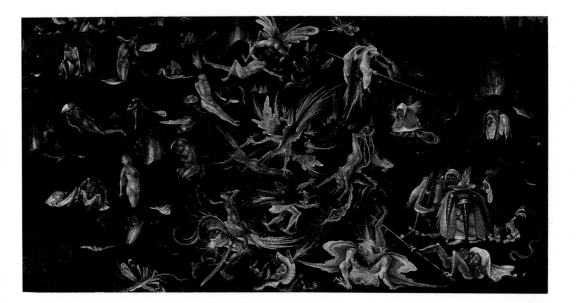

with the Greek omega, demonic musicians and duck-billed, reptilian devils. The Bruges triptych, however, has long been a disputed work, and its pastiche-like quality is typical of a workshop product. Scholarly opinion favours the Vienna version as more likely to be the *Last Judgement* commissioned from Bosch in 1504 by Philip the Handsome, son of Maximilian I and sovereign of the Lowlands. The commissioning document, the only one we have for Bosch, reads as follows, roughly translated from the archaic French: 'September, 1504. To Jeronimus van Aeken, called Bosch,

191
Hieronymus
Bosch or
Workshop,
*Last
Judgement*,
c.1442 or
later.
Oil on panel;
60 × 114 cm,
23⅝ × 44⅞ in.
Alte
Pinakothek,
Munich

painter living in Boisleduc, the sum of thirty-six livres given in advance … for a large painting nine feet high and eleven feet long of the Judgement of God also showing paradise and hell.'

The Vienna triptych (192, 193) is in a poor state of preservation. It has been retouched several times since the sixteenth century, and modern restorers believe that several inches were cut from its top. It is possible that inept attempts at preservation have blunted its original appearance, which may account for the hard-edged landscape forms, somewhat clumsy figures and thick paint layers that mar some sections. Furthermore, the commissioning document stipulates the dimensions of the panels as 'nine feet high and eleven feet wide', and the Vienna triptych measures only about $1 \cdot 7 \times 2 \cdot 3$ m ($5^1_2 \times 7^1_2$ ft). These anomalies have caused scholars to question the triptych's identification as the one commissioned by Philip the Handsome. Is the modern foot longer than that employed in 1504, or was the stipulated size only provisional? Would the inclusion of a frame and predella, now lost, have brought the Vienna triptych to the dimensions stated in the contract? Is the Vienna *Last Judgement*, after all, the same work mentioned in the commissioning document or a good copy after the lost original? Perhaps, also, the work he ordered in 1504 was not complete at the time of Philip the Handsome's death in 1506, in which case the Vienna triptych could be an abbreviated version of the one originally commissioned. This may explain why the cartouches at the bottoms of the exterior panels (see 193), intended to display the coats of arms of the donor, are curiously empty.

The association of apocalyptic imagery with Philip the Handsome would have reminded contemporary audiences of the prophecy of the 'last emperor', a 'king of the Romans', who would appear in the End Time to usher in the new age. In 1488, the *Prognostications* (*Prognosticatio*), a book of

192
Last Judgement, c.1476 or later. Oil on panel; centre panel 163·7 × 127 cm, 64¹₂ × 50 in, side panels 163·7 × 60 cm, 64¹₂ × 23⅝ in. Gemälde-galerie der Akademie der bildenden Künste, Vienna

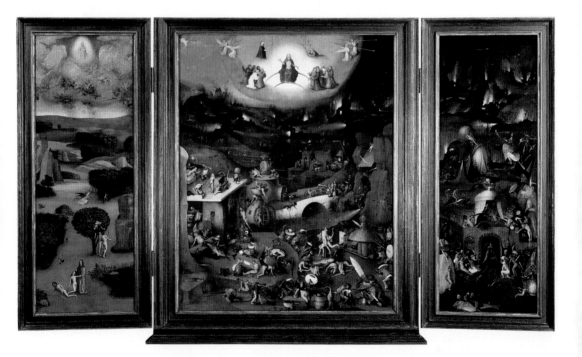

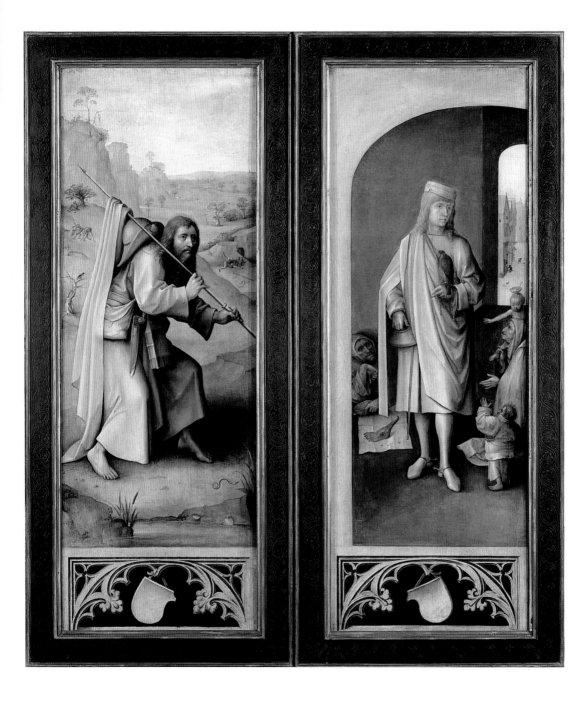

predictions written by the German astrologer John of Lichtenberger, claimed that the Last Emperor of millennial myth was Philip the Handsome, heir to the title of Holy Roman Emperor and the very patron who ordered the *Last Judgement* triptych from Bosch in 1504. Again, in 1496, the astrologer Wolfgang Aytinger calculated the date of the world's end as 1509 and named Philip as Christ's last representative on earth. In fact, the designation Last Emperor was granted every Holy Roman Emperor from Maximilian onwards. Each believed that his would be the honour and responsibility of leading the Elect of the world into redemption and renewal.

The subjects of the grisaille exterior panels of the Vienna triptych (193), devoted to St James the Greater and St Bavo, support a commission by Philip the Handsome. St James the Greater is the patron of pilgrims, who, to this day, make the difficult journey to his shrine at Compostela in Spain. Pinned to James's hat is his attribute, the scallop shell pilgrims' badge. Like the *Wayfarer* on the exterior of the *Haywain* triptych (see 44), Bosch's saint trudges anxiously through a threatening landscape containing scenes of violence and brigandage. St Bavo, who occupies the companion panel, was a rich nobleman from the Netherlands. His legend records that, upon his conversion to Christianity, Bavo gave all his belongings to the poor and lived out the rest of his life as a hermit in a hollow tree. Some of the unsavoury types to whom he administers in the Vienna panel also inhabit the *St Anthony* triptych (see 90), most notably the ergotant beggar, whose detached foot rests ceremoniously on a white napkin before him. It is tempting to see, in the bland, handsome features of Bosch's elegant St Bavo, a portrait of Philip the Handsome, whose youthful good looks earned him his enviable soubriquet and who appears similarly in other works of the time (194). In 1504, the 26-year-old Philip was both Prince of the Low Countries and King of Spain. St James the Greater, whose shrine is

193
Last Judgement, exterior, c.1476 or later. Oil on panel; each panel 163·7 × 60 cm, 64½ × 23⅝ in. Gemälde-galerie der Akademie der bildenden Künste, Vienna

in Spain, and St Bavo, patron of the cathedral in Ghent, represent both realms and distinguish the Vienna triptych as a statement of Habsburg imperial objectives.

The open triptych shows traditional scenes of the Fall of Man in the left panel, and apocalyptic displays of hellish torture and damnation in the centre and right panels. Together, the three scenes present the birth of sin and its consequences, as well as the beginning of the human race and its fiery end. The upper regions of the left panel (195), painted in cool tones of green and blue, depict Lucifer's banishment from heaven. Bosch's rendering is similar, in its atmospheric haziness, to the fall of the rebel angels in the left interior panel of the *Haywain* triptych (see 50). In both works, cast-off angels – soon to be servants of Satan – swarm like insects and are swatted and clubbed by heaven's angelic defenders. The familiar saga of the Fall of Man unfolds beneath the

194
Anonymous,
Philip the Handsome,
c.1500–3.
Oil on panel;
32 × 21 cm,
12⅝ × 8¼ in.
Rijksmuseum,
Amsterdam

195
Last Judgement,
left panel,
c.1476 or later.
Oil on panel;
163·7 × 60 cm,
64½ × 23⅝ in.
Gemälde-
galerie der
Akademie der
bildenden
Künste,
Vienna

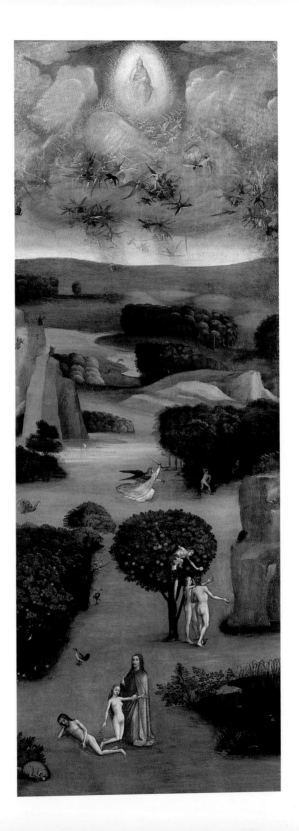

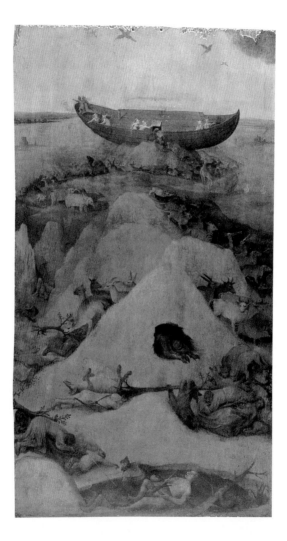

swarm of exiled angels. The creation of Eve recalls the trio
of Adam, Eve and God in the *Garden of Earthly Delights*
triptych (see 139). The tempter, shown as part nubile,
blonde female and part slimy, reptilian salamander, as in
the *Haywain*, offers Eve the forbidden fruit, after which the
first couple are driven from Eden by a sword-wielding angel.

Eve's legacy of sin occupies both the centre and right
panels of the open triptych. Here, Bosch presents a murky
landscape, punctuated by bursts of steam and flame, within
which demons perpetuate the tortures of eternal damnation
amid painful pandemonium, unrelieved by the promise of
redemption. Only a handful of the elect sit by the side of
God, who performs his Last Judgement in a blue semi-circle
of sky overlooking the holocaust. Some of the horrifying
images beneath are borrowed from Bosch's other works.

196
Flood,
*c.*1508 or
later.
Oil on panel;
69 × 36 cm,
27⅛ × 14⅛ in.
Boijmans Van
Beuningen
Museum,
Rotterdam

Yet fresh inspiration also abounds, such as in the twisted
vignette of a reptilian demon cook who sautés a gluttonous
sinner in a large omelette pan (see 185). Dutch scholars point
to other darkly droll scenes as embodiments of vernacular
idioms. An example may be a figure with an arrow through
its stomach, which could represent the expression 'to shoot
through the belly' meaning to throw money away.

Two other of Bosch's problematic works, the so-called
Flood (196) and *Devastation by Fire* (also referred to in the
literature as *Fall of the Rebel Angels* and *Scenes of Hell*; see
199), are best appreciated in the context of apocalyptic
anxiety, and have much in common with his more obviously
eschatological hell scenes. Both panels are long and narrow,
and painted on both sides, which suggests strongly that they
were once part of a triptych, the centre panel of which is
now lost. The restoration undertaken by the Boijmans Van
Beuningen Museum in 1981 revealed that each has only
one unpainted edge, suggesting that they were trimmed
on three sides. Scientific examination of the underdrawings
also revealed many *pentimenti* beneath the top paint layer,

showing a continually evolving composition. Dendro-chronological examination indicates that the paintings date *c.*1508 or later. Owing to their poor condition and unusual imagery, they have often been treated lightly by art historians. The two panels, however, would seem to be products of Bosch's mature imagination, perhaps the last from his hand, and must be seen as reflecting the same moralistic, apocalyptic imagery as other works in his *oeuvre*.

Each panel displays a single scene on one side and two roundels in grisaille on the reverse. The most easily identifiable subject is Noah's ark, which appears beached on the peak of Mount Ararat in the *Flood* panel. Four pairs of people inhabit the deck of the Biblical boat, conforming to Genesis 7–8, which says that the 600-year-old Noah, his wife, three sons and their wives were the only human beings allowed to escape destruction. They appear just to have released the carefully chosen pairs of animals, who descend two by two into a frightful landscape, filled with the bloated, drowned corpses of animals and people. Similar images occur throughout the history of art and, if Bosch travelled to Venice as some historians believe, he would have seen the spectacular cycle of mosaics devoted to the story of Noah in the Church of St Mark (197). Though he may have been influenced by artistic tradition, Bosch's monochromatic vision of the world after the flood invokes, more powerfully than any earlier image, the palpable horror described in Genesis 7:23: 'every living substance was destroyed which was upon the face of the ground, both man, and cattle, and the creeping things, and the fowl of the heaven.'

Awareness of the first destruction of the world by water was renewed in Bosch's day, when astrologers, scanning the heavens for clues to the date of the Apocalypse, saw portents of watery doom. The German prognosticators Johannes Stoeffler and Jacob Pflaum, in their 1499 *Almanach* (*Almanach nova*), predicted a second massive flood,

197
The Story of the Flood, twelfth century. Mosaic. St Mark's, Venice

198
The Flood,
from
Alexander
Seitz,
*Ein Warnung
des Sündtfluss*,
Augsburg,
1520

scheduled to inundate the earth in February 1524. They
based their claim on the belief that, at that time, sixteen
conjunctions of all the major planets would occur in the
watery sign of Pisces (the fish). The coming flood would
'portend certain changes and transformations for the whole
world, for all regions, kingdoms, provinces, states, ranks,
beasts, marine animals, and everything that is born of
the earth – changes such as we have hardly heard of for
centuries before our time, either from historians, or from
our elders. Raise your heads accordingly, Christian men.'
Stoeffler's and Pflaum's *Almanach* was printed many times
and translated into several languages in the decades before
1524. In all, nearly sixty authors wrote over 160 treatises
commenting on their prediction. The title page of one tract,
A Warning of the Flood (*Ein Warnung des Sündtfluss*), printed
in 1520, shows a scene similar to Bosch's, though crude by

comparison (198), of the ark floating in a sea choked with corpses. Even the sophisticated Albrecht Dürer was so unnerved by predictions of a final deluge that he dreamed of its coming, recording his nightmare in his diary. Goaded by sermons and science, people built their own arks and fled to high ground in preparation for the coming flood.

Bosch's choice of Noah is appropriate, given the painter's preference for pious subjects that serve as exemplars of righteousness. The early Church Fathers St Augustine and St John Chrysostom present Noah as an instrument of God and equate the ark with the Church. When Noah urged repentance and warned of the coming disaster, as the Church did repeatedly throughout history, nobody listened, for the population of the earth was entirely given over to vice. In the *Flood* panel, Bosch comments on sin and folly, alluding once again to the dire consequences awaiting unrepentant sinners in this world 'as it was in the days of Noah'.

To Christians living in the late fifteenth and early sixteenth centuries, Genesis 6:9 struck a familiar chord in its description of a corrupt earth, 'full of lawlessness'. Their fears were bolstered by the New Testament, which is filled with typological references to the first destruction as a forewarning of future devastation. Matthew 24:37–9, for example, likens Noah's world to the wickedness that will prevail in the final days: 'As were in the days of Noah, so will be the coming of the Son of Man. For as in those days before the flood, they were eating and drinking, marrying and giving in marriage, until the day when Noah entered the ark, and they did not know until the flood came and swept them all away, so will be the coming of the Son of Man.' Likewise, II Peter 3:5–7 compares the first devastation of the world by water to a future devastation by fire: 'The world that then existed was deluged with water and perished. But by the same Word the heavens and earth that now exist have

been stored up for fire, being kept until the day of judgement and the destruction of ungodly men.'

The fire of judgement foretold in Revelation would dissolve all things, just as the waters of the flood left none alive save Noah and his family. The earth and its inhabitants would experience a universal baptism by fire, as it had once before by water. In this context, we can read Bosch's *Devastation by Fire* (199) as another vivid spectre of the future destruction of the earth. This panel, painted in warm shades of orange and umber, is a heated contrast to the cool grey-blues that predominate in the *Flood* panel. The scene shows a world like that described in Revelation, swarming with monsters and alive with smoke and flame. In the mid-left and lower sectors, people cower in caves, fulfilling the words of Revelation 6:15, which tells of those who 'hid themselves in the dens and in the rocks of the mountains'. In 1512, astrologer Johannes Virdung described the End similarly:

There will occur such a storm that the winds will all blow together and turn the air to darkness, and they will make a horrible sound and dismember bodies and destroy buildings ... Make provisions for finding a shelter while the winds will rule and blow in the month I have mentioned, since it will be almost impossible to find a safe dwelling: prepare a small cave in the mountains and take with you the equipment necessary for thirty days. There will also be many dangers and murders in different regions and a universal earthquake.

Each of Bosch's eschatological panels is painted on its reverse with two monochromatic roundels. On the back of the *Devastation by Fire* (200), a pale woman flees a burning building inhabited by devils, as a kneeling figure witnesses the conflagration. The roundel beneath shows a man prostrate on the ground, presumably thrown from his plough horse by a cavorting, claw-footed demon. The roundels on the reverse of the *Flood* panel (201) show, at the top, a sparsely dressed man being beaten by two anthropomorphic demons. The

199
Devastation by Fire, c.1508 or later. Oil on panel; 69·5 × 39 cm, 27⅜ × 15⅜ in. Boijmans Van Beuningen Museum, Rotterdam

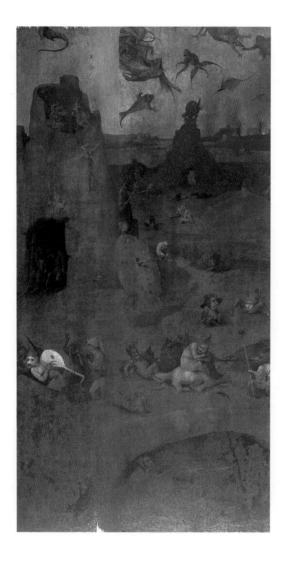

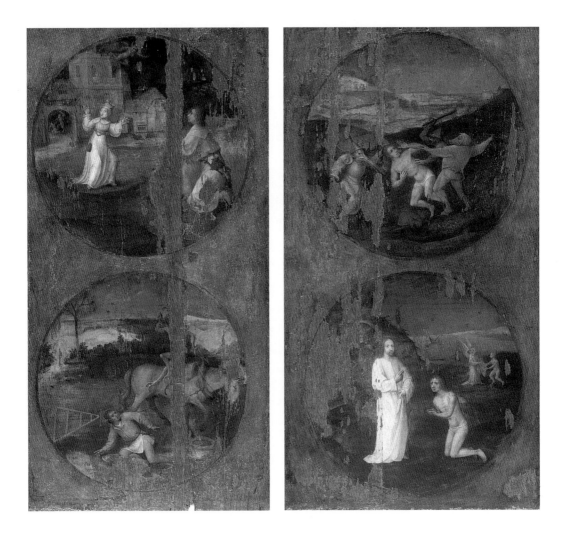

scene beneath reinforces the apocalyptic context that binds together all the scenes on both panels, front and back. In place of the imps and demons that bedevil people in the three other roundels, Christ appears, making the sign of blessing to a pious follower. In the background, an angel offers another man a cloak. The image recalls the words of Revelation 6:11, 'And white robes were given unto every one of them', which describes the elect receiving robes of redemption. Here, the long-suffering Christian soul seems to find asylum, having been sorely tested by the agents of sin.

As a pair, Bosch's panels accomplish a typological link between the Old and New Testaments, a connection that was keenly felt in every fibre of millennialist rhetoric. Essential to eschatological thought is the concept of divine secrets revealed to a few Christian elect. Humanist scholars saw apocalyptic imagery not only as Biblical prophecy, but also as fulfilment of paganism's best wisdom. Michelangelo's Sistine Chapel ceiling, a work roughly contemporary with Bosch's, shows pagan sibyls comfortably rubbing elbows with Old Testament prophets in a seamless synthesis of Christian/pagan imagery. Michelangelo's iconographic programme was intended to reinforce the glory of the reign of Pope Julius II, who, like the Habsburg emperors, thought of himself as the prophesied world leader of the Last Days. In the Renaissance, pagan and Christian lore shared common ground when it came to visions of past and future destructions of the earth. Plato both prefigured and echoed the Bible when he wrote, 'There have been and there will be many and divers destructions of mankind, of which the greatest will be by fire and water.'

Bosch's so-called *Afterlife Panels* (see 204–207), in the Doge's Palace in Venice, are believed to have been part of Cardinal Grimani's bequest, which also included the *Crucified Martyr* (see 74) and *Hermit Saints* (see 84) triptychs. Though vertical in their proportions, the four panels lack their top and bottom

200
Reverse of *Devastation by Fire*, c.1508 or later. Oil on panel; 69·5 × 39 cm, 27⅜ × 15⅜ in. Boijmans Van Beuningen Museum, Rotterdam

201
Reverse of *Flood*, c.1508 or later. Oil on panel; 69 × 36 cm, 27⅛ × 14⅛ in. Boijmans Van Beuningen Museum, Rotterdam

burrs (original unpainted edges), indicating that they have
been trimmed, and once may have been even longer. Each
was originally painted on the reverse with a mottled faux-
porphyry pattern, which suggests that they may have
functioned as wings of a polyptych the centre panel of which,
perhaps a Last Judgement, is lost. Examination of the wood
suggests a date of *c.*1484 or later for these paintings. Though
scholars disagree about the original disposition of the four

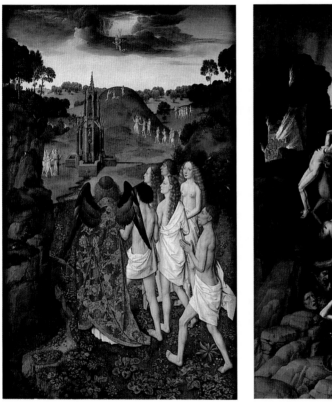

panels, a horizontal arrangement corresponds to the broad
dimensions of other early Netherlandish altarpieces.

The four scenes illustrate, in a fairly straightforward way,
the events that await humanity after the Last Judgement.
Bosch's contemporary Dieric Bouts did much the same,
though in diptych form, showing the the blessed ascending
to heaven (202) and the damned falling into hell (203). Bosch's

two additional panels chronicle each group's journey to its ultimate destination. The first scene (204) is devoted to the damned, and shows their descent into the inferno. Here, unfortunate sinners tumble downwards, assisted by leering demons, into a murky morass punctuated by bursts of flame. The damned have reached their destination in the second panel (205), and one of them sits in an attitude of abject melancholy beneath a mountainous crag topped by a beacon of fire. These panels can sensibly be titled the *Fall of the Damned* and *Hell*.

The first of the two panels devoted to the virtuous elect (206) shows resurrected souls being helped upwards through a bucolic, Eden-like landscape, the earthly paradise described by Joachim of Fiore. The second panel, the *Ascension of the Blessed* (207), is unique in its view of the elect ascending to heaven. Borne by helpful angels, they float towards an extraordinary, foreshortened tunnel of light, marked by ever-smaller concentric circles. At the centre is a brilliant vortex, into which the resurrected souls enter, their figures dissolving into its radiant core. Bosch's unique invention is reminiscent of Simon Marmion's astrological vision of the planetary orbits encircling the earth and rising to the empyrean heaven (208). Presumably, a soul making its way towards God would have to transect each planetary circle on its way up. Scholars have connected Bosch's tunnel of light with the tenets of the Modern Devotion. In fact, the group's founder, Jan Ruysbroeck, used the metaphor of unification with the Light to describe the soul's becoming one with the Creator: 'The sun will draw us with blinded eyes into its light where we will be united with God.' Bosch links the essence of God with light itself.

Readers who lived through the closing years of the second millennium will be familiar with the apocalyptic panic that gripped the world as the year 2000 appeared on the horizon. Though Christianity is not a universal faith, and its doctrines

202
Dieric Bouts,
Terrestrial Paradise,
c.1460.
Panel;
115 × 70 cm,
45¼ × 27½ in.
Musée des
Beaux-Arts,
Lille

203
Dieric Bouts,
Fall of the Damned,
c.1460.
Panel;
115 × 70 cm,
45½ × 27½ in.
Musée des
Beaux-Arts,
Lille

204
*Afterlife
Panels,
Fall of the
Damned,*
*c.*1484 or
later.
Oil on panel;
87 × 40 cm,
34¼ × 15¾ in.
Palazzo
Ducale,
Venice

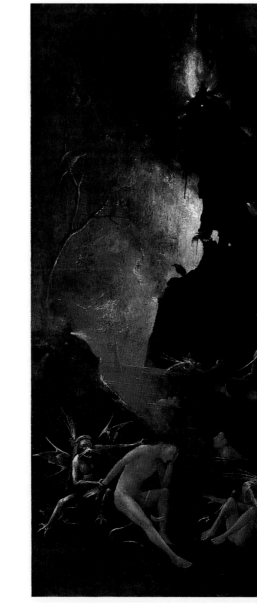

205
*Afterlife
Panels,
Hell*,
c.1484 or
later.
Oil on panel;
87 × 40 cm,
34¼ × 15¾ in.
Palazzo
Ducale,
Venice

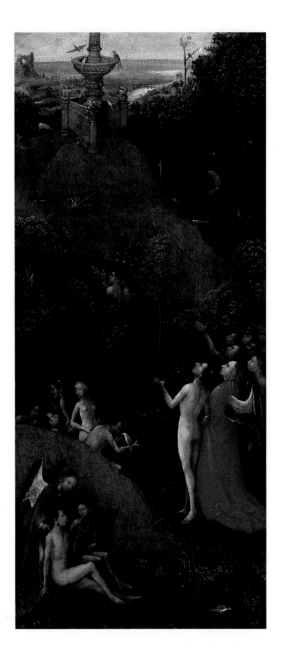

206
*Afterlife
Panels,
Earthly
Paradise*,
*c.*1484 or
later.
Oil on panel;
87 × 40 cm,
34¼ × 15¾ in.
Palazzo
Ducale,
Venice

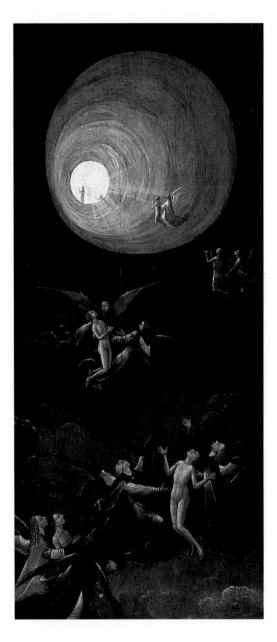

207
*Afterlife
Panels,
Ascent of
the Blessed,*
*c.*1484 or
later.
Oil on panel;
87 × 40 cm,
34¹⁄₄ × 15³⁄₄ in.
Palazzo
Ducale,
Venice

208
Simon Marmion, *Le Livre des sept âges du monde*, folio 12, mid-fifteenth century. Bibliothèque Royale, Brussels

are no longer binding to all people, the fear of a worldwide 'Y2K' computer failure held the industrial world in its grip until the fateful date had passed. Today, preparation for the impending Last Judgement and membership in the chosen elect is confined mainly to Christian fundamentalist sects, such as Jehovah's Witnesses and the Church of the Latter Day Saints. However, fear of the Apocalypse in Bosch's day involved everyone. Expressions of high-minded morality pervaded both lofty wisdom and daily life, as writers from Erasmus to Brant commented on those doomed to eternal damnation. Practical scientists – alchemists, physicians and astrologers – saw their professions as holy quests involving both research and revelation, and practised their crafts as means of redemption. Bosch's millennialism fits with artistic tradition and reflects the fears of his age, for all of his paintings, in some way or another, warn of the wages of sin and the rewards of virtue.

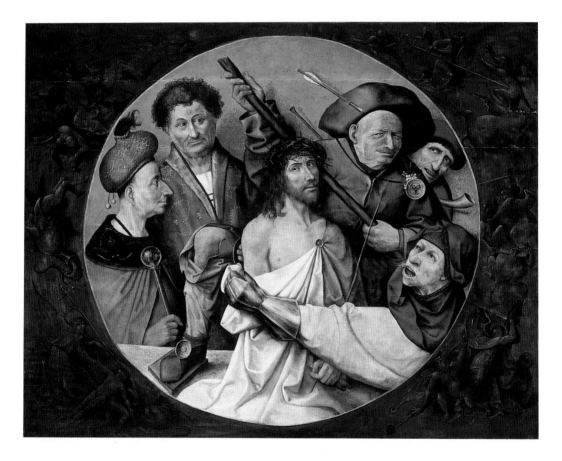

Bosch's fame increased rapidly in the decades following his death in 1516. Felipe de Guevara wrote that by the mid-sixteenth century artists of lesser fame and ability not only imitated Bosch's style, but also copied specific works by him, some even illicitly signing his name. In the days before copyright laws protected an artist's creativity, unauthorized reproduction was accepted as a form of flattery and a demonstration of admiration. In fact, Northern Renaissance art is rife with copies and interpretations of famous paintings by 'Great Masters', such as Jan van Eyck and Rogier van der Weyden. Popularity with aristocratic, wealthy patrons guaranteed a good price for a 'posthumous' work. Even today distinguishing authentic works from copies is not always easy (and can be complicated by personal, political or financial considerations).

Only seven of the twenty or so panels bearing Bosch's signature are considered to be authentic. There exist, for example, at least twenty copies of all or part of the famous *St Anthony* triptych (see 90) and at least as many versions of Bosch's Passion scenes dispersed throughout the museums of the world. The best of these, a triptych in the Escorial, the central panel of which shows *Christ Crowned with Thorns* (209), has often been considered an authentic work, though its distinctly un-Boschian stylistic anomalies – somewhat harsh lighting effects and the elongated proportions of its figures – link it more convincingly with Dutch painters such as Quinten Metsys, who specialized in reviving earlier Dutch masters later in the sixteenth century. Dendrochronology affirms the stylistic suspicions, dating the panel to 1527 at the earliest, some years after Bosch's death.

209
After Bosch, *Christ Crowned with Thorns*, c.1527 or later. Oil on panel; 165 × 195 cm, 65 × 76¾ in. Patrimonio Nacional, Palacio Real, Madrid

Establishing the authenticity of drawings attributed to Bosch is especially difficult. The dating of drawings is accomplished primarily by stylistic analyses and identifying watermarks; there is, as yet, no definitive scientific way to date paper comparable to dendrochronology for wood. Furthermore, there is no way of knowing for certain if a drawing was done by an admirer after a painting or as a preliminary stud y by Bosch himself. Some, such as the beautifully rendered *The Woods Have Ears, and the Fields Have Eyes* in Berlin (210), the subject of which relates to a popular proverb, have been treated as original compositions by Bosch. Such drawings are, without a doubt, technically superior. However, the only way to determine authorship is to compare them with underdrawings and hatchings visible beneath the paint surfaces of paintings firmly attributed to Bosch. When this is done, differences in the styles of execution often become plain. The hatchings and contour lines visible beneath Bosch's painted surfaces usually adhere to the traditional manner of following a single, straight, parallel course, regardless of the shape of the thing being delineated.

By contrast, the beautiful *Woods Have Ears*, for one, contains hatchings that follow contours of delineated objects, an advancement in drawing that, though more appealing to modern sensibilities, did not come into fashion until the innovative prints of Albrecht Dürer. Furthermore, it was very rare for a drawing to be considered a finished work of art in the context of fifteenth- and early sixteenth-century Northern Renaissance painting. Considering the fact that attribution is far from definitive in Bosch's *oeuvre* and that the underdrawings in his works vary markedly in character from the drawings made in his style, the task of assigning works on paper to Bosch is, to use a popular proverb, tantamount to 'building a house on sand'. It seems wiser to await the invention of a definitive, scientific method of dating paper before attempting to assign drawings to Bosch's hand.

210
Attributed to Bosch, *The Woods Have Ears, and the Fields Have Eyes*, early sixteenth century. Pen and ink on paper; 20·2 × 12·7 cm, 8 × 5 in. Kupferstich-kabinett, Staatliche Museen, Berlin

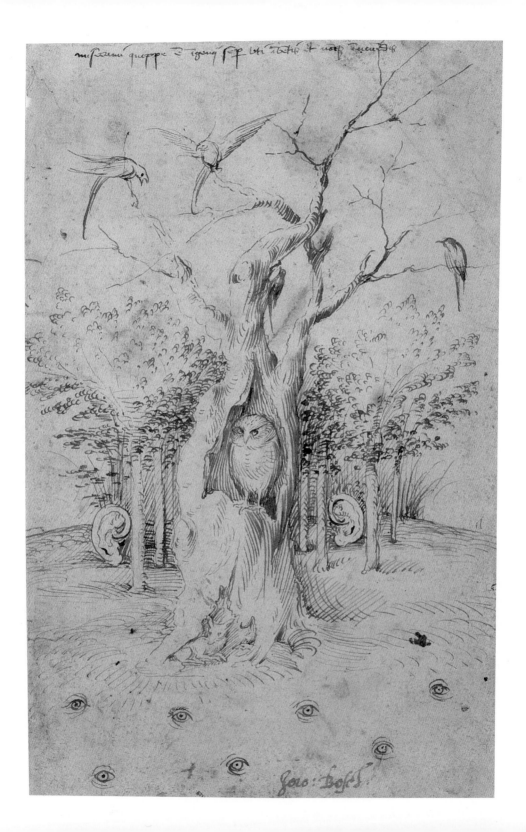

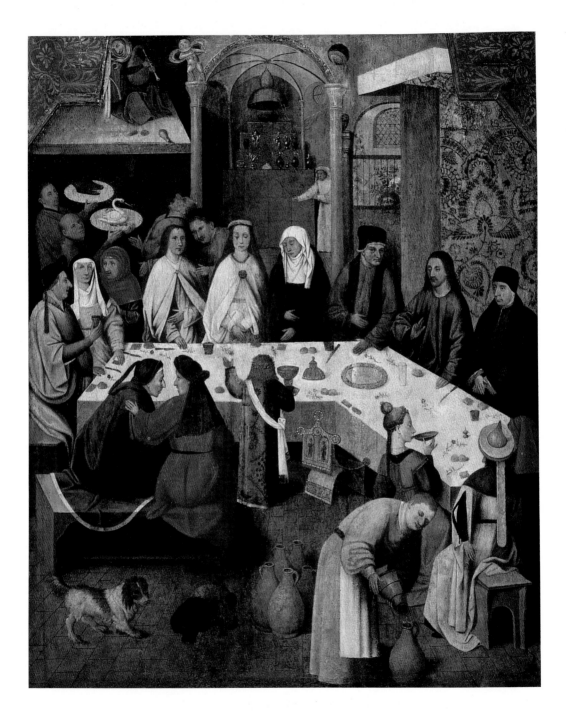

While science has helped immensely in supporting the authenticity of paintings by Bosch by dating their wooden panel supports to within the painter's lifetime, technical advances have also led to inevitable casualties, as art historians have been forced reluctantly to jettison a favourite painting from Bosch's *oeuvre* on the basis of irrefutable scientific evidence. One of these, the marvellously perverse *Marriage at Cana* in Rotterdam (211), has, until recently, been given to Bosch. Its compositional and iconographical quirks are uniquely Boschian, and the inclusion of alchemical motifs, such as a pelican vessel and a mortar and pestle on the stepped altar in the background, link it to other works by Bosch that display familiarity with chemical apparatus. Furthermore, the subject, Christ's transformation of water into wine at a marriage feast, was used by churchmen and chemists alike as a metaphor for the transubstantiation of the Mass and the transmutation of elements.

The composition of the *Marriage at Cana* is preserved in other versions in 's-Heerenbergh and Antwerp, as well as in an early drawing that includes two donors absent from the painted versions. Scientific examination, however, provides conclusive evidence that the Rotterdam panel is not by Bosch's hand. Unlike other 'authentic' works, there is no underdrawing, a strong indication that the painting is a copy. Furthermore, paint samples show traces of pigments that came into use between 1540 and 1560. Dendrochronological evidence clinches the case, dating the panel to *c.*1560 at the earliest, nearly fifty years after Bosch's death. We must therefore reluctantly eliminate the fascinating *Marriage at Cana* from the ever-diminishing group of authentic works by Bosch, while allowing the possibility that it and its siblings in 's-Heerenbergh and Antwerp are copies of a lost original.

The medium of engraving was instrumental in distributing Bosch's compositions throughout Europe. The famous Antwerp publisher Hieronymus Cock, active from *c.*1550 to

211
After Bosch,
The Marriage at Cana,
*c.*1555 or later.
Oil on panel;
93 × 72 cm,
36⅝ × 28⅜ in.
Boijmans Van Beuningen Museum, Rotterdam

his death in 1570, did much to make Bosch an international name in the sixteenth century by providing ready models for imitators. In this way, tantalizing references to lost paintings have come down to us in the form of print copies, pastiches and free variations. An engraving by Alart Duhameel (c.1449–c.1507), the *Beleaguered Elephant* (212), once attributed to Bosch himself, may be a copy of a painting of the same subject mentioned in an inventory of Philip II's art holdings in the Royal Palace in Madrid. Prints such as these, inspired by Bosch's distinctive style and unique imagery, circulated widely throughout Europe in the sixteenth century. They were immensely successful, and doubtless stimulated the production of many painted imitations, copies and fakes.

The great number of paintings done in the style of Bosch points to a veritable 'Bosch revival' in sixteenth-century northern European art. Artists freely appropriated the master's style and motifs, and were especially drawn to his diabolical hellscapes. The subject of St Anthony lent itself naturally to borrowings from Bosch's demonic bestiary, as the demand for images of the saint continued as long as the plague of ergotism held sway in Europe. In many cases, imitators of Bosch's style became obsessed with copying his satanic, composite monsters, producing, at best, catalogues of grotesqueries without understanding or communicating the underlying messages in his works. However, some paintings are as original and imaginative as one would expect a work by Bosch to be. Several of Bosch's more accomplished followers lived and worked in Antwerp, an important international financial and cultural centre in the sixteenth century. Here, art was mass-produced for the open market, and well-known artists such as Jan Mandijn (c.1500–59) and Pieter Huys (c.1520–c.1584; 213) readily acceded to public demands for works in the style of Bosch by inserting firescapes and grotesques into their paintings.

212
Alart Duhameel after Bosch,
Beleaguered Elephant,
1478–94.
Engraving;
20·4 × 33·5 cm,
8 × 13¼ in

213
Pieter Huys,
*Temptation of
St Anthony*,
1547.
Oil on panel;
69·5 × 102·5 cm,
27³⁄₈ × 40³⁄₈ in.
Musée du
Louvre, Paris

Though Bosch's influence is more immediately apparent in
the repetition of recognizable motifs in the works of followers
and copyists, his original way of representing the natural
world also influenced the important Antwerp School of land-
scape painters. Joachim Patinir (*c.*1480–1524) elaborated
Bosch's background vistas in his so-called 'cosmic land-
scapes', and further paid tribute to Bosch by scattering
demonic vignettes throughout the scene, as in his *Passage to
the Infernal Regions* (214). Patinir's cosmic landscapes, like
Bosch's, present the world in receding horizontal vistas
of green and blue that culminate in a high horizon line, a
method of representing the natural world that would become
standard in the art that developed in the seventeenth century.

Bosch's most famous imitator was Pieter Bruegel the Elder
(*c.*1525/30–69), whose compositions, when printed, were
occasionally inscribed by his publisher Hieronymus Cock as
inventions of Hieronymus Bosch. Several of Bruegel's works
clearly show a debt to the earlier master, particularly *Mad
Meg* (*Dulle Griet*; 215), one of the most Boschian of all his

compositions. The painting, which has been interpreted as a metaphor for anger and madness, a political assault against the current regent of the Lowlands, Margaret of Parma, and a statement of cultural paranoia about the growing power of women, is the very embodiment of the world turned upside down. There is no escaping the influence of Bosch here, as giant Meg strides through an inferno populated with Boschian monsters, accompanied by her mischievous housewife minions.

Bosch's original genius seemed inherently suited to the turbulence of the Netherlands in the sixteenth century, which formed the context for Bruegel's art and that of the prolific Antwerp School. Under siege by the Catholic, Spanish-born Philip II, the Low Countries struggled to define themselves as a distinctive nation and culture. It was during this time that the Dutch language gained respect and prominence as a literary vehicle, and the great early 'fathers of Dutch painting' were revived, emulated and honoured as heroes. Bosch, whose works once commanded

214
Joachim Patinir,
Passage to the Infernal Regions,
c.1524.
Oil on panel;
64 × 103 cm,
25¼ × 40½ in.
Museo del Prado, Madrid

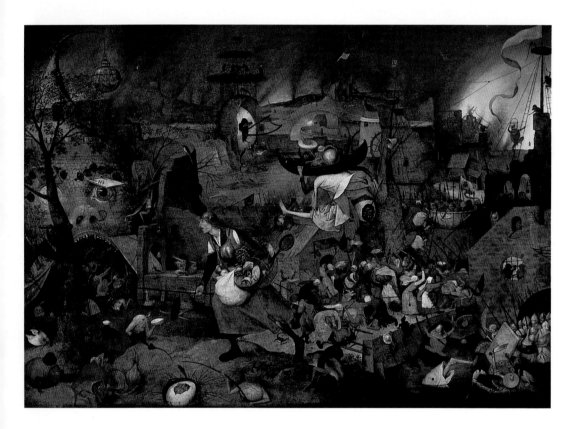

an international audience, became revered at home as a distinctly Dutch painter.

As often happens in the fickle cycle of history, the art of Hieronymus Bosch eventually slipped into obscurity, where it remained for over three centuries, eclipsed by the realism of Dutch Baroque painters and the social consciousness of the Enlightenment. Bosch was dropped from the art history canon, and the few references to his works in the nineteenth century refer to them as manifestations of heresy and perversion. Bosch's anonymity was most evident in his native country, where his paintings are, to this day, significantly absent from most Dutch museums. Not until 1931 did the Boijmans Van Beuningen Museum in Rotterdam acquire a work by Bosch, the *Wayfarer* panel (see 27), now known to have been part of a triptych that included other paintings by Bosch in Paris, New Haven and Washington, DC.

Revival of interest in Bosch did not occur again until the early twentieth century, coinciding with the rise of Surrealism and other exotic movements in modern art. His nightmarish depictions of hellfire and imaginative, conglomerate, anthropomorphic forms appealed to modern artists seeking to reflect the turmoil of their times. The Surrealist Manifesto of 1924 named as precursors Bosch, Bruegel, Poe, Baudelaire and others who explored the realm of fantasy and the imagination. Though the Manifesto's author, André Breton, denied any concrete relationship between Bosch's imagery and the aims of his movement, the illusive dream images and archetypal symbols popularized by Carl Jung and embraced by the Surrealists seemed nevertheless to have been anticipated by Bosch. Without question, Bosch worked in a completely different way from the Surrealists and with different intentions, and we must study him primarily as a Netherlandish painter. Yet, a common link exists in the worlds of astrology and alchemy, to which artists such as Max Ernst (1891–1976), Leonora

215
Pieter
Bruegel the
Elder,
*Mad Meg
(Dulle Griet)*,
1562.
Oil on wood;
117 × 162 cm,
46 × 63¾ in.
Musée Mayer
van den
Bergh,
Antwerp

Carrington (b.1917) and Salvador Dalí (1904–89) were openly attracted, and upon which Jung drew in forming his psychological theories. Thus Dalí's *Great Masturbator* of 1929 (217) quotes Bosch directly, giving the anthropomorphic profile on the left interior panel of the *Garden of Earthly Delights* (216) an overtly erotic look in keeping with the sexual basis of Freudian psychoanalysis. The idea of art as a spiritual quest, the search for a balanced, unified, androgynous spirit and the permeability of physical and spiritual realms were alchemical ideals that became hallmarks of Surrealism. Of course, by the twentieth century,

216
Garden of Earthly Delights (detail of 137)

217
Salvador Dalí,
The Great Masturbator,
1929.
Oil on canvas;
110 × 150 cm,
43³⁄₈ × 59¹⁄₈ in.
Museo Nacional Centro de Arte Reina Sofía, Madrid

alchemy had long been relegated to the realm of the occult, and was no longer the venerable and practical science that Bosch knew. However, twentieth-century artists and writers alike were struck anew by the power and inventiveness of alchemical imagery, making the link to Bosch not by a scholarly route, but by recognition of common themes.

The last fifty years have seen a revival of interest in Bosch, led by the Dutch. Scholarly reassessment was given much encouragement by an exhibition of Bosch's works in 1967 at the Boijmans Van Beuningen Museum in Rotterdam, which

was accompanied by much fanfare and publicity. The same museum mounted a second important show of Bosch's works in 2001. This exhibit presented Bosch's paintings in light of the latest dendrochronological findings and reassembled panels of the Rotterdam *Wayfarer* triptych (see 32) discussed in Chapter 3. More importantly, the exhibition attempted a broader interpretation of Bosch's imagery by including items of material culture and bringing together works by contemporary artists that demonstrate Bosch's direct influence. As the exhibition showed, Bosch is quoted in many different ways, accurately or freely, associatively or interpretatively, consciously or unconsciously, in drama, literature and music of the twentieth and early twenty-first centuries.

An example is the cover of an issue of the underground comic *Weirdo* (218), signed 'R. Hieronymus Crumb', which is a modern parody of Bosch's *Christ Carrying the Cross* in Ghent (see 63). The artist, Robert Crumb, replaces the evil enemies of Christ, which Bosch distinguished by their cruel and ugly faces, with representatives of modern-day depravity bearing the same features. Drawn from the shocking headlines of contemporary news accounts, pimps and politicians share space with corrupt lawyers, oil company executives, a dishonest evangelist, an Internal Revenue agent (tax collector) and a brutal helmeted policeman, while buxom Saint Veronica is groped by a lustful sex-fiend in the lower left. Crumb's Christ, still wearing the crown of thorns in the centre of it all, is not the serene figure painted by Bosch, but sweats nervously as he considers the state of the world reading the very comic book in which he appears. Surrounding this disturbing caricature are marginal vignettes, filled with Boschian demons and fiends, that expand the message of the central scene. Crumb accomplishes what Bosch himself sought to do – to comment with biting wit on the folly and frailty of human beings.

218
Robert
Crumb,
Weirdo,
number 4,
1981

Our interest in Bosch stems from a shared fascination with the fantastic, satiric and unusual. References to Bosch's creative forms permeate our popular culture, providing scenic backgrounds for film and television fantasies, monsters for science fiction films and provocative imagery for the covers of record albums and paperback books. Though the Christian context in which Bosch worked is absent from many of the modern interpretations of his imaginative forms, the visual effect is not so different after all. Contemporary art reflects the realities of daily life and the higher goals of philosophy and science just as Bosch's art did in his time. Much more remains to be discovered about Hieronymus Bosch, and future generations will doubtless continue to unravel his fascinating imagery. However, all who venture into the realm of Boschian interpretation would be wise to heed the words of José de Siguenza, who noted, 'If there are absurdities in his work, they are ours, not his.'

Glossary | Brief Biographies | Key Dates | Map
Further Reading | Index | Acknowledgements

Glossary

The Apocalypse From the Greek verb meaning 'to reveal', and the title given to Revelation, the last book of the New Testament, which foretells the world's end. Tradition maintains that John the Evangelist composed the account on the island of Patmos with divine guidance. It tells of a future war between good and evil (Armageddon), followed by a thousand years (a millennium) of peaceful existence, after which Christ will appear to preside over the final destruction and judgement of the human race.

Alchemy From the Arabic, meaning 'about chemistry', the forerunner of modern chemistry. Alchemy was a practical science that used **distillation** as an adjunct to both medicine and metallurgy. Its philosophical basis was the belief that all matter could be transmuted into a higher substance with divine guidance. Philosopher-chemists devoted their talents to making gold and to crafting an 'elixir of life', capable of healing all illnesses and returning the human race to the pristine health and immortality enjoyed by Adam and Eve in the Garden of Eden. The rise of mechanical philosophy and the fall of **humoral medicine** in the late seventeenth century gradually undermined alchemy, eventually relegating it to occult status.

Astrology From the Arabic, meaning 'about the stars', the forerunner of modern astronomy. Once a venerable science, astrology was associated mainly with theories of celestial influences of the zodiac and planets, understood as forces that literally flow down to the earth, influencing all things, including human destiny. Once the earth was shown to be a rotating and revolving planet within an infinite universe, and genetics placed human individuality beyond the control of the heavens, astrology ceased to be a serious science.

Attribution A term in art history for the assignment to an artist of a work, often unsigned, of uncertain authorship. Attributions can be made either on the evidence of documents or by style alone, usually based on the notion that an artist, consciously or unconsciously, expresses individuality to such an extent that, to connoisseurs, not even the closest imitation would be mistaken for an authentic work. Attribution is, by nature, often highly subjective, which is why experts frequently disagree and change their minds. The works of Bosch have been subject to many changes in attribution, owing to the great number of imitators and copyists throughout the centuries.

Bestiary A medieval treatise containing accounts of animals, both real and imagined. Bestiaries are based on ancient Greek and Latin sources and are often fancifully illustrated. They frequently ascribe healing properties to animals and derive moral lessons from their legends.

Confraternity A lay association providing spiritual, professional and social benefits to members through the performance of works of charity, often associated with a specific church or charitable foundation.

Dendrochronology A precise dating technique for wooden supports of **panel paintings**, using the growth rings of trees. The process depends on the fact that trees in the same locality show characteristic patterns of growth rings resulting from climatic conditions. On the basis of this information, it is possible to deduce when the tree in question was felled and to arrive at a date after which a panel painting must have been created.

Distillation A process of boiling a liquid and condensing and collecting the vapour; the basis of alchemical laboratory procedure.

Engraving An *intaglio* printing process, whereby a metal plate, usually copper, is incised with lines that make an image. The plate is then inked and the residue of ink wiped off so that the ink remains only in the furrows of the metal plate. A piece of damp paper is then laid against the plate and both are rolled through a heavy press. Under intense pressure, the damp paper is forced into the ink-filled furrows so that a reverse impression of the image is embossed upon the paper.

Grisaille A painting done entirely in shades of grey or another neutral greyish colour. Grisaille sometimes is used for sketches or underpainting, though it became popular in the Renaissance in finished works, particularly the exteriors of altarpieces, where it imitated the effects of sculpture.

Herbal A collection of descriptions and illustrations of plants and their medicinal uses, often based on astrological affinities or humoral relationships. Many derive from the oldest surviving manuscript version of a herbal written by the Greek Dioscorides, dating from the sixth century.

Humoral medicine The system of healing, originating with the ancient Greeks, that held sway through most of the seventeenth

century. The tradition was based on the belief that all things consist of four elements – earth, air, water and fire – or combinations thereof. Each element corresponded with one of four humours within the body – black bile (earth), blood (air), phlegm (water) and yellow bile (fire). These humours predominated in four designated physical and personality types that comprise the human race: melancholic (earth, black bile), sanguine (air, blood), phlegmatic (water, phlegm), and choleric (fire, yellow bile). Illness was defined as an imbalance of humours in the body, and health as the maintenance of humoral equilibrium.

Iconography The branch of art history dealing with identification, description, classification and interpretation of the subject matter of art. Erwin Panofsky, in his *Studies in Iconology* (1939), proposed that the term 'iconology' should be used instead, distinguishing a broader approach towards subject matter that considers the totality of a work of art in its historical context. However, the distinction is rarely made today, and 'iconography' is much more commonly used.

Inquisition An institution, sometimes called Holy Office, of the medieval and early modern Church designed to combat heresy. First instituted in 1231 by Pope Gregory IX, it attempted to place control and punishment of heresy in papal hands. Inquisitors, most often Dominicans or Franciscans, were appointed by the pope and possessed considerable power and authority. The Inquisition lapsed during the fourteenth century, but was revived in the second half of the fifteenth century and beyond, when its furor was directed primarily against apostate Jews, Muslims and witches in response to renewed Apocalyptic fear.

Modern Devotion The name (*Devotio Moderna*, or Brothers and Sisters of the Common Life) adopted by the followers of Gerard Groote (1340–84), a widely travelled and educated Dutch Carthusian monk and mystic. Groote's aim was to keep religion simple, devout and charitable. The Modern Devotion were a semi-monastic order of lay folk and clergy dedicated to the cultivation of inner spirituality, good works and voluntary poverty in imitation of Christ. Their emphasis on inner spirituality greatly influenced Christian humanists, and the great reformers **Desidarius Erasmus** and **Martin Luther** were educated by its members. The order, which was essentially conservative in its practices, reached its height during the second half of the fifteenth century and was a dominant presence in the town of 's-Hertogenbosch.

Panel painting A painting done on wood. Normally, a wood panel (usually poplar) would be carefully selected and aged for several years before it could be used as a support for painting. The wood was prepared by filling holes and covering with linen cloth, which was then sized and coated with layers of gesso, a chalky substance, in order to present a smooth, even surface. The panel was then ready for the **underdrawing**. For large pictures, several panels were jointed together and glued with casein.

Pentimenti From the Italian word for 'repentance', a part of a picture that has been painted over by the artist, but which has become visible again (often as a ghostly outline) as the upper layers of pigment have become translucent with age. It is believed that pentimenti are evidence of second thoughts by an artist, which would be more likely to occur in an original painting than in a copy.

Physiognomy Originating from a treatise once attributed to Aristotle, the science of judging moral character and disposition from the features of the face and the form of the body.

Proverb From the Latin *proverbium*, meaning a saying supporting a point. A short traditional saying, sometimes originating in ancient Latin, of a didactic or advisory nature, in which a general statement assumes a metaphorical expression. Proverbs are found in many cultures, and continue to be created today.

Transmutation The conversion of one element into a higher form. In Renaissance **alchemy** it was the goal of the chemical work, in which substances are perfected in imitation of the transubstantiation of the Mass and the Christian cycle of life, death and resurrection.

Triptych Three painted panels, usually wooden, hinged together. The two outer wings can be closed over the central panel and may be decorated on their reverses.

Typology In Christian **iconography**, a system in which figures and scenes from the Old Testament prefigure those of the New Testament. It became customary for Old Testament 'types' to be juxtaposed with New Testament 'antitypes', to demonstrate that the promise of the Old Testament was fulfilled in the New.

Underdrawing The preparatory drawing made directly on the gesso surface of a **panel painting**, intended to guide the artist in the application of pigments.

Woodcut A relief printing process, whereby an image is printed from a block of wood onto a sheet of paper. The image is first drawn, in reverse, on the face of the block. The areas that will remain white in the final image are then removed by cutting out and the lines which form the design remain standing. The surface is then inked and pressed firmly against a sheet of paper, transferring the image to it, much as text is printed from movable type.

Brief Biographies

Sebastian Brant (1457/8–1521) The German humanist and poet was also famous as a legal authority. Born at Strasbourg, he attended Basle University, where he studied law, which he later taught. Throughout his life he corresponded with other important humanists and wrote poetry, legal and humanist works, secular pamphlets and broadsheets. He is known today for his satirical book *Das Narrenschiff* (*Ship of Fools*), which first appeared in German in 1494. Composed as a series of poems, it describes every imaginable type of fool, including complacent priests and proud professors, with the intent of bringing readers to the recognition of their own folly. The *Ship of Fools* was an immediate popular success – not least because of its outstanding woodcuts, some of which are attributed to **Albrecht Dürer**. It was printed in numerous editions and translated into many languages.

Charles the Bold (1433–77) The last Duke of Burgundy (1467–77), whose lands included much of the modern Netherlands, he attempted to create a Burgundian kingdom with himself as independent sovereign. He engaged in a protracted quarrel with King Louis XI over dominion of French territories, and extended his own lands to the Rhine. He was killed at Nancy during a battle with the Swiss. The last of his three wives was Margaret of York, sister of Edward IV of England, and his daughter, Mary of Burgundy, married **Maximilian I** of Germany and became the mother of **Philip the Handsome** and **Margaret of Austria**.

Charles V (1500–58) Son of **Philip the Handsome** and Juana of Castile, Charles was born in Ghent and educated in the Netherlands, where he succeeded his father in 1506 under the regency of his aunt, **Margaret of Austria**, and took personal control in 1515. At the time of his assumption to the position of Holy Roman Emperor, a title he held from 1519 to 1556, Charles inherited vast territories from his grandparents: from **Maximilian I** came Austria and Germany; from Mary of Burgundy, the Netherlands and other territories near the Rhine; and from Ferdinand of Aragon and **Isabella I** came Spain and all of the Spanish territories in North Africa and the New World. A devout Catholic, Charles was determined to protect his faith against the Turks, who reached Vienna in 1529, and the Protestants, whose numbers were increasing throughout northern Europe.

Upon his death, Spain, the Spanish territories and the Netherlands went to his son **Philip II of Spain**, and Austria, Germany and the Holy Roman Empire passed to his brother, Ferdinand I.

Christopher Columbus (1451–1506) An Italian explorer born in Genoa, Columbus went to sea as a boy, travelled widely, and eventually settled in Lisbon, where he married in 1479. After the Portuguese king refused to support an Atlantic expedition in search of an Asian trade route, he moved to Spain. He gained the patronage of the monarchs Ferdinand and **Isabella** with his millennialist rhetoric, which stressed the importance of triumphing over heresy in preparation for the coming **Apocalypse**. On 3 August 1492, he began his momentous westward voyage with three small ships. He founded the first Spanish settlement in the New World in Hispaniola (Haiti) and returned to Spain a famous man with treasures and curiosities. Columbus made more journeys to the New World, and died at Valladolid.

Nicholas Cusanus (1401–64) A German philosopher and theologian, Cusanus was born at Kues (from where he took his name), the son of a poor family. He entered the service of Ulrich, Count of Manderscheid, who supported his studies at Deventer with the Brethren of the Common Life. He became a doctor of law in 1423 and entered the Church, becoming a papal legate, cardinal and finally bishop of Brixen. Cusanus's reforms included the rejection of scholasticism, based upon the belief that God could only be known intuitively. He was also a scientist and mathematician, and anticipated Copernicus in his belief that the earth was not the centre of the universe.

Albrecht Dürer (1471–1528) The German artist who revolutionized printmaking was born at Nuremberg and initially trained as a goldsmith under his father. He began a second apprenticeship with the painter and **woodcut** designer Michael Wolgemut (1434/7–1519), with whom he collaborated in the printing of illustrated books. After travelling through the Upper Rhine, he returned to Nuremberg, where he married and set up his own atelier. His revolutionary series of woodcuts illustrating the **Apocalypse** (1498) made him famous and set new standards for the medium. He was a consummate engraver, and imbued his works with light and texture. Dürer visited Italy twice, in 1494–5 and 1505–7, and the influence of Italian artists and art theory

greatly enriched his work. Late in his life, he became increasingly involved with the decorative printing projects of **Maximilian I** and the reforms of **Martin Luther**. Though best known for his remarkable success with *intaglio* print media, Dürer never abandoned painting, and continued to produce portraits and religious panels throughout his life. He also wrote three illustrated books on geometry, fortification and human proportions, which further spread his influence throughout Europe.

Engelbert II of Nassau (1451–1504) A courtier serving the ruling Habsburg dynasty and Count of Nassau, from which the House of Orange originated, Engelbert had broad intellectual training and elevated tastes. From 1473, he was a knight of the chivalric Order of the Golden Fleece and a *stadholder* in Brabant. Under **Philip the Handsome**, he was promoted to *stadholder* general of the Netherlands. Engelbert or his nephew Hendrick III may have been the patron of Bosch's *Garden of Earthly Delights*. This belief arises from the first description of the **triptych**, by Antonio de Beatis, secretary to Cardinal Louis of Aragon, as hanging in the Brussels family palace in 1517, a year after Bosch's death. Given the early date of the triptych's wooden panels, and the fact that the House of Nassau were supporters and members of the Brotherhood of Our Lady, the **confraternity** to which Bosch belonged, it seems likely that Engelbert II, who must have known Bosch personally, was the patron, and not the younger Hendrick III.

Desiderius Erasmus (*c.*1469–1536) Born illegitimately Gerhard Gerhards, probably in Rotterdam, the Dutch humanist Erasmus became the most famous living scholar in Europe, thanks largely to the power of the new medium of print. Though he became an Augustian monk, he was allowed to leave the cloister and travel extensively, lecturing often in England, where he befriended Thomas More and the painter Hans Holbein (1497/8–1543). As a humanist intellectual, Erasmus wrote in Latin and translated many classical texts. The fundamental principles of his writings include respect for common sense, hard work, moral integrity and the recognition of free will, from which follows each person's responsibility for their own actions. Though some of his beliefs were in sympathy with those of **Martin Luther**, he opposed the rancorous, intolerant atmosphere that characterized the Reformation as well as the cultural decline that he saw as resulting from it. Erasmus's early religious training included a short time in one of the houses of the **Modern Devotion** in 's-Hertogenbosch. Though there is no evidence that Erasmus knew Bosch or that they ever met, the two share much in common, including the use of humble **proverbs** as carriers of higher moral truths, and biting wit, often employed in criticism of the clergy.

Felipe de Guevara (1500–70) A Spanish nobleman and cartographer, Felipe de Guevara was the son of Diego Guevara, who knew Bosch as a fellow member of the Brotherhood of Our Lady and owned some of his paintings. Felipe's *Comentarios de la pintura* (*Commentaries on Painting*), which contains the first discussion of Bosch and his art, appeared in 1525.

Domenico Grimani (1461–1523) Italian cardinal, humanist and patron of the arts, Grimani came from a Venetian family that produced three doges from the thirteenth to the sixteenth centuries. The son of Doge Antonio Grimani, Domenico was named apostolic secretary and protonotary in 1491 and was employed thereafter by Venice as envoy to the pope. He was a collector of antiques and paintings, including several by Bosch.

Isabella I, Queen of Castile (1451–1504) The daughter of John II of Castile and Isabella of Portugal, the marriage of Isabella I to Ferdinand of Aragon united the two important kingdoms of Aragon and Castile, thus forming the basis of modern Spain. The couple ruled jointly during the discovery of America by **Christopher Columbus**, whom they supported, and the terror of the **Inquisition**, which they also upheld. Isabella's fervent devotion to Roman Catholicism led her to play a personal role in condemning and persecuting non-Catholics throughout Europe, leading to the expulsion of Jews from Spain and the defeat of the Muslims at Granada in 1492. In her last years, Isabella witnessed the deaths of three of her five children and the madness of her daughter Juana, wife of the Habsburg heir **Philip the Handsome**; her daughter Catherine became the ill-fated first wife of Henry VIII of England. At her death in 1504, Isabella owned three of Bosch's paintings, probably gifts from the Burgundian court, now lost.

Thomas à Kempis (1380–1471) Kempis was born Thomas Hemmerken of humble parents at Kempen (from where he took his name) near Cologne. He became an Augustinian monk in Agnietenberg near Zwolle in the Netherlands, where he spent most of his life writing and teaching. Kempis's most famous mystical work is *Imitatione Christi* (*Imitation of Christ*), which was widely read during his lifetime, and translated into many languages. The book traces in four stages the progress of the soul to perfection by means of detachment from the material world, and its eventual union with God. Its tendency to personalize religion and minimize the importance of formal Christianity, reflects the beliefs of the **Modern Devotion** and inspired the Reformation.

Martin Luther (1483–1546) The instigator of the Reformation, the son of a prosperous copper miner at Eisleben, Luther received his education at the university in Erfurt. He entered an Augustinian priory and, in

1507, was appointed to the faculty at the new university at Wittenberg, where he became a doctor of theology in 1512. His impatience with Catholic doctrine led to the publishing of his *Ninety-five Theses against Indulgences* in 1517. Other writings critical of the Catholic Church followed, leading to his excommunication in 1521. Luther was summoned before Emperor **Charles V** at the Diet of Worms (1521), but refused to recant. He was protected in his defiance by Frederick the Wise, Elector of Saxony, whose support made it possible for Luther to return to Wittenberg, where he remained until his death. Significant reforms that were part of Luther's protest are still in the Protestant creed today.

Margaret of Austria (1480–1530) Margaret of Austria was born in Brussels, the daughter of the Habsburg Archduke Maximilian (later Holy Roman Emperor **Maximilian I**) and Mary of Burgundy, heiress of the Valois dukedom. Between 1483 and 1502, Margaret married three powerful men: the future King Charles VIII of France, who repudiated her in 1491; Prince John of Spain, who died after only a few months of marriage; and Philibert II, Duke of Savoy, who died three years later. After the death of her brother **Philip the Handsome** in 1506, Margaret was appointed regent of the Netherlands by her father. In that capacity, she acted as guardian of her infant nephew Charles (future Holy Roman Emperor **Charles V**) until he came of age in 1515. Margaret was an avid art connoisseur, and at least one painting by Bosch, a *St Anthony*, was part of her personal collection. She was also a patron of the Brotherhood of Our Lady, the **confraternity** to which Bosch belonged.

Maximilian I (1459–1519) The son of Frederick III and Eleonora of Portugal, Maximilian was not only a capable politician and brave knight, but also a man of letters who continued patronage of the arts on the grand scale of his Burgundian forebearers. His marriage in 1477 to Mary of Burgundy secured the northern European territories of the Valois Dukes under Habsburg rule, though his early years as archduke were fraught with difficulties, most notoriously with King Louis XI of France. Maximilian was named Holy Roman Emperor in 1493. He ceded control of the Netherlands first to his son **Philip the Handsome** and then to his daughter **Margaret of Austria**, who acted as regent for her nephew Charles. Maximilian arranged the marriage of Philip the Handsome to the Infanta Juana, daughter of Ferdinand and **Isabella** of Spain, thus bringing the Spanish inheritance to his grandson, the future Holy Roman Emperor **Charles V**. The marriages of two of his grandchildren to Hungarian royalty brought Bohemia and Hungary under Håbsburg rule. This dynasty continued unbroken until the early twentieth century.

Philip the Handsome (1478–1506) Son of Emperor **Maximilian I** and Mary of Burgundy, he inherited his mother's territories, which included the Netherlands and territories bordering the Rhine, in 1482. In 1496 he married the Infanta Juana, daughter of Ferdinand and **Isabella** of Spain, and ruled jointly with her as King of Castile. Their son became Holy Roman Emperor **Charles V**. Philip ordered a **triptych** from Bosch in 1504, probably the Vienna *Last Judgement*.

Philip II of Spain (1527–98) Born at Valladolid, the son of Holy Roman Emperor **Charles V** and Isabella of Portugal, Philip II married three times. The second marriage, to Mary I of England, made him joint sovereign of her realm. Philip inherited the vast territories of Spain, Milan, Naples, Portugal and the Netherlands, as well as the New World territories of the Caribbean, Mexico and Peru, though the Habsburg possessions in Germany went to his uncle Ferdinand I. A devout Catholic, Philip was vigilant in support of the **Inquisition** and fought against heresy, defeating the Turks at Lepanto, launching the Spanish Armada against Protestant England, and intervening in the French Wars of Religion against the Hugenots. An austere and dedicated ruler, Philip lived simply, but spent lavishly on the books and paintings that he loved to collect, including some twenty-six by Bosch. These were placed in the Escorial, where Philip spent much of his time in semi-seclusion, and in his palaces in Madrid.

George Ripley (c.1415–90) An important fifteenth-century alchemist, little is known about Ripley, who may have been a canon at the Priory of St Augustine at Bridlington in Yorkshire, where he studied the physical sciences. He travelled throughout Europe and lived for a time in Rome, where he was appointed chamberlain to Pope Innocent VIII in 1477. Back in England by 1478, he continued his work, including King Edward IV of England among his patrons. Ripley is reputed to have given vast amounts of money to the Knights of St John of Jerusalem at Rhodes to help their defence against the Turks. His name is attached to several important alchemical works, including the *Ripley Roll*.

José de Siguenza (c.1544–1606) Named after his birthplace, Siguenza was a monk and librarian of the Escorial, the palace–monastery complex built by King **Philip II of Spain**, and later the historian of the Hieronymite order there. He is known for having written the *Historia de la Orden de San Jerônimo* (*History of the Order of St Jerome*), which contains a full description of the Escorial, including the paintings by Bosch that hung there.

Key Dates

Numbers in square brackets refer to illustrations

The Life and Art of Hieronymous Bosch

A Context of Events

*c.*1450 Hieronymus Bosch probably born	1450 Jubilee year in Rome
	1452 Leonardo da Vinci born
	1453 End of Hundred Years War. Turks capture Constantinople. First printing of Gutenberg's 42-line Mazarin Bible
1462 Bosch's father, Anthonis, buys a house on the market square in 's-Hertogenbosch [3]	
	1466 Erasmus of Rotterdam born
	1467 Philip the Good, Duke of Burgundy and patron of Jan van Eyck, dies; his son Charles the Bold succeeds as Duke of Burgundy
	1471 First of many editions of Denis the Carthusian's *Cordiale Quattuor Novissimorem* published. Albrecht Dürer born
	1472 Thomas à Kempis's *Imitation of Christ* (written in 1414) published
1474 First mention of Bosch in the historical record as involved with his brothers in a legal transaction on behalf of his sister	
	1475 Michelangelo born
	1477 Death of Charles the Bold, Duke of Burgundy; his daughter Mary of Burgundy marries the German Habsburg prince Maximilian I, who becomes ruler of the Netherlands
1480 Bosch and Aleyt van der Mervenne appear in the historical record as married	1480 First edition of *Common Proverbs* published
1480–1 First mention of Bosch in the historical record as 'Jerome the painter'	1481 Spanish Inquisition revived under Torquemada
	1482 Mary of Burgundy dies; Maximilian I inherits the Netherlands
	1484 First printing press set up at 's-Hertogenbosch. Momentous astrological conjunction of Jupiter, Mars and Saturn in Scorpio occurs
	1485 Maximilian I inaugurated as regent of the Netherlands. Published edition of Bartholomeus Anglicus's *De proprietatibus rerum* (*On the Properties of Things*) appears
1486 Bosch probably becomes a member of the Brotherhood of Our Lady	1486 Maximilian I elected German king. Dutch edition of Deguilleville's *Pilgrimage of the Life of Man* and Bernard Breydenbach's *Sanctae peregrinationes* (*Holy Pilgrimages*) published
1488 Bosch celebrates his 'elevation in rank', probably to a sworn member of the Brotherhood of Our Lady, at a confraternal banquet	1488 Dutch edition of *The Art of Dying* published

The Life and Art of Hieronymus Bosch	A Context of Events
	1489 Marsilio Ficino's *De Vita Triplici*, on Saturnine melancholia, published
	1490 Hieronymus Brunswyck's *Book of Distillation* published
	1492 First trip of Columbus to the western hemisphere
	1493 Maximilian I named Holy Roman Emperor; his son, Philip the Handsome, becomes ruler of the Netherlands. Hartmann Schedel publishes the *Nuremberg Chronicle*
	1494 Sebastian Brant's *Narrenschiff* (*Ship of Fools*) published
	1496 Philip the Handsome marries Juana, heiress of Spain
	1497 Albrecht Dürer's *Apocalypse* woodcut series published
	1498 Savonarola burned in Florence
1499 Bosch hosts an elaborate confraternal banquet at his house	**1499** Johannes Stoeffler and Jacob Pflaum publish *Almanach Nova* predicting a millennial flood
	1500 Important millennial year. European persecution of witches begins. Jubilee year in Rome
	1503 Petrus Bonus's alchemical treatise *New Pearl of Great Price* and Erasmus's *Handbook of the Christian Knight* published
1504 Bosch contracts with Philip the Handsome to paint a large *Last Judgement* altarpiece and hosts another confraternal banquet	
1505–6 Tax assessments in 's-Hertogenbosch show Bosch to be in the top one percent of its wealthiest citizens	**1506** Death of Philip the Handsome
	1507 Margaret of Austria is regent of the Netherlands (to 1515)
	1508 Michelangelo begins painting the Sistine Chapel ceiling
1510 Bosch hosts a confraternal banquet at his house	
1511 Bosch first mentioned in the historical record as signing his name 'Bosch'	**1511** Giovanni di Andrea's *Hieronymianus*, an important biography of Saint Jerome, and Erasmus's *In Praise of Folly* published
	1512 Copernicus writes *Commentariolus*, which expounds his theory of the heliocentric universe
1513 The 'Last Judgement Machine' [189] is installed in the Church of St Jan in 's-Hertogenbosch	
	1515 Prohibition of publishing books without consent of papacy. Archduke Charles of Austria is governor of the Netherlands
1516 9 August, Bosch's funeral held by the Brotherhood of Our Lady	**1516** Charles V begins reign as King of Spain. Erasmus publishes a complete edition of the writings of Saint Jerome
1517 Bosch's *Garden of Earthly Delights* [133] reported hanging in the Brussels palace of the House of Nassau	**1517** Martin Luther initiates the Protestant Reformation by posting ninety-five theses on the door of the Palastkapel in Wittenberg
	1519 Death of Maximilian I; Charles V becomes Holy Roman Emperor
1522 Bosch's wife, Aleyt van der Mervenne, dies	

Borders shown are those at the beginning of the 21st century

IRELAND

North Sea

UNITED
KINGDOM

NETHERLANDS

Utrecht

Elbe

London

Nijmegen

's-Hertogenbosch

Atlantic Ocean

Antwerp

Brussels

Aachen

GERMANY

BELGIUM

Rhine

Paris

LUXEMBOURG

Nuremberg

FRANCE

SWITZERLAND

Venice

PORTUGAL

Florence

ITALY

Madrid

SPAIN

Rome

Mediterranean Sea

0 100 200 miles

0 100 200 300 kilometres

Further Reading

The literature on Hieronymus Bosch, in fields ranging from art history to psychology, is vast. Out of necessity, the following is a highly selective list, in English whenever possible, consisting of studies that are, in this author's opinion, both sensible and readable. All are related to specific paintings, iconographical theories and contextual issues discussed in this book.

Early Sources

Filipe de Guevara, *Commentarios de la pintura* (c.1560), ed. Antonio Ponz (Madrid, 1788, repr. Barcelona, 1948)

Karel van Mander, *Het schilder-boeck* (1604, repr. Utrecht, 1969)

José de Siguenza, *Historia de la Orden de San Jeronimo* (Madrid, 1605)

Wolfgang Stechow, *Northern Renaissance Art, 1400–1600: Sources and Documents* (Englewood Cliffs, NJ, 1966)

General

Walter S Gibson, *Hieronymus Bosch* (London, 1973)

—, *Hieronymus Bosch: An Annotated Bibliography* (Boston, 1983)

Jos Koldeweij and Bernard Vermet (eds), *Hieronymus Bosch. New Insights into his Life and Work* (Rotterdam, 2001)

Jos Koldeweij, Paul Vandenbroeck and Bernard Vermet, *Hieronymus Bosch, The Complete Paintings and Drawings* (exh. cat., Museum Boijmans Van Beuningen, Rotterdam, 2001)

Roger H Marijnissen and Peter Ruyffelaere, *Hieronymus Bosch, The Complete Works* (Antwerp, 1995)

James Snyder, *Bosch in Perspective* (Englewood Cliffs, NJ, 1973)

www.boschuniverse.org (a wonderfully-designed and informative website planned by the Boijmans Van Beuningen Museum to accompany their 2001 exhibition)

Introduction

Jan Piet Filedt Kok, 'Underdrawing and Drawing in the Work of Hieronymus Bosch: A Provisional Survey in Connection with Paintings by him in Rotterdam,' *Simiolus*, 6 (1972–3), pp.133–62

Peter Klein, 'Dendrochronological Analysis of Works by Hieronymus Bosch and His Followers', in Jos Koldeweij and Bernard Vermet, *Hieronymus Bosch. New Insights into his Life and Work*, op.cit., pp.121–32

Paul Vandenbroeck, 'Problèmes concernant l'oeuvre de Jheronimus Bosch: Le Dessin sous-jacent en relation avec l'authenticité et la chronologie', in Roger Van Schoute and Dominique Hollanders-Faveart (eds), *Le Dessin sous-jacent dans la peinture, Colloque IV: Université Catholique de Louvain, Institute Supérieur d'Archéologie et d'Histoire de L'Art, Document de travail no.13* (1982), pp.107–19

Chapter 1

Life and Times

Bruno Blondé and Hans Vlieghe, 'The Social Status of Hieronymus Bosch', *Burlington Magazine*, 131 (1989), pp.699–700

G C M Van Dijck, *Op zoek naar Jheronimus van Aken alias Bosch, De feiten familie, vrienden en opdrachtgevers ca.1400–ca.1635* (Zaltbommel, 2001)

Ronald Glaudemans, Jos Koldeweij, Jan van Oudheusden, Ester Vink and Aart Vos, *The World of Bosch* ('s-Hertogenbosch, 2001)

Walter Prevenier and Wim Blockmans, *The Burgundian Netherlands* (Cambridge, 1986)

Ester Vink, 'Hieronymus Bosch's Life in 's-Hertogenbosch', in Jos Koldeweij and Bernard Vermet, *Hieronymus Bosch. New Insights into his Life and Work*, op.cit., pp.19–24

Style

Hans van Gangelen and Sebastiaan Ostkamp, 'Parallels Between Hieronymus Bosch's Imagery and Decorated Material Culture from the Period between circa 1450 and 1525', in Jos Koldeweij and Bernard Vermet (eds), *Hieronymus Bosch, New Insights into his Life and Work*, op.cit., pp.152–70

Walter S Gibson, 'Hieronymus Bosch and the Dutch Tradition', in J Bruyn, J A Emmens, E de Jongh and D P Snoep (eds), *Album Amicorum J C van Gelder* (The Hague, 1973), pp.128–31

Lynn F Jacobs, 'The Triptychs of Hieronymus Bosch', *Sixteenth-Century Journal*, 31 (2000), pp.1009–41

Yona Pinson, 'Hieronymus Bosch: Marginal Imagery Shifted into the Center and the Notion of Upside Down', in Nurith Kenaan-kedar and Asher Ovadiah (eds), *The Metamorphosis of Marginal Images: From Antiquity to Present Time* (Tel Aviv, 2001), pp.203–12

Roger Van Schoute, Helene Verougstraete and Carmen Garrido, 'Bosch and his Sphere. Technique', in Jos Koldeweij and Bernard Vermet (eds), *Hieronymus Bosch, New Insights into his Life and Work*, op.cit., pp.103–20

James Snyder, *Northern Renaissance Art* (New York, 1985)

Patronage

Pilar Silva Maroto, 'Bosch in Spain: On the Works Recorded in the Royal Inventories', in Jos Koldeweij and Bernard Vermet (eds), *Hieronymus Bosch, New Insights into his Life and Work*, op.cit., pp.41–8

Jaco Rutgers, 'Hieronymus Bosch in El Escorial. Devotional Paintings in a Monastery', in ibid., pp.33–40

Paul Vandenbroeck, 'The Spanish *Inventorios Reales* and Hieronymus Bosch', in ibid., pp.49–64

Chapter 2

The *Seven Deadly Sins and Four Last Things*

Walter S Gibson, 'Hieronymus Bosch and the Mirror of Man: The Authorship and Iconography of the *Tabletop of the Seven Deadly Sins*', *Oud Holland*, 87 (1973), pp.205–26

Barbara G Lane, 'Bosch's *Tabletop of the Seven Deadly Sins and the Cordiale Quattuor Novissimorum*', in William W Clark, Colin Eisler, *et al.* (eds), *Tribute to Lotte Brand Philip, Art Historian and Detective* (New York, 1985), pp.89–94

The *Stone Operation*

Hyacinthe Brabant, 'Les traitements burlesques de la folie aux XVIe et XVIIe siècles', *Travaux de l'Institut pour l'Étude de la Renaissance et de l'humanisme, Université libre de Bruxelles*, 5 (1976), pp.75–97

Henry Meige, 'L'opération des pierres de tête', *Aescalupe*, 22 (1932), pp.50–62

William Schupbach, 'A New Look at the *Cure of Folly*', *Medical History*, 22 (July, 1978), pp.267–81

The *Conjurer*

Jeffrey Hamburger, 'Bosch's *Conjuror*: An Attack on Magic and Sacramental Heresy', *Simiolus*, 14 (1984), pp.4–23

M A Katritzky, 'Marketing Medicine: The Image of the Early Modern Mountebank', *Renaissance Studies: Medicine in the Renaissance City*, 15 (June, 2001), pp.121–53

Chapter 3

The *Ship of Fools, Allegory of Intemperance* and *Death of the Miser*

Anna Boczkowska, 'The Lunar Symbolism of the *Ship of Fools* by Hieronymus Bosch', *Oud Holland*, 86 (1971), pp.47–69

Charles D Cuttler, 'Bosch and the *Narrenschiff*: A Problem in Relationships', *Art Bulletin*, 51 (1969), pp.272–6

Anne M Morganstern, 'The Rest of Bosch's *Ship of Fools*', *Art Bulletin*, 66 (June, 1984), pp.295–302

—, 'The Pawns in Bosch's *Death and the Miser*', *Studies in the History of Art*, 12 (1982), pp.33–41

Kay C Rossiter, 'Bosch and Brant: Images of Folly', *Yale University Art Gallery Bulletin*, 34 (1973), pp.18–23

Pierre Vinken and Lucy Schlüter, 'The Foreground of Bosch's *Death and the Miser*', *Oud Holland*, 114 (2000), pp.69–78

The *Wayfarers* and *Haywain* Triptych

W P Blockmans and W Prevenier, 'Poverty in Flanders and Brabant from the Fourteenth to the Mid-Sixteenth Century: Sources and Problems', *Acta historiae Neerlandicae, Studies on the History of the Netherlands*, 10 (1978), pp.20–57

Eric de Bruyn, 'Hieronymus Bosch's so-called Prodigal Son Tondo: The Pedlar as a Repentant Sinner', in Jos Koldeweij and Bernard Vermet, *Hieronymus Bosch, New Insights into his Life and Work*, op.cit., pp.133–44

Walter S Gibson, 'The Turnip Wagon: A Boschian Motif Transformed', *Renaissance Quarterly*, 32 (1979), pp.187–96

René Graziani, 'Bosch's *Wanderer* and a Poverty Commonplace from Juvenal', *Journal of the Warburg and Courtauld Institutes*, 45 (1982), pp.211–16

David L Jeffrey, 'Bosch's *Haywain*: Communion, Community, and the Theater of the World', *Viator*, 53 (1973), pp.311–31

Lotte Brand Philip, 'The *Peddler* by Hieronymus Bosch, A Study in Detection', *Nederlands Kunsthistorisch Jaarboek*, 9 (1958), pp.1–81

Andrew Pigler, 'Astrology and Jerome Bosch', *Burlington Magazine*, 92 (1950), pp.132–6

Kurt Seligmann, 'Hieronymus Bosch, The *Pedler*', *Gazette des Beaux-Arts*, 42 (1953), pp.97–104

Virginia G Tuttle, 'Bosch's Image of Poverty', *Art Bulletin*, 63 (March, 1981), pp.88–95

Irving L Zupnick, 'Bosch's Representation of Acedia and the Pilgrimage of Everyman', *Nederlands Kunsthistorisch Jaarboek*, 19 (1968), pp.115–32

Chapter 4

Jan Bialostocki, '"Opus quinque dierum": Dürer's *Christ among the Doctors* and Its Sources', *Journal of the Warburg and Courtauld Institutes*, 22 (1959), pp.17–34

Witold Dobrowolski, 'Jesus With a Sustentaculum', *Ars auro prior. Studio Ionni Bialostocki sexganario dicata* (Warsaw, 1981), pp. 201–8

Richard Foster and Pamela Tudor-Craig, 'Christ Crowned with Thorns by Hieronymus Bosch', in *The Secret Life of Paintings* (New York, 1986), pp.58–73

Walter S Gibson, 'Bosch's *Boy With a Whirligig*: Some Iconographical Speculations', *Simiolus*, 8 (1976–6), pp.9–15

—, '*Imitatio Christi*: The Passion Scenes of Hieronymus Bosch', *Simiolus*, 6 (1972–3), pp.83–93

James Marrow, '*Circumdederunt me canes multi*: Christ's Tormentors in Northern European Art of the Late Middle Ages and Early Renaissance', *Art Bulletin*, 59 (1977), pp.167–81

Ursula Nilgen, 'The Epiphany and the Eucharist: On the Interpretation of Eucharistic Motifs in Medieval Epiphany Scenes', *Art Bulletin*, 49 (1967), pp.311–16

Sixten Ringbom, *Icon to Narrative: The Rise of the Dramatic Close-Up in Fifteenth-Century Devotional Painting*, Acta Academiae Aboenis, ser. A. Humaniora, 31:2 (Aboi, 1965), pp.155–70

Chapter 5

Martha Moffitt Peacock, 'Hieronymus Bosch's Venetian St Jerome', *Konsthistorisk tidskrift*, 64 (1995), pp.71–85

Wendy Ruppel, 'Salvation Through Imitation: The Meaning of Bosch's *St Jerome in the Wilderness*', *Simiolus*, 18 (1988), pp.5–12

Leonard J Slatkes, 'Hieronymus Bosch and Italy', *Art Bulletin*, 57 (1975), pp.335–45

Chapter 6

Andre Chastel, 'La tentation de Saint Antoine ou le songe du mélancolique', *Gazette des Beaux-Arts*, 15 (1936), pp.218–29

Laurinda S Dixon, 'Bosch's *St Anthony Triptych*: An Apothecary's Apotheosis', *Art Journal*, 44 (Summer, 1984), pp.119–31

Erik Larsen, 'Les tentations de Saint Antoine de Jérôme Bosch', *Revue belge d'archeologie et d'historie de l'art*, 19 (1950), pp.3–41

Jacques van Lennep, 'Feu Saint Antoine et Mandragore: À propos de la 'Tentation de saint Antoine' par Jérôme Bosch', *Bulletin, Musèes royaux des beaux-arts de belgique*, 17 (1968), pp.115–36

Chapter 7

Allison Coudert, *Alchemy: The Philosopher's Stone* (Boulder, Colorado, 1980)

Ernst H Gombrich, 'The Evidence of Images', in Charles S Singleton (ed.), *Interpretation: Theory and Practice* (Baltimore, 1969), pp.35–104

Craig Harbison, 'Some Artistic Anticipations of Theological Thought', *Art Quarterly*, 2 (1979), pp.67–89

Will H L Ogrinc, 'Western Society and Alchemy from 1200–1500', *Journal of Medieval History*, 6 (March, 1980), pp.104–32

Lotte Brand Philip, 'The Prado *Epiphany* by Jerome Bosch', *Art Bulletin*, 35 (1955), pp.267–93

Chapter 8

Hans Belting, *Hieronymus Bosch, Garden of Earthly Delights* (Munich, 2002)

Eric De Bruyn, 'The Cat and the Mouse (or rat) on the Left Panel of Bosch's *Garden of Delights Triptych*: an Iconological Approach', *Jaarboek Koninklijk Museum voor Schone Kunsten Antwerpen* (2001), pp.6–55

Laurinda S Dixon, 'Bosch's *Garden of Delights Triptych*: Remnants of a 'Fossil' Science', *Art Bulletin*, 63 (1981), pp.96–113

—, 'Hieronymus Bosch and the Herbal Tradition', *Text and Image, Acta*, 10 (1983), pp.149–69

Walter S Gibson, 'The *Garden of Earthly Delights* by Hieronymus Bosch: The Iconography of the Central Panel', *Nederlands Kunsthistorisch Jaarboek*, 24 (1973), pp.1–26

Ernst H Gombrich, 'The Earliest Description of Bosch's *Garden of Delight*', *Journal of the Warburg and Courtauld Institutes*, 30 (1967), pp.403–6

Robert Koch, 'Martin Schongauer's Dragon Tree', *Print Review*, 5 (Spring, 1976), pp.115–19

Phyllis Williams Lehman, *Cyriacus of Ancona's Egyptian Visit and Its Reflections in Gentile Bellini and Hieronymus Bosch* (Locust Valley, NY, 1977)

Hans H Lenneberg, 'Bosch's *Garden of Earthly Delights*: Some Musicological Considerations and Criticisms', *Gazette des Beaux-Arts*, 58 (1961), pp.135–44

Robert L McGrath, 'Satan and Bosch: The *Visio Tundali* and the Monastic Vices', *Gazette des Beaux-Arts*, 71 (1968), pp.45–50

Chapter 9

Albert Châtelet, 'Sur un jugement dernier de Dieric Bouts', *Nederlands Kunsthistorisch Jaarboek*, 16 (1965), pp.17–42

Norman Cohn, *The Pursuit of the Millennium* (Oxford, 1970)

Bernard McGinn, *Visions of the End: Apocalyptic Traditions in the Middle Ages* (New York, 1979)

Patrick Reuterswärd, 'Hieronymus Bosch's Four Afterlife Panels in Venice', *Artibus et historiae*, 12 (1991), pp.29–35

Heike Talkenberger, *Sintflut, Prophetie und Zeitgeschehen in Texten und Holzschnitten astrologischer Flugschriften 1488–1528* (Tübingen, 1990)

Chapter 10

Laurinda S Dixon, 'Water, Wine and Blood: Science and Liturgy in the *Marriage at Cana* by Hieronymus Bosch', *Oud Holland*, 96 (1982), pp.73–96

Walter S Gibson, 'Bosch's Dreams: A Response to the Art of Bosch in the Sixteenth Century', *Art Bulletin*, 74 (1992), pp.205–18

—, *'Mirror of the Earth': The World Landscape in Sixteenth-Century Flemish Painting* (Princeton, 1989)

Fritz Grossman, 'Notes on Some Sources of Bruegel's Art', in J Bruyn, J A Emmens, E de Jongh and D P Snoep, *Album Amicorum J G van Gelder*, op.cit., pp.263–8

Helmut Heidenreich, 'Hieronymus Bosch in Some Literary Contexts', *Journal of the Warburg and Courtauld Institutes*, 33 (1970), pp.176–87

Gerta Moray, 'Miró, Bosch and Fantasy Painting', *Burlington Magazine*, 115 (1971), pp.387–91

Herbert Read, 'Bosch and Dalí', in *A Coat of Many Colors: Occasional Essays* (New York, 1973), pp.55–8

Larry Silver, 'Second Bosch: Family Resemblance and the Marketing of Art', in *Kunst voor de Markt (Art for the Market) 1500–1700, Nederlands Kunsthistorisch Jaarboek*, 50 (Zwolle, 1999), pp.30–56

Gerd Unverfehrt, *Hieronymus Bosch: Die Rezeption seiner Kunst im fruhen 16. Jahrhundert* (Berlin, 1980)

Index

Numbers in **bold** refer to illustrations

Aachen (Aix-la-Chapelle)
 19
*Abigail Bringing Presents to
 David* (lost work) 32
Adamites 231, 286–7, 331
Adoration of the Magi (New
 York) 143–6, 218; **71**
Adoration of the Magi
 (Philadelphia) 143–5; **72**
Adoration of the Magi
 (Madrid) 11, 33, 201,
 207–24, 227, 251, 269, 273,
 277; interior **114–15, 118,
 121, 126–8;** exterior **116**
Adoration of the Magi
 (Rotterdam, after Bosch)
 145–6
Adoration of the Magi (lost
 work) 33
Afterlife Panels 149, 281,
 305–7; **204–7**
Aken, Anthonis van (Bosch's
 father) 19, 22
Aken, Anthonis van (Bosch's
 nephew) 19
Aken, Goessens van (Bosch's
 brother) 19, 27
Aken, Jan van (Bosch's
 grandfather) 19
Aken, Johannes van (Bosch's
 nephew) 19
Aken, Katherijn van (Bosch's
 sister) 20
Albertus Magnus 59, 206,
 241, 250
alchemists
 charlatan 59–62, 201,
 204–5
 devout 59–62, 195, 201,
 204–5, 216, 224, 241,
 275–7, 312; **111, 117, 124**
alchemy *see also* distillation
 ablution 234, 271–2, 276;
 182
 Adoration of the Magi
 (Madrid) and 193, 201,
 212–14, 217–24
 Apocalypse and 217, 255,
 278
 apparatus 60, 193–94, 198,
 207, 212–14, 241–2,
 255–60, 264, 271, 276, 319;
 **105, 107–9, 111, 113, 122,
 142, 149, 161–3, 165–6,
 168–9, 174–5, 178, 182,
 184**
 birds 218–221, 246; **129**
 books and manuscripts 59,
 206–7
 chemistry and 10–11, 59,
 201, 273–8
 child's play 162, 234,
 250–1, 258, 277; **151–2**

Christianity and 59, 201,
 204–5, 214–18, 234; **117,
 123, 124**
conjunction 233–4, 236,
 248; **136, 138, 162**
cyclic nature of 246, 250–1,
 255, 258; **160, 163**
eucharistic parallels in
 217, 224, 239, 319; **123–4**
Garden of Earthly Delights
 and 233–44, 246–51,
 255–64, 268–78
golden apple 221; **130**
green dragon 194–5, 206;
 110
hermaphrodite 251; **154**
lay practice of 59, 190,
 192–3, 198, 204; **113**
medicine and 59, 190–8,
 204
metallurgy and 59, 204,
 217–18; **125**
opposites in 194, 236, 248,
 251, 248, 258; **110, 136,
 138, 162**
patrons of 59, 205, 276–7
pharmacy and 59, 190–3,
 182–98
philosopher's stone (lapis)
 60–61, 214–18, 221, 224,
 236, 250–1; **24, 123, 131**
prima materia 240–1, 248
putrefaction (*nigredo*) 218,
 221–4, 234, 268–71; **178–9**
St Anthony Triptych and
 193–8
sex in 228–32, 236, 248–50,
 258, 275–6; **136, 138, 162**
Stone Operation and 59–62
Surrealism and 325–6
symbolism of 194–5, 210,
 212, 206–7, 218–21, 233,
 246
transmutation 205, 214,
 216–17, 274
Alfonso IV, King of Castile
 205
Allegory of Intemperance 69,
 72–8, 89, 96; **29–30, 32**
*Allegory of Poverty and
 Wealth* (engraving) 93–4;
 42
*Altarpiece of the Brotherhood
 of Our Lady* 157; **79**
Alva, Duke of 207, 227, 276
Amberg, Johannes von
 *The Vagrant's Life (De vita
 vagorum)* 92
Ambrose, St 166
Ancona, Cyriacus d'
 Egyptian Voyage 245; **146**
anger *see also* sin
 52–3

Anglicus, Bartholomaeus
 *On the Properties of Things
 (De proprietatibus rerum)*
 47, 245; **15, 147**
Anglicus, Johannes 185
Anthony, St 175–90, 198,
 276, 320; **74, 84, 90, 93–5,
 97, 112**
Antonite order 181–5, 189,
 190, 193, 198, 201
Antwerp 17, 320, 322–3
Apocalypse *see also*
 Revelation 161–3, 217,
 231, 271, 278, 281–312;
 186, 188
Apuleus Platonicus 188
Aquinas, Thomas 59, 206
Aristotle 132, 135, 159–60,
 241
 Physiognomia 132
*The Art of Dying (Ars
 moriendi)* (blockbook)
 86–8; **40**
Artephius
 Secret Book 258
astrology 10–11, 79–83, 89,
 95–6, 231, 239, 284–5,
 300–1, 307; **19, 40, 42, 49,
 187, 199**
Athanasius, Bishop 176
Augustine, St 166, 301
 City of God (De civitate Dei)
 47; **16**
 *Mirror of Sinners (Speculum
 peccatoris)* 45
avarice *see also* sin
 52, 54, 88–9, 93, 96, 107–14;
 18, 31–2, 39–40
Aytinger, Wolfgang 293

Bacon, Roger 206, 241, 250
badges, pilgrim 230; **134**
Baudelaire, Charles 325
Bavo, St 293–4; **193**
Bax, Dirk 51, 150, 232
Beatis, Antonio de 227,
 228
Beatrix, Queen of the
 Netherlands 32
Bellini, Gentile 245
Bening, Simon, Workshop of
 May 77; **33**
Bergh family 77
Bergman, Madeleine 206
Bernard, St 103–4
Boczkowska, Anna 79, 239
Boijmans Van Beuningen
 Museum, Rotterdam 297,
 325, 328
Bonus, Petrus 214, 277
 *New Pearl of Great Price
 (Pretiosa margarita
 novella)* 214, 218, 258; **125**

Book of the Holy Trinity (Buch der heiligen Dreifaltigkeit) 214–15; **179**
Book of Hours of Catherine of Cleves 36–7, 86, 141; **10, 38**
Bosch, Balthasar van den
The Conjuror (after Bosch) 64; **26**
Bosch, Hieronymus
birth date 20–1
copies of 64–5, 145–6, 175, 315–20, 322; **209, 211, 212**
death of 29
drawings 316–17; **210**
establishing authenticity of works 8–10, 315–19
family background 19, 146
and heretical sects *see also* Adamites 6, 19, 34, 206, 211–12, 287
home in 's-Hertogenbosch 24; **3**
influence of 320–30; **213–15, 217–18**
interpretations of 4–6, 10–11, 232
lack of documentary evidence of 15–16, 18–19
landscape and 35, 55, 107, 163, 212
lost works 33, 319–20
marriage 19, 21–2
membership in the Brotherhood of Our Lady 24–33, 34, 104
name 19–20
patrons 33–4, 55, 77, 155, 207–8, 290–4
social status 19, 21, 22–4, 34
style and technique 6–7, 34–5, 38, 143–6, 316
underdrawings 6–7, 75, 297–8, 316
Bosch, Jhorine 33
Bosch, School of
Ecce Homo 28–9, 122; **8–9**
Bosschuysen family 33, 207–8
Bouts, Dieric 36
Fall of the Damned 306; **203**
Terrestrial Paradise 306; **202**
Brant, Sebastian 78, 312
Ship of Fools (Das Narrenschiff) 77–9, 86, 96, 116; **34, 39**
Brethren of the Free Spirit *see* Adamites
Breton, André 325
Breydenbach, Bernhard von
Holy pilgrimages (Sanctae peregrinationes) 245
Bronckhorst family 33, 207–8
Brotherhood of Our Lady
account books 9, 18–19
activities of 29, 109
Altarpiece of 157; **79**
Apocalypse and 211, 287
Bosch's association with 24–34

Chapel of 27–8, 32–3; **5**
converted Jews and 211–12, 287
membership 28, 29–32, 86, 208, 228
meeting house of 27; **6**
insignia 28–9, 122; **8–9**
poor relief and 100, 104–5
Brothers and Sisters of the Common Life *see* Modern Devotion
Bruegel, Pieter the Elder 322, 325
Mad Meg (Dulle Griet) 322–3; **215**
Brunfels, Otto
Herbarium vivae icones 198; **113**
Brunswyck, Hieronymus 188
Book of Distillation (Liber de arte distillandi) 161, 190–3, 255, 260; **83, 161**
Brussels 33, 104, 227–8
Buxheim St Christopher (woodcut) 154; **76**

Campin, Robert 34–5
Carrington, Leonora 325–6
Carthusian order 18
Chailley, Jacques 206
Charles VI, King of France
Royal Work of Charles VI, King of France (Oeuvre royale de Charles VI, roi de France) 205
Charles VII, King of France 205
Charles the Bold, Duke of Burgundy 16, 18
Chaucer, Geoffrey
Canterbury Tales 90
chemistry *see* alchemy
Children of Luna (blockbook) 83; **37**
Children of Saturn (engraving) 95–6, 161, 218; **43**
Christ 44, 111, 211–12
appearance of 128, 132, 135–6
incarnation 141–3
as lamb of God 159
as lapis *see also* alchemy 214–18, 224; **123**
imitation of *see also* Kempis 99, 120–73
infancy and youth of 138–46, 208–9; **65, 67, 70–2, 114, 116**
man of sorrows 129; **61**
passion of *see also* passion tracts 46, 122–146, 209–11, 224, 231; **55–61, 63, 68, 82, 91–2, 116, 209**
pelican as 161, 240; **83**
as quintessence 130; **62**
second coming of 211, 278, 281, 284
Christ Carrying the Cross (Madrid) 127–8; **58**
Christ Carrying the Cross (Vienna) 138, 145; **68;**

obverse of *Christ Child with Whirligig and Walking Frame* 69
Christ Child with Whirligig and Walking Frame 138–43, 145; **69**; reverse of Vienna *Christ Carrying the Cross* 68
Christ Carrying the Cross (Ghent) 7–8, 128, 131–2, 328; **63**
Christ Crowned with Thorns (London) 128–31, 132, 135; **59**
Christ Crowned with Thorns (after Bosch) 315; **209**
Christian Church *see also* Christ, clergy, sin
and alchemy 59, 201, 204–5, 214–18
Apocalypse 161–3, 217, 231, 271, 278, 281–312; **186, 188**
eucharist 138, 142, 209–12, 212–13, 216–17, 224, 239, 319; **120**
Great Schism of 284
and voluntary poverty 99–104, 117
Christopher, St 153–5; **75–6**
Chrysostom, St John 301
Church Fathers 166
Church of St Jan, 's-Hertogenbosch 27, 33, 104, 150, 153–4, 158, 287; **4, 5, 48**
Church of St Mark, Venice (mosaic) 298; **197**
Cibinensis, Melchior
Symbolum 216; **124**
clergy, castigation of 65–6, 111, 313; **13**
Cleves, Counts of 32
Clusius, Carolus 61
Cock, Hieronymus 319–20, 322
Cocles, Bartolommeo 134
Cohn, Norman 287
Columbus, Christopher 285–6
Combe, Jacques 206, 264
Common Proverbs (Proverbia communia) 116–17
confraternities *see also* Brotherhood of Our Lady and Catholic Church 24–33
functions of 24–6
The Conjuror 43, 62–5, 141; **25**
Constantinople 284
Copernicus, Nicolas 79
The Creation of the World (lost work) 33
Crucified Martyr 149–50, 157, 175, 305; **73–4**
Crucifixion with Donor 39–40; **2**
Crumb, Robert
Weirdo 328; **218**
Cuperinus 18

Dalí, Salvador 326
The Great Masturbator 326; **217**

David, Gerard 36
Death of the Miser 69, 72–6, 84–9, 96, 265; **31–2**
Deguilleville, Guillaume
 The Pilgrimage of the Life of Man (Pèlerinage de la vie humaine) 45, 78–9, 88, 103, 142
dendrochronology 8–9, 315
Denis the Carthusian
 Four Last Things (Quattuor novissima) 52
Devastation by Fire 281, 297–8, 302–5; **199**; reverse **200**
Devotio moderna see Modern Devotion
Dioscorides
 De materia medica **99**
distillation *see also* alchemy
 manuals of 190–3, 201, 244, 255; **113, 143–4, 158–9, 161**
 cycle of 275–6
Dominican order 17–18, 33
Domitian, Emperor 161
dragon palm 239
Duhameel, Alart
 Beleaguered Elephant (engraving after Bosch) 320; **212**
Dürer, Albrecht 15–16, 20, 78, 160, 168, 239, 301, 316
 Christ Among the Doctors 136; **65**
 Four Horsemen of the Apocalypse (woodcut) 285; **188**
 Melencolia I (engraving) 159–60; **81**
 St Jerome in his Cell (engraving) 166; **87**
 St Jerome in the Wilderness (engraving) 166; **86**
 Small Passion (woodcut) 129; **61**
 Syphilitic with Conjunction of Saturn, Jupiter and Mars in Scorpio (broadsheet) 284–5; **187**

Edward III, King of England 205
Edward IV, King of England 274
elements, four *see* humoral medicine
 80, 129–30, 201, 205, 260; **35–6**
Engelbert II, Count of Nassau 228
enthousiasme see also melancholia
 161, 163, 166
envy *see also* sin
 52, 54
Erasmus, Desiderius 83, 88, 111, 117, 135, 136–7, 168, 312
 Adages 136
 Handbook for the Christian Knight (Enchiridion militis Christiani) 88

In Praise of Folly (Encomium moriae) 83, 111
On Language (De lingua) 136
Edition of the *Writings of St Jerome* 168
ergotism (holy fire, St Anthony's fire) *see also* LSD, mandrake
 179–90, 193, 284, 293, 320
Ernst, Max 325
Escorial 43, 97, 276–7
Eyck, Jan van 34–5, 205, 315

Ferdinand, King of Spain 286
Ficino, Marsilio
 Three Books on Life (De vita triplici) 160
Finé, Oronce
 Protomathesis 79; **35**
flood
 of Noah 271, 298; **196–7**
 and Apocalypse 274, 298–305; **198**
Flood 281, 297–305; **196**; reverse **201**
Florence 245, 284
four last things 44, 52–4; **14**
Fraenger, Wilhelm 231, 286
Francis of Assisi, St 100; **3**
Franciscan order *see also* Poor Clares 17–18, 32, 100
Frederick I, Count of Nuremberg 214–15

Gaddi, Taddeo, Workshop of
 Allegory of Poverty 100; **45**
Galileo 79
Garden of Earthly Delights 4, 7, 11, 33, 227–78, 283, 289, 297, 326; interior **1, 132–3, 137, 139, 141, 145, 148, 150, 153, 155–7, 164, 167, 170–3, 177, 180, 216**; exterior **181, 183**
Garden of Health (Hortus sanitatis) 244, 255; **143–4, 158–9**
Geertgen tot Sint Jans
 St John the Baptist in the Wilderness 38, 159; **11**
geocentric universe 79; **35**
Gersdorff, Hans von
 Feldbuch der Wundartznei 56, 176, 189; **21, 93, 103**
Gesner, Conrad
 Quatre livres des secrets **169**
Ghent, 294
Gibson, Walter S 44–5, 141, 184, 232
Giles, St 166
 in *Hermit Saints Triptych* **84**
Giovanni di Andrea
 Hieronymianus 168
Gislebertus
 Last Judgement, Autun, west tympanum 282; **186**
gluttony *see also* sin
 52, 54, 83, 96–7, 265
Goes, Damiaan de 175
Goes, Hugo van der 107, 128, 137
Fall of Man 107; **51**

Portinari Altarpiece 137–8; **67**
Gombrich, Ernst 212, 275
gout *(podagra)* 94
Gramaye, Jan Baptiste de 33
Graziani, René 99
Gregory the Great, Pope 49, 112–13, 166, 209, 224
Grimani, Cardinal Domenico 34, 149, 153, 163, 305
Groote, Gerard 18, 103
Grünewald, Matthias
 Isenheim Altarpiece 181
Guevara, Diego de 33, 55
Guevara, Felipe de 4, 33, 43, 55, 315
 Commentary on Painting (Commentarios de la pintura) 43
Guildbook of the Barber Surgeons of York 130; **62**

Haarlem 38
Habsburg dynasty 16–18, 112, 205, 228, 277, 293–4, 305
Haywain (Escorial) 97
Haywain (Prado) 33, 69, 89–91, 97–104, 107–14, 117, 172, 289, 293, 294, 297; interior **frontispiece, 49–50, 52, 54, ;** exterior **44**
Hendrick III, Count of Nassau 227–8, 276
Henry VI, King of England 205, 216–17
heretics *see also* Adamites, Jews, Turks
 34, 122, 127, 131, 206, 211–12, 281, 284, 286–7
Hermes Trismegistus 241, 250, 274
Hermetic Museum (Museum hermeticum) 215
Hermit Saints Triptych 149, 155, 163–9, 175, 305; **84–5**
hermits 149, 155, 158–71, 174–81; **84–6, 88, 90, 111–12**
Herod, King 212
Herrera, Juan de 276
Hildegard of Bingen
 Causes and Cures 83
 Physica 56; **22**
Hippocrates 134
 The Nature of Man 131
Hofmann, Albert 189
holy fire *see* ergotism
Hoornbach, Gerhard
 Golf Book **33**
humanism *see also* Erasmus 10, 15, 116–17, 136, 153, 159, 305
humoral theory *see also* temperaments
 80–3, 129–31, 160–1
Hundred Years War (1337–1453) 216–17, 284
Huys, Pieter 320
 Temptation of St Anthony **213**

Indagine, Johannes
 Chiromantia 134; **64**
indulgences 29, 64–5,
 209–10
Inquisition 43, 211
Isaac, Sacrifice of 208–9,
 221, 224
insanity see luna
Isabella, Queen of Spain 33,
 286

James the Greater, St 293–4;
 193
Janssen, Hans 230
Jerome, St 155, 163, 166–72
 in Hermit Saints Triptych **74**
Jews 211–12, 287
Joachim of Fiore 282–3, 307
John II, King of France 205
John XXII, Pope 204–5
 The Art of Transmutation
 (Ars transmutatoria) 205
John the Baptist, St 155–9;
 77, 79, 80
John the Evangelist, St see
 also Revelation
 155–9, 161–3, 211, 281, 287;
 78–9, 80
John of Lichtenberger
 Prognostications
 (Prognosticatio) 290–3
Julia, St 150–3
Julius II, Pope 131, 305
Jung, Carl 325, 326
Jupiter (planet) 80, 131, 217,
 284

Kempis, Thomas à 100, 111,
 166
 Imitation of Christ (Imitatio
 Christi) 100–3, 111–12
Knights of Columbus 24
Knowledge of Mankind by
 Many Signs (Den mensche
 te bekennen bi vele
 tekenen) 132–4
Koch, Robert 239
Koldeweij, Jos 157

Lament of a Poor Man Over
 his Cares (Lamento de uno
 poveretto humomo sopra la
 carestia) 91
Last Judgement see
 Apocalypse
Last Judgement, fragment
 (Munich) 289; **191**
Last Judgement (Vienna) 9,
 33, 281, 289–97; interior
 185, 192, 195; exterior **193**
Last Judgement (Bruges)
 281, 289; **190**
'Last Judgement Machine'
 287; **189**
Latin language 15, 55,
 116–17
Lehman, Phyllis Williams
 245
Lennep, Jacques van 206
Leonardo da Vinci 10
 Drawing of Grotesque
 Heads 136; **66**
leprosy see also Saturn
 211, 218, 269

Libavius, Andrae
 Alchymie 246; **149, 166**
Lives of the Church Fathers
 (Vitae patrum) 176
Louis of Aragon, Cardinal
 227
Lowinsky, Edward 36
Lull, Raymond 251
LSD (byproduct of ergot)
 181, 189–90
Luna (moon) 80, 217,
 239
 crescent 76, 127, 131
 insanity and 83–4, 90, 94,
 131
lust see also sin
 52, 83, 92, 97, 113, 168,
 228–9, 265
Luther, Martin 66, 278

Maier, Michael
 Symbola aureae mensae
 251; **154**
Mander, Karel van 35
 Het Schilder-boeck (Book of
 Painters) 16
Mandijn, Jan 320
mandrake 185–90; **98–100,
 102**
Manuel et exercitations
 spagyriques **122**
Margaret of Austria 33
Margaret of Parma 323
Marijnissen, Roger 231–2
Marmion, Simon
 Le Livre des sept âges du
 monde 307; **208**
The Marriage at Cana (after
 Bosch) 319; **211**
Marrow, James 121, 135
Mars (planet) 80, 131, 217,
 284
Mary of Burgundy 16
Mass of St Gregory 209–10,
 224; **116, 120**
Master of the Banderoles
 Fountain of Youth 232; **135**
Master E S
 Fantastic Alphabet 39; **13**
Master of the Karlsruhe
 Passion
 Arrest of Christ 122; **56**
Mattioli, Pier Andrea
 Commentarii 188; **102**
Maximilian I, Emperor
 16–17, 293
Meckenem, Israhel van
 Mass of St Gregory 210; **120**
medicine see also ergotism,
 humoral theory
 11, 59, 63, 181–90, 201
 surgery 56, 189–90; **20–1,
 23, 103**
Meervenne, Aleyt Goyarts
 van den (Bosch's wife)
 21–2, 190
melancholia see also Saturn,
 temperaments
 genius and 95–6, 159–60
 hermits and 159–61
 pose of 159–168, 271, 307;
 61, 81
Memling, Hans 128, 159
 Deposition of Christ 128; **60**

The Mystic Marriage of St
 Catherine 158, 161–3; **80**
Mercury (planet) 80, 217
metals, hierarchy of 217–18
Metsys, Quinten 36, 315
Meun, Jean de
 A Demonstration of Nature,
 Made to the Erring
 Alchemists 60
Michelangelo 66, 305
Miracle of St Chandelle
 (Anonymous) 184; **96**
Mirror of Christianity
 (Speculum christiani) 45
Mirror of Man (Miroir de
 l'omme) 45
Mirror of Sinners (Speculum
 peccatoris) 45
Mirror of Understanding (Der
 Spiegel der Vernunft)
 (woodcut) 103; **47**
Mirror of Vagrants (Speculum
 cerretanorum) 92
misericord from Breda 100;
 46
Mocking of Christ 122; **55**
Modern Devotion (Devotio
 moderna) 18, 52, 100–3,
 111, 121, 155, 171, 307
moon see Luna
Morganstern, Anne 72, 88
Mosmans, Jan
 'Last Judgement Machine'
 287; **189**
mountebanks 63–4; **25–6**
music 264–5, 271
 Brotherhood of Our Lady
 and 28
Mynnen, Aleyt van der
 (Bosch's mother) 22

Nassau, Counts of 33, 227–8
Newton, Isaac 206
Nicholas of Cusa
 Vision of God (De visione
 dei) 45
Northern Renaissance style
 34–7, 315–17
Nuremburg Master
 Cliff Landscape with
 Wanderer 91; **41**

Oestvoren, Jacob van
 Blue Ship (Blauwe Schute)
 78
Os, Peter van 122; **8–9**
Ouroboros 255, 276; **160**
owl
 evil 76–94
 wise 169, 240

Panofsky, Erwin 4, 35
Paradise
 expulsion from 107
 regained 251–2, 255,
 274–5, 277–8, 283, 286
 terrestrial 306; **202, 206**
Passion tracts 121–43, 146,
 169–71, 172, 179
Patinir, Joachim 322
 Passage to the Infernal
 Regions 322; **214**
Paul, St 88
pentimenti 6, 75, 97, 297–8

Pflaum, Jacob
Almanach (Almanach nova)
298–300
pharmacy see also alchemy,
distillation
11, 190–3, 198
Philip II, King of Spain 43,
55, 97, 127, 207, 276–7,
320, 323
Philip VI, King of France 205
Philip of Burgundy, Bishop of
Utrecht 33–4, 55
Philip the Good, Duke of
Burgundy 16, 33–4, 55,
205, 268
Philip the Handsome, King of
Castile and Prince of the
Netherlands 33, 228, 289,
290–4
Philip the Handsome
(Anonymous) 194
Philip, Lotte Brand 95,
211–12
Philosophical Rose (Rosarium
philosophorum) 215; 123,
136
physiognomy 11, 132–7,
218, 231; 64
Pigler, Andrew 95
pilgrims see also badges
84, 89, 91, 103, 117, 182,
185, 293; 47
planets see also astrology,
specific planets
children of 95–6, 161, 218;
43, 49
in geocentric universe 79;
35
hierarchy of 217
Plato 305
Platonicus, Apuleus 188
Poe, Edgar Allan 325
Poor Clares see also
Franciscan order
100
Porta, Giambattista della
188–9
De distillationibus 240; 142
poverty 91–4, 96–7, 99–105,
117; 27, 32, 39, 42, 44, 45,
46
Prado Epiphany see
Adoration of the Magi
Prague 277
Protocol 18, 20, 21, 22
proverbs 114, 109–11,
116–17, 136, 316
Pucelle, Jean
Hours of Jeanne d'Évreux
39; 12
Pythagoras 79

rederijker kamers
(chambers of rhetoric)
17, 57, 114
Reformation 66, 116
Revelation, Book of see also
Apocalypse, St John the
Evangelist
52, 161–3, 275, 281–2, 302,
305
Ripley, George 251, 274
Ripley Roll 60, 236–9; 24,
138

Rising Dawn (Aurora
consurgens) 194–5, 221;
110, 129
Robert the Bruce 205
Romance of Alexander
(manuscript) 113; 53
Rome 66, 209
Rudolf II, Emperor 277
Ruppel, Wendy 171
Rupus, Alanus de 143
Ruysbroeck, Jan van 18, 307

's-Hertogenbosch see also
Brotherhood of Our Lady,
Church of St Jan
16, 17–18, 19, 20, 22–33, 65,
84, 100, 104, 171, 228, 230,
287; 3–6
St Anthony (Madrid) 195–8;
112
St Anthony (anonymous
woodcut) 181; 95
St Anthony Triptych (Lisbon)
11, 155, 175–6, 184–95,
201, 212–14, 273, 293, 315;
89–90, 97, 101, 104, 106;
exterior 91–2
St Anthony's fire see
ergotism
St Christopher 153–5, 166;
75
St Dorothy with the Christ
Child (woodcut) 141; 70
St Jerome at Prayer 155,
169–71; 88
St John the Baptist 155–9; 77
St John the Evangelist on
Patmos 155–9, 161–3, 240;
78; obverse of Scenes of
the Passion 82
Satan 86, 107, 177, 264–5,
294–5; 176
appearance of 107, 297
Satan Eating and Excreting
the Souls of the Damned in
Hell (engraving) 176
Saturn (planet) see also
leprosy, melancholia
80, 89, 95, 96, 131, 159, 160,
161, 217, 218, 269, 271,
284; 43
Savonarola, Girolamo 284
Scenes of the Passion 161;
82; reverse of St John the
Evangelist on Patmos 77
Schedel, Hartmann
Nuremberg Chronicle 239;
140
Schlüter, Lucy 88
Schongauer, Martin 239
Christ Carrying the Cross
(engraving) 122; 57
Temptation of St Anthony
(engraving) 181; 94
Schott, Johann 56
Schupbach, William 57
Seitz, Alexander
A Warning of the Flood (Ein
Warnung des Sündtfluss)
300–1; 198
Seneca
Moral Epistle XIV 100
Seven acts of mercy
24–5

Seven Deadly Sins and Four
Last Things 33, 43–56, 66,
76, 85, 111, 129, 171–2,
231; 14, 18–19
The Seven Sins (woodcut)
47–9; 17
Ship of Fools 11, 69–79, 83–4,
89, 95, 96, 169, 265; 28, 30,
32
Siguenza, Fra José de 207,
276, 330
sin see also specific sins
beginning of 294–5; 49–50,
192, 195
original 14; 49–51, 140,
192, 195
physiognomy and 134–5,
231
punishment of 52–4,
113–14, 264–8; 19, 49, 54,
133, 172–3, 176–7, 180,
185–6, 190, 191, 192, 203,
204, 205
seven 44–52, 265; 14, 16,
17
Slatkes, Leonard 150
sloth see also sin
52, 54, 92
Solomon and Bathsheba (lost
work) 32
spontaneous generation
241–5
Stoeffler, Johannes
Almanach (Almanach nova)
298–300
Stone Operation 11, 34, 43,
55–62, 65, 66, 116, 193; 20,
23
Sullivan, Margaret 116
Surrealism 325–6
sustenacula (walking frame)
141, 143
syphillis 284; 187

talismans, mandrake 185–8;
100
temperaments see also
humoral theory
4, 80–3, 129–31; 36, 62
Tricht, Aert van
baptismal font 104; 48
Trismosin, Salomon 273
Splendour of the Sun
(Splendor solis) 221, 248;
130, 152
Turks 83, 127, 284
Turba philosophorum 250,
251, 258, 269–71
Tuttle, Virginia 100
typology 122, 208, 301, 305;
119

Utrecht 37

Vandenbroeck, Paul 21,
228–30, 231–2
vanity see also sin
51–2, 111–12
Vasari, Giorgio
Le Vite (Lives of the Artists)
16
Venice 19–20, 149, 298; 197
Venus (planet) 76, 80, 217,
232

vernacular language
114–17, 297, 333
Veronica, St 132
*View of the Market at
's-Hertogenbosch*
(Anonymous) 22–4; **3**
Vincent of Beauvais
*Mirror of Human Salvation
(Speculum humanae
salvationis)* 45, 208; **119**
Vinken, Pierre 88
Virdung, Johannes 302
Virgil 168
Virgin Mary
as apocalyptic woman 163;
124
mother of Christ 208–216;
10, 71–2, 80, 114–15
Zoete Lieve Vrouw 27–9; **7**
Vliederhoven, Gerard de
*Cordiale quattuor
novissimorum* 52
Voragine, Jacobus de
Golden Legend 153, 175,
176

Wayfarer see also Haywain,
exterior
11, 69, 75–6, 89–104, 157,
159, 269, 325, 328; **27, 32**
Weber, Eugen 283
Wesel, Adriaen van
*Altarpiece of the
Brotherhood of Our Lady*
(sculpted panels) 157; **79**
Weyden, Rogier van der
34–5, 315
Wilde, Oscar 137
Wilgeforte, St 150
*The Woods Have Ears, and
the Fields Have Eyes*
(drawing) 316; **210**
Wouterszoon, Peter 287
Wyngaerde, Antonius van
den
View of 's-Hertogenbosch **4**

zodiac *see also* astrology
47; **15, 208**

Acknowledgements

In my attempt to synthesize the vast amount of scholarship on Hieronymus Bosch, I owe a great deal to more people than I can possibly name here. However, special recognition is due to several individuals whose counsel and guidance contributed substantially to the current form and content of this book. I thank, above all, Walter S Gibson, to whom this book is dedicated, for his extraordinary generosity in sharing his bibliographic research with me and in critically reading the manuscript, which was much enhanced by his vast knowledge of the many contexts of Northern Renaissance art. To him also goes my appreciation for many years of valued friendship, professional support and good humour, all with the aim of understanding the enigma of Bosch. I also thank Barbara Wisch, whose groundbreaking work on confraternities and artistic patronage opened my eyes to the importance of the Brotherhood of Our Lady in the study of Bosch, and whose editorial talents greatly enriched the text. My understanding of the role of the Brotherhood was further enhanced by the director, G J de Bresser, and staff of the confraternity house (*Zwanenbroederhuis*) in 's-Hertogenbosch, whose graciousness and generosity towards an American researcher were greatly appreciated. I express my gratitude as well to Bernard Vermet, of the Boijmans Van Beuningen Museum, for kindly allowing me to view the 2001 'Hieronymus Bosch' exhibition on the day before its official opening. Travel to the Netherlands, on behalf of this book, was funded by the Department of Fine Arts and the Dean of the College of Arts and Sciences at Syracuse University. Finally, for their patience and professionalism, I thank Charles Klaus, for his critical readings of the manuscript in all its stages, and my colleagues at Phaidon, whose efforts brought this book to fruition: David Anfam who commissioned the text, my editors, Pat Barylski, Julia MacKenzie and Ros Gray, and the picture researcher, Liz Moore.

LD

To Walter S Gibson, scholar and friend

Photographic Credits

351 Acknowledgements

Phaidon Press Limited
Regent's Wharf
All Saints Street
London N1 9PA

Phaidon Press Inc.
180 Varick Street
New York, NY 10014

www.phaidon.com

First published 2003
Reprinted 2004
© 2003 Phaidon Press Limited

ISBN 0 7148 3974 4

Typeset in Rockwell

Printed in Singapore

Cover illustration Detail from the *St Anthony*
triptych, *c.*1495 or later (see p.177)